ADOBE® PHOTOSHOP®

LIGHTROOM®

EDIT ON THE GO

2023 EDITION

OCTOBER 2023 RELEASE
COVERING VERSIONS:

Windows / Mac: 7.0

iOS / Android: 9.0

VICTORIA BAMPTON

Adobe Photoshop Lightroom—Edit on the Go (2023 Edition)

Publication Date 10 October 2023
Last Updated 20 October 2023

Published by The Lightroom Queen, an imprint of LRQ Publishing Ltd.

ISBN 978-1-910381-18-2 (eBook Formats)
ISBN 978-1-910381-19-9 (Color Paperback)

TABLE OF CONTENTS

ACKNOWLEDGMENTS

Many people have contributed to this project, and although I'd love to thank everyone personally, the acknowledgments would fill up the entire book. Some people deserve a special mention, though.

First and foremost, my heartfelt thanks go to Paul McFarlane, who has worked closely with me on this book yet again.

I also have to thank the entire Lightroom team at Adobe, including those who have since moved on to other projects. Special thanks go to Rikk Flohr, who willingly answers my never-ending questions.

Thanks are also due to the team of Lightroom Gurus, who are always happy to discuss, debate, and share their experience!

And finally, I have to thank you, the Reader. Over the years, you've honed my writing and teaching skills, and you continue to do so. The lovely emails you send me and the reviews you post online make all the late nights and early mornings worthwhile—so thank you.

Victoria Bampton—Isle of Wight, England, October 2023.

IMPROVE THE BOOK!

This book is constantly being updated. We'd love to hear about what you like and what you think could be improved.

You can send us your feedback using the Contact form on the website at https://www.lightroomqueen.com/contact.

CONNECT ON SOCIAL MEDIA

We'd love to connect with you on:

The Forum: https://www.lightroomqueen.com/community/

Facebook: https://www.facebook.com/lightroomqueen

X / Twitter: https://twitter.com/LightroomQueen

The Newsletter: https://www.lightroomqueen.com/newsletter/

INTRODUCTION

1

For many years, Lightroom has been the industry standard for photo editing. When Lightroom was first introduced to the world in 2006, editing your photos meant sitting at a desk at a "proper" computer. Mobile phones were used for phoning people and sending text messages, and iPads didn't exist. How times have changed!

In 2017, Adobe announced that the Lightroom family was growing and being reorganized. Like a human family, the Lightroom family of apps all share the same foundation: the Camera Raw engine. But like the members of a human family, the individual apps have different strengths and weaknesses.

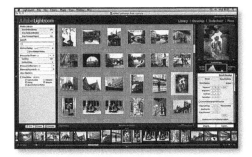

Lightroom Beta (2006)

THE LIGHTROOM CLOUD ECOSYSTEM

The Lightroom cloud ecosystem, with its mobile, desktop, and web interfaces, has been redesigned and rewritten from the ground up to meet the needs of today's photographers.

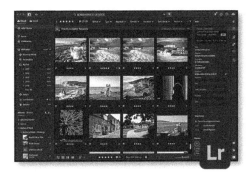

Lightroom

These cloud-based apps retain the best of Lightroom's heritage, including the world-class non-destructive editing tools, but also add cutting-edge image-analysis artificial intelligence, allowing you to find your photos by subject, even if you haven't manually added that information.

They're cloud-native, which means that

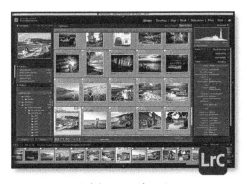

Lightroom Classic

the photos are stored safely on Adobe servers in the cloud. They're available on all your devices, so you can work on them wherever you are without worrying about file management.

LIGHTROOM CLASSIC

The traditional folder-based version of Lightroom, now known as Lightroom Classic, has been refocused on its greatest strength—being an advanced desktop app. It's had many years of development, so it has a lot of advanced features and a steep learning curve to match.

Lightroom Classic is a distant cousin of the Lightroom cloud ecosystem. Its communication with the cloud is limited as it's focused on single-desktop editing, so we won't go into detail on Lightroom Classic in this book. However, we will demonstrate a simple workflow that utilizes both Classic and mobile for those who want the best of both worlds. If you're ready to switch, we'll also consider how to migrate to and from Lightroom Classic.

Lightroom Classic is covered in detail in another of our books, Adobe Lightroom Classic—The Missing FAQ.

THE BOOK FORMAT & BONUS DOWNLOADS

This book is broken up into topic-based chapters, each containing bite-sized lessons. It's written in a logical workflow order, starting with importing photos, viewing them and adding metadata, exploring the editing tools, and finally sharing them with others.

DIAGRAMS & CROSS REFERENCES

Wherever possible, I've used annotated illustrations and graphics rather than thousands of words so that you can grasp the information quickly. **Bold text** helps you find the information quickly when using the book as a reference.

Likewise, instead of constantly repeating the same information, page references link to related topics, and these are clickable links in the eBook formats.

At the end of the book, you'll find a glossary of unfamiliar terms (page 437) and an index (page 441), so you can easily find the information again later.

MULTIPLE OPERATING SYSTEMS

Lightroom runs on multiple operating systems and devices. The same principles apply, but the user interface varies due to screen size, and some behavior varies depending on the operating system.

To keep things simple, if there are only minor differences, they'll be listed inline, for example, *action (iOS) / action (Android) / action (desktop)*. If there are more significant differences, we'll discuss the mobile behavior first and then the desktop app, simply because more people use the mobile apps. The web interface (page 20) works just like the apps, so we won't go into great detail, but we'll cover Web-only features where applicable.

FOCUS ON EDITING

Much of the book is focused on editing photos (page 123) because that's why most of us are using the software. We won't just discuss what the individual sliders do but also how they interact and how professional photographers *think* as they edit their photos.

NEW LESSONS & UPDATES

As Lightroom is subscription software, Adobe adds new features every couple of months. This means all printed books will be outdated within a few months of release—but don't worry, I've got you covered. I'm constantly updating the eBook formats for changes and new features, and these are available to download from the Lightroom Cloud Premium Members Area.

A year's access to the Lightroom Cloud Premium Members Area is included in your book purchase, and you can extend your access at a low cost (by visiting the Memberships page in the Members Area), so you always have the most up-to-date information.

ACCESS TO THE PREMIUM MEMBERS AREA

If you purchased this book directly from my Lightroom Queen website, your Members Area access will have been set up automatically at the time of purchase.

If you purchased your book from Amazon, Barnes & Noble, or another retailer, you'll need to register your copy of this book to gain access to the Members Area. For instructions, turn to the end of the book (page 440).

GETTING STARTED 2

I'm sure you're excited to start, but you may also be a little apprehensive if you're not entirely comfortable with technology. Even if you consider yourself computer-literate, every app is different, and you won't want to create additional work for yourself, or worse still, risk losing any of your photos. So, let's start with the basics...

APPS RUN LOCALLY

Although Lightroom stores the photos in the cloud, the application installs and runs on your mobile device or computer. This means you can still use Lightroom even if your internet connection goes down.

LIGHTROOM ON THE WEB

If you're using someone else's computer or device, there's no need to install the Lightroom app. You can access your photos using Lightroom Web by navigating to https://lightroom.adobe.com in any modern web browser and logging in with your Adobe ID (page 20). You can also share web gallery links with family, friends, and clients to allow them to view your photos and add their own (page 386).

IN THIS CHAPTER, WE'LL CONSIDER:

• The hardware & operating system requirements.

• How to install Lightroom on your devices.

• How to find your way around the interface.

• How to start to build your workflow.

WHAT DO YOU NEED TO USE LIGHTROOM?

To run Lightroom, you'll need a mobile device or computer that meets (or preferably exceeds) the minimum specification. If you want to use the desktop app or the mobile app's Premium features (including cloud sync), you'll also need a trial or active subscription that includes Lightroom and cloud storage space.

MOBILE SYSTEM REQUIREMENTS

The mobile apps have minimum system requirements. If your device doesn't meet the criteria, the apps won't install. Higher specification hardware significantly improves performance.

On iOS, you need to be running *iOS 15 or later* on a recent iPhone or iPad.

Android devices need to be running *Android OS 8.0.x or later* with this minimum specification:

- *Processor: Quad Core CPU and ARMv8 or x86_64 architecture (Octa Core CPU and ARMv8 or x86_64 architecture recommended).*

- *RAM: 4 GB (8 GB recommended).*

- *Internal storage: 32 GB (128 GB and above is recommended).*

Some features are only available on high-specification devices. For example, on iOS, only devices with a 12MP+ camera can capture in DNG format, and only A11 chips or later can take advantage of AI-based masking. Only a few Android phones can capture HDR (high dynamic range) images and access multiple lenses.

You'll also need enough storage space to hold the local cache of the database, some photo previews, and any originals that haven't been uploaded to the cloud yet. This is especially important on iOS/iPadOS, as Lightroom can't use external storage to store photos, whereas an SD card can be used on Android.

For Adobe's latest system requirements for mobile devices, check https://www.Lrq.me/ccmob-sysreq

DESKTOP SYSTEM REQUIREMENTS

Adobe publishes minimum system requirements (shown as bullets below, correct at the time of publication), but these are the bare minimum to make Lightroom run. Higher specification hardware significantly improves performance. These minimum specifications are occasionally updated as new operating systems and features are released, so to check the latest system requirements, visit https://www.Lrq.me/cc-sysreq

If you've purchased your computer in the last 2-3 years, it's likely to be able to run Lightroom. However, if you're considering buying a new computer, it helps to understand what these specifications mean, so let's take a closer look...

Operating System

- *Required on Windows: Windows 10 (64-bit) Version 22H2 or later, or Windows 11 Version 21H2 or later.*

- *Required on Mac: macOS 12 (Monterey) or later.*

If you're running an older operating system, you'll need to upgrade it before installing Lightroom. Support for new operating

systems is added after they're officially released, so we wouldn't recommend running a beta operating system.

CPU / Processor

• *Required on Windows: Intel, AMD, or ARM processor with 64-bit support and SSE 4.2 support. 2 GHz or faster processor*

• *Required on Mac: Multi-core Intel processor with 64-bit support or Apple Silicon processor.*

The CPU is the "brain" of the computer. It tells the other computer components what to do, depending on the instructions given by the software and the user.

CPUs come in different clock speeds (measured in GHz), which determine how quickly computations are made, so higher numbers are generally better.

They're also available with different numbers of cores, which allow them to do lots of different things at once. Lightroom makes good use of multiple cores for image processing tasks such as editing and exporting photos, so a quad-core processor is an excellent choice if you're buying a new computer.

RAM / Memory

• *Required: At least 8GB of RAM, ideally 16GB or more.*

RAM, or Random Access Memory, is short-term storage for the data the CPU is working on, allowing it to be quickly stored and retrieved as needed.

When your computer runs out of space in RAM, it has to write the data out to the hard disk, which is much slower.

I'd recommend at least 32GB if you're buying a new computer and your budget will stretch.

GPU / Graphics Card

• *Required on Windows: At least 2GB of Video RAM (VRAM) and DirectX 12 support. 4GB VRAM is recommended for 4k or greater displays. 8GB of VRAM is recommended to enable GPU-supported preview generation and export.*

• *Required on Mac: At least 2GB of Video RAM (VRAM) and Metal support. 4GB VRAM is recommended for 4k or greater displays. 8GB of VRAM is recommended to enable GPU-supported preview generation and export.*

The GPU (graphics card) does more than just display the image. It's designed to do thousands of calculations simultaneously, but just for graphics-related tasks.

The GPU needs somewhere to store all of this information temporarily, and this is where the VRAM (or video memory) comes into play. The bigger the screen, the more data it needs to store in VRAM, so the more VRAM you need.

Lightroom can use the GPU to speed up specific tasks, such as how quickly the image preview updates on the screen when you switch photos or move an Edit slider. This is called GPU acceleration. We'll discuss this later in the book (page 428).

Lightroom also uses the GPU for AI-based tasks, such as AI-based masks (page 311), Content-Aware Healing (page 303), and the Enhance tool (page 274). For the best performance with these tools on Windows, select a dedicated GPU with a large amount of VRAM (e.g., 8GB+) and TensorCores. For a Mac, choose an Apple silicon chip with plenty of RAM (e.g., 32GB).

Hard Drive Space

- *Required: At least 10GB of available hard drive space. Additional free space is required during installation and sync.*

- *Note the Mac version can't install on a volume that uses a case-sensitive file system or on removable flash storage devices (such as USB sticks).*

The hard disk drive is long-term storage. This is where you store all your files, including the computer's operating system, program files, and photos.

Hard drives can be stored inside your computer (internal drives) or connected using a cable (external drives). SSDs are faster than traditional spinning disks, making them a better choice for your computer's boot drive.

Lightroom requires a relatively small amount of disk space, as most of the photos are stored in the cloud and just downloaded as needed. However, although the minimum specifications state only 10GB is required to run the program, more space is needed on the boot drive to hold the local cache of the database and some photo previews.

It's worth keeping at least one local copy of your photos as a backup. To do so, simply buy and plug in another drive, tell Lightroom to store the original files on that drive, and the rest happens automatically. We'll learn about this later (page 76).

SUBSCRIPTION

There are multiple Adobe Creative Cloud subscriptions, each including different apps and amounts of cloud storage space.

The mobile apps are free of charge in the iOS App Store and Android App stores. The low-cost in-app purchases unlock additional Premium features and include 100GB of cloud storage, but they can't be used on other operating systems.

The Lightroom 1TB subscription includes Lightroom (for Windows, macOS, iOS, iPadOS, Android, ChromeOS, and Web) and 1TB of cloud storage space. If you later run out of space, you can pay for additional cloud storage. As your skills progress, you can add Photoshop to your subscription.

If you don't already have a subscription, here's the link to sign up: https://www.Lrq.me/LRCC

Whichever subscription you choose, you're not locked in. If you decide to cancel your subscription in the future, you'll have a year to download all of your photos before they're deleted from Adobe's servers.

INTERNET CONNECTION

An internet connection is required during the initial login and activation and intermittently after that to confirm your subscription status.

To sync your photos to Lightroom's cloud so they're backed up and available on other devices, you need a reasonably fast unmetered internet connection (or a lot of patience), as there's a lot of data to transfer!

You don't need an internet connection all of the time. Lightroom continues to work when you go offline, whether your connection drops or you go on vacation. It asks you to connect briefly every so often (about every 30 days) to confirm your subscription status, but it will usually allow you to postpone this check for up to 99 days.

Some features won't work without an internet connection, including:

• Photos/videos can't be downloaded from the cloud for viewing/editing if they're not already stored locally.

• New photos/videos and edits can't sync up to the cloud.

• New photos/videos added on other devices and edits made on other devices can't sync down from the cloud.

• Searching for photos/videos using the text search field won't work.

• The map in the Info panel and reverse geocoding (address lookup) won't work.

If you know you will be offline, you can store smart previews or originals locally while you still have an internet connection, so the photos are available for viewing and editing offline (page 76).

PRIVACY CONCERNS

No one has access to your photos unless:

• They have access to your Adobe account.

• They have access to your computer/ mobile device.

• You choose to share them.

By default, Adobe automatically collects usage information to help the engineers improve the software. This includes your computer specifications and which tools you use in Lightroom, but not your photos or other personal information.

Adobe also utilizes machine learning, which means you can search the content of your photos in Lightroom without having to tag them manually.

If you want to learn more about how this information is used or adjust your preferences, log into your account on Adobe's website and go to *Manage Account > Security & Privacy > Privacy*.

INSTALLING & UPDATING LIGHTROOM

Ready to get started? You can be signed in on multiple mobile devices and web browsers. The desktop app is limited to five desktop/laptop computers if you have the *Lightroom 1TB* plan or only two if you have a *Photography Plan 20GB / 1TB* or an *All Apps* subscription.

INSTALLING THE MOBILE APPS

To install Lightroom on your phone or tablet, visit the Apple App Store (iOS) or Google/ Samsung Play Store (Android), as you would for any other app. Here are the direct links:

iOS: https://www.Lrq.me/ios

Android: https://www.Lrq.me/android

Once the installation completes, return to your Home screen and tap the app icon to open Lightroom. You need to be connected to the internet while setting it up.

Permissions: iOS (top), Android (bottom)

The first time you open Lightroom on mobile, it displays a series of welcome screens highlighting the main features, so swipe through them or skip to move on.

You must sign in using your Adobe ID and password or social login. Previews immediately start downloading if you've already synced photos to the cloud using another device.

The first time Lightroom uses a device feature, such as the camera or notifications, it asks for permission. These permissions can be granted or revoked again later in *Settings app > Lightroom* (iOS) / *Settings app > Apps > Lightroom* (Android).

INSTALLING LIGHTROOM ON THE DESKTOP

The desktop app installation and updates are managed using the Creative Cloud app (often shortened to CC app), which is a small app that constantly runs in the system tray (Windows) / menu bar (Mac).

To install the CC app, follow Adobe's instructions at https://www.Lrq.me/ccinstall. When the installation completes, sign in with your Adobe ID and password.

To install Lightroom, select the *Apps* tab in the CC app, find Lightroom (not Lightroom Classic), and click the *Install* button to start the installation.

After installation, Lightroom opens automatically. To open Lightroom again in the future, click the *Open* button in the CC app or go to *Start menu > Adobe Lightroom* (Windows) / *Applications folder > Adobe Lightroom > Adobe Lightroom.app* (Mac).

While Lightroom's open, let's set up a shortcut for easier access. On Windows, right-click on the Lightroom icon in the Taskbar and select *Pin to Taskbar*. On macOS, right-click on the Lightroom icon in the Dock and choose *Options > Keep in Dock*.

When Lightroom opens for the first time, it displays some welcome screens, followed by a series of tips to introduce you to the main features. If you've already synced photos to the cloud, previews immediately start downloading.

If Lightroom Classic or an earlier version of Lightroom is installed on the computer, Lightroom may ask whether you wish to migrate your catalog. If so, say no for now, as we'll cover this process in detail (page 66), avoiding potential problems.

CHECKING FOR UPDATES

Lightroom is updated regularly, adding new camera support, feature enhancements, and bug fixes.

On mobile, updates are available from App Stores. They usually update automatically, but if you're in a hurry, return to Lightroom's page on the App Store and tap the *Update* button.

On the desktop, updates are installed using the CC app, where you can click the *Update* button to start the update installation. You can open the CC app from the system tray (Windows) / menu bar (Mac) or go to the *Help menu > Updates* within Lightroom.

CREATIVE CLOUD APP (DESKTOP)

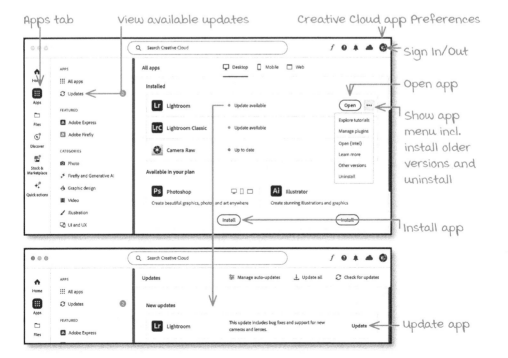

OPERATING SYSTEM DIFFERENCES

There are differences between apps due to operating-system-specific features, screen sizes, and processing power. Different teams work on developing the apps in parallel, so some features are available on one operating system before the other.

Many of the screenshots in this book were captured using iOS and macOS because these are the platforms I use most. If there are significant differences in other operating systems, these are noted and illustrated, too.

One of the most notable differences is where to find the preferences. To find them on iOS, go to ... *menu > App Settings*. On Android, tap the hamburger icon in the top left corner of the Lightroom Grid view. On the desktop, go to *Edit menu > Preferences* (Windows) / *Lightroom menu > Preferences* (Mac).

KEYBOARD SHORTCUTS

Throughout the book, we'll focus primarily on which buttons to click to accomplish a task, but many tools are also available as menu commands or keyboard shortcuts.

As you become more familiar with Lightroom on the desktop, the shortcuts will help to increase your efficiency.

If you're using an external keyboard with your phone or tablet, there are a few keyboard shortcuts, for example, to assign a star rating to your photo. I've added a Keyboard Shortcut list to your Members Area downloads for easy reference.

INTRODUCTION TO WORKFLOW

Before we start adding photos, let's talk briefly about workflow. It's one of the most popular topics among photographers, but why? What does it mean?

WHAT IS WORKFLOW?

The term workflow describes a series of steps undertaken in the same order each time. For photographers, this workflow runs from the time of shooting (or even before) through adding your photos to Lightroom, sorting and selecting your favorites, editing and retouching them, and then outputting to various formats, whether on screen or in print.

WHY HAVE A CONSISTENT WORKFLOW?

Doing the same thing in the same order every time reduces the risk of mistakes. Photos won't get lost or accidentally deleted, metadata won't get missed, and you won't end up redoing work you've already completed.

There's no perfect workflow for everyone, as everyone's needs and priorities differ. The following diagrams guide you through the main elements of some typical workflows. We'll return to more detailed diagrams of specific stages, such as rating your photos (page 102) and editing them (page 154). As you gain experience, you can build your ideal workflow.

Once you've established a good workflow, that isn't the end of the story. You'll likely find that you continue to tweak it as you discover slightly more efficient ways of doing things. It'll continue to build with time, experience, and the introduction of new Lightroom tools. The principles, however, remain the same.

CLOUD ECOSYSTEM WORKFLOW

This is a typical workflow using Lightroom on mobile, desktop
and web, and storing photos safely in Lightroom's Cloud...

ADD TO LIGHTROOM & SYNC TO THE CLOUD

Import photos directly into
Lightroom's library

Copy device/local photos
to Lightroom's library (see
Browse workflows)

VIEW & ORGANIZE

View thumbnails in a Grid

View in larger Detail view

View Grouped by Capture Date

Group into Albums

Delete bad photos

Group into Stacks (desktop only)

ADD METADATA & SEARCH FOR PHOTOS

Add Flags & Star Ratings

Add Keywords

Add Titles, Captions & Copyright

Add People's Names

Add Location Data

Fix Incorrect Dates &
Times (desktop only)

Search using metadata
you've added

Search using Lightroom's AI

EDIT & RETOUCH

See Edit Workflow diagram

SHARE ON THE WEB

Share photos as web galleries

Get notifications of likes
and comments

EXPORT EDITED COPIES

Save edited photos back to
Photos (iOS) / Gallery (Android
app) / folders (desktop)

Share photos to email/
social media (mobile)

BROWSE MOBILE DEVICE WORKFLOW

If you prefer to organize your photos using your mobile device's Photos (iOS) / Gallery (Android) app and just use Lightroom for its editing tools, this simplified workflow may suit you better...

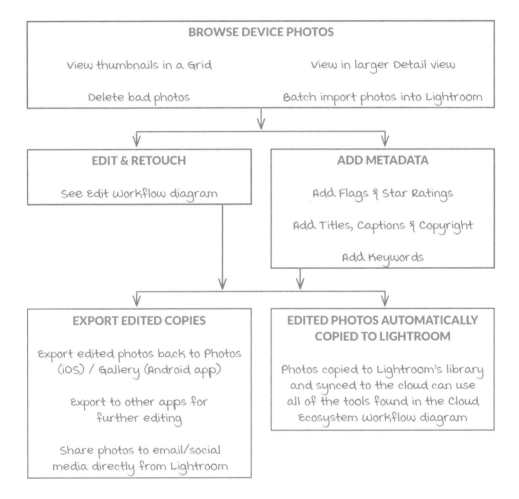

BROWSE DEVICE PHOTOS

View thumbnails in a Grid View in larger Detail view

Delete bad photos Batch import photos into Lightroom

EDIT & RETOUCH

See Edit Workflow diagram

ADD METADATA

Add Flags & Star Ratings

Add Titles, Captions & Copyright

Add Keywords

EXPORT EDITED COPIES

Export edited photos back to Photos (iOS) / Gallery (Android app)

Export to other apps for further editing

Share photos to email/social media directly from Lightroom

EDITED PHOTOS AUTOMATICALLY COPIED TO LIGHTROOM

Photos copied to Lightroom's library and synced to the cloud can use all of the tools found in the Cloud Ecosystem Workflow diagram

BROWSE LOCAL DESKTOP WORKFLOW

If you don't want to sync your photos to Lightroom's cloud to access on other devices, this simplified workflow may suit you better...

It can also be used alongside the Cloud Ecosystem Workflow, only adding your best photos to Lightroom's cloud and keeping others locally.

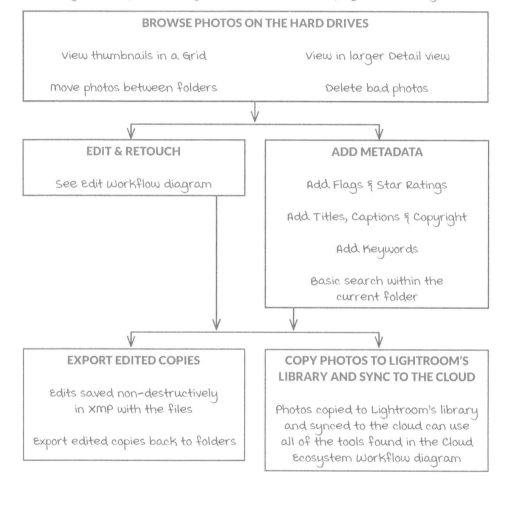

BROWSE PHOTOS ON THE HARD DRIVES

View thumbnails in a Grid

View in larger Detail view

Move photos between folders

Delete bad photos

EDIT & RETOUCH

See Edit Workflow diagram

ADD METADATA

Add Flags & Star Ratings

Add Titles, Captions & Copyright

Add Keywords

Basic search within the current folder

EXPORT EDITED COPIES

Edits saved non-destructively in XMP with the files

Export edited copies back to folders

COPY PHOTOS TO LIGHTROOM'S LIBRARY AND SYNC TO THE CLOUD

Photos copied to Lightroom's library and synced to the cloud can use all of the tools found in the Cloud Ecosystem Workflow diagram

LIMITATIONS FOR LOCAL PHOTOS:

No Versions tool
No Enhance tool
No merge to HDR or Panorama
No Edit in Photoshop

No Flags
No Albums
No People tags
No AI-based search
No cloud backup

LIGHTROOM CLASSIC SYNC WORKFLOW

Lightroom Classic is a distant cousin of the Cloud Ecosystem, but it can do some basic cloud syncing. This means you can use the Lightroom Ecosystem apps to upload new photos and edit existing photos while you're away from your main Lightroom Classic catalog, and have these changes synced down on your return.

ADD TO LIGHTROOM ECOSYSTEM & SYNC UP TO THE CLOUD	SYNC UP FROM LIGHTROOM CLASSIC
Import photos directly into Lightroom's library on mobile/desktop/web and wait for them to sync up to the cloud	Add photos to All Synced Photos collection or mark a collection to sync photos up to the cloud from Lightroom Classic

VIEW & ORGANIZE

View thumbnails in a Grid View in larger Detail view

View Grouped by Capture Date Group into Albums

ADD METADATA & SEARCH FOR PHOTOS

Add Flags & Star Ratings Add Titles, Captions & Copyright

Search using metadata you've added Search using Lightroom's AI

EDIT & RETOUCH

See Edit Workflow diagram

SHARE ON THE WEB	EXPORT EDITED COPIES
Share photos as web galleries	Save edited photos back to Photos (iOS) / Gallery (Android app) / folders (desktop)
Get notifications of likes and comments	Share photos to email/ social media (mobile)

ON RETURN TO LIGHTROOM CLASSIC

New photos and videos added on Ecosystem apps sync down to Lightroom Classic in their original formats

New metadata and edits added on Ecosystem apps sync down to Lightroom Classic, with notable exceptions

MAIN LIMITATIONS OF LIGHTROOM CLASSIC SYNC

Albums become Classic collections
Folders don't sync
Keywords don't sync
People tags don't sync
Versions don't sync
Stacks don't sync
Videos only sync down into Classic

Deleting photos in Ecosystem apps only removes them from sync in Classic

Photos that sync up to the cloud from Lightroom Classic only have 2560px smart previews in the cloud, not full size originals

Like the rest of the cloud ecosystem, there's no direct or wired sync... you will require enough cloud space to hold all originals uploaded using Ecosystem apps, and a good internet connection

THE TIP OF THE ICEBERG

This workflow gives a quick summary of how you might use the Ecosystem apps when you're away from your desk

For more detail on Lightroom Classic's Sync integration, see our other book, Adobe Lightroom Classic—The Missing FAQ

VIEWING PHOTOS & VIDEOS

3

Lightroom offers two different options to view your photos:

• You can **browse and edit photos** stored on your device or computer's hard drive. The name of this mode varies by operating system: *Device* (iOS) / *Gallery* (Android) / *Local* (desktop). We'll refer to this as "browsing device photos" for simplicity. It's a good option if you only use Lightroom on one device and prefer to organize photos using the Photos app (iOS) / Gallery app (Android) / folders on your hard drive (desktop). The downside is that some of Lightroom's tools only work on photos in Lightroom's library. These include albums, stacks, people tags, AI-based search, versions, cloud backup, multi-device access, and web gallery sharing.

• You can **copy photos to Lightroom's managed library** and sync them safely to the Lightroom cloud. You don't have to worry about file management or backup; your photos are accessible on all your devices, and all Lightroom's tools are available.

Sticking to one or the other is most straightforward, as you don't have to remember where you've stored your photos and which tools are available in each mode. However, some people choose a hybrid workflow, browsing their photos in the *Device* (iOS) / *Gallery* (Android) / *Local* (desktop) view, then only copying their best

photos to Lightroom's library and cloud.

IN THIS CHAPTER, WE'LL CONSIDER:

• How to explore the Lightroom Workspace

• The difference between the Device and Lightroom tabs (iOS) / Gallery and Lightroom tabs (Android) and Cloud and Local tabs (desktop).

• How to view photos on a mobile device

• How to view photos on the desktop

• How to play videos

THE LIGHTROOM WORKSPACE

Once the welcome screens are cleared, you're looking at the Lightroom workspace. You might also hear it called the UI or user interface.

There are four main elements, which are laid out slightly differently depending on the device.

• The **Grid views** allow you to view thumbnails and select photos and videos.

• The **Detail views** show a larger view of the photos and allow you to zoom in on photos and play videos. This view is also used for editing. On iPad and desktop, a Filmstrip of thumbnails runs along the bottom.

• The **Albums panel** (mobile) / **Photos panel** (desktop) allows you to organize the photos into albums in your Lightroom cloud library. When browsing in the *Device* (iOS) / *Gallery* (Android) / *Local* (desktop) view, the same panel shows your device albums (mobile) / local folders (desktop).

• The **Toolstrip** at the bottom of the iPhone/Android Detail view, or on the right on iPad/desktop, opens the Edit panels.

THE MOBILE WORKSPACE

Due to their small screen size, the **iPhone** and **Android** apps use a series of screens. The Grid view shows first, with a pop-up at the top to open the Albums panel. When you tap on a photo, it opens into the Detail view, which has the Toolstrip at the bottom.

On the **iPad**, the Albums panel is on the left of the Grid view and can be hidden using the button at the top. When you tap on a photo to open the Detail view, the Toolstrip on the right opens the Edit panels.

THE DESKTOP WORKSPACE

The central preview area on the **desktop** holds the Grid and Detail views. The Photos panel on the left can be opened and closed using the button above, and the Toolstrip on the right opens the Edit and Metadata panels.

ACCESSING LIGHTROOM ON THE WEB

You can also access your photos using Lightroom Web by navigating to https://lightroom.adobe.com in any modern web browser and logging in with your Adobe ID. If you click the Cloud Sync icon in the desktop app, a link will take you straight there.

The web interface will look familiar because it's designed to look like the other apps. To avoid cluttering the main text, we won't give specific web instructions along with the mobile and desktop instructions, but we have added extra detail to the workspace diagram to help you find specific tools (page 24).

A few tools are only available in the web interface, so these are covered in more detail. For example, advanced customization for shared web galleries is explored later (page 393). If you're having problems syncing, a *Sync Errors* album appears below *All Photos*, offering additional clues about which photos are stuck and why (page 430).

THE LIGHTROOM WORKSPACE (IPHONE/ANDROID)

In the Device/ Gallery tab, browse photos stored on your device and open them into Detail view.

Or in the Lightroom tab, tap the blue button to add photos to your library and then browse, organize and edit them.

In the Lightroom tab, tap the pop-up at the top to view the Albums panel.

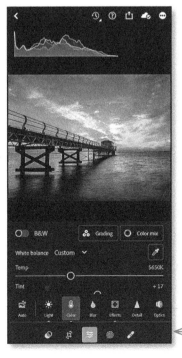

Use the Toolstrip buttons to access the Edit tools

THE LIGHTROOM WORKSPACE (IPAD)

On an iPad, the Albums panel and Grid view can be active at the same time.

1. Tap the button to show/hide the Albums panel. Tap All Photos or an album to display the photos in the Grid view to the right.

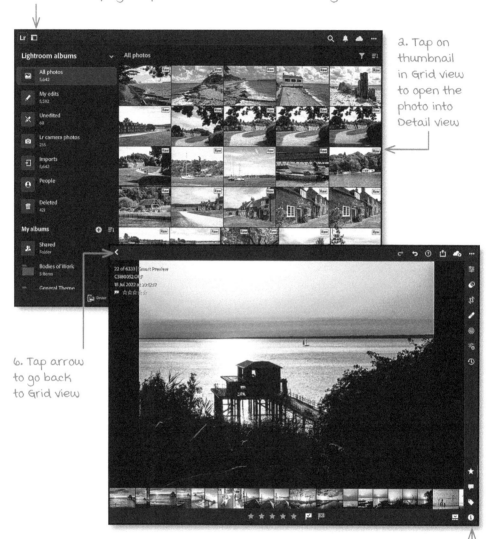

2. Tap on thumbnail in Grid view to open the photo into Detail view

6. Tap arrow to go back to Grid view

3. Tap the buttons in the Toolstrip to open the edit and metadata panels

4. Swipe left <> right to flip through the photos

5. Double-tap on the photo to zoom in

THE LIGHTROOM WORKSPACE (DESKTOP)

In the Cloud mode, add photos to your library and then browse, organize and edit them.

Cloud Sync Status

Share/Save Edited Photos

Or switch to Local mode to browse and edit photos stored on your local drives.

—menubar

View Notifications

Search for photos or refine the current view.

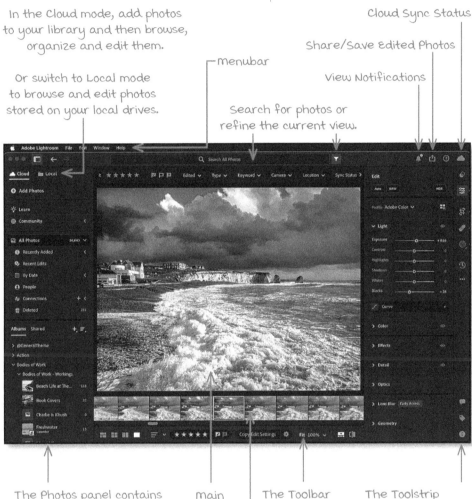

The Photos panel contains organizational tools.

In Cloud mode, it shows All Photos, photos organized by date, people, albums or shared web galleries.

In Local mode, it shows your local drives and folders.

Open & close the Photos panel using the button at the top, or step forward/backward through recent sources.

Main Preview Area shows the Grid, Compare and Detail Views.

Switch photos using the Filmstrip when in Compare or Detail view, or use the left/ right arrow keys.

The Toolbar shows view modes, zoom, star star and flags, and some edit tools.

The Toolstrip buttons open/close the right panels.

The top buttons open the Edit tools: Presets, Edit Sliders, Crop, Healing, Masking, Versions and the ... menu.

The lower buttons open the Info, Keyword and Activity panels.

THE LIGHTROOM WORKSPACE (WEB)

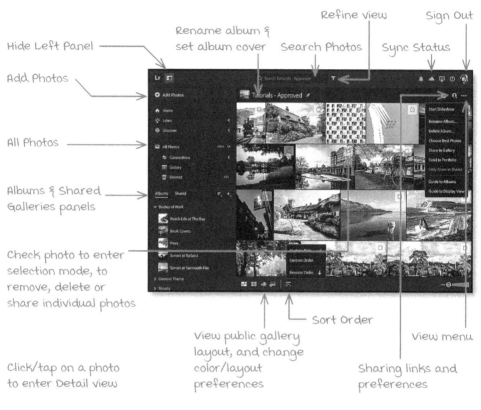

Refine view

Sign Out

Rename album &
set album cover Search Photos Sync Status

Hide Left Panel

Add Photos

All Photos

Albums & Shared
Galleries panels

Check photo to enter
selection mode, to
remove, delete or
share individual photos

View public gallery
layout, and change
color/layout
preferences

Sort Order

View menu

Click/tap on a photo
to enter Detail view

Sharing links and
preferences

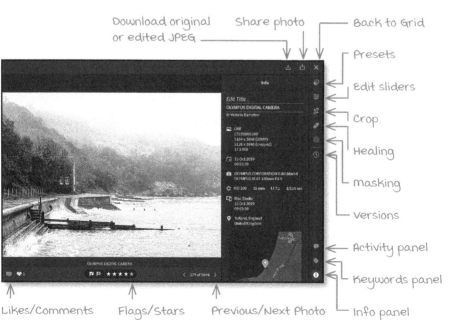

Download original
or edited JPEG

Share photo

Back to Grid

Presets

Edit sliders

Crop

Healing

masking

Versions

Activity panel

Keywords panel

Likes/Comments Flags/Stars Previous/Next Photo Info panel

VIEWING PHOTOS ON A MOBILE DEVICE

Let's find some photos to start exploring Lightroom's Grid and Detail views...

DEVICE & LIGHTROOM ALBUMS

At the bottom of the screen, Lightroom is split into the *Device* (iOS) / *Gallery* (Android) mode and the *Lightroom* mode.

To **view photos in the local device storage**, tap the ***Device*** (iOS) / ***Gallery*** (Android) button at the bottom of the screen. Using the pop-up at the top of the Grid view, you **select which device album to show**. The Android app also lets you view photos from other storage locations, such as Google Photos.

To **view photos that you've already added to the cloud**, tap the ***Lightroom*** tab. Then to **open the Albums panel** on iPhone/Android, tap the pop-up at the top of the screen. On an iPad, the Albums panel is on the left, and you can show/hide it by tapping the button at the top. We'll come back to managing albums (page 81), but for now, tap on ***All Photos***, and we'll start viewing some of your photos in more detail.

GRID VIEW OPTIONS

The Grid views allow you to view and select multiple photos to see them in context and quickly scroll through them, looking for specific photos.

To **scroll through the photos**, swipe up/down the screen. On iOS, you can scroll right to the top of the thumbnails by tapping the very top of the screen (e.g., on the WiFi icon).

If you tap on a photo in the grid, it **opens in the Detail view**, where you can zoom in and edit the photo... We'll come back to that shortly.

To **segment the grid** into dates on iOS, tap the ... menu and select ***Segment by Capture Date*** (iOS), then the time period. On Android, tap the ... menu, then select the time period. When a grid is segmented, tap the arrows to expand and collapse each segment (page 81).

Device /Gallery Albums buttons: iOS (top), Android (bottom)

Lightroom Albums panel buttons: iPhone (top), Android (center), iPad (bottom)

When viewing the Device/Gallery Grid, thumbnail badges identify which device photos have already been added to Lightroom's library. If you tap on a photo with the edited or exported badges, it opens back into the Detail view with its non-destructive edits. You can use the Versions tool (page 157) to view, undo, or make additional edits.

 Photo already in Lightroom

 Photo edited in Lightroom

 Photo exported by Lightroom

The iOS app has a few other grid view options that aren't available on Android at the moment:

To **resize the thumbnails**, use a pinch/ spread gesture.

In Device/Gallery mode, switch between a square and justified (brickwork pattern) **grid format** by tapping the ... menu and

DEVICE GRID VIEW (IOS)

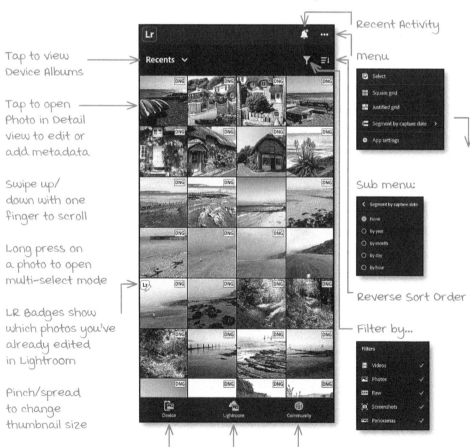

Recent Activity

... menu

Tap to view Device Albums

Tap to open Photo in Detail view to edit or add metadata

Swipe up/ down with one finger to scroll

Long press on a photo to open multi-select mode

LR Badges show which photos you've already edited in Lightroom

Pinch/spread to change thumbnail size

Sub menu:

Reverse Sort Order

Filter by...

Device Photos view Lightroom Grid Community Tutorials

selecting **Square Grid** or **Justified Grid**.

In Lightroom mode, if you two-finger tap on the thumbnails, you can cycle through a series of **metadata overlays** or select an overlay by going to ... menu > Info Overlays.

FILTERING & CHANGING THE SORT ORDER

Tap the filter icon at the top of the grid to **filter the photos** by file type. In Lightroom mode, additional filter options include star rating, flags, camera, people, location,

keywords, and edit status.

In the Device/Gallery Grid view, you can only **reverse the sort order** by tapping the sort order icon.

Filter ⟶ ▼ ≡↓ ←Sort Order

The Lightroom Grid view has more extensive sort options: Capture Date, Import Date, Modified Date, File name, and Star Rating. To **change the sort order**, tap the icon in Grid view. In the following menu, you can select the sort order of your choice. To **reverse the sort order**, for example, from

GALLERY GRID VIEW (ANDROID)

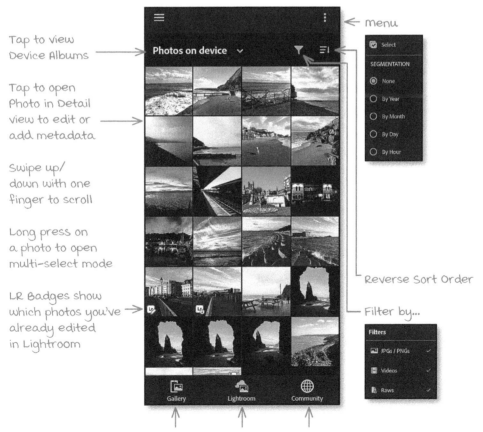

Tap to view Device Albums

Tap to open Photo in Detail view to edit or add metadata

Swipe up/ down with one finger to scroll

Long press on a photo to open multi-select mode

LR Badges show which photos you've already edited in Lightroom

menu

Reverse Sort Order

Filter by...

Gallery Grid view Lightroom Grid Community Tutorials

LIGHTROOM GRID VIEW (IOS)

On an iPad, the Albums panel and Grid view can be active at the same time. Tap the button to show/hide the Albums panel.

Recent Activity

Sync Status

Filter by...

Sort by...

menu

Search Photos

Current Filter

Tap for Albums panel

Tap to open Photo in Detail view

Swipe up/ down with one finger to scroll

Two finger tap anywhere to cycle through the metadata overlays

Long press on a photo to open multi-select mode

Pinch/spread to change thumbnail size

Sub menus:

Device Photos Grid

Lightroom Grid

Community Tutorials

Add photos to Lightroom

Camera

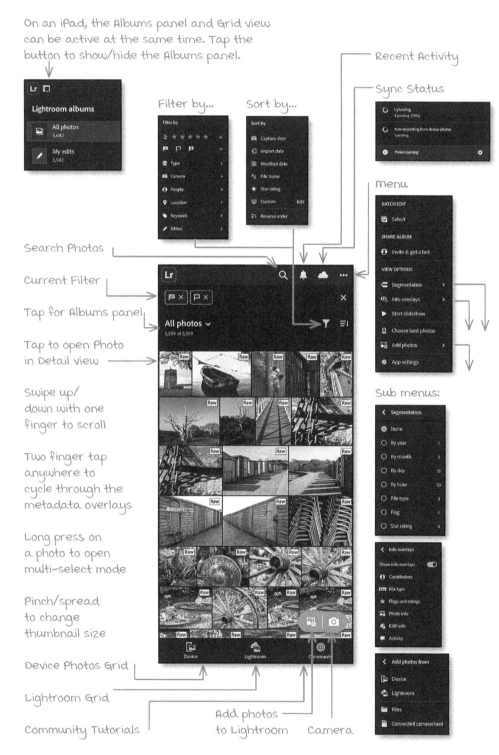

LIGHTROOM GRID VIEW (ANDROID)

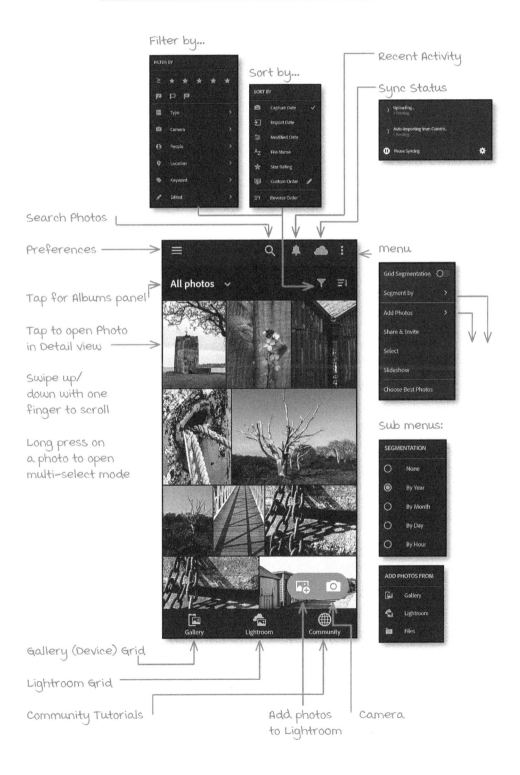

Filter by...

Sort by...

Recent Activity

Sync Status

Search Photos

Preferences

menu

Tap for Albums panel

Tap to open Photo
in Detail view

Swipe up/
down with one
finger to scroll

Long press on
a photo to open
multi-select mode

Sub menus:

Gallery (Device) Grid

Lightroom Grid

Community Tutorials

Add photos
to Lightroom

Camera

oldest to newest photos at the top, select **Reverse Order**.

When viewing a Lightroom album, you can manually rearrange the photos into a **custom sort order**. Select **Custom** from the Sort menu, then tap *Edit* (iOS) / pencil icon (Android). On iOS, tap photos to select them, then hold your finger on one of the selected photos and drag them to a new location between two photos. Tap *Done* when you're finished. On Android, hold your finger on a photo and drag it to a new location between two photos, then release your finger. (You can only move one photo at a time on Android.) Press the X to return to Grid view.

SELECTING MULTIPLE PHOTOS IN GRID VIEWS

To **select multiple photos**, hold your finger on a photo in the grid to enter multi-select mode (or go to ... *menu > Select*). Tap the individual photos to select them, or drag across a series of photos to select multiple.

Tap an icon at the bottom of the screen to apply an action. What you can do with the selected photos depends on which grid you're viewing.

In *Device/Gallery* multi-select mode, you can:

• Import all of the selected photos into Lightroom's library.

• Delete from the Photos app (iOS) / device

Device/Gallery multi-select mode

storage (Android).

In *Lightroom* multi-select mode, you can:

• Add photos to an album or move photos to a different album (only if viewing an album).

• Copy & paste edit settings.

• Share or save photos.

• Apply some metadata such as Copyright (currently Android only).

• Remove photos from albums or delete photos from the Lightroom library.

DETAIL VIEW

The Detail view displays a much larger view of a photo, so you can take a closer look and zoom in to check it's perfectly in focus.

To **view a photo in Detail view**, tap on it in the grid. Double-tap on the photo or use a spread/pinch gesture to **zoom in or out**.

To **switch to a different photo**, tap the

Lightroom multi-select mode:
iOS (top), Android (bottom)

back arrow in the top left corner and select a different photo from the grid, or swipe through the photos in Detail view. Switching photos in Device mode on iOS is currently slightly different: you can't swipe through the photos by default, but you can enable a Tech Preview to make it possible. Go to ... *menu > App Settings > Early Access* and enable the *Swipe through device photos* switch. Once enabled, you can double-tap the thumbnail to open straight into Detail view and start editing, or swipe through the photos in Detail view and then tap the *Edit* button to start editing.

EDITING PHOTOS

To **access the Edit tools**, tap the buttons in the Toolstrip below the photo (iPhone/Android) / on the right (iPad). We'll explore the Edit tools in more detail later in the book. You'll find the mobile Edit Tool diagrams here: iPhone (page 148), Android (page 149), iPad (page 150).

Using ... *menu > Info and Rating* (iPhone/Android) or the *i* button in the Toolstrip (iPad), you can **open the Info panel**. This displays the photo's metadata and allows you to edit the *Title, Caption, and Copyright* and add star ratings and flags.

When viewing Lightroom's Detail view on iPad, there are additional *Rating, Activity,* and *Keywords* panels to add metadata and view people's comments on shared photos (page 95). A filmstrip below the photo allows you to view and select nearby photos without returning to the Grid view. You can **show/hide the filmstrip** using the Filmstrip button.

 ← Show/Hide Filmstrip

If you make any type of edit, whether using the Edit tools or metadata, the photo and

Toolstrip:
iPhone/Android
(left), iPad (right)

edits are **automatically saved into Lightroom's library** when you return to the grid or move to the next photo. If you have a subscription, it's also synced up to the Lightroom cloud, so it's available on other devices.

VIEWING LIGHTROOM PHOTOS AS A SLIDESHOW

To access the Slideshow view, go to ... *menu > Start Slideshow*, then tap the triangular Play button to start the slideshow.

If you tap the ... icon at the top, you can change the slide transition effect and duration.

If you pause the slideshow using the Play/Pause button, the viewer can swipe through the photos without seeing the rest of the Lightroom interface.

DETAIL VIEW (IOS)

Share menu

Sync Status incl.
download full size
original (if available)

Undo/versions
menu

Back to Grid view ——→

Two finger tap
anywhere to cycle
through metadata
overlay & histogram,
metadata only,
histogram only
or neither

One finger tap on
metadata cycles
metadata views

Swipe left <>
right on the photo
with one finger
to view the next/
previous photo

Double-tap
anywhere or
pinch/spread to
zoom in and out

Tap on the photo
to hide controls

menu

Sub menus:

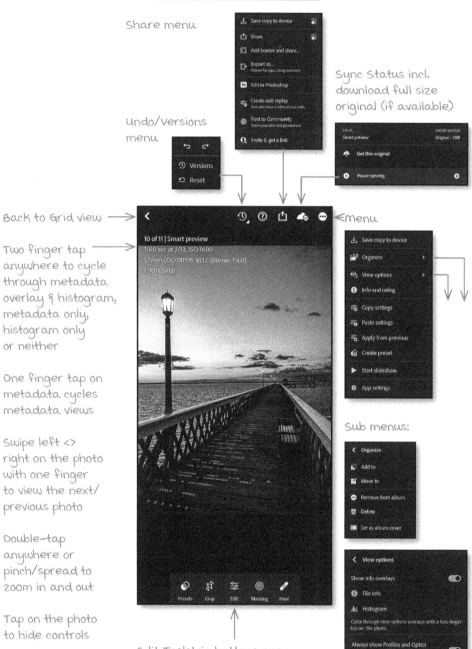

Edit Toolstrip buttons are
on the right on iPad, see
the Editing Tools chapter
for full iPad screenshots

DETAIL VIEW (ANDROID)

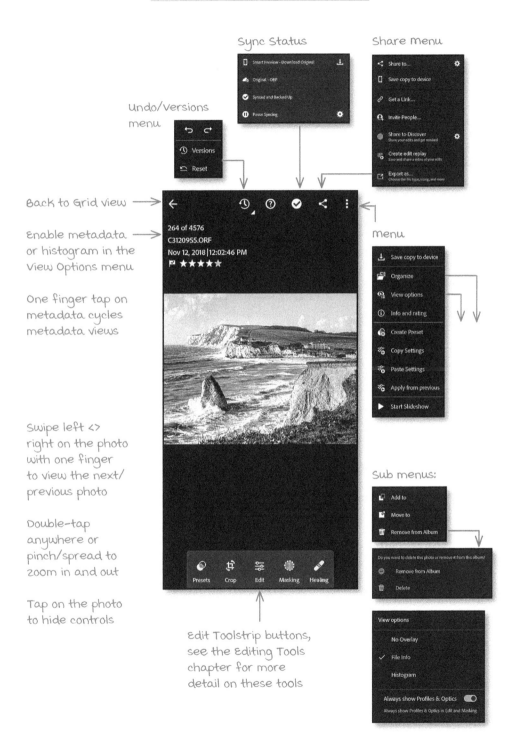

Sync Status

Share menu

Undo/versions menu

Back to Grid view →

Enable metadata or histogram in the View Options menu

menu

One finger tap on metadata cycles metadata views

Swipe left <> right on the photo with one finger to view the next/ previous photo

Double-tap anywhere or pinch/spread to zoom in and out

Tap on the photo to hide controls

Sub menus:

Edit Toolstrip buttons, see the Editing Tools chapter for more detail on these tools

VIEWING PHOTOS ON THE DESKTOP

Let's find some photos to start exploring Lightroom's Grid and Detail views...

LOCAL FOLDERS AND CLOUD ALBUMS

On the desktop, your photos are organized using the Photos panel. It may already be visible on the left of Lightroom's interface, but if you can't see it, click the button above the left panel or press the P key.

Show/Hide Photos panel (desktop)

At the top, it's split into the *Cloud* mode, which displays Lightroom's managed library, and *Local* mode, which shows the folders on your hard drive.

SELECTING AN ALBUM OR FOLDER

To **view photos on your hard drive**, select the *Local* tab. We'll come back to exploring

the *Local* tab in more detail (page 43), but for now, just select a folder of photos to view.

To **view photos that you've already added to the cloud**, select the *Cloud* tab and then select *All Photos*, or skip ahead to learn how to add photos (page 62).

GRID VIEW

The Grid views allow you to view and select multiple photos at once, so you can see them in context and quickly scroll through them, looking for specific photos.

To **select a Grid view style**, use the buttons in the toolbar below the grid or press the G key.

Photo Grid Square Grid

The **Square Grid** view displays the photos in a grid of square cells with extra icons showing helpful information, such as flags,

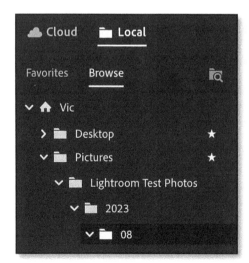

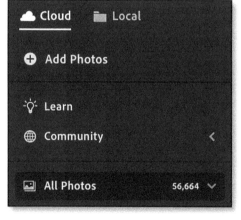

Photos panel: Local (left), Cloud (right)

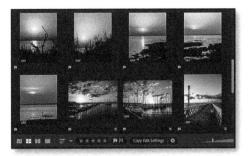

Grid views:
Square (top left), Photo (top right)

Square Grid Thumbnail badges (left)

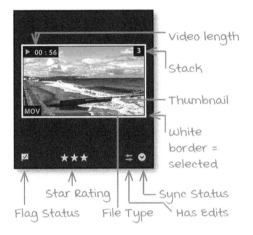

- video length
- Stack
- Thumbnail
- White border = selected

Star Rating | Sync Status
Flag Status File Type Has Edits

The **size of the thumbnails** can be changed using the slider in the toolbar at the bottom of the grid.

CHANGING THE SORT ORDER

You can change the order of the photos, for example, to see your vacation photos in the order that they were captured.

stars, file type, and sync status. It's available in both Cloud and Local mode.

The **Photo Grid** displays the photos in a mosaic pattern and is only available in the Cloud mode. It's a distraction-free view that doesn't waste any space, but vertical photos are smaller than horizontal photos and panoramic photos can appear stretched.

To **change the sort order**, click the sort order button in the toolbar below the grid. Your chosen sort order is saved with the selected album. The options are:

Capture Date sorts the photos by capture date/time. If multiple photos were captured in the same second, the file name is used as a secondary sort to ensure they're in the

TOOLBAR (DESKTOP)

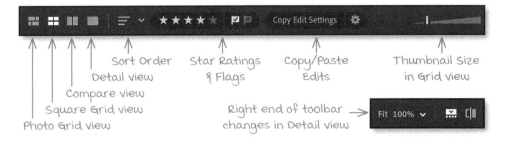

Sort Order Star Ratings Copy/Paste Thumbnail Size
Detail view & Flags Edits in Grid view
Compare view
Square Grid view Right end of toolbar → Fit 100% ▾
Photo Grid view changes in Detail view

correct order.

Import Date sorts the photos based on when you added them to Lightroom.

Modified Date sorts the photos based on whether you've changed their metadata or edited them.

File Name sorts the photos based on their file name.

Star Rating sorts the photos based on their star rating, from 0-5.

To **reverse the sort order**, for example, from oldest to newest photos at the top, select **Reverse Order**.

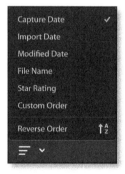

Finally, **Custom Order** displays the photos in a manual sort order for the album. Simply select one or more photos in Grid view and drag them to a new location. As you drag, a blue line appears between the photos, showing where the photo will drop.

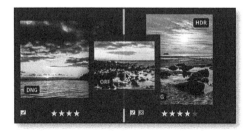

SELECTING MULTIPLE PHOTOS

In the Grid views, you can select the photos you want to view, edit, and share. Selected photos have a white border.

Selected Not Selected

If you select multiple photos in Grid view, your actions apply to all of the selected photos. For example, you can select ten photos and add your copyright or star rating to them all in one go.

When you switch to the Detail view (discussed next), most actions only affect the single photo you're viewing. A few functions, such as saving edited photos to your hard drive, apply to all photos regardless of view mode.

To **select one photo**, simply click on it, and the border becomes highlighted in white.

To **select a consecutive series of photos**, click on the first thumbnail, hold down the Shift key, and click on the last thumbnail in the series.

To **select multiple scattered photos**, click on the first thumbnail, hold down the Ctrl key (Windows) / Cmd key (Mac), and click on each of the other thumbnails so they all have white borders.

To **select all** of the photos in the current view, go to *Edit menu > Select All* or use the keyboard shortcut Ctrl-A (Windows) / Cmd-A (Mac).

If the photos are already selected, you can deselect them, removing the white border.

To **deselect one or more photos**, hold down the Ctrl key (Windows) / Cmd key (Mac) and click on the thumbnails.

To **deselect all photos**, go to *Edit menu > Select None* or use the keyboard shortcut Ctrl-D (Windows) / Cmd-D (Mac).

DETAIL VIEW

The Detail view displays a much larger view of a photo, so you can take a closer look and zoom in to check it's perfectly in focus.

To **switch to the Detail view**, click the button on the toolbar or press the D key. You can move between photos using your keyboard's left/right arrow keys.

Detail view

Detail view & Filmstrip

FILMSTRIP

Below the main Detail preview is the Filmstrip, which displays thumbnails of your photos. This allows you to select a different photo without returning to the Grid view or using the keyboard.

To **show or hide the Filmstrip**, click the button in the toolbar or use the / shortcut. To **resize the Filmstrip**, drag the top edge.

Right-click on the Filmstrip to select *Filmstrip Style > Photo* or *Filmstrip Style > Square* from the context-sensitive menu to **change the Filmstrip style**.

ZOOMING IN

To **zoom in** to see more detail, click on the photo or click the **100%** button in the toolbar. 100% was called 1:1 in earlier Lightroom versions, and it displays the

The Detail view toolbar is the same as Grid view, except the Thumbnail Size slider is replaced with these buttons:

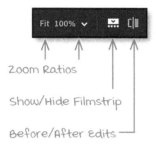

↑ Zoom Ratios

↑ Show/Hide Filmstrip

↑ Before/After Edits

individual pixels.

If you click the arrow next to the zoom percentage, you can **select a zoom ratio** ranging from 6% to 1600%.

When you're zoomed in, click and drag the photo to move it around to see hidden sections of the photo. If you're using an editing tool like the brush (page 315), hold down the Spacebar key while clicking and dragging.

To **zoom out**, click on the photo again or click **Fit** to zoom out. *Fit* view fits the whole photo in the preview area.

There are a few more options for easy zooming:

The Spacebar key toggles between the last two zoom ratios you clicked on, so by default, it toggles between *Fit* and *100%* view. The Ctrl = (Windows) / Cmd = (Mac) and Ctrl - (Windows) / Cmd - (Mac) shortcuts zoom in and out through all of the zoom ratios.

Scrubby Zoom and *Box Zoom* are both useful when you want to zoom in on a specific area of the photo.

To use **Scrubby Zoom**, click and hold the mouse to show the Scrubby Zoom cursor, then drag right/left to zoom in/out continuously.

To use **Box Zoom**, hold down Ctrl (Windows) / Cmd (Mac) and click and drag on the image to draw a rectangular marquee. Lightroom zooms in to fill the preview area with the selected area of the photo.

COMPARE VIEW

The Compare view allows you to compare two photos at a time to help you decide which one you like best or to help you match the appearance when editing.

To **switch to the Compare view**, click the button on the toolbar or use the keyboard shortcut Alt-C (Windows) / Opt-C (Mac).

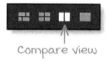

↑ Compare view

If two photos are selected, both display in the preview area. Otherwise, select a second photo from the Filmstrip.

The photos can be displayed side by side or above and below. To **change the orientation**, click the buttons above the photos.

A white border surrounds the active photo. This photo is replaced when you select another photo, and any keyboard shortcuts (e.g., flags/stars) apply to this photo too. Either photo can be active. I like to have the photo on the left/top fixed (no border) and

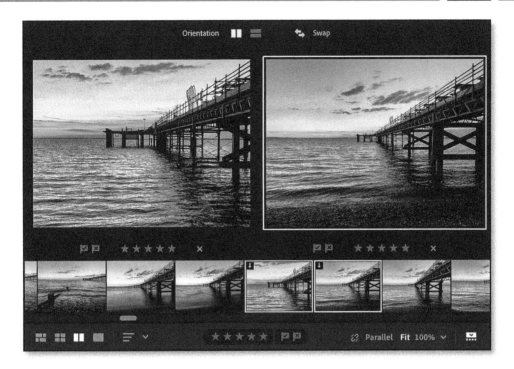

the photo on the right/bottom active (white border). To **change which photo is active**, click on its large preview.

To **swap the two photos** around, click the **Swap** button above the photos. We'll see this in action later in the lesson.

The zoom features are identical to those used in Detail view, discussed in the previous lesson (page 34). There's an additional button next to the zoom controls, marked **Parallel** with a small lock icon. When it's enabled, both photos zoom and pan around simultaneously. This is particularly useful when comparing details, for example, whether everyone has their eyes open in a group photo. When *Parallel* is disabled, the zoom controls only apply to the active photo.

Compare View

The thumbnails are small, but there are some helpful identifying marks. The white border shows the active photo and the gray border shows the other selected photo. Clicking a down arrow removes the thumbnail from the Compare view, whereas clicking an up arrow adds a photo to the Compare view. Clicking the double arrow swaps the active photo with the thumbnail photo.

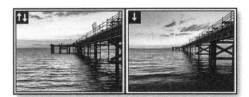

Let's take Compare view for a spin to see its power in action. Imagine you have a series of 5 similar photos and want to pick the best one. We'll use numbered images to make it easy to see what's happening.

1. In the Grid view, select photo 1 and switch to the Compare view.

2. Click on photo 2 in the Filmstrip to add it to the Compare view. Make sure photo 2 is active, shown by a white outline. If it isn't, click on it.

3. Having decided you don't like photo 2, press the right arrow key to select photo 3 or click on its thumbnail in the Filmstrip.

4. You prefer photo 3 to photo 1, so click the *Swap* button to switch them. Photo 3 is now fixed as the current favorite.

5. Click photo 4's thumbnail in the Filmstrip. It replaces photo 1 as the active photo.

6. Photo 4 is out of focus, so you mark it as rejected by clicking on the reject flag under the photo or using the keyboard shortcut X.

7. Select photo 5 in the Filmstrip. When you decide which one you like best, click the flag under it.

8. Return to Grid view and move on to the next set of photos!

CHANGING THE BACKGROUND COLOR

The background color surrounding the preview image in Detail or Compare view can affect your perception of the image's brightness. Therefore, you may want to change the background color if you're editing photos for display on a light-colored background (such as a website or printed with a light border). To do so, right-click on the border and select your chosen color from the context-sensitive menu.

PLAYING VIDEOS

Most photographers capture short video clips on mobile phones, even if they're not "into video." While Lightroom is primarily designed for photographs, it can store and play many popular video formats.

The videos are identified using a small icon and timestamp at the top of the thumbnails in Grid view.

When you open a video in Detail view, the timeline appears below.

To **play the video**, click the triangular play button. Click again to pause.

To **minimize data usage** on mobile, tap the cog icon to select the playback quality.

To **scrub through the video**, drag the marker along the timeline.

To **step through the video one frame at a time**, tap/click the arrows on either side of the play button. These are replaced by buttons to fast-forward/rewind in 10-second increments while the video is playing.

To **mute the video** on mobile, adjust your device's volume buttons (mobile) / click the mute button (desktop).

To **view the video full screen** on mobile, tap on the video preview to hide most buttons and overlays. On the desktop, click the two arrows.

You can also edit (page 152) and trim (page 190) the videos. We'll come back to these features later in the book.

VIDEO PLAYBACK (MOBILE)

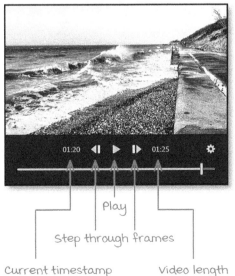

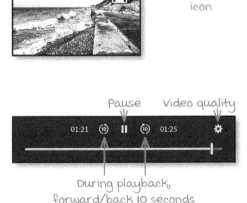

Thumbnail icon

Pause Video quality

During playback, forward/back 10 seconds

Play

Step through frames

Current timestamp Video length

VIDEO PLAYBACK (DESKTOP)

Timestamp on thumbnail

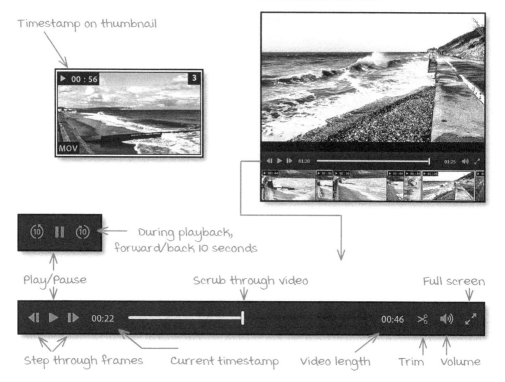

During playback,
forward/back 10 seconds

Play/Pause

Scrub through video

Full screen

Step through frames Current timestamp Video length Trim Volume

BROWSING LOCAL FOLDERS ON THE DESKTOP

At the beginning of the chapter, we mentioned that Lightroom has two different options to view your photos: browse local photos or copy photos to Lightroom's managed cloud library. As with everything, there are pros and cons to both choices.

LOCAL PROS AND CONS

In the Local mode's favor, hard drives are cheaper than cloud storage, you don't need fast internet, and you still get all of Lightroom's advanced editing tools. The edits are still non-destructive, as they're saved with the files in a format called XMP. It's also easier to use than Lightroom Classic, as Local mode is a lightweight file browser rather than a catalog/database.

The downside is that some of Lightroom's tools only work on photos in Lightroom's managed cloud library. These include albums, stacks, people tags, AI-based search, versions, cloud backup, multi-device access, and web gallery sharing.

The biggest difference I have to highlight again... in Local mode, you are entirely responsible for organizing and backing up your files. Local photos are not backed up to Lightroom's cloud.

HOW WILL LOCAL FIT IN YOUR WORKFLOW?

Some photographers will purely use Local mode on one desktop/laptop computer and never upload anything to the cloud. Others may never use it, preferring to keep all their photos in one place.

Sticking to one or the other is most straightforward, as you don't have to remember where you've stored your photos. But you might consider a hybrid workflow to reduce the amount of cloud storage space you need, for example:

• You upload your photos to a folder on your hard drive, flag/star them to select your best photos, and then only copy the best ones to the cloud for further editing, organization, and web sharing.

• You upload all of your photos to the cloud for browsing and editing on your other devices and then later export the ones that weren't so good to a folder on your hard drive and remove them from the cloud, only keeping your best photos in the cloud.

It's up to you... how might Local mode fit into your workflow?

BROWSING FOLDERS IN LOCAL MODE

To **switch from Cloud to Local mode**, click the button at the top of the left panel.

At the top of the panel are any connected devices, such as mobile phones (we'll come back to these shortly), and then the Folders panel splits in two. **Browse** shows your disk drives and external storage (including memory cards) and **Favorites** bookmarks specific folders that you use regularly. The button to the right allows you to browse folders using your operating system dialog. If the panel's not wide enough, drag the right edge to **increase the panel width**.

Browsing the folders works in exactly the way you'd expect: click a folder to show the subfolders.

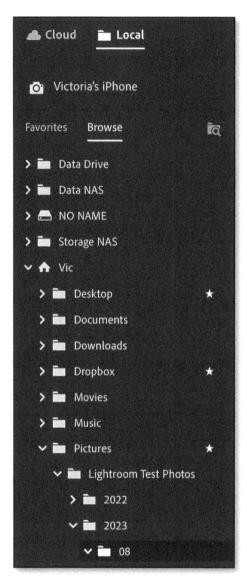

Photos panel > Local tab:
Browse (left), Favorites (right)

breadcrumb bar showing the currently selected file. Click the ... to show the full file path. Clicking on a folder in the path switches to that folder, and if you click it by accident, use the Back button at the top of the screen to return to your previous view.

ORGANIZING PHOTOS IN LOCAL FOLDERS

As a lightweight file browser, Lightroom allows you to do some very simple file organization.

To **move photos to a different folder**, select them in the Grid view or Filmstrip and drag them to a new folder.

To **delete photos**, select them, right-click and choose *Delete Photos*, or use the shortcut Backspace (Windows) / Delete (Mac), then confirm that you want to move the photos to the operating system's Recycle Bin (Windows) / Trash (Mac).

To **find the photos** in your operating system file browser, right-click on a photo or a folder and select *Show in Explorer* (Windows)

When you select a folder that contains photos or videos, they're shown in the main preview area in the Grid, Compare, or Detail view, which we've already discussed (page 34).

At the top of the preview area is a

Breadcrumb bar: collapsed (top), expanded (bottom)

/ Show in Finder (Mac).

If there's a folder you use frequently, click its star icon or right-click and choose **Add to Favorites** to add a bookmark in the Favorites panel.

If you right-click on a folder or click its ... button, you can **rename** it or **create a new subfolder**.

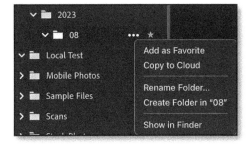

COPYING PHOTOS FROM CONNECTED DEVICES

Above the folder list are any **connected devices**, such as phones, tablets, or cameras. Because Lightroom can't save edits back to these devices, it offers to copy the photos to your local hard drive.

To select the photos you want to copy, check the individual checkboxes or *Select All* to check them all in one go. If you only want to select a series, perhaps those taken today, uncheck *Select All*, then click on the first of the photos so it shows a white border. Hold down the Shift key and click the last photo in the series so they're all surrounded by a white border, then click the checkbox on one of the selected photos to check them all.

Click *Choose Folder*, navigate to a suitable folder on your hard drive, and click Save X Photos to start copying. When Lightroom finishes copying, it automatically opens that folder so you can start browsing through the photos.

COPYING PHOTOS TO/FROM THE LIGHTROOM CLOUD

While it's possible to work entirely on local storage, you may want to **copy specific photos to Lightroom's managed cloud library**. For example, you may only want to send your best photos to the cloud to access from other devices and leave the rest in local storage, or perhaps you want to share some as a web gallery.

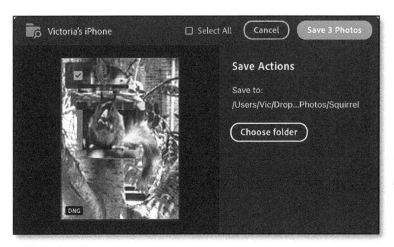

When you select a connected device such as a phone, you can only copy the photos to the hard drive

You could add them through the normal Add Photos dialog (page 62), but if you already have them open in the Local mode, you can send them directly to the cloud from there. This is particularly useful if you've already flagged or star-rated the photos and used the Refine filters to select only the best photos to send to the cloud.

To **copy an entire folder to the cloud**, right-click on the folder or click its ... button and select *Copy to Cloud*.

To **send one or more individual photos to the cloud**, there's a **Copy X Photos to Cloud** button at the top right corner of the main preview area. There are two options in the right-click menu: the *Copy X Photos to Cloud* option is there again, but there's also an additional **Add X Photos to Album** option, which adds the photos directly to a Lightroom album of your choice (page 83).

If you've already copied a photo from Local to Cloud, pressing *Copy Photo to Cloud* updates the existing cloud photo and saves the previous edits as an *Auto Version* (page 157) so you can go back at any time. It also offers to overwrite any metadata (for example, *Title, Caption,* keywords, etc.) while copying, so you can decide whether to keep the cloud metadata for that photo or the local metadata.

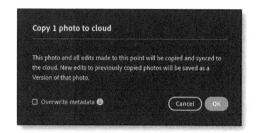

In Detail view, the button name changes to **Update edits to cloud**, but it does the same thing. Clicking the arrow to the right offers a **View in cloud** option, which opens the photo in the Cloud tab to save you hunting for it. This automatic file linking is limited... it only recognizes that you've already copied a photo to the cloud if you did so from within Lightroom on the desktop.

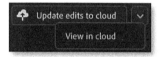

You can also **filter photos** based on whether they've been copied to the cloud or not. You'll find this in the Refine toolbar (page 119), accessed using the button at the top of the screen.

If you want to go in the other direction, **moving photos from Lightroom's cloud into local storage** to archive them offline is a two-step process. First, export the photos (page 401) to the folder of your choice in the *Original* format. Then, once you're confident that you have additional local backups, delete them from the cloud

The Refine toolbar allows you to filter the Grid based on whether the photos have been copied to the cloud or not.

(page 91). Of course, photos moved to local storage lose access to cloud-only features; for example, Versions and Album Membership are lost in the process.

WHICH CHAPTERS DON'T APPLY TO LOCAL MODE?

We mentioned that some of Lightroom Desktop's tools only work on photos in its managed Cloud library and not in the Local mode. If you've decided you're only going to use Lightroom's Local mode, there are a few chapters in the book that won't apply to you:

Almost all of the viewing options in this chapter work in Local mode, except for the Photo Grid view and Custom Sort Order.

Chapters 4-6 don't apply to Local mode, as they talk about adding photos to Lightroom's managed library, syncing with the cloud, and organizing photos in the cloud.

Chapter 7 discusses metadata (flags, keywords, locations, etc.) and search. Most of the chapter applies to Local mode, except for People tagging and AI-based Search, which rely on photos being synced to the cloud. In Local mode, Refine and Search only work on the selected folder, so you can't search your entire photo collection.

Almost all of the Editing tools (Chapters 8-20) work in Local mode, except Versions and Duplicates.

Chapter 21 discusses sharing photos and albums on the web, which means they need to be in Lightroom's Cloud, so that chapter doesn't apply.

Lightroom's edits are stored non-destructively, which means that only Adobe programs can see the edits. To create an edited copy of the files with the changes applied, use Export, discussed in Chapter 22.

ADDING TO LIGHTROOM

4

We've already learned that if you edit photos in *Device* view (iOS) / *Gallery* view (Android), they're automatically added to Lightroom's library (page 31). We've also learned how to copy photos to the cloud from the *Local* tab on the desktop (page 45). In this chapter, we'll focus on how to add photos directly to Lightroom's managed library, ready to sync to the cloud.

FINDING EXISTING PHOTOS

You likely already have a large number of photos stored on your phone or tablet, on your computer's hard drive, or in another company's cloud. Of course, you need to find them before you can add them to Lightroom. These are the most frequent places to check:

• Your phone or tablet.

• Your camera's memory card.

• The Pictures or Photos folder on your computer.

• Other internal or external hard drives.

• DVD's/CD's.

• Cloud services, such as Google Photos, Dropbox or iCloud.

• Organized using other software that stores the files in its own library, such as macOS Photos.app.

• In boxes, albums, or slide trays of photos shot on film. (You might consider photographing or scanning them to create digital files.)

MIGRATING EXISTING PHOTOS

Existing photos on your device or hard drives can be browsed and added just like new ones. There are a couple of exceptions of note:

If you've **previously used other desktop software** to organize and edit your photos, you may want to preserve these edits where possible. On the desktop, Lightroom's migration tools (page 66) can help you easily transfer photos, videos, and some edits into Lightroom from Lightroom Classic (and earlier Lightroom versions) or Apple Photos.

Other unsupported software may allow you to write the metadata (for example, titles, captions, keyword tags, and star ratings) back to the files using a standardized format called XMP, which Lightroom can understand. To check whether your software can write some or all of the metadata to the files, search the web for the name of your software and XMP, for example, *Picasa XMP*.

If your **photos are on a cloud service**, you'll need to download them to your computer/device before adding them to Lightroom, as there are no direct transfer tools. For example, the Google Takeout tool makes it easy to download your photos and videos from Google Photos. Other cloud services like Flickr and Dropbox offer similar bulk download tools.

FILE FORMATS

Lightroom can manage a wide range of file formats. There's a complete list at https://www.Lrq.me/file-formats

In addition to photos, many photographers also shoot short video clips on their mobile devices. Lightroom allows you to view, organize, and edit some video formats. We'll refer to adding photos for simplicity, but the same principles apply to adding videos.

IN THIS CHAPTER, WE'LL CONSIDER:

• How to capture photos using your mobile device.

• How to add photos to Lightroom's library.

• How to migrate photos and edits from other desktop apps.

CAPTURING PHOTOS USING THE LIGHTROOM CAMERA

The mobile apps include a built-in camera with some specific advantages over other camera apps, including:

- Advanced manual controls.

- Non-destructive crop for zoom.

- Raw capture (on supported devices).

- HDR capture (on supported devices).

Some settings are only available on more powerful devices due to the complexity of the image processing or the operating system's limitations.

BASIC CAMERA CONTROLS

Tap the camera icon in the Lightroom Grid view to open the camera.

← Camera

If you're an experienced photographer or you've used the camera app on your phone, the controls may be self-explanatory, but here's a quick summary...

The large button at the bottom is, of course, the **shutter**. You can also use the volume keys to trigger the shutter. (On Android, you can enable/disable the volume trigger in the camera settings.)

iOS (top), Android (bottom)

By default, Lightroom is in **Auto** mode. This means you can point the camera at a scene and leave Lightroom to figure out the settings.

If you want more control, tap the mode pop-up to the left of the shutter to select an advanced shooting mode.

Pro mode gives you access to the camera settings, like the manual mode on a camera (although phone lenses have a fixed aperture). These appear as a toolbar above the shutter. The reset button on the right resets all the Pro settings, or double-tap on a tool button to reset that tool. We'll come back to the settings shortly.

iOS (top), Android (bottom)

Small mobile device camera sensors have a much more limited dynamic range than many traditional cameras, so highlight or shadow detail can be clipped. **HDR** mode captures multiple exposures and merges them into a 32-bit high dynamic range image. (On Android, go to *App Settings > Early Access* to enable the Tech Preview to show the HDR option if it's available on your device.) Hold the camera steady while capturing an HDR photo so Lightroom can merge the photos without ghosting.

The thumbnail on the left shows the **last**

photo captured, and tapping on it briefly enlarges the photo so you can check whether you captured the moment.

SET THE FILE FORMAT

At the top of the screen, you can choose the file format, switching between **DNG** (where available) or **JPEG** format. The raw data in DNG format offers greater editing flexibility, whereas JPEG files are smaller. If you're unsure which to choose, skip to page 127 to learn more about the pros and cons.

A raw file captured by Lightroom is a mosaic

LIGHTROOM'S CAMERA (IOS)

Available options vary depending on the device used

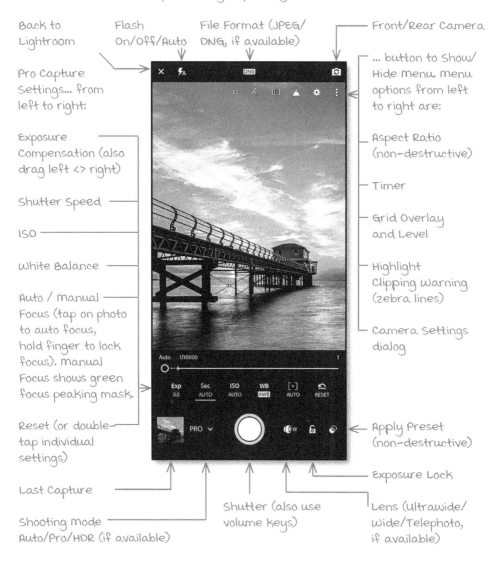

Back to Lightroom

Flash On/Off/Auto

File Format (JPEG/ DNG, if available)

Front/Rear Camera

Pro Capture Settings... from left to right:

... button to Show/ Hide menu. menu options from left to right are:

Exposure Compensation (also drag left <> right)

Aspect Ratio (non-destructive)

Shutter Speed

Timer

ISO

Grid Overlay and Level

White Balance

Auto / manual Focus (tap on photo to auto focus, hold finger to lock focus). manual Focus shows green focus peaking mask.

Highlight Clipping warning (zebra lines)

Camera Settings dialog

Reset (or double-tap individual settings)

Apply Preset (non-destructive)

Exposure Lock

Last Capture

Shooting mode Auto/Pro/HDR (if available)

Shutter (also use volume keys)

Lens (ultrawide/ wide/Telephoto, if available)

raw file containing the unedited sensor data. This differs from the partially processed ProRaw (iOS) / compressed linear DNG (Android) files captured by many other camera apps. There are pros and cons either way. For example, Apple applies its proprietary processing to its ProRaw format, so they look better in Apple Photos, but the file sizes are bigger than the mosaic raw, and as the file is already demosaiced,

Lightroom can't apply tools like Denoise (page 274).

COMPOSE THE PHOTO

You can **zoom** in and out using the standard pinch/spread gestures. Because it's stored as a non-destructive crop, you can change it later.

LIGHTROOM'S CAMERA (ANDROID)

Available options vary depending on the device used

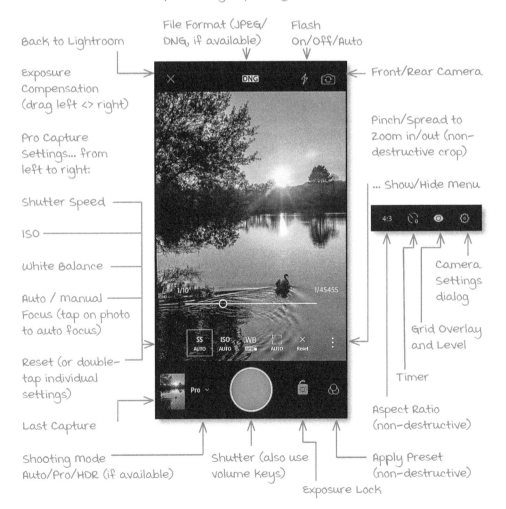

Back to Lightroom

File Format (JPEG/ DNG, if available)

Flash On/Off/Auto

Exposure Compensation (drag left <> right)

Front/Rear Camera

Pinch/Spread to Zoom in/out (non-destructive crop)

Pro Capture Settings... from left to right:

Shutter Speed

... Show/Hide menu

ISO

White Balance

Camera Settings dialog

Auto / manual Focus (tap on photo to auto focus)

Grid Overlay and Level

Reset (or double-tap individual settings)

Timer

Last Capture

Aspect Ratio (non-destructive)

Shooting mode Auto/Pro/HDR (if available)

Shutter (also use volume keys)

Apply Preset (non-destructive)

Exposure Lock

If your phone/tablet has **multiple lenses**, for example, ultra-wide, wide-angle, and telephoto, you can switch between them using the button to the right of the shutter. Most iPhone/iPad lenses are supported, but Android support is more limited.

The button in the top right corner switches between the **front and rear cameras**.

SET THE EXPOSURE & WHITE BALANCE

Lightroom automatically calculates the exposure based on the scene. You can dial in **exposure compensation** (making the photo darker or lighter) by dragging left/right on the photo preview. You can see the amount of exposure compensation marked as **Exp** in the toolbar (iOS) / under the Exposure Lock icon (Android).

In *Pro* mode..., you have complete control over the shutter speed (marked **Sec** on iOS or **SS** on Android), **ISO**, and white balance (**WB**).

The **exposure lock** button in the bottom row locks the current auto exposure so you can recompose the shot or use the same exposure settings for multiple photos.

At the top of the screen, the lightning bolt controls whether the **flash** is on, off, or set to fire automatically depending on the lighting conditions.

FOCUS THE PHOTO

Lightroom autofocuses by default. On iOS, it focuses on the main subject wherever they are in the scene. On Android, it focuses within the white box.

If you want to **choose where to focus**, tap on the screen to set the location of the white

focus box. On iOS, double-tap to revert to autofocus.

In *Pro* mode, you can also tap the focus button to show the manual focus slider. On iOS, as you drag the slider into the manual focus range, a green focus peaking overlay shows which areas of the photo are in focus, or a long-press on the photo auto-focuses on that point and locks the focus.

TOOLS & OVERLAYS

If you tap on the button in the bottom right corner, you're given a choice of five **shoot-through presets**. High Contrast, Flat, Warm Shadows, High Contrast B&W, and Flat B&W. These are displayed on the screen while taking the photo, but they're applied non-destructively, so you can easily reset the photo if you change your mind. The first thumbnail turns off the preset.

If you tap on the ... button, there's a selection of useful tools:

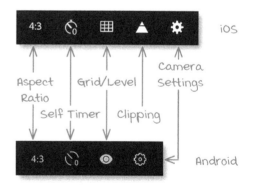

Aspect Ratio sets the aspect ratio of the photo (*16:9, 3:2, 4:3,* or *1:1*), but it still captures the entire sensor area and just applies a non-destructive crop, which can be changed later.

The **Timer** delays the shutter by 2, 5, or 10 seconds, or the default is *Off*.

Grid Overlay & Level offers a choice of overlays to help compose the photo. The grids are *Halves* (to show the center point), *Thirds* (rule of thirds), and *Golden* (golden ratio). The level helps you get the horizon straight, of course.

Highlight Clipping Warning (iOS only) shows clipped highlights as a zebra-stripe overlay, so you know to reduce the exposure.

CAMERA SETTINGS

The cog opens the camera settings dialog:

iOS (top), Android (bottom)

Max Screen Brightness increases the screen brightness while you're using the camera.

Geotag Photos adds the GPS location to the file's metadata.

Save Unprocessed Original (iOS) / **Save Unprocessed HDR** (Android) adds the standard exposure file to Lightroom, in addition to the merged HDR photo.

Volume Keys Function (Android only) determines whether the volume keys adjust the shutter (*Capture*), *Exposure Compensation*, or *Zoom*.

Save Original (Android only) saves photos captured using Lightroom's camera to the device storage in addition to Lightroom's library.

CAMERA SHORTCUTS

On **iOS**, you can use the Lightroom camera widgets for quicker access. To add the Lightroom camera widget to the Lock screen on iOS 16 or later, long press on the Lock screen, then tap the + button and select the wallpaper of your choice. Tap *Add Widgets*, select Lightroom, and tap its button to add it to the widgets area. This makes Lightroom's camera available from the lock screen, just like the built-in camera. After editing your Lock screen, tap *Done* and select your new Lock screen.

While the Lock screen widget was new to iOS 16, Lightroom's widgets can also be added to the Home screen and Today view on all supported iOS versions. The exact steps vary by version, so here's Apple's help page: https://www.Lrq.me/ioswidgets

On **Android**, the Lightroom Camera widget can be placed on the Home Screen for fast access. To do so, touch and hold a space on a Home Screen. Tap *Widgets*, then swipe to find the Lightroom Camera widget. Hold your finger on the widget and drag it to the location of your choice.

ADDING PHOTOS ON MOBILE

If you want to use Lightroom to view and organize all of your photos, it's easier to add them directly to the **Lightroom** tab on your mobile device rather than using the *Device* (iOS) / *Gallery* (Android) tab. Photos can be added to your Lightroom library automatically, or you can add them manually.

ADDING PHOTOS AUTOMATICALLY

If you're going to add all of your mobile photos to Lightroom, the easiest option is to **enable Auto Add**. On iOS, go to *App Settings > Import* and toggle the *Photos, Screenshots,* and *Videos* switches to the right.

On Android, go to *App Settings > Preferences*, toggle *Auto Add from Device*, and select which file formats to add automatically. You can also choose whether to automatically *Import from all locations* or select specific device folders for Auto Add.

Adding photos automatically saves you from having to remember to upload your photos. On iOS, you must open the Lightroom app occasionally to allow the photos to import, whereas on Android, the import happens in the background.

ADDING PHOTOS MANUALLY

Auto Add only adds new photos automatically, but you can add older photos using the *Add Photos* button.

1. Tap the *Add Photos* button at the bottom of the Lightroom Grid view.

2. Lightroom asks whether to add photos from:

Device displays the photos in the Photos app (iOS) / Gallery app (Android)

Files allows you to navigate through folders and files, including the Downloads folder, cloud storage such as iCloud or Dropbox,

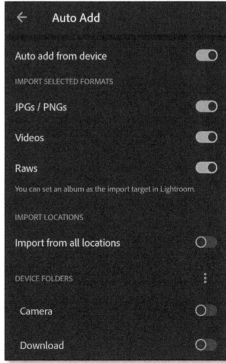

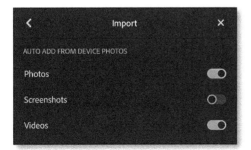

Auto Add Preferences:
iOS (left), Android (right)

and external storage units like Gnarbox or WD My Passport Wireless.

Connected Camera/Card (iOS) allows you to import photos from a camera connected by cable or from a memory card in a card reader.

Lightroom only shows if you're viewing an album. It adds photos from *All Photos* into the selected album.

iOS (left), Android (right)

3. At the top of the grid, select the album of your choice, for example, *Device*.

At the top of the grid, select the grouping of your choice, for example, *Time* or *Device Folders*. Tapping the ... icon allows you to filter the photos by file type.

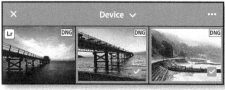

iOS (top), Android (bottom)

Photos already imported into Lightroom have an LR icon in the corner. Tapping the ... icon allows you to filter the photos by file type and change the thumbnail size.

4. Tap the photos individually, a segment at a time (Android only), or tap the ... button to select all. Selected photos have a blue border.

5. After selecting the photos to import, tap the *Add* button to confirm your selection.

ADDING PHOTOS FROM A MEMORY CARD

If you're shooting with a separate camera, for example, your DSLR or mirrorless camera, you can add the photos to Lightroom in the same way. This is particularly useful when traveling without a laptop, allowing you to start viewing, editing, and sharing them.

You'll need a card reader, camera cable, or adaptor with a supported connector, for example, USB-C, Lightning, or Micro USB. When importing via a camera cable, you'll also need to ensure the camera is turned on, and you may need to switch it to PTP or MTP mode.

The steps vary slightly by operating system:

iOS (Camera or Card Reader)

1. Insert the memory card into the SD card reader, or connect the camera and turn it on. The first time, Lightroom asks permission to access the connected device.

2. On iOS, tap *Continue* on the Device Connected dialog.

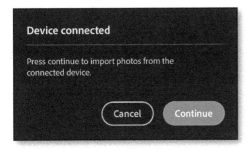

3. Lightroom reads the card and presents an import dialog where you can select specific photos. Tap the checkmarks on individual photos or date segments, or tap the ... menu to *Select All*. The ... menu also allows you to filter specific types. (Screenshot edited to remove some thumbnails.)

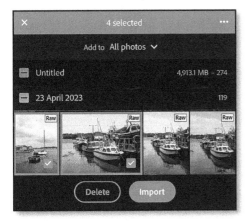

4. At the top of the screen, choose whether to add the photos to *All Photos* or a new album.

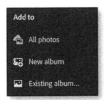

5. Tap *Import* to begin the import process. Don't remove the card/camera or switch to another app until the import completes.

6. Tap the X to close the Direct Import dialog and return to Lightroom.

One word of warning: At the time of writing, direct import on iOS does not copy videos. Check that you have all the photos and videos before formatting the card.

Android (Camera Connection)

1. Connect the camera and turn it on.

2. In the app picker, select Lightroom. If your device automatically opens another app, you'll need to check your device manufacturer's documentation to clear the default setting.

3. Tap specific photos to select them (shown by a blue border), or tap the ... icon to *Select All*, *Select None*, or filter by file type. Once you've selected the photos, tap *Add*. (Screenshot edited to remove some thumbnails.)

4. Lightroom asks whether to add the photos to *All Photos*, a specific album, or create a new album. By default, *All Photos* is selected. Once you've made your choice, tap *Add* again. (Screenshot edited to remove some albums and folders.)

5. Lightroom displays a progress dialog while it copies the photos to your Android device. When it's finished importing the photos, you can disconnect the camera. I'd recommend keeping the photos on the card until they're safely uploaded to the cloud so that you have a backup.

Android (Card Reader)

If you're **using a card reade**r rather than connecting a camera, use the *Gallery* tab > *Albums* pop-up > *Browse* to navigate to the photos as external storage instead.

IOS SHORTCUTS APP

The iOS Shortcuts app, available from the App Store, is designed to automate several steps. Lightroom's integration is currently limited to adding photos, but there are a few potential advantages compared to the standard *Auto Add* switches:

• Apply a preset to the new photos as they're added to Lightroom. (Only the default presets at this time.)

• Filter the photos to only add specific file formats (by extension), those marked as favorites in Photos app, or those in a specific album. There's a scrollable list of criteria.

• Send multiple photos directly to Lightroom from another app (e.g., Google Photos or some tethering apps).

• Automatically delete photos from the device once they're added to Lightroom.

Let's try **building a simple workflow**:

1. Download the Shortcuts app from the App Store.

2. Open the Shortcuts app and tap + to create a shortcut. Here's one I made earlier...

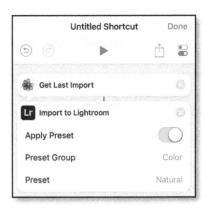

3. Scroll down the list to the Photos & Videos section or type *Photos* into the Search field.

4. Select the source of the photos. For example, **Get Latest Photos** (selects a specific number), *Get Last Import* (if you've just imported from an SD card), *Find Photos* (to filter for specific photos), or another option. You may need to give permission to access these photos.

7. Scroll through the list again or search for **Delete Photos**. Adding this step moves them to the *Recently Deleted* album, which works like a Recycle Bin / Trash. It asks for permission each time the workflow runs so you can change your mind later.

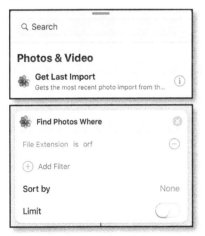

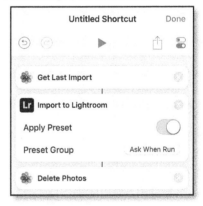

5. Scroll through the list again or search for *Import to Lightroom*.

6. (Optional) Toggle the *Apply Preset* switch and select a preset to apply to the photos during import. You may prefer to select *Ask When Run* to choose the preset each time the workflow runs.

8. Tap the toggle switch icon (top right) to access the workflow settings, and give the shortcut a name. You can also change the icon and add a shortcut to the home screen for easy access.

To **run the workflow**, tap on it in the Shortcuts app or tap on the home screen shortcut if you created one.

ADDING PHOTOS ON THE DESKTOP

You can copy photos to Lightroom's library from the Local view (page 45), or you can add them directly to the Cloud tab.

If you want to use Lightroom to view and organize all of your photos, it's easier to add them directly to the **Cloud** tab on your desktop rather than browsing folders in the *Local* tab. You're in control of which photos (or videos) you import, and the same principles apply whether you're adding existing photos from your hard drive or new photos from your camera.

STEP-BY-STEP

1. If your photos are not currently stored on the computer, plug in the mobile phone, tablet, camera, or memory card reader. (Card readers are generally more reliable than camera cables.)

2. Click the **Add Photos** button at the top of the left panel.

3. To add photos from a memory card or mobile device, select the device from the pop-up.

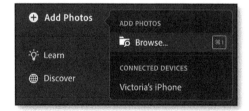

4. To add photos from your computer's hard drive, select **Browse...** from the pop-up to show the standard file browser for your operating system. (If no memory cards or mobile devices are connected, Lightroom skips the pop-up and immediately opens the file browser for you.)

Select a folder (such as the Pictures folder) or individual photos, then click **Choose Folder** (Windows) / **Review for Import** (Mac) to move to the next window.

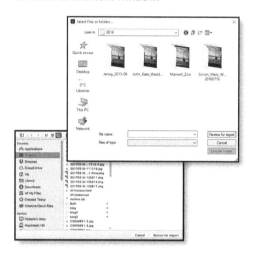

windows (top), mac (bottom)

If your photos are currently organized into folders by topic, you may want to add one folder at a time (rather than selecting the parent folder) so you can create an album per folder, retaining your topic-based organization.

Alternatively, you can select the files in Explorer (Windows) / Finder (Mac) and then drag and drop them onto Lightroom's Grid view. The Import dialog opens with only these photos selected for import. This is particularly useful if you want to filter the photos before importing, for example, only the raw files from raw+JPEG pairs.

5. The thumbnails start to appear in a Grid view.

6. Select the photos you want to import by

ADD PHOTOS DIALOG (DESKTOP)

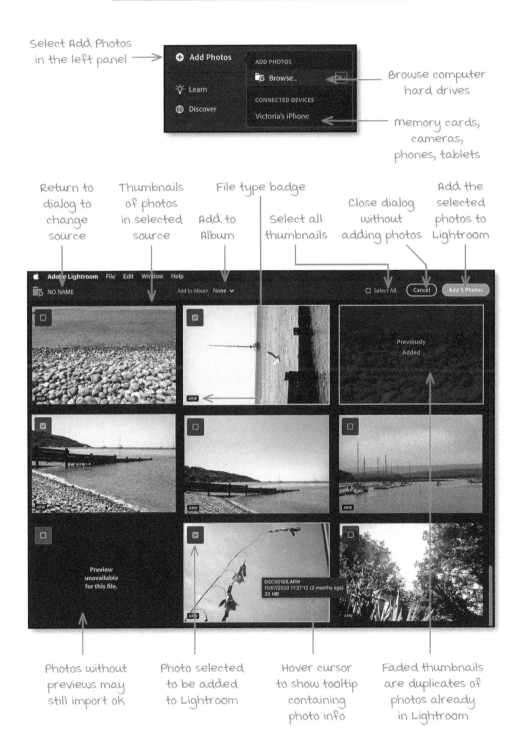

Select Add Photos in the left panel →

Browse computer hard drives

memory cards, cameras, phones, tablets

Return to dialog to change source

Thumbnails of photos in selected source

File type badge

Add to Album

Select all thumbnails

Close dialog without adding photos

Add the selected photos to Lightroom

Photos without previews may still import ok

Photo selected to be added to Lightroom

Hover cursor to show tooltip containing photo info

Faded thumbnails are duplicates of photos already in Lightroom

clicking the **checkmark** in the top left corner of each thumbnail. To select or deselect all photos simultaneously, toggle the **Select All** checkbox.

To check a series of consecutive photos, click on the first of the photos so it shows a white border. Hold down the Shift key and click the last photo in the series so they're all surrounded by a white border, then click the checkbox on one of the selected photos to check them all.

7. If the selected photos are all from the same shoot or topic-based folder, you may want to group them into an album (page 83) to make them easy to find later.

In the **Add to Album** pop-up, select New to create a new album, or select an existing album from the list. (A quick tip: if you select the album in the Albums panel before opening the Add Photos dialog, the album is automatically set in the Add to Album pop-up.)

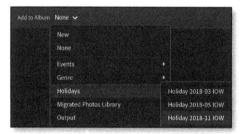

8. Click **Add X Photos** to start importing the photos into Lightroom.

9. The dialog closes, and a progress bar appears in the top left corner of Lightroom,

showing the current status. Float over it to see the image count. If more than one task is in progress, click on it to see the individual tasks.

10. The photos appear in the preview area, and you can start looking through them immediately (page 34).

CLEANING UP AFTER ADDING PHOTOS

Adding photos to Lightroom doesn't remove them from their previous location, so you may want to clean up after adding them to Lightroom.

If your photos were on a camera memory card, keep the photos on the memory card as a backup until they're safely uploaded to the cloud. Once they've finished uploading, reformat the memory card in the camera rather than simply deleting the photos. This helps to avoid card corruption.

If the photos were stored on the hard drive, you can delete the original folders once the photos/videos are safely in Lightroom to free up space on your computer. Before you delete these folders, double-check all of the photos imported into Lightroom and that the folders don't contain any non-photo/video files, for example, Word documents or other file formats that aren't supported by Lightroom.

FIXING IMPORT PROBLEMS

Import issues are relatively rare, but there are a couple of things you may run into...

Can't Find Device—If the camera or card reader doesn't appear in the Add Photos

dialog, check that it's visible in Explorer (Windows) / Finder (Mac). Lightroom relies on the operating system to show the mobile device or memory card. Card readers are usually more reliable than camera cables.

Faded Thumbnails—If you can see thumbnails in the Add Photos dialog, but they're faded, Lightroom knows they're duplicates of existing photos. Floating the cursor over the photo reminds you that the photo is already in Lightroom.

Lightroom errs on the side of caution, calculating the file's checksum (hash) to ensure it's an exact duplicate. It won't identify duplicates that are edited copies of an existing photo or if another program has changed the metadata in the file. If you believe a photo has been falsely identified as a duplicate, rename it in Explorer (Windows) / Finder (Mac) to force Lightroom to import it.

Preview Unavailable—If you can only see gray rectangles rather than thumbnails of your photos, try adding them anyway. Lightroom then provides additional information in an error message or builds the previews from the full-resolution file.

If Lightroom can't add all of the selected images, it displays an **error message** at the end of the import.

The file appears to be unsupported or damaged has a few possible causes:

• Your Lightroom version doesn't support the raw file format. To fix it, check for updates (page 11). If the camera is very new, you may need to wait for an update that supports your camera. You can check whether your camera is currently supported at https://www.Lrq.me/camerasupport

• The file is corrupted. There's usually nothing you can do to fix a corrupted file other than adding the same file from an uncorrupted backup.

• The file format isn't on the list of supported file types (https://www.Lrq.me/file-formats). For example, it uses an unsupported color mode (e.g., duotone), it's too big, or it's a PSD file that was saved without *Maximize Compatibility* enabled.

Duplicate image within session means some of the thumbnails you checked in the Add Photos dialog are exact duplicates of other checked photos in the same import. This error message is for information only.

Low Disk Space—When you add photos, Lightroom copies the selected photos to its cache on your computer's hard drive and then uploads them to the cloud. Once they're uploaded, it can free up space on your hard drive again, but if you're doing a big import (such as all of your existing photos), you may run out of space.

If so, you can add the photos in smaller chunks and wait for these to finish uploading before adding more, or better still, change the location of the originals to another drive that has more space available (page 80).

MIGRATING FROM DESKTOP PHOTO APPS

If you've used one of the supported desktop apps to manage your photos in the past, Lightroom's migration tools can help you easily transfer the photos into Lightroom. There are tools for:

• Lightroom Classic (and earlier Lightroom versions)

• Apple Photos (Mac only)

Before going through the migration process, we'll look at what does and doesn't migrate from each of these apps and how to prepare properly to avoid errors.

Before you start a migration, you'll need:

• On your boot drive (e.g., C:\ or Macintosh HD), you need space for the catalog and smart previews, which can be as much as 20% of the size of your Lightroom Classic catalog and original files.

• The migration process creates a copy of your images, so you'll need free space for all originals, either on the boot drive or another internal/external hard drive or NAS (network-accessible storage). You can set the location of the originals in *Preferences > Cache* (page 425) before opening the migration tool. This extra space is only needed temporarily, as the local cache can be cleared once the files have been safely uploaded.

• Enough cloud storage space to hold all of your photos, or Lightroom won't be able to upload your photos. If you have a larger library, you can add extra storage space on your account page on Adobe's website.

• You should only migrate each catalog/library once, as repeating the process can create duplicates, so ensure everything's set up before moving forward.

MIGRATING FROM LIGHTROOM CLASSIC

Lightroom can migrate catalogs from Lightroom Classic, Lightroom CC 2015, or Lightroom 6. If you're migrating from an earlier Lightroom version (1.0-5.7.1), you'll need to install a trial of Lightroom Classic and allow it to upgrade a copy of your catalog to Lightroom Classic format before running migration.

Most of your organization and edits are transferred during the migration process. Many Lightroom Classic features don't exist in Lightroom.

Data that doesn't transfer to the Lightroom database includes:

• Folders and folder hierarchy (but you can convert to collections before migrating, which become albums in Lightroom).

• Develop History States (but the current Develop settings do transfer).

• Snapshots (but you could manually convert to virtual copies before migrating).

• Custom metadata from plug-ins.

• Creations (books, slideshows, prints, and web galleries).

• Map module saved locations (but the GPS data itself does transfer).

• Smart collections.

• Shared web galleries must be shared again after migration, as the URLs may

change.

Some data gets converted to Lightroom's format:

- Color labels become keywords.

- Virtual copies become real copies.

- Collection sets become album folders.

- Collections become albums.

A word of warning—the migration is a one-way process. Continuing to use and sync Lightroom Classic after migration is not officially recommended because it won't let you migrate the same catalog again. Not all metadata syncs with Lightroom Classic, which can result in metadata or photos being orphaned.

Be sure of your decision before migrating. If you're unsure whether Lightroom offers all the functionality you require, don't migrate until you're confident, as it's not as easy to return. Instead, use Lightroom Classic to sync smart previews to the cloud so you can view/edit them in Lightroom. This will allow you to thoroughly test Lightroom before committing to switching over completely. See the Cloud Sync chapter of my *Adobe Lightroom Classic— The Missing FAQ* book to avoid potential problems. I've also published a feature comparison at https://www.Lrq.me/lightroom-cc-vs-classic-features/

Before you start the migration, there's some **prep work to do in Lightroom Classic**:

1. Go to *File menu > Optimize Catalog.*

2. Go to *Library menu > Find Missing Photos* to check that all of the originals are available. If some photos are marked as missing, follow the instructions at https://www.Lrq.me/

lightroom-photos-missing-fix/ to locate the missing originals.

3. Create a smart collection to search for metadata conflicts. (Criteria is *Other Metadata > Metadata Status > is > Conflict Detected.*)

In the smart collection, click on the metadata icon in the corner of each thumbnail to fix the conflict. If you're happy that the catalog's metadata is correct (which is usually the case), click *Overwrite Settings*.

4. If you organize your photos into named folders in Lightroom Classic and wish to retain that organization, create collections/collection sets to replicate your folder structure (up to 4 deep). The quickest way to do this is to right-click on the parent folder, select *Create Collection Set "xxx,"* and repeat until all your chosen folders have been replicated in the Collections panel.

5. Finally, you may need to know your catalog name and where it's stored. If you're not sure, go to *Edit menu* (Windows) / *Lightroom menu* (Mac) > *Catalog Settings > General tab* to check.

Develop presets designed for Lightroom 4 or later will also work in Lightroom, so you may also want to **transfer your profiles and presets**.

1. Create a temporary folder to store the presets and profiles.

2. Copy any DCP format profiles, XMP format profiles, and XMP format presets by:

On Windows, open the Start menu search box and type *%appdata%\Adobe\CameraRaw*.

On macOS, go to *Finder > Go menu > Go to Finder* and paste *~/Library/Application Support/Adobe/CameraRaw*.

Copy the contents of the *CameraProfiles* and *Settings* folders to the folder you just created on the desktop.

3. If you're using Lightroom 6, Lightroom CC 2015, or Lightroom Classic 7.2 or earlier, also...

On Windows, open the Start menu search box and type *%appdata%\Adobe\Lightroom*.

On macOS, go to *Finder > Go menu > Go to Finder* and paste *~/Library/Application Support/Adobe/Lightroom*.

Copy the contents of the *Develop Presets* folder to the folder on the desktop.

4. Check if there's a *Lightroom Settings* folder next to your catalog, and if so, copy the contents of the *Develop Presets* and *Settings* folders to the temporary folder.

5. In Lightroom, go to *File menu > Import Profiles & Presets*, navigate to the folder on the desktop, then press *Import*. A progress bar displays at the top of the Preset and Profile Browser panels while they're importing.

Now everything's prepared, you're ready to move on to the migration process itself (page 69).

MIGRATING FROM APPLE PHOTOS

Lightroom can migrate your desktop Apple Photos library, including much of your organization and edits. (If you use an iPhone/iPad and don't own a Mac, use Add Photos to import your photos and videos into Lightroom instead: page 57).

During migration, most of your organization is converted to Lightroom's format:

• Photos Folders and Albums become Lightroom Folders and Albums.

• Photos marked as Favorites are grouped into a Favorites album, so you can choose to flag or star them after migration.

Standard metadata also migrates from Photos to Lightroom, including the photo EXIF metadata, Titles and Captions, keywords, and people tags.

Some Apple Photos features are not currently supported in Lightroom, so some data is only partially migrated:

• Edits—Only the untouched originals are migrated. The edits are not migrated.

• Bursts—Only the key frame is transferred. If you want to keep the individual frames, unstack them using Photos before migration.

• Live Photos—The still key frame and video are migrated but no longer combined as a live photo.

• Portrait Mode—The unedited original is migrated without the depth effect.

• People—Face data for cropped or rotated images is not migrated. However, the unmodified original is migrated.

A few things don't get migrated at all:

• Shared Albums are not migrated.

• Hidden photos/videos are not migrated.

• Recently Deleted photos/videos are not migrated.

• Photos/videos stored in iCloud but not cached locally are not migrated. (Don't worry, we'll download these while preparing the Photos Library.)

Duplicate checks aren't done during migration, so it's worth migrating as early as possible in your Lightroom journey. Otherwise, you may end up with some duplicates.

Before you start the migration, there's **some prep work to do in Photos**:

1. Ensure your operating system has the latest updates installed.

2. Most people only have one Apple Photos Library, but if you have more than one, open the one you want to migrate in Apple Photos and go to *Preferences > General tab > Library Location > Use as System Photo Library* before proceeding with the migration. Then, repeat this process for each of the other libraries. Each library can only be migrated once.

3. Photos must be cached locally before they can be migrated to Lightroom. To ensure you have a local copy, go to *Photos menu > Preferences > iCloud tab*. If *iCloud Photo Library* is checked, select *Download Originals to this Mac*.

Select the Photos view and scroll to the end, where it shows the upload/download status, and wait for the download to complete before starting migration.

Now your Photos library is prepared; you're ready to move onto the migration process itself.

MIGRATION STEP-BY-STEP

Now it's time to start the migration itself... We'll use Lightroom Classic migration for the screenshots.

1. Quit the other app and open Lightroom.

2. In Lightroom, go to *File menu > Migrate From* and select *Lightroom Classic Catalog or Apple Photos Library*.

3. In the information dialog that appears, click *Continue*.

and fix the problems, click *Check Again*, or ignore the exceptions by clicking *Continue Anyway*. If you've prepared for migration in advance, there may not be any exceptions.

4. Review the information in the Before You Begin dialog and click *Continue*.

5. If you're migrating from Lightroom Classic, select the catalog you want to migrate, then click *Start Scan*.

6. Lightroom scans the catalog/library and launches the migration tool, displaying a progress bar to monitor. This step may take some time to complete, depending on the size of your catalog.

7. Review any exceptions in the migration tool reports, for example, if you don't have enough cloud or local storage space. Stop

8. Review the information in the Ready for Migration dialog. If necessary, click *Open Log File* to check the details of any errors. Then click *Start Migration* to begin the migration process.

A progress bar is displayed during the migration process. Depending on the catalog size and your computer specifications, this step may take some time to complete (e.g., many hours or even a few days if you have tens of thousands of photos), as it copies all of the photos into Lightroom's own storage space, ready for upload to the cloud.

9. When migration is complete, Lightroom displays a confirmation dialog. If there are exceptions, click *Open Log File* to review what went wrong. Otherwise, you're all done and ready to start using Lightroom. Photos may take hours, days, or weeks to sync to the cloud, depending on your internet connection speed and the number and size of the photos.

10. You can repeat the process if you have more than one Lightroom Classic catalog. An album folder is created for each catalog so that you can identify the source of the photos.

11. Once you're happy that everything's safely in Lightroom's storage space and you have a local backup of the originals (page 76), you may choose to delete the old catalog and photos to free up hard drive space or move them to a disconnected hard drive as an extra backup.

MIGRATION ERRORS

You may run into errors with the migration since it's a relatively complex process. The most frequent issues and their solutions are listed at:

Lightroom Classic:
https://www.Lrq.me/migration-errors

Apple Photos:
https://www.Lrq.me/migration-errors-apple

SYNCING WITH THE CLOUD

5

Once you've added photos to Lightroom's library, Lightroom automatically uploads them to the cloud whenever you have an internet connection and downloads changes made on other devices. (You must have an active Lightroom subscription to use Cloud Sync.)

Lightroom's smart about minimizing the space it uses on your mobile device or computer's hard drive, so you don't need to worry too much about file management. Still, there are a few preferences that you may want to adjust, depending on your usage.

IN THIS CHAPTER, WE'LL CONSIDER:

• How to check the sync status.

• How to store photos locally for offline use.

• How to manage the space Lightroom uses on your device or hard drive.

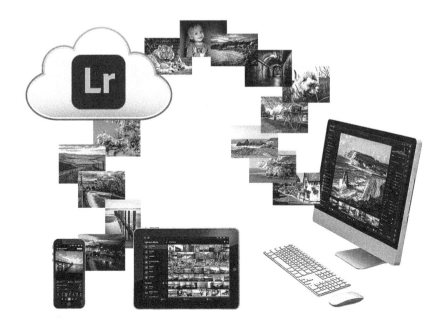

SYNCING WITH THE CLOUD

Lightroom automatically syncs photos up to the cloud and syncs down the photos as they're needed, so there's very little you need to do. However, occasionally, you may need to check the sync status, for example, to check your photos uploaded before turning off your device.

OVERALL SYNC STATUS

You can check the **overall sync status** by tapping/clicking the cloud icon in the top right corner.

Synced and Backed Up means the local database cache is in sync with the cloud.

Syncing X Items means originals and/or edits are currently being synced to/from the cloud. The mobile apps show extra detail, such as *Uploading X Photos* or *Auto-Importing from Device*.

PAUSING/RESUMING SYNC

If you're on a limited bandwidth connection, for example, on vacation or tethering a mobile phone, or have a more urgent upload underway, you may want to pause sync temporarily.

To **pause sync** on mobile, tap the cloud icon, then tap *Pause Syncing*. On the desktop, click the cloud icon, then float over the sync status line to display the *Pause Syncing* button. Later, return to the same location to resume syncing.

Syncing photos, especially full-size originals, can quickly use up your cellular data allowance, so on mobile, you can limit Lightroom to **WiFi only**. To do so, go to *App Settings > Cloud Storage & Sync* (iOS) / *App Settings > Preferences* (Android) and toggle **Use Cellular Data** to the left to turn it off. It doesn't completely stop cellular data usage, but it's minimized.

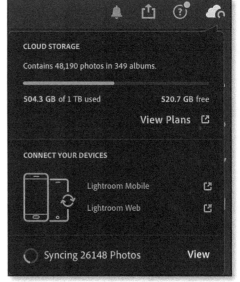

Sync Status:
iOS (top left), Android (bottom left), Desktop (right)

SMART PREVIEWS VS. ORIGINALS

Lightroom uses smaller proxy files in addition to the full-resolution originals to reduce internet bandwidth and storage space. Since they each have pros and cons, it's helpful to understand which type of file you're working with at any time.

A **Smart Preview** is a medium-resolution (2560px) copy of the photo that can be used in place of the original file for editing when the original isn't available. It's a small file, so it downloads quickly and doesn't take up much space, and in most cases, you won't notice a difference when viewing and editing.

Original refers to the original full-size file in its original file format. Lightroom uploads all originals to the cloud and downloads them when needed, for example, when sending a photo to Photoshop, when exporting, or when zooming into 100% on the desktop. The originals may also be cached locally, depending on your preference settings and range of behind-the-scenes criteria, such as how recently you've viewed the photo.

It's easy to **check what type of file you're currently viewing and what's available in the cloud**. On mobile, open the photo in Detail view and tap on the sync icon. If Lightroom says there's only a smart preview in the cloud, it's because you synced the photo using Lightroom Classic. In this case, you won't be able to access the full-size original until you add it to Lightroom (page 62).

On the desktop, you'll find the information in the Sync Status section of the Info panel (page 98). It's also displayed in the lower right corner of their thumbnail in the Cloud Square Grid view on the desktop if the sync status is not the default *Synced and Backed Up*. The badge style varies depending on the sync status.

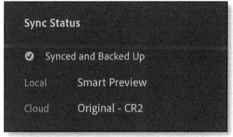

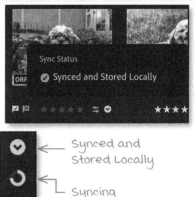

Mobile Detail View Sync Status: iOS (top), Android (bottom)

Desktop Info Panel Sync Status (top), Thumbnail icon (center), icons (bottom)

STORING PHOTOS LOCALLY

If you always have an internet connection, you can leave Lightroom to download photos from the cloud as needed. However, there are occasions when you might want a little more control over which photos are stored locally, for example, if you know you're going to want to work offline.

AUTOMATED LOCAL CACHES

Before making decisions about manually controlling Lightroom's caches, it's helpful to understand how Lightroom behaves by default...

When you log in to Lightroom for the first time on a device/computer, it downloads a local cache of its **cloud database**, containing a list of your albums and photos and their metadata/edits.

Next come the **thumbnails** to display in the Grid view. On mobile, they download as you try to view them in Grid view, whereas on the desktop, they're downloaded during the initial sync.

As you flip through the photos in Detail view, Lightroom downloads the **smart previews** for those photos so they can be viewed and edited.

The **originals** are downloaded more selectively because they occupy much more storage space.

As mobile storage space is usually limited, Lightroom doesn't automatically download the full-size original from the cloud because the smart preview is fine for editing. When you send a photo to Photoshop or export the photo, Lightroom downloads the original.

If you need to **forcibly download an**

original on mobile, perhaps because you need to fine-tune sharpening adjustments, you can manually download it by tapping on the Detail view's cloud icon and then *Get This Original* (iOS) / *Download Original* (Android).

If you'd prefer that Lightroom always downloads the original as soon as you view the photo in Detail view, go to *App Settings > Cloud Storage & Sync* (iOS) / *App Settings > Preferences* (Android) and turn off **Only Download Smart Previews**.

On the desktop, Lightroom automatically downloads the full-size original from the cloud when needed. For example, when you zoom in, edit a photo, send a photo to Photoshop, or export the photo.

WHY STORE LOCALLY

Although Lightroom is smart about managing its local cache, you can choose to store specific albums (desktop/mobile) or everything (desktop only) locally.

There are a few reasons you may want to decide which files are stored locally, including:

Performance—Loading a photo or video from local storage is almost always faster than downloading it from the cloud.

Bandwidth—Working from a local cache means Lightroom doesn't need to download the files from the cloud, reducing your internet usage.

Work Offline—A local cache means you can continue working on your photos without an internet connection. It's particularly useful on mobile devices, where you may not always have high-speed internet access.

Backup—While extremely unlikely, something could go wrong with Adobe's servers, so keeping a local copy of the originals may offer peace of mind.

Locally Stored Album: mobile (top), Desktop (bottom)

STORING ALBUMS LOCALLY

Albums are found in the Albums panel (mobile) / Photos panel (desktop), and they're used for grouping photos. We'll learn about creating and managing the albums themselves later (page 83).

You may decide to cache specific albums locally, for example, the albums you're currently working on or those containing your best photos. This is particularly useful if you want to work on an album offline.

To **mark an album for local storage** on mobile, go to the Albums panel and tap the ... icon next to the album you wish to store locally, then select **Store Locally**. The photos download while you have an internet connection, and the album cover photo is marked with a small blue arrow when the download is complete. On the desktop, right-click on the album and select **Make Albums Available Offline**. It displays a green arrow when it's downloaded. Repeating the process reverts to automatic cache management.

STORING ALL FILES LOCALLY ON THE DESKTOP

On the desktop, it's possible to **keep all smart previews and/or originals locally** rather than specific albums. (There's no matching option on mobile, but some people add all their photos to an album and then store that locally on their device to get the same result.)

To keep a copy of all originals locally, check the **Store a copy of all originals at the specified location** checkbox in *Preferences > Cache*. I'd recommend storing a copy of all originals on at least one desktop computer as a local backup if you can.

The **Store a copy of all smart previews locally on C:\ or Macintosh HD** checkbox retains a local copy of the smaller smart previews. This can be valuable for performance and offline work, especially if you don't have a local cache of all originals.

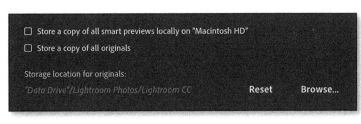

Store a copy of all smart previews or originals locally on Desktop

MANAGING THE LOCAL CACHE

Lightroom manages its local storage automatically, but it provides some information about the space used and a couple of preference settings.

PRIMARY STORAGE LOCATION

On iOS, Lightroom's data is stored in a hidden location assigned by the operating system. This location can't be changed, so you can't store Lightroom's data on external storage.

On Android, you can move most of the Lightroom data to your expansion storage (SD card). Go to *App Settings > Local Storage* and change the *Storage used* pop-up to *SD Card*.

On the desktop, Lightroom's primary cache is held on the boot drive, and you can't change the location. However, you can select a different drive for the originals to free up space on the boot drive (page 80).

Windows—C: \ Users \ [your username] \ AppData \ Local \ Adobe \ Lightroom CC \ Data

Mac—Macintosh HD / Users / [username] / Pictures / Lightroom Library.lrlibrary

CACHE BREAKDOWN

You can check how much space Lightroom is using on your device/boot drive by going to *App Settings > Local Storage (mobile) / Preferences > Cache (desktop).* (On the desktop, these cache sizes don't include originals stored on another hard drive.)

App & User Data is space required for Lightroom to run. It includes the database

and small previews, other user data such as presets, and photos/videos that haven't synced to the cloud yet. (This isn't shown on iOS.)

Locally stored copies are photos and videos you've chosen to store locally using the preferences discussed in the previous lesson (page 76).

Photo cache is the cache of smart previews and originals that Lightroom manages on the boot drive. It can be cleared using the *Clear Cache* button that we'll return to shortly. (*Cached Files* on iOS is similar but includes photos that haven't been uploaded yet.)

Free Space is the amount of free space on the hard drive/device available for Lightroom to use.

LIMITING THE CACHE SIZE

Lightroom automatically manages the space it uses for its local cache, but it's a balancing act. Lightroom can use a larger amount of storage space to keep many previews and originals locally or save local space by downloading files from the cloud as needed.

You can control the balance by selecting the **Cache Size Limit** in *App Settings > Local Storage* (Android) / *Preferences > Cache (desktop).* On iOS, it's a fixed 10GB limit.

This setting determines how much of the available storage space can be used for the *Photo cache* that Lightroom manages. It doesn't limit locally stored copies or originals stored on a different hard drive.

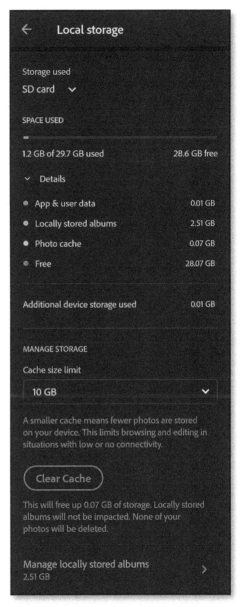

RECLAIMING PHOTO CACHE SPACE

If you need to **clear some space** on your device (mobile) / boot drive (desktop), tap/click the **Clear cache** button.

This only clears the *Photo cache*, so you don't need to worry about originals that haven't been uploaded yet, or any photos you've chosen to store locally.

RECLAIMING SPACE FROM ALBUMS STORED LOCALLY

To free up even more space, you can **clear the locally stored albums** (page 76). On mobile, select the album's ... icon and toggle *Store Locally* off, or on the desktop, right-click on the album and uncheck *Store Album Locally*. This makes them part of the standard *Photo cache* that is managed automatically and can be cleared using the *Clear cache* button.

Local storage caches:
iOS (top left),
Android (top right),
Desktop (bottom)

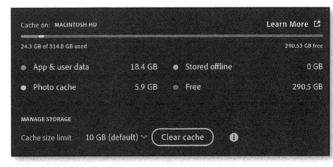

The Android app has an additional handy feature for finding locally stored albums. Go to *App Settings > Local storage > Manage locally stored albums*, check the albums you want to clear, and tap *Offload selected albums*. Like toggling the *Store Locally* switch off, this makes the albums part of the standard *Photo cache* that is managed automatically.

← **Locally stored albums**

LOCAL ALBUMS ° 282.7 MB

☐ Select All

✓ **Anyone Can View**
199.1 MB 33

(**Offload selected albums**)

This adds 199.1 MB of resources back to the cache, where they are subject to automatic cache clearing.

SETTING THE STORAGE LOCATION OF ORIGINALS ON THE DESKTOP

By default, Lightroom stores any downloaded originals and its database and preview files in its local cache on the boot drive.

Original photos and videos can take up a significant amount of disk space. Still, you can select another hard drive (e.g., an internal/external hard drive or a network drive) to avoid filling up your boot drive. The local database cache and previews remain on the main hard drive. Only the originals move to your selected location.

To change the location of the originals, go to *Preferences > Cache*, click **Browse**, and navigate to another drive. Lightroom automatically moves downloaded originals to the new location, so you don't have to do anything else. If you change your mind, the **Reset** button moves the originals back to the main hard drive.

When that location is unavailable (e.g., the external drive is disconnected), Lightroom obviously can't access the originals stored there, so it downloads them from the cloud as needed and stores them in the default location on the boot drive, along with any new photos you add to Lightroom. When you next restart Lightroom with the drive attached, Lightroom automatically moves any originals to your custom location.

☐ Store a copy of all smart previews locally on "Macintosh HD"
☐ Store a copy of all originals

Storage location for originals:

"Data Drive"/Lightroom Photos/Lightroom CC Reset Browse...

Set the storage location of originals on Desktop

ORGANIZING PHOTOS & VIDEOS

6

Having added your photos to Lightroom's managed library, you can start organizing them into albums. Lightroom also offers a number of special albums that populate automatically. They vary slightly, depending on whether you're using a mobile device or a desktop computer.

VIEWING SPECIAL ALBUMS

To view the special albums on mobile, select the *Lightroom* tab. On iPhone/Android, show the Albums panel by tapping the pop-up at the top of the Lightroom Grid view. On an iPad, the Albums panel is on the left, and you can show/hide it by tapping the button at the top. If you can't see the special albums, tap the arrow next to *Lightroom Albums*.

To view the special albums on the desktop, select the *Cloud* tab in the Photos panel and then click the arrow to the right of *All Photos* if they're not already showing.

All Photos is useful for scrolling through your photos or searching.

My Edits (mobile) / *Recent Edits* (desktop) shows all of the photos you've edited, sorted to show the most recently edited photos first. *Unedited* (mobile only) shows the photos that haven't been edited yet.

LR Camera Photos (mobile only) shows

Special Albums:
mobile (left), Desktop (right)

photos captured using Lightroom's Camera (page 51).

Imports (mobile) / **Recently Added** (desktop) shows the most recently imported photos, grouped with other photos imported at the same time.

By Date (desktop only) allows you to browse the photos using a year/month/day hierarchy. To display photos from multiple dates at once, for example, multiple vacation days, click on one date and then either hold down Ctrl (Windows) / Cmd (Mac) and click on each of the other dates or hold down the Shift key and click on the first and last dates in the series.

If you're already viewing a photo and want to see other photos captured on the same date, right-click on the photo and select **Show Photos from Same Date** to automatically select the date.

On mobile, there isn't a *By Date* view, but you can view photos grouped by capture date using grid segmentation. On iOS, tap the ... menu icon, select *Segmentation*, and then select *None, By year, By month, By day, By hour, File Type, Flag,* or *Star Rating*. On Android, tap the ... menu and toggle *Grid Segmentation*, then go to *Segment by...* to select the time period. Tap the arrow on the right to collapse or expand individual segments.

People view uses Artificial Intelligence to group photos based on facial recognition (page 109).

Connections (desktop/web only) allows you to connect your Lightroom library to external web services such as Adobe Portfolio, Blurb, and SmugMug (page 395).

Deleted shows all of the photos that you've deleted in the last 60 days and allows you

to restore or permanently delete them (page 91).

IN THIS CHAPTER, WE'LL CONSIDER:

- How to group photos into albums.

- How to group similar photos into stacks.

- How to delete photos (carefully!)

On mobile (top) the Grid view can be segmented by date. On the desktop (bottom), use the By Date album to browse photos by capture date.

GROUPING PHOTOS INTO LIGHTROOM ALBUMS

Albums are found in the Albums panel on iPhone/Android or in the left panel on the iPad/desktop. They allow you to group photos for a specific purpose, for example:

- Your best photos as a portfolio.

- Photos to share with someone, perhaps as an online gallery.

- Photos of an event, such as a vacation.

- Photos of specific genres.

- Photos you've published on social media.

- Photos for output as a slideshow, prints, or a photobook.

The same photo can appear in lots of different albums. Even if a photo is not in an album, it's still available in the *All Photos* and *By Date* views.

Folders are a way of grouping related albums, for example, family vacations. We'll come back to folders in more detail later in the lesson.

To **open the Albums panel** on iPhone/Android, tap the pop-up at the top of the Lightroom Grid view. On an iPad, the Albums panel is on the left, and you can show/hide it by tapping the button at the top. On the desktop, albums are in the Photos panel on the left.

CREATING ALBUMS

To **create an album** on mobile, tap the *Create New* button at the bottom of the Albums panel, then select *Album*. If you have a folder selected, the new album is automatically added to the selected folder.

On the desktop, click the + button at the top of the panel, select *Create Album*, then give the album a name. If a folder is selected, you can place the album inside by checking the *Inside folder* checkbox (desktop only). While creating an album on the desktop, you can also choose to include any currently selected photos.

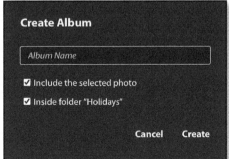

To **add photos to an existing album** on mobile, hold your finger on a photo in Grid view to activate selection mode (or go to *... menu > Select*). Tap the photos to select them, or hold a finger on a photo and swipe across other photos to select multiple

LIGHTROOM ALBUMS PANEL (IOS)

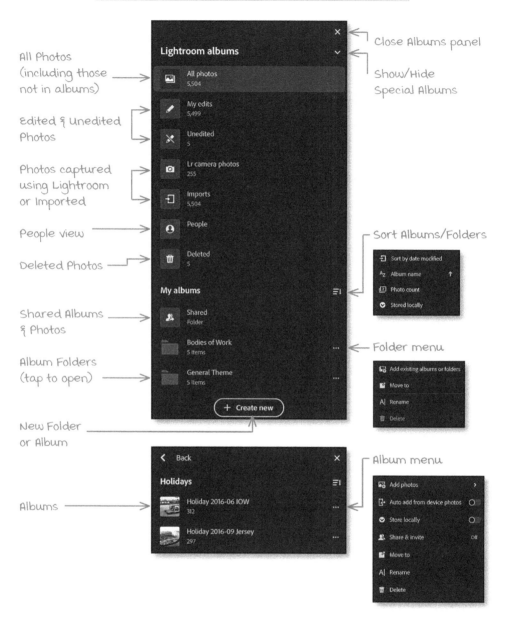

All Photos
(including those
not in albums)

Edited & Unedited
Photos

Photos captured
using Lightroom
or Imported

People view

Deleted Photos

Shared Albums
& Photos

Album Folders
(tap to open)

New Folder
or Album

Albums

Close Albums panel

Show/Hide
Special Albums

Sort Albums/Folders

Folder menu

Album menu

On an iPad, this Albums panel
and Grid view can be active at
the same time. Tap the button to
show/hide the Albums panel.

LIGHTROOM ALBUMS PANEL (ANDROID)

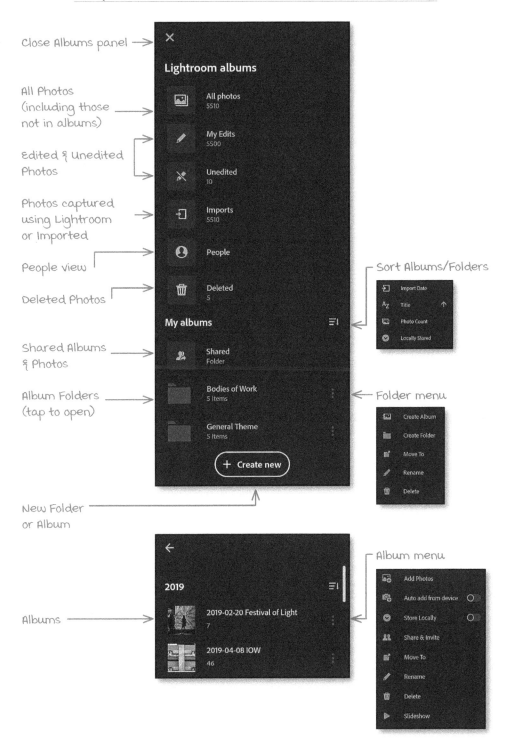

Close Albums panel →

All Photos (including those not in albums) →

Edited & Unedited Photos

Photos captured using Lightroom or Imported →

People view

Deleted Photos

Shared Albums & Photos →

Album Folders (tap to open) →

New Folder or Album

Albums →

Lightroom albums

All photos
5510

My Edits
5500

Unedited
10

Imports
5510

People

Deleted
5

My albums

Shared
Folder

Bodies of Work
5 Items

General Theme
5 Items

+ Create new

Sort Albums/Folders

Import Date
Title
Photo Count
Locally Stored

Folder menu

Create Album
Create Folder
Move To
Rename
Delete

Album menu

Add Photos
Auto add from device
Store Locally
Share & Invite
Move To
Rename
Delete
Slideshow

2019

2019-02-20 Festival of Light
7

2019-04-08 IOW
46

photos. On iOS, tap the *Add To* button; on Android, tap the ... menu and select *Add To*. Finally, select the target album and tap *Add*. On the desktop, select the photos in Grid view (or in the Filmstrip) and drag them to the album in the Albums panel.

If you're viewing an album on iOS/Android, there's an additional *Move To* option that removes the photos from the current album while adding them to a different album, which can be handy if you have an album of photos you need to sort into topic-based albums.

On the desktop, you can also **find photos that aren't organized into an album** yet by going to the Search field (page 116), typing *album:* and waiting... When the pop-up appears, scroll right to the end and select *Not in any album*.

ALBUMS PANEL (DESKTOP)

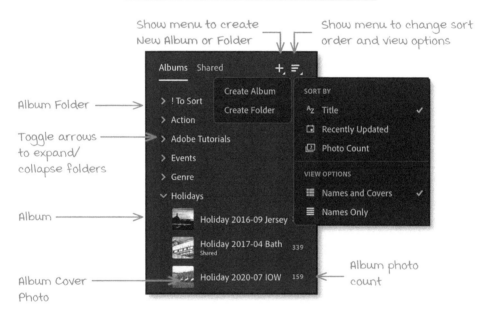

Show menu to create New Album or Folder

Show menu to change sort order and view options

Album Folder

Toggle arrows to expand/ collapse folders

Album

Album Cover Photo

Album photo count

Right-click on folder or album to rename/delete

Right-click on Album to share using Lightroom Web

Drop the album/folder on a folder to nest them

Drag an album/folder to the left to show the blue bar to un-nest them

SETTING A TARGET ALBUM ON THE DESKTOP

If you're scrolling through your photos, looking for ones to add to a specific album, dragging them over to the Albums panel can be slow. On the desktop, there's a customizable shortcut that can help, called the Target Album. To **set an album as the Target Album**, right-click on the album and select *Set [album name] as the Target Album*. To **add the selected photos to the Target Album**, simply press the T key. You can change the target album to a different album by repeating the process.

MANAGING ALBUMS

Your photo groupings are likely to change over time, so you'll need to know how to remove photos and manage the albums.

If you're viewing a photo on the desktop, check the Info panel to see **which albums contain that photo**. Click on an album name to view the rest of the album.

To **remove photos from an album** on mobile, hold your finger on a photo in Grid view to activate selection mode, select the photos, tap the trashcan icon, and select *Remove from Album*. On the desktop, select the photos in the Grid view, then right-click and choose *Remove Photos* or press the Backspace key (Windows) / Delete key (Mac).

Remove from Album just removes the photos from the selected album, but the photos remain available in the *All Photos* and *Date* views, as well as in any other albums that contained the photos. *Delete*, on the other hand, actually deletes the photos everywhere (page 91), so be careful to select the right option!

These *Remove from Album* options are also available in Detail view but only apply to single photos.

To **delete an album**, tap the album's ... menu (mobile) / right-click on the album (desktop) and select *Delete*. This deletes the album but not the photos inside the album.

To **rename an album**, tap the album's ... menu (mobile) / right-click on the album (desktop), select *Rename*, then type the new name.

If the album name is too long to display in the Albums panel on the desktop, drag the edge of the panel to make the panel wider or float the mouse cursor over the album name to show the full name in a tooltip.

To **change the cover photo** on iOS, select the photo in Detail view, tap the ... menu, and select *Organize menu > Set as Album Cover*. On Android, hold your finger on the photo in Grid view to select it, then tap the ... menu and choose *Set as Cover*. On the desktop, click on the album, then right-click on a photo in Grid view and choose *Set as Album Cover*, or drag it to the album cover thumbnail at the top of the grid.

The cover photos always show on mobile, but to **show/hide the cover photos** on the desktop (to minimize the vertical height required), click the sort order button at the top of the Albums panel and change it to

Names only.

Album Names vs. Names & Cover Photos

To **change the Albums panel sort order** on mobile, tap the sort order button at the top of the Albums panel.

Sort Order (mobile)

Sort Order (Desktop)

GROUPING ALBUMS IN FOLDERS

As your list of albums grows, it can be hard to find specific albums. Like folders on your computer's hard drive, you can group the related albums into folders. For example, you may want to group your vacation albums in a folder and perhaps create another folder for albums related to your photography projects.

To **create a folder** on mobile, tap the *Create New* button at the bottom of the Albums panel, then select *Folder*. On the desktop, click the + button at the top of the panel, select *Create Folder*, then give the folder a name.

To **move an album into a folder** or nest folders inside other folders (up to 5 deep) on mobile, tap on the album/folder's ... menu, then select *Move to Folder*. Select the folder to place it inside, then tap *Move*. (You can also create a new folder by clicking the + button.) On the desktop, select it and drag it onto the folder, which turns blue, and release the mouse.

To **move an album/subfolder out of folders** and back up to the top of the list on mobile,

tap the album/folder's ... menu, then select *Move to Folder*. This time, don't select a folder before tapping *Move*. On the desktop, drag the album/subfolder to the left until a blue bar appears, and then release the mouse.

To **open/close a folder** to see the albums inside, tap the folder (mobile) / toggle the arrow to the left of its name (desktop).

If you can't remember where you stored an album, rather than opening all of the folders, simply select the *All Photos* view and start to type the album name in the search field (desktop only).

To **view all the photos** in all the albums inside a folder, click on the folder name (desktop only).

To **delete a folder**, right-click on the folder (desktop) / tap the folder's ... menu (mobile) and select *Delete*. The folder and any albums inside it are deleted, but the photos are not.

GROUPING PHOTOS USING STACKS ON THE DESKTOP

Sometimes, you might shoot a series of similar photos, for example:

- A high-speed burst to capture action.

- A series of photos to merge into a panorama.

- Bracketed exposures for HDR.

- Raw+JPEG pairs of photos because you like the in-camera picture style.

- An original photo plus the TIFF you edited in Photoshop.

You may not want to delete the similar photos, but these groups of photos can clutter the grid view, making it hard to see the wood for the trees.

Stacking allows you to group similar photos and display them as a single photo in the Grid view. It's currently only available on the Windows/Mac apps.

MANAGING STACKS

To **stack photos**, select the photos in the Grid, right-click, and select *Group into Stack*.

To **view the photos in a stack**, click on the stack icon. The thumbnails appear in a special Filmstrip at the bottom of the preview area.

To **view the hidden photos in Detail view**, open the stack by clicking the stack icon, then switch to Detail view. The Filmstrip at the bottom of the preview area displays the stacked photos until you collapse the stack.

To **collapse the stack**, click the X button in the Filmstrip or click the stack icon in the Grid again.

To **ungroup the stack** of photos, changing them back into separate photos, right-click on the collapsed stack, and select *Ungroup*.

To **remove one or more photos** from a stack without ungrouping the whole stack, select the photos you want to remove, right-click and select *Remove Photo(s) from Stack*, or select the photos and press the Backspace key (Windows) / Delete key (Mac).

STACKS (DESKTOP)

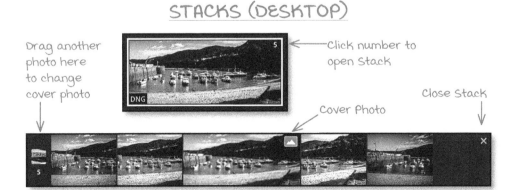

Drag another photo here to change cover photo

Click number to open Stack

Cover Photo

Close Stack

To **change the stack cover photo**, which is the one that shows in the main Grid view, right-click on your chosen photo and select *Set as Stack Cover* or drag the thumbnail onto the small square to the left of the stack.

STACKS ARE ALBUM-SPECIFIC

Stacks are album-specific, so stacking photos in one album doesn't stack them in another.

If you create a stack in *All Photos* and then add the stack to an album, it's stacked in the new album, too; however, the photos aren't automatically stacked in other existing albums.

If you create a stack in an album, it's displayed as a stack in *All Photos* but not in other albums.

EDITING STACKS

In some situations, your actions affect all of the photos in a stack, whereas others only affect the cover photo.

The principle is that organizing tasks (such as adding or removing a stack from an album) applies to the whole stack. In contrast, editing tasks (metadata edits or slider adjustments) apply only to the cover photo.

To apply metadata to all photos inside a stack, you must expand the stack, select the photos, and then apply your keyword or other metadata edits.

DELETING & RESTORING PHOTOS

Whether your finger slipped, the camera settings were incorrect, or you just missed the moment, some photos aren't worth keeping.

While you could mark bad photos as rejects and hide them, completely deleting the really bad photos frees up space on your device/hard drive and in the cloud.

REMOVE VS. DELETE

In earlier lessons, we discussed how to remove photos from an album (page 87) and how to remove photos from a stack (page 89).

It's worth noting the difference in terminology between removing photos and completely deleting them.

Remove just removes the photos from the selected album or stack, but the photo remains available in the *All Photos* and date views.

Delete deletes the photos from your computers and mobile devices. They're temporarily placed in the cloud trash if they were already synced to the cloud.

DELETED PHOTOS (MOBILE)

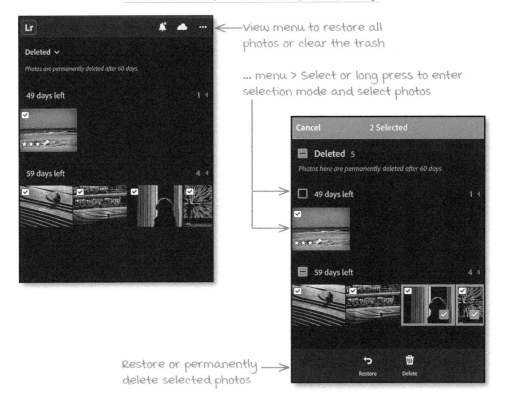

←— View menu to restore all photos or clear the trash

... menu > Select or long press to enter selection mode and select photos

Restore or permanently delete selected photos

DELETING PHOTOS

To **delete photos from All Photos** on mobile, hold your finger on a photo to activate multi-select mode (or go to ... *menu > Select*). Tap the photos to select them, or hold a finger down on a photo and then swipe across other photos to select multiple photos, then tap the trashcan icon and select *Delete*.

If you're viewing a single photo in a Detail view, tap the ... *menu* and select *Organize > Delete*. On Android, if you're viewing an album, it's ... *menu > Organize > Remove from Album* and then *Delete*.

On the desktop, select them, right-click and choose **Delete Photos**, go to *Edit menu > Delete Photos* or use the shortcut Alt-Backspace (Windows) / Opt-Delete (Mac), then confirm your choice.

The confirmation dialog confirms the number of photos you're deleting. Always double-check this number!

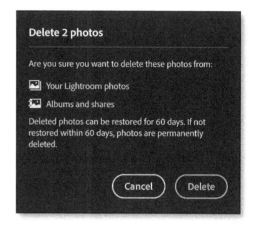

DELETE 2 photos dialog:
Delete 2 photos

Are you sure you want to delete these photos from:

- Your Lightroom photos
- Albums and shares

Deleted photos can be restored for 60 days. If not restored within 60 days, photos are permanently deleted.

Cancel Delete

DELETED PHOTOS (DESKTOP)

View Deleted Photos

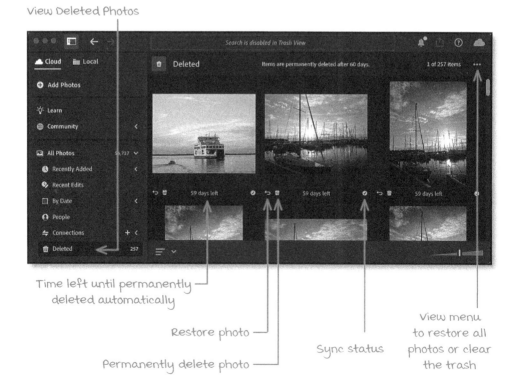

Time left until permanently deleted automatically

Restore photo

Permanently delete photo

Sync status

View menu to restore all photos or clear the trash

SAFELY DELETING PHOTOS

When you're sorting through photos, don't try to delete one photo at a time. It's inefficient because you must keep confirming your decision, and making a mistake is easy. Instead, mark them with a reject flag (page 99), then use Refine View to show only the rejected photos (page 119), select them all, double-check you definitely want to delete them, then go ahead and delete.

RESTORING ACCIDENTAL DELETIONS

Deleted photos remain in the cloud trash for 60 days unless you restore them or empty the trash. They don't count towards your cloud storage quota.

There are currently a couple of limitations to be aware of:

• If the photos were only low-resolution smart previews synced from Lightroom Classic, then only smart previews can be restored.

• It may take some time to restore photos to your desktop or mobile app if they need to be downloaded from the cloud again. If you're offline, the photos may not be fully restored until you're next online.

• Album membership and almost all metadata and edits are restored with the photo. The exception is stack membership (page 89).

If you accidentally delete some photos, select the **Deleted Photos** view on the desktop, mobile, or web app. You'll find it just below *All Photos*.

To **restore a single photo** on mobile, long press on one or more photos to enter selection mode and tap **Restore**. On the desktop/web, click the undo icon below the thumbnail.

To **permanently delete a single photo** on the desktop/web, click the trash icon.

To **restore or permanently delete multiple photos** on mobile, long press on a photo to enter selection mode, tap to select multiple photos, then tap the *Restore* or *Delete* icons. On the desktop/web, click the checkmark to select them, then select the restore or delete icons from the blue bar at the top. Having checked the first photo, you can hold down the Shift key and click on the last photo in a series to select multiple consecutive photos, like selections on the desktop.

To **manually empty the trash** or restore all deleted photos, tap/click the ... icon and select **Permanently Delete All** or **Restore All** from the menu.

Permanently delete all

All 225 photos will be permanently deleted and cannot be restored. Are you sure you want to continue?

Cancel Delete

ADDING METADATA & SEARCHING

7

Metadata is often defined as 'data describing data.' As far as photos are concerned, there are two main types of metadata:

EXIF data is technical information the camera adds at the time of capture. It includes camera and lens information, such as the make and model, and image information, such as the capture date/time, shutter speed, aperture, ISO, and pixel dimensions.

IPTC data is added by the photographer to describe the photo, for example, title, caption, keywords, and the photographer's name and copyright.

Lightroom also stores all of your edits as metadata, which means that it records your changes as a set of text instructions (e.g., *Exposure +0.33*, *Highlights −30*, *Shadows +25*, etc.) instead of applying them directly to the image data. This means you can edit the photo again later without degrading the image quality.

Metadata can help you find photos again later, and examining the camera settings can also help you learn to become a better photographer. For example, if you find blur caused by movement in a photo, your shutter speed was too slow. Or, if the photo is too noisy (grainy), check the ISO value.

VIEWING METADATA & KEYWORDS

To **open the Info and Rating panel on iPhone/Android**, go to the Detail view's ... *menu > Info and Rating*. The star rating and flags button show at the top of the panel, and then it's split into three tabs:

Info displays the EXIF metadata.

Metadata allows you to add IPTC metadata, specifically the title, caption, copyright, and keywords.

Activity displays comments and likes for shared web galleries... we'll come back to that later in the book (page 385).

You can adjust the panel's height using the handle at the top and return to the main Detail view using the back arrow.

To **open the Info and Keywords panels on iPad/desktop**, tap/click the buttons in the Toolstrip to open the Info or Keyword panels, or press the I key for Info or the K key for Keywords (desktop only).

To view the star ratings and flags on iPad, tap the star button in the Toolstrip. On the desktop, they always show under the Detail view photo.

Keywords panel

Info panel

IMAGE ANALYSIS

In addition to the metadata you add manually, Adobe's computers scan your images, looking for recognizable content. Like any artificial intelligence, it's not perfect, but it allows you to search for photos even if you haven't manually added metadata to describe the content.

IN THIS CHAPTER, WE'LL CONSIDER:

• How to flag and star rate photos.

• How to view metadata added by the camera.

• How to add titles, captions, and copyright.

• How to view and add location metadata.

• How to add keywords.

• How to use Lightroom's image analysis to search for specific subjects without manually adding metadata to the photos.

• How to refine the current view based on your flags or star ratings, keywords, camera models, locations, and more.

INFO & RATING PANEL (MOBILE)

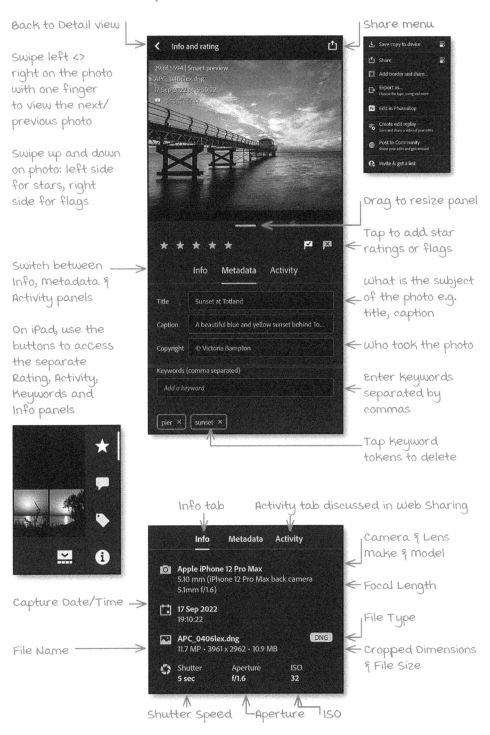

Back to Detail view

Swipe left <> right on the photo with one finger to view the next/ previous photo

Swipe up and down on photo: left side for stars, right side for flags

Switch between Info, metadata & Activity panels

On iPad, use the buttons to access the separate Rating, Activity, Keywords and Info panels

Share menu

Drag to resize panel

Tap to add star ratings or flags

What is the subject of the photo e.g. title, caption

Who took the photo

Enter keywords separated by commas

Tap keyword tokens to delete

Info tab Activity tab discussed in Web Sharing

Camera & Lens make & model

Focal Length

File Type

Cropped Dimensions & File Size

Capture Date/Time

File Name

Shutter Speed Aperture ISO

INFO PANEL (DESKTOP)

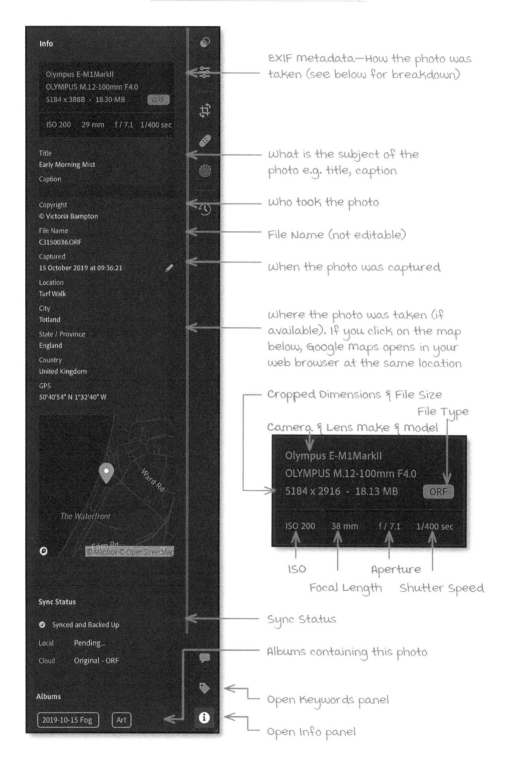

EXIF metadata—How the photo was taken (see below for breakdown)

What is the subject of the photo e.g. title, caption

Who took the photo

File Name (not editable)

When the photo was captured

Where the photo was taken (if available). If you click on the map below, Google maps opens in your web browser at the same location

Cropped Dimensions & File Size

File Type

Camera & Lens make & model

Olympus E-M1MarkII
OLYMPUS M.12-100mm F4.0
5184 x 2916 · 18.13 MB ORF

ISO 200 38 mm f / 7.1 1/400 sec

ISO

Aperture

Focal Length Shutter Speed

Sync Status

Albums containing this photo

Open Keywords panel

Open Info panel

FLAGGING OR STAR RATING PHOTOS

Marking the best photos with flags or star ratings makes them easy to find again later.

WHICH PHOTOS ARE WORTH KEEPING?

How you decide which photos are deserving of a specific ranking is a personal decision, but there are a few questions that may help:

- Does the photo immediately grab you?

- Does the photo trigger a strong emotion or a memory?

- Does the photo tell a story or capture a special moment?

- Do you have a similar photo that's better?

- Is the subject (person/animal) making eye contact? Does it capture their personality?

- Are there significant technical issues? For example, is it in focus?

Move fast, and don't agonize over decisions. Your gut instinct is often right.

FLAGS VS. STARS

Lightroom offers two different ways of ranking your photos:

Flags have three states—flagged (picked), unflagged, and rejected. Most people use flags to mean:

- Flagged—photos worth keeping.

- Unflagged—not sorted yet.

- Rejected—to be deleted.

Star Ratings are used by photographers worldwide. Most use five stars for their best portfolio images and 0 stars for unsorted photos.

APPLYING FLAGS OR STARS ON MOBILE

To **show the star and flag buttons** on iPhone/Android, open the photo into the Detail view, then go to ... *menu > Info and Rating*. On an iPad, tap the star icon in the Toolstrip. You can then:

- Tap the star and flag buttons.

- Swipe up/down on the left of the screen for stars or on the right for flags.

- If you have an external keyboard connected, you can use the keyboard shortcuts: P to flag, U to unflag, X to reject, and 0-5 for 0-5 stars.

APPLYING FLAGS OR STARS ON THE DESKTOP

The star and flag buttons are always displayed under the photo in Square Grid or Detail view. You can:

- Click the icons in the toolbar beneath the photo in Grid or Detail view.

- Click the icons on the thumbnail border in the Square Grid view. The icons appear as you float the mouse cursor over the border.

• Use the keyboard shortcuts: Z to flag, U to unflag, X to reject. 0-5 for 0-5 stars. Add the Shift key to these shortcuts to automatically move to the next photo.

AI-BASED BEST PHOTO SELECTION ON MOBILE/WEB

Best Photos is an Adobe Sensei-based artificial intelligence that analyzes your photos and tries to figure out which it thinks are your best photos. At the time of writing, it can be accessed from the iOS, Android, and Web apps.

To **see Lightroom's recommendations**, select an album with 10-2000 photos. Go to the Grid view and select ... *menu > Choose Best Photos*. Lightroom analyzes the photos and then displays a grid of thumbnails. At the bottom is a slider to increase or decrease the quality threshold.

If you **agree with Lightroom's selection** of the best photos, tap the ... menu and select *Create Album* to create an album of these best photos, *Flag as Picked* to flag them, or simply export them. Alternatively, you can remove the other photos using *Flag as Rejected* or *Remove from Album*.

If you only agree with some of the selections, you can open individual photos in the Detail view to flag/reject them.

RATING WORKFLOW

Everyone has a different system. Some

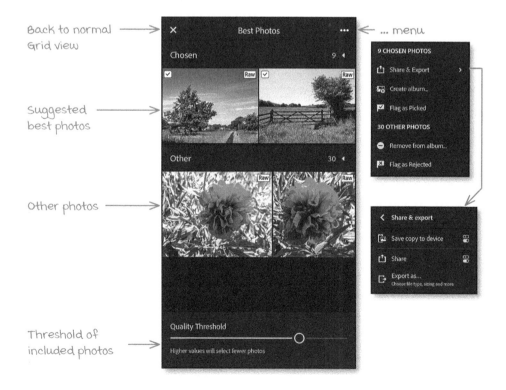

BEST PHOTOS (MOBILE)

Back to normal Grid view

Suggested best photos

Other photos

Threshold of included photos

... menu

photographers use Grid view, and others prefer Detail view. Some like to rate their photos in a single pass, and others like multiple passes. Some like flags, and some prefer stars. Whatever you pick, just be consistent.

Flexibility is beautiful, but so much choice can be confusing, so I've included my tried and tested desktop rating workflow to help you get started.

MY RATINGS MEAN...

	meaning	What's Next...
🏴	Really bad photo worthy of deletion	Nothing (deleted).
✗	Should be deleted really, but I'm a packrat	Nothing (ignored) or moved to offline storage.
✗ ✗	Triggers a memory, but not great as a photo. The hotel room, a meal out with friends, etc.	A fast edit and a few keywords. They might end up in a photo book or slide show, but they'll never be great photos in their own right.
✗ ✗ ✗	A decent photo I'd be willing to show someone	
✗ ✗ ✗ ✗	Good photo, might end up on the wall or social media	A careful edit, possibly some Photoshop work, titles/ captions and more extensive keywords. These are the photos that will end up on the wall or on social media.
✗ ✗ ✗ ✗ ✗	Best photos I've ever taken. Rare!	

MY RATING WORKFLOW

FIRST PASS - INITIAL IMPRESSIONS

Swipe through the photos quickly, assigning a flag to photos that stand out. It's easier to make decisions when you're not bogged down in the details.

 "Yeah, I like that!"

 "Boring..."

Assign flags to photos you like for any reason, and reject ones that should definitely be deleted.

 "Ooops!"

If something doesn't stand out, leave it unflagged.

On mobile, use Detail view. On the desktop, large Grid thumbnails are even better for this stage. Try not to get distracted editing them yet!

SECOND PASS - GRADE THE KEEPERS (OPTIONAL)

Set the Refine filter to show only the flagged photos and switch back to Detail view.

 "I LOVE that!"

Give them 2, 3 or 4 stars, depending on how much you love the photo. In groups of similar photos, you might unflag some at this stage too.

 "Pretty good photo"

These are the photos it'll be worth spending time working on.

 "It sparks a memory"

FINAL PASS

With the photos still filtered to only show the flagged ones, do the photos tell the story? Is anything missing? If so, change the Refine filter to show only the unflagged photos and see if there are any you want to upgrade.

It's often worth doing this final pass another day, or maybe even a few weeks later. It's easier to make an objective decision when time has passed.

TIDY UP - DELETE THE DUDS

Switch to Grid view and set the Refine filter to show just the rejects. Look through the grid to confirm they should all go, then select all and delete. Some people also delete their unflagged photos or move them to offline storage.

ADDING TITLES, CAPTIONS & COPYRIGHT

Some photographers like to add descriptive text to the photos to remind them of the story behind the photo.

The **Title** and **Caption** fields do have official IPTC definitions (https://www.iptc.org/), but many photographers simply use *Title* for a short image title (e.g., "Blue Eyes") and *Caption* for a more descriptive paragraph (e.g., "Kanika, the Amur Leopard cub, has piercing blue eyes").

To **open the Info panel** on iPhone/Android, go to the Detail view's ... *menu > Info and Rating* and select the **Metadata** tab. You can adjust the panel's height using the handle at the top. On an iPad or desktop, tap/click the i button in the Toolstrip or press the I key.

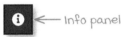

ENTERING A TITLE & CAPTION

To **add metadata to a single photo**, simply tap/click in the field and type!

On Android devices and desktop computers, you can **add the same metadata to multiple photos** simultaneously. (It's not currently possible on iOS.) From the Android Grid

view, hold your finger on a photo to enter selection mode, tap to select the photos you want to edit, and then go to ... *menu > Edit Info*. Enter the metadata and tap the checkmark to confirm. On the desktop, select the photos in Grid view, and then type the metadata in the Info panel.

Some cameras automatically add text into a metadata field; for example, Olympus cameras add *OLYMPUS DIGITAL CAMERA* as the caption. To **delete the metadata from multiple photos** on Android, select the photos in the Grid view, go to ... *menu > Edit Info*, tap the X at the end of the field to clear the existing metadata, and then tap the checkmark to confirm. On the desktop, select them in Grid view, click in the text field, and delete the text.

ADDING YOUR COPYRIGHT

It's important to add your copyright to your photos. While it doesn't prevent theft, it does make it easy to identify you as the photographer, especially if you post the photos online.

In many countries, the **Copyright** notice requires the copyright symbol ©, the year of first publication, and then the name of the copyright owner, for example, © *2023 Victoria Bampton*. Copyright laws vary by

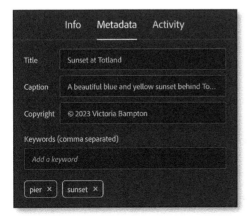

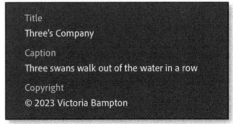

Info panel > metadata: mobile (left), Desktop (right)

country, so please check your local laws for exact specifications.

You can have your copyright automatically applied to photos as you add them to Lightroom so you don't forget. On iOS, go to *App Settings* > *General* > **Add Copyright**, or on Android, go to *App Settings* > *Preferences* > *Photo Import Options* > *Add Copyright*. On the desktop, check *Preferences* > *General* > *Add copyright to imported images*. It's smart enough to only add copyright to new photos that don't have an existing copyright entry.

But how do you type that © symbol? On iOS, you can type (c) followed by a space, and it's automatically converted. On Android, the copyright symbol may be found with the emojis or symbols on some third-party keyboards, or you can simply do a web search for *copyright symbol* and copy/paste from a web page. On the desktop, it's automatically entered for you, but if you accidentally delete it, type Ctrl-Alt-C (Windows) / Opt-G (Mac).

FIXING THE CAPTURE DATE & TIME ON THE DESKTOP

We've all done it... you go on vacation abroad, or Daylight Savings Time starts, and you forget to change the time stamp on the camera. It's not a problem, though, as Lightroom on the desktop makes it easy to correct the time stamp. (This isn't currently available on mobile.)

STEP-BY-STEP

1. Select the photos in the Photo Grid or Square Grid.

2. Go to *Photo menu > Edit Date & Time* or click the pencil icon next to the date field in the Info panel.

3. In the Shift Date Range dialog, enter the correct date and time for the most recent photo in the selection. Other selected photos automatically shift by the same increment rather than all being set to the same time.

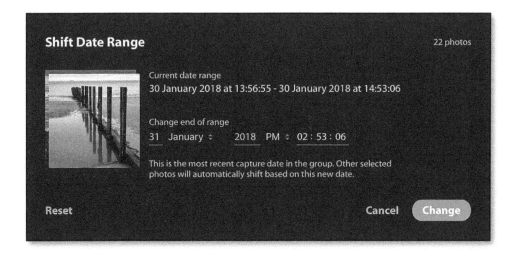

EDITING THE PHOTO LOCATION ON THE DESKTOP

Location information on a photo can be useful for:

• Searching for photos by location, for example, vacation destinations.

• Knowing exactly where a photo was taken so you can replicate it, perhaps at a different time of day or a different season.

AUTOMATIC GPS DATA

If your phone or camera embeds GPS metadata into the photos, the **City**, **State/Province**, and **Country** fields in the Info panel on the desktop are automatically populated, and the map appears below. This reverse geocoding is done on the server and then synced to your computer, so there may be a delay before the fields are populated.

MANUALLY ADDING A LOCATION

If your camera doesn't record the location, you can enter an approximate location manually. If you type the zip code / postal code into the **Location** field and the country into the **Country** field, Lightroom automatically looks up the rest of the address and displays the map.

Better still, if you have a mobile phone photo shot at the same location, you can copy the content of the **GPS** field and paste it onto photos that are missing location data. Alternatively, find the location in Google Maps, select the GPS coordinates from the right-click menu, and paste them into Lightroom's *GPS* field.

MAP STYLES

If you right-click on the map, you can choose between the *Dark* and *Light* styles and the *Road Map*, *Hybrid*, *Satellite*, or *Terrain* map views. The *Satellite* option is shown in the screenshot.

VIEWING IN GOOGLE MAPS

The small map is helpful to see the approximate location, but sometimes you need more detail. If you click on the map, Lightroom opens your default web browser to the same location in Google Maps.

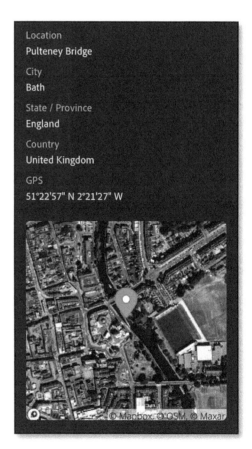

ADDING KEYWORDS

Keyword tags are text metadata used to describe the content of a photo.

Lightroom's image analysis technology can already identify many subjects, reducing the need for keywords. However, it's likely to be some time before software can correctly name your friends and family without your input or tell the difference between a lesser spotted and a great spotted woodpecker, so some keywords are still important.

Focus your efforts on your best photos, as they're the ones you're likely to want to find again in the future.

TYPES OF KEYWORDS

You may wonder where to start if you've never keyworded photos. There are no hard and fast rules for keywording unless you're shooting for Stock Photography.

Assuming you're shooting primarily for yourself, the main rule is simple—use keywords that will help you find the photos again later! For example, they can include:

Who is in the photo (people). (Lightroom can help with this task. We'll come back to identifying people from page 109.)

What is in the photo (other subjects or objects).

Where the photo was taken (names of locations).

Why the photo was taken (what's happening).

When the photo was taken (sunrise/sunset, season, event).

How the photo was taken (HDR, tilt-shift, panoramic).

CONSISTENCY

For keywords to be beneficial, you need to be consistent, for example:

Capitalization—stick to lowercase for everything except names of people and places.

Quantity—either use singular or plural, but avoid mixing them. Either have "bird, cat, dog" or "birds, cats, dogs."

Verbs—stick to a single form, for example, "running, playing, jumping" rather than "run, play, jumping."

APPLYING KEYWORDS

To **open the Info panel on iPhone/Android**, go to the Detail view's ... *menu > Info and Rating* and select the **Metadata** tab. You can adjust the panel's height using the handle at the top.

To **open the Keywords panel on an iPad/desktop**, tap/click the button in the Toolstrip or press the K key (desktop only).

 ← Keywords panel

To **add a keyword**, type directly in the text field. You can add multiple keywords by separating them using commas. On mobile, voice recognition can speed up keyword entry. Simply tap in the text field, then select the microphone on your keyboard to dictate the keywords.

To **delete a keyword** from a photo on

mobile, tap on the keyword tag. On the desktop, hover over it in the tag cloud so it turns red, then click.

On the desktop, you can add or delete keywords from **multiple photos** simultaneously. It's just like adding or deleting a keyword on a single photo, except you must be viewing a Grid view with the photos selected. When you're in Detail view, your actions only affect the single visible photo.

On mobile, you can't update keywords on multiple photos at once. However, on the iPad, you can copy keywords from one photo to another, which is useful when adding a whole series of keywords. To do so, tap the ... menu, then select *Copy Keywords*. Move to the next photo, return to the ... Menu, and select *Paste Keywords*.

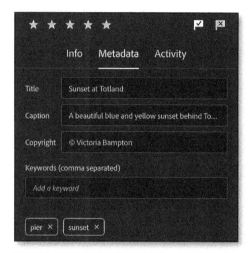

Keywords are in the Info and Rating panel > metadata tab on iPhone/Android (top) or in the Keyword panel on iPad (bottom)

KEYWORDS (DESKTOP)

To add a keyword, type it here

These keywords are applied to all of the selected photos

To delete a keyword from all of the selected photos, click on it when it turns red

These keywords are applied to some of the selected photos

To apply a keyword to all of the selected photos, click on it when it turns blue

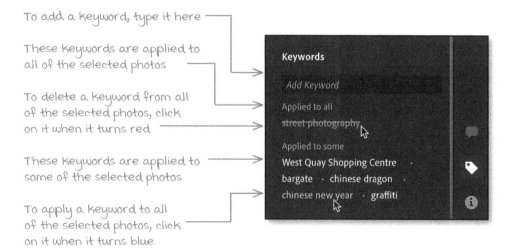

IDENTIFYING PEOPLE

Lightroom's image analysis technology can identify many subjects automatically, but it needs a helping hand with the names of your friends and family.

Once the photos are uploaded to the cloud, they're automatically searched for faces. The faces are then grouped into clusters of photos that are likely the same person. It's not perfect, but it does a pretty good job, even recognizing people as they age.

To **open the People view**, tap/click on *People* underneath *All Photos* in the Albums panel on iPhone/Android or in the left panel on iPad/desktop. Here, you can add names, merge photos of the same people captured at different angles, and hide people you don't want to see.

ADDING NAMES

To **name a person**, tap/click on their thumbnail (cover photo) to enter the Person view, and tap/click at the top to enter the

person's name. Tap/click the back arrow to return to the People view and repeat for the next person.

Before you start, consider how you'll handle nicknames or last names for married women. Many people use the married name followed by the maiden name, for example, *Mary Married née Maiden*. Some also like to add the date of birth for children, for example, *Katie Smith 2018-10-15*.

If you have as much trouble remembering names as I do, you might want to name them with clues that might prompt your memory later, such as *Katie ? née Smith, married to Michael Jones* or *Emma Brown's oldest son*. You can fix their name later when you remember, or someone else can tell you the answer!

If you want to **change a person's name**, perhaps to fix a spelling mistake or add extra information, tap/click on the name in Person view and type the correct name. On the desktop, you can also right-click on the person in People view and select *Rename Photo*, which saves a little time loading all of

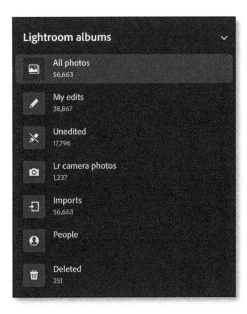

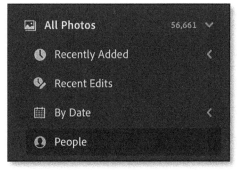

Select People view in the Albums panel on mobile (left) / Photos panel on desktop (right)

PEOPLE VIEW (MOBILE)

Show Albums panel

People menu incl.
Show/Hide and
Merge People

Tap on a person
to open into
Person view
(below)

PEOPLE VIEW (DESKTOP)

Click cover photo
to open into Person
view (below)

Number of
photos of
this person

Change sort order

Open People view

menu

Select multiple people
(to hide/merge) by
holding down Ctrl
(Windows) / Cmd
(Mac)

Hide a person using
right-click > Hide Person
or enter Show/Hide
People view from ...
menu

Merge people by dragging a
person onto another person
or enter Merge People view
from ... menu

PERSON VIEW (MOBILE)

Back to People view

Person menu

Tap on name to rename person

Tap on photo to open into Detail view

Swipe up/down with one finger to scroll

To remove a photo from a person, long press on a photo to open multi-select mode then select Remove

PERSON VIEW (DESKTOP)

Back to People view

Type person's name

Merge with existing person by selecting from autocomplete pop-up

Selected photos

Number of photos of this person

Menu

Switch between Grid and Detail views

Remove selected photo from this person

Set selected photo as thumbnail cover photo

the photo thumbnails.

MERGING PEOPLE

If Lightroom's not sure that photos are of the same person, perhaps because they're at a different angle, it errs on the side of caution and leaves them as separate clusters.

To **merge duplicate people**, tap/click the ... icon and select **Merge People**. Check the clusters you want to merge into a single person and tap the checkmark on mobile or click *Merge* on the desktop.

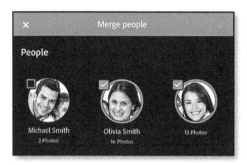

Lightroom asks for confirmation that these are the same person and allows you to correct the name.

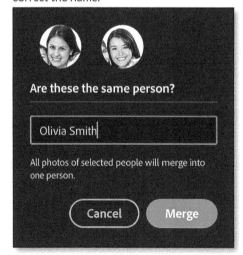

On the desktop, there are additional shortcuts. In People view, drag one cluster onto another cluster to merge them, or hold down Ctrl (Windows) / Cmd (Mac) to select multiple people and then click *Merge* at the top of the screen. In the Person view, if you start to type the name of an existing person, Lightroom displays a pop-up, giving you the option to select that person and merge in one go.

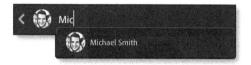

When you tap/click on a person to enter Person view, Lightroom displays other clusters of photos it suspects may be the same person and asks *Is this also the same person?* If you know the answer, click *Yes, Merge*, or *No*, but if you're not sure, click the X in the corner.

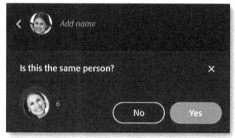

SPLITTING PEOPLE

Occasionally, Lightroom makes a mistake and includes a photo of a different person.

To **tell Lightroom that this is a different person** on mobile, hold your finger on the photo to enter selection mode, then tap the *Remove* icon, followed by *Remove from Person*. On the desktop, right-click on the photo and select *Remove Photo from Person* or tap the Backspace key (Windows) / Delete key (Mac). The photos are then reevaluated, and Lightroom takes another guess at who they might be.

If the photo belongs to a different named person, you can move them to the correct person. This saves some double-handling. Moving to a different person is not currently available on iOS, but on Android, hold your finger on a photo to enter selection mode, then go to *... menu > Move To > the correct name*. On the desktop, right-click on the photo and select *Move to > the correct name*.

SELECTING A COVER PHOTO

Lightroom picks a default thumbnail for a person, but it's rarely the most flattering choice, so you can **select an alternative cover photo**. On iOS, tap the photo from Person view to view it in Detail view, then go to *... menu > Organize > Set as Cover Photo*. (This isn't currently possible on Android.) On the desktop, click on the person to enter Person view, select a better photo, right-click on it (or click the *...* menu), and choose *Set as Cover Photo* or drag it to the album cover thumbnail at the top of the grid.

FINDING PEOPLE

As the number of named people grows, you may want to **change the sort order**. From the People view, select the *...* menu, then select *First Name*, *Last Name*, or *Count*.

On the desktop, you can also type the person's name in the Search bar at the top of the screen to save scrolling through the People view.

HIDING PEOPLE

People view will likely include people you don't know, such as people standing in the background at a tourist location. To minimize this issue, it only shows clusters of more than five photos of the same person.

There may also be people you know, but you don't want to search for, such as friends of friends.

To **hide people**, tap/click the *...* menu in the corner of the People view and select *Show and Hide People*. Uncheck the people you want to hide and tap/click *Done*. On the desktop, you can also right-click a thumbnail in People view and select *Hide Person*.

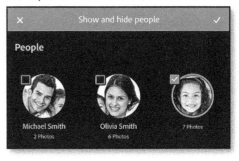

Return to the Show and Hide People view to **show hidden people** and check their thumbnails again.

EXTRA CONTEXT IN DETAIL VIEW ON THE DESKTOP

Sometimes, extra context can help to identify a person. If you switch to Detail view on the desktop and open the Keywords panel, all identified people are listed above the keywords.

Click on *Add Name* to type the person's name, or click on the X to remove the person from the photo. Clicking on the thumbnail cover photo takes you to the Person view for the selected person.

The thumbnails are a bit small, so to **see who's who** in the photo, float the cursor over a name in the Keywords panel. A rectangular overlay appears on the photo, identifying the person.

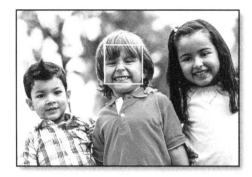

TAGGING MISSING PEOPLE

When looking in Detail view, you may find that Lightroom has missed a person, perhaps because the person is facing away from the camera, their face is partially hidden, or they're simply too small in the photo. There isn't currently a way of drawing a face region, but you can add the missing person's name as a normal keyword (page 107).

STEP-BY-STEP

Let's give this a try...

1. In the Albums panel (iPhone/Android) / left panel (iPad/desktop), select the *People* view.

2. Tap/click on the thumbnail of a person you recognize to open them into Person view.

3. At the top, tap/click on *Add Name* and type the person's name.

4. If Lightroom suspects other clusters of photos may be the same person, it displays a thumbnail and asks *Is this also the same person?* If you know the answer, tap/click *Yes, Merge,* or *No,* but if you're unsure, tap/click the X in the corner.

5. (Desktop only) Scroll down to find your favorite photo of that person, then right-click and choose *Set as Cover Photo.*

6. As you're scrolling, if you spot any photos that don't include that person, you can remove them. On mobile, hold your finger on the photo to enter selection mode, then tap the *Remove* icon, followed by *Remove*

PEOPLE IN KEYWORDS PANEL (DESKTOP)

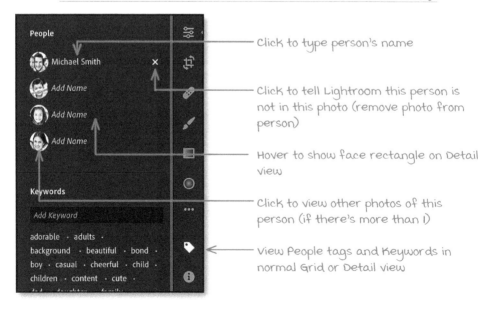

Click to type person's name

Click to tell Lightroom this person is not in this photo (remove photo from person)

Hover to show face rectangle on Detail view

Click to view other photos of this person (if there's more than 1)

View People tags and Keywords in normal Grid or Detail view

from Person. On a desktop, right-click and select *Remove Photo from Person*.

7. Tap/click the Back arrow to return to People view and repeat these steps with the next person you recognize.

8. After naming everyone you know, tap/click the ... menu in the top right corner of People view and select *Show and Hide People*. Uncheck any people you haven't named, then click *Done*.

TURNING OFF PEOPLE RECOGNITION

If you don't want Adobe to run the face recognition on your photos, perhaps for privacy reasons, you can deactivate it. The switch is found in *App Settings > People View* on mobile or under *Preferences > General tab* on the desktop.

Any faces that have already been identified remain accessible in People view, so you don't lose your work. However, Lightroom deletes its recognition data from the server and stops scanning new photos. If you change your mind, you can enable it again later, and scanning will resume after a short delay (around 90 minutes).

SEARCHING FOR PHOTOS

One of the main benefits of having all your photos in one place is that they're easy to search.

ENTERING SEARCH CRITERIA

To **access the search field** on mobile, tap the magnifying glass icon at the top of Grid view. On the desktop, the search field is found at the top of the Lightroom window, and the shortcut Ctrl-F (Windows) / Cmd-F (Mac) moves the cursor to the Search field.

To **search your photos**, simply type the search terms in the search field and press the Enter key or tap one of the suggestions in the pop-up.

All screenshots:
iOS (top), Android (center),
Desktop (bottom)

Lightroom searches the photos in the current view. To **search all of your photos**, select *All Photos* in the Albums panel (iPhone/Android) / left panel (iPad/desktop), or select an album to limit the search.

To **delete a search term**, tap/click on its token.

To **clear the search,** tap/click the X at the end of the search criteria (iOS/desktop) / on the blue results line (Android).

SEARCHING CONTENT

If your photos are synced to the cloud, Adobe's artificial intelligence machine learning tool, Adobe Sensei, can search your photos and guess their content.

This image analysis allows you to find your photos, even if you never got around to adding keyword tags manually.

This automated tagging is done in Adobe's cloud, so there is a slight delay before they're searchable, and it does rely on you being connected to the internet.

You can search for all sorts of terms, for example:

Subjects, such as *boats, cats, dogs, trees,* or *water,* whether they're identified automatically or you've added them as keywords.

People you've named using the People view.

Colors, such as *red* or *blue.*

Locations, such as *London* or *UK.*

Cameras, such as *Canon EOS R6 Mark II, Sony A7 IV,* or *iPhone 15 Pro.*

Lenses, such as *75-300mm.*

Dates, such as *October 2022 or 21 August 2023.*

Filenames and extensions, such as *IMG_2948* or *.jpg.*

Other words in the *Title* or *Caption* fields.

Lightroom offers several suggestions as you start typing, just like Google or Amazon.

SEARCHING METADATA

You can also specify which metadata field to search by adding "facets." Type the facet followed by a colon (:), and a list of options pops up.

The available facets in English are:

camera: and **lens:** search the camera and lens

models.

f: searches aperture (f-stop).

shutter speed: searches shutter speed.

iso: checks the ISO rating.

focal length: searches the focal length used.

flash: checks whether the flash fired.

depth map: checks whether a depth map was recorded by the camera/phone.

rating: searches the star rating from 0 to 5.

flag: searches the flagged/unflagged/reject status.

location: searches the GPS fields.

keyword: searches keywords you've manually added to the Keyword panel.

people: searches for people tagged in the People view.

album: limits the search to a specific album. This also allows you to search for photos that aren't in any album. (Currently desktop only.)

type: separates photos, HDR/panos, and videos.

extension: searches by file extension, such as jpg or cr2.

orientation: searches for vertical, horizontal, panoramic, or square photos.

edited: looks for photos that have been edited since importing into Lightroom.

These facets can be combined; for example, you might search for *rating:equal to 5*

extension:cr2 camera:Canon EOS 5D Mk III

It's not possible to specify boolean operators. However, facets of the same type, for example, two cameras, run an OR type search, so they'd find photos taken by either camera. Facets of different types run AND searches so they find photos that match all of the criteria.

Remembering all the different facets is tricky, so when you click on an empty search field on the desktop, Lightroom displays a helper screen. Just click on the facet and then select from the options pop-up.

SEARCH LANGUAGE

Lightroom searches are based on the operating system language on mobile or the language selected in *Preferences > Interface* on the desktop. For example, if you need to search in Spanish, you must set the Lightroom interface to Spanish.

REFINING THE CURRENT VIEW

The Refine toolbar filters the current view based on specific criteria, for example, to show all of your photos marked with 4 stars that were shot using your iPhone.

To **show the Refine toolbar** on mobile, tap the Refine button at the top of the Grid view. On the desktop, click the Refine button to the right of the Search bar.

 ← Refine View

If you're viewing photos from a specific date or album, it only searches those photos. To **search all of your photos**, select *All Photos* in the Albums panel (iPhone/Android) / left panel (iPad/desktop).

FILTERING BY STAR RATING

The star filters allow you to show/hide photos and/or videos based on their rating. For example, to **show only photos with 3 or more stars**, tap/click on the third star.

The **symbol** to the left of the stars allows greater control, so you can filter based on:

≥ rating is greater than or equal to.

≤ rating is less than or equal to.

= rating is equal to.

REFINING THE VIEW (MOBILE)

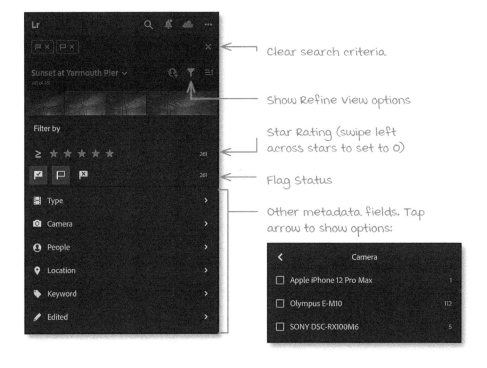

For example, to display only photos with 0 stars, tap/click on the symbol to the left of the stars, select the = icon, and leave the stars themselves deselected.

FILTERING BY FLAGS

The flag filters allow you to show/hide photos and/or videos based on their flag status.

To **show only flagged photos**, tap/click on the flag so it's highlighted.

To **show both flagged and unflagged photos** (hiding the rejected ones), tap/click on both the flagged and unflagged icons to highlight them.

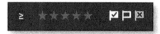

To **show only rejected photos**, ready to delete them, click only the rejected flag so it's highlighted.

FILTERING BY METADATA

The **Metadata** filters allow you to refine the view based on additional metadata. This metadata is searchable using the text search field (page 116); however, the Refine pop-ups work even if you're offline.

The *Sync Status* criteria on the desktop is particularly useful if you're having sync issues, as it shows which photos are yet to be uploaded. It's also helpful if you previously uploaded photos using Lightroom Classic, as it shows which photos only have smart

REFINING THE VIEW (DESKTOP)

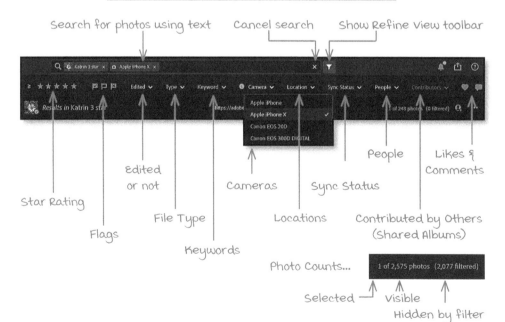

Search for photos using text

Cancel search

Show Refine View toolbar

Star Rating

Flags

Edited or not

File Type

Keywords

Cameras

Locations

Sync Status

People

Likes & Comments

Contributed by Others (Shared Albums)

Photo Counts...

Selected — Visible

Hidden by filter

1 of 2,575 photos (2,077 filtered)

previews available in the cloud.

As they all work the same way, let's use the *Cameras* pop-up to illustrate how they work. On mobile, tap the arrow to show the list of cameras (or other metadata) and check the cameras you want to include in your filtered view.

On the desktop, click the pop-up to **show the list** of cameras. Click on one of the lines to select it, such as the Olympus E-M1 Mark II in the screenshot. Any photos shot with other cameras are hidden from view. You can click to select multiple lines to display photos from more than one camera. To remove a camera from the selection, click on the line again. To cancel the camera filter and show photos from all cameras, click the circular number icon on the pop-up.

FILTERING ON SHARED ALBUMS

If any of the photos are shared (page 385), you can also filter on photos that have been contributed by others and those with likes or comments.

CLEARING FILTERS

To **reset the filters** to show all photos, click the X at the end of the search criteria.

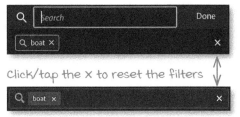

Click/tap the × to reset the filters ↓

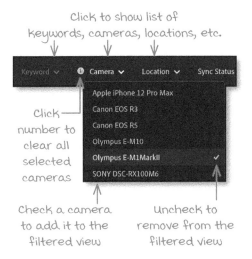

Click to show list of
keywords, cameras, locations, etc.
↓ ↓ ↓

Click ─ number to clear all selected cameras

Check a camera
to add it to the
filtered view

Uncheck to
remove from the
filtered view

INTRODUCTION TO EDITING

8

Most photographers want to get on to the fun bit—editing their photos! Editing photos is not about making them look fake or photoshopped, nor is it a new phenomenon. Photographers were editing their photos in the darkroom long before computers existed. Even the Masters, such as Ansel Adams, edited their photos, not to fix mistakes but because a print can't match the dynamic range of the human eye.

WHY ARE YOU EDITING YOUR PHOTOS?

Before you start editing, ask yourself why you're editing your photos. Are you editing...

• To fix mistakes? (Yes, even pros make mistakes!)

• To compensate for intentional overexposure (ETTR), done to retain the largest amount of data?

• To adjust the photo's dynamic range to match the scene you remember?

• To draw the eye to specific areas of the photo?

• To match your artistic vision for the photo?

• For consistency, perhaps across your portfolio, in an album, or on the wall?

• To crop in closer because you didn't have a long enough lens?

The reason you're editing the photos will affect the editing choices you make, for example:

• If you're figuring out the kind of style you like, you might experiment with lots of different presets.

• If you're aiming for consistency, you'll view the images as a group rather than individually.

• If you're editing an image to put on the wall, you'll probably spend more time on it than a photo to put on social media.

WHICH PHOTOS SHOULD YOU EDIT?

You'll soon get frustrated if you spend hours editing every photo you capture. Consider these time-saving tips:

• Don't try to edit everything. Editing won't fix bad photos. They can be improved, but you can't make a silk purse from a sow's ear. Flag/star the photos first, and only edit the best ones.

• Just do a "quick" edit on most of the photos you decide to keep, and focus most of your editing time on the photos you'll be proud to share with the world.

HOW DO YOU USE LIGHTROOM TO EDIT YOUR PHOTOS?

You can get the gist of how Lightroom's sliders work simply through experimentation. It doesn't take a rocket scientist to work out that the *Exposure* slider brightens or darkens the photos.

However, many of Lightroom's sliders do all sorts of clever calculations behind the scenes. Understanding how the sliders work—and how they work together—means you can get the best result.

Before we dive into the sliders themselves, we'll learn how to analyze the photos before you start editing and how to figure out what you need to adjust to fix or enhance them. For example:

• How do you know where to crop a photo?

• How do you know how bright or dark to make the photo?

• How do you decide on the color?

• How much sharpening should you apply?

• How do you know which photos will look better in B&W without testing it on every single one?

In the following chapters, we'll answer these questions and more besides.

IN THIS CHAPTER, WE'LL CONSIDER:

• Why it's worth learning photo editing skills instead of always relying on presets.

• How to avoid looking like a new photographer.

• Which camera settings affect editing flexibility.

WHY LEARN TO EDIT PHOTOS USING SLIDERS?

Most new photographers edit photos using profiles, presets, and filters. So why bother learning to use the sliders?

PHOTO EDITING IS LIKE A LANGUAGE

Photo editing is a skill, just like any other. If you're trying to learn a language, repeating phrases from a phrase book will only get you so far. To become fluent in a language, you must learn its structure and vocabulary to start to build your own sentences that can apply in any situation.

Editing photos is the same. Profiles and presets are like those pre-built phrases. They'll work okay in some situations, but they'll never be a perfect fit.

Skilled editing can enhance photos in a way that presets simply can't match. Learning which sliders to tweak is also much faster than hunting through hundreds of presets trying to find one that works.

PRESETS & PROFILES HAVE THEIR PLACE

Please don't misunderstand me... presets and profiles have their place. Benefits include:

• Selecting a base profile can be a good starting point for your editing.

• Presets (especially those you've created yourself) can help ensure consistency over a group of photos or your entire portfolio.

• Presets can be helpful in learning the kind of styles of editing you prefer, and looking at which sliders are adjusted by presets is an excellent way of learning how to create a specific look.

IT TAKES TIME

Developing any new skill takes time, and you'll improve with practice. When you start trying to edit photos with sliders, rather than relying on presets, you won't always be happy with the result initially. But that's OK! That's the benefit of non-destructive editing—you can change them later as your skills develop. If you've saved a "classic" edit (as opposed to a fashionable look), your future changes will be tweaks, not a complete overhaul.

LEARNING THE LANGUAGE OF EDITING

We'll start by introducing the sliders and tools, like adding new words to your vocabulary.

Then, we'll learn how to combine related sliders to get a specific result, like combining words to make a sentence.

Finally, we'll start combining different sets of sliders into full photo edits, like turning these sentences into whole conversations.

WHAT NOT TO DO WHEN EDITING

Some weird and wonderful photo effects are popular with new photographers. Play with them and get them out of your system. But then, if you want to be respected as a photographer, your photos should usually look like photos.

There are a few red flags that make it easy to identify new photographers, and of course, you don't want to look like a newbie, so here are a few things to avoid:

• You don't need to use every single slider on each photo, just as you don't need to use every word in the dictionary in each conversation.

• Less is more. Unless you're intentionally aiming for a surreal look, keep it natural. Sliders rarely need pushing to the ends.

• Be especially careful with photos of people. Glowing eyes, bright white teeth, and plastic skin rarely look good.

• Watch your white and black clipping. Most photos benefit from a few pure white and pure black pixels, but you don't usually want large areas of white or black without detail.

• Reduce digital noise, but don't make it so smooth it looks like plastic.

• Avoid using too many different presets because your photos won't look like "yours."

• Don't crop too far; you'll cause visible pixelation (noticeable square pixels).

• Watch out for halos on either side of the edges in the photo, whether they're wide halos caused by overzealous use of the *Highlights*, *Shadows*, or *Clarity* sliders or narrow halos caused by too much sharpening or chromatic aberration (a lens defect).

• Limit your use of the latest fad and fake film presets that go out of fashion again just as quickly as they arrived. Likewise, limit your use of special effects such as selective color (B&W photos with one element in color), as these effects date quickly.

• Don't go out and buy every software program on the market. Master the ones you already have first. "The grass is always greener on the other side of the fence" doesn't always hold true. Often, you just need to learn which slider to adjust to make it greener on this side!

• Finally, don't spend hours on every photo. If you get stuck, consider printing it, sticking it on the wall, and "living with it" for a while. This makes it easier to see what needs changing.

Don't worry; as you continue through this book, I'll show you how to avoid these issues and skillfully edit your photos.

SET A GOOD FOUNDATION WITH YOUR CAMERA SETTINGS

Whether you're shooting with a mobile device or a separate camera, your settings will affect the ease of editing your photos and the quality of the result. This isn't a camera manual, so we won't go into detail, but there are a few main settings to look out for...

RAW VS. JPEG/HEIF—WHAT'S THE DIFFERENCE?

Arguably, the most important decision is your file format.

JPEGs (and HEIF files) are already processed by the camera in the way the camera manufacturer thought the photo should look.

Raw files (e.g., DNG, CR3, NEF, ARW) are the unprocessed sensor data, ready for you to process the way you prefer.

Raw vs. JPEG creates a bit of a religious war on the internet, and the decision is yours, but consider a few pros and cons...

WHY SHOOT JPEG OR HEIF

Most photographers start with JPEGs, and many phones and compact cameras only offer JPEG format. Newer Apple devices default to HEIF format. There are some advantages:

Size—JPEGs are much smaller than raw files, and HEIF files are smaller still. That means you can fit many more photos on your memory card or phone.

Speed—JPEGs and HEIF files come out of the camera ready to go, whereas raw files require editing. Speed shooters, such as sports photographers, often prefer JPEG for this reason.

Camera Settings Applied—The photos look exactly the same as they did on the back of the camera.

Compatibility—All image editing software understands JPEG format, whereas raw files must first be converted to standard image formats using software like Lightroom. HEIF files are not widely supported yet, but support is growing.

Image captured with incorrect white balance and overexposed

Edited JPEG. The clipped highlights couldn't be recovered and the color is unnatural

Edited raw file. Notice the detail recovered on the nose and head, and natural colors

WHY SHOOT RAW

Raw files are bigger, and you do have to edit them, but there are some huge advantages:

Dynamic Range—Raw files have a much wider dynamic range than JPEGs. This means that clipped highlight or shadow detail can often still be recovered from a raw file, whereas in the JPEGs, that detail's gone forever. You can see the difference in the dog's face. The HEIF file format can hold a wider dynamic range than JPEG, depending on the camera, but raw files still offer more flexibility.

Mistake Recovery—We all make mistakes, and if you have to make significant exposure changes, there's far more data to work with in a raw file, resulting in a higher-quality image.

White Balance—Raw files can have their white balance adjusted while editing (page 226), whereas it's already applied to the pixels of JPEGs/HEIFs. This gives much more flexibility when editing, as you can see in the photo of the dog.

IF YOU'RE SHOOTING RAW

If you're shooting raw, there are a few things to bear in mind:

Unprocessed Raw Data—When you shoot in your camera's raw file format, the data isn't fully processed by the camera. Each raw processing software (like Lightroom) interprets the raw data slightly differently. As a result, the photos won't look exactly the same in Lightroom as they did on the back of the camera. There isn't a right or wrong rendering—they're just different.

Camera Picture Styles—While many cameras offer picture styles such as Portrait,

Landscape, and Monochrome, these editing presets only apply to the JPEGs (and the preview you see on the back of the camera), not the raw data. When you add the raw photos to Lightroom, these effects disappear, ready for you to edit the photos in whatever style you like. It is possible to use Camera Matching Profiles to emulate these picture styles for many cameras (page 174) and to select these automatically using raw defaults (page 180).

ETTR—Short for "expose to the right," consider setting the exposure to be as bright as possible without clipping the highlights to pure white in order to retain the largest amount of data. Search the web for ETTR for more information on this concept.

Low ISO—To minimize noise, use the lowest ISO possible, balanced against the shutter speed and aperture, and avoid underexposing the photos.

Turn Off Smart Camera Settings—Some camera settings apply shadow brightening to the JPEG preview and histogram on the back of the camera but not to the raw data. This may fool you into accidentally underexposing the photo, so these settings are best left disabled when shooting raw. Every manufacturer uses a different name, such as Auto Lighting Optimizer (Canon), Active D-Lighting (Nikon), Dynamic Range Optimization (Sony), Shadow Adjustment Technology (Olympus), and Intelligent Exposure (Panasonic).

IF YOU'RE SHOOTING JPEG/HEIF

If you're shooting JPEG/HEIF, there's less flexibility when editing, so you need to get your photo as perfect in the camera as possible.

Set White Balance—Make sure the white

balance is about right when capturing the photo, using a WB preset (sunny, cloudy, etc.) or custom white balance. If the white balance is completely wrong, it won't be possible to fix it.

Expose Accurately—Overexposure results in clipped highlights (white areas with no detail), which can't be recovered later. Underexposure results in lots of noise and blocked shadows (black areas with no detail) that can't be recovered.

ANALYZING THE IMAGE

9

When you watch a professional photo editor editing a series of photos, it looks like they "just know" what to change. They don't start randomly moving sliders, hoping to hit on the right combination of adjustments. Instead, they first analyze the photo.

Due to years of experience, that analysis may only take a few seconds and may be a subconscious process, but it happens every time. Without necessarily realizing they're doing so, they're running through a series of questions in their head—and you can ask yourself the same questions. This process of analysis is the focus of this chapter.

PLAN YOUR JOURNEY

Starting to edit a photo without first taking the time to analyze it is like setting off on a road trip without looking at a map. You'll end up somewhere, and the trip might still be fun, but you're unlikely to get to the best destination.

You don't have to plan every detail, but having a rough idea of where you want to end up means you can make good decisions along the way and avoid going in circles.

ANALYZING YOUR OWN PHOTOS

I've included a checklist and worksheet to help guide you through the process.

Printable copies are available for download in the Members Area (page 440), and we'll use these worksheets again later in the book when we edit some photos from start to finish (page 347).

Analyzing your photos may look like a lot of work, but once you understand what you're looking for, you'll be able to analyze your photo in a matter of seconds, like you do when shooting a photo.

You don't have to complete a written worksheet every time you sit down to edit a photo, but your editing will improve if you run through the process a few times on paper before switching to doing it in your head. As you gain experience, it'll become second nature.

IN THIS CHAPTER, WE'LL CONSIDER:

• How to analyze the image, looking for technical faults.

• How to analyze the image from an artistic point of view.

• How to start to develop your own consistent editing style.

PHOTO ANALYSIS CHECKLIST

Technical

Light & Contrast
- ☐ Is the overall exposure about right?
- ☐ Is there enough detail in the highlights and shadows?
- ☐ Does the photo fill the entire dynamic range?
- ☐ Are the highlights and/or shadows clipping?

Color
- ☐ Is there a color cast?
- ☐ Do the memory colors look natural?

Detail
- ☐ Is it sharp?
- ☐ Is there noise?
- ☐ Is there moiré patterning?

Optical Distortion
- ☐ Is there vignetting?
- ☐ Is there barrel/pincushion distortion?
- ☐ Is there chromatic aberration or other fringing?

Geometric Distortion
- ☐ Is the horizon straight?
- ☐ Are the vertical lines straight, or do they converge?

Sensor Dust
- ☐ Are there any sensor dust spots?

Output
- ☐ Does the photo need to fit a specific aspect ratio, for example, a frame?
- ☐ Does it need to match the color of another photo?
- ☐ How big is the photo going to be?

Artistic Intent

Purpose
- ☐ Why did I capture the photo?
- ☐ What's important in the photo?
- ☐ What did I want to show the viewer?

Story
- ☐ What's the story I'm trying to tell?
- ☐ How can I use light, contrast, color and saturation to help tell the story?

Mood/Emotion
- ☐ How do I want the viewer to feel?
- ☐ How can I use light, contrast, color and saturation to influence the viewer's response?

Simplify
- ☐ Are there any distractions I can exclude from the scene by cropping, darkening, blurring, etc?

Draw the Eye
- ☐ Can I guide the viewer's eye around the photo by highlighting or diminishing:
 - People
 - Contrasts in Size
 - Contrasts in Brightness
 - Contrasts in Color & Saturation
 - Contrasts in Sharpness
 - Lines
 - Something else?

PHOTO ANALYSIS WORKSHEET EXAMPLE

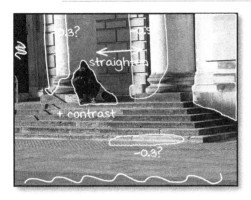

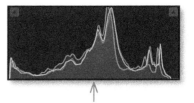

Good dynamic range, no
notable clipping

Purpose
The guy looked small and
insignificant against the huge
pillars of the government building.

Exposure
Needs a little more detail
in his clothes. No pure white
expected in the photo.

Color
Color doesn't add to the photo.
The strong lines and stone
texture would work well in B&W.

Story
Is he homeless? Or just waiting for
a friend? He looks cold and lonely.

Detail
Shot at low ISO in good light, so no
notable noise. Texture of stone can
take some crunchy sharpening.

Mood/Emotion
Very cold day (hat). Feeling lonely?
High contrast B&W with lots of local
contrast for a gritty urban look?

Optical & Geometric Distortion
Horizon needs straightening
(use bricks in background).

Simplify the Scene & Draw the Eye
Notes scribbled on photo.

Remove the sign from the
door on the left.

Sensor Dust
None found.

Even up lighting on the pillars, front
step and bricks in the background
to reduce background contrast.

Output
Nothing specific planned.

Increase contrast on face/
clothing of man to draw the eye
in that direction even more.

ANALYZING THE IMAGE—TECHNICAL FAULTS

One of the aims of the editing process is to get the best possible result from whatever data you capture, so there are some technical issues to look out for. You may not be familiar with all of the terminology, so we'll explain a few new terms as we go along.

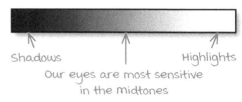

Shadows Highlights
Our eyes are most sensitive in the midtones

LIGHT

In the real world, our eyes don't care whether something is light or dark, as they automatically adjust to see detail in both the highlights and shadows, even in high-contrast situations such as the midday sun.

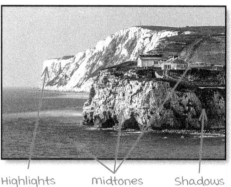

Highlights midtones Shadows

A photo (especially a print) cannot hold that wide a range of tones while still looking natural. Something has to give. Editing photos is a balancing act, determining which range of tones is most important and where you're willing to sacrifice detail.

Is the overall exposure about right? Is there enough detail in the highlights and shadows?

There is no such thing as "correct" exposure, but the human visual system (the combination of our eyes and brain) expects to see an image in a specific way. This means there's room for creative expression, but there's a narrow band of exposure most people prefer.

Our eyes are most comfortable when the main focus of interest is around middle gray (called the midtones). Therefore, the optimum exposure setting may lighten or darken the highlights or shadows to move the most important tones toward the midtones.

What does the histogram tell you?

A Histogram is a bar graph showing the distribution of tonal values. To **show the histogram** on mobile, go to Detail view > ... *menu > View Options > Show/Hide Histogram* (iOS) / *Histogram* (Android). On the desktop, click the ... button in the Toolstrip, select *Show Histogram* or use the shortcut Ctrl-0 (Windows) / Cmd-0 (Mac).

The brightness of each pixel is measured from 0% (black) to 100% (white), so a histogram runs from the blackest shadow on the left to the brightest highlight on the right. Vertically, it shows the number of pixels with that specific tonal value. A color photo is made up of three channels—red, green, and blue—so the histogram has a line for each channel.

There's no such thing as a 'correct' histogram. When analyzing your photo, a histogram can provide helpful information on your photo's exposure values, but don't

get too hung up on it. We're trying to make great photos, not great histograms! However, we can learn a few valuable things from the histogram...

Does the photo fill the entire dynamic range?

The difference between the brightest and darkest tones in the photo is called the dynamic range.

The histogram of a scene with a much wider dynamic range than the camera could capture shows spikes at both ends. These are pixels that are currently pure white or pure black, but if it's a raw file, there may be details that can be recovered with careful editing. This is called a high dynamic range; these photos usually have too much contrast.

A histogram stuck in the middle of the range, without reaching the ends, is a narrow or low dynamic range. These photos usually benefit from stretching to create a real white and black point because they lack contrast. However, some photos, such

READING THE HISTOGRAM

Number of pixels with that brightness value

0% 25% 50% 75% 100%

Pixel brightness, from pure black (0%) to pure white (100%)

Spikes at the ends = dynamic range too wide, so detail is clipped

Data doesn't reach ends = low dynamic range

missing detail in the highlights and shadows

Low dynamic range Stretched to full dynamic range

WATCH FOR CLIPPING

Enable/disable blue Shadows Clipping warning

Enable/disable red Highlight Clipping warning

Clipped blacks show as black on a white background when you hold down the Alt/Opt key and move the sliders. Pixels only clipped in one or two channels show in color

as those shot in thick fog, may not have any true white or black details.

Are the highlights and/or shadows clipping?

If the last pixel on the left or the right of the histogram spikes, it means that a significant number of pixels in your photo are solid white or black without any detail. These are called clipped highlights or shadows, or you may hear them referred to as blown highlights and blocked shadows. Clipping can be a fault, or it can be intentional.

Pure white clipped highlights don't look out of place on shiny objects

To check whether the clipped pixels are in areas of important image detail on mobile, drag the *Exposure, Highlights, Shadows, Whites,* or *Blacks* sliders using two fingers, or start dragging the slider and then add another finger elsewhere on the image. On the desktop, hold down the Alt key (Windows) / Opt key (Mac) while dragging the *Exposure, Highlights, Shadows, Whites,* or *Blacks* sliders to view the clipping warnings.

Avoid clipping skin tones

In addition to these on-demand clipping warnings, on the desktop you can turn on automatic clipping warnings to show while you work. To do so, click the triangles in the corners of the histogram or press the J key. Clipped highlights turn red, and blocked shadows turn blue.

Clipping is expected in some areas of the photo, such as bright spots on shiny objects. Small areas of clipping on a light source, such as a light bulb or the sun, can also look fine, but ideally, you don't want large clipped areas, such as a window with no detail. Clipping on skin looks unnatural and is worth avoiding at all costs.

Some studio or product photographers like to clip their backgrounds to pure white or black, and intentionally compressing the shadow detail can be a creative choice. It's not always bad, as long as there's a smooth transition to image detail.

We'll use the tools in the Light and Effects panel to make these adjustments (page 191).

COLOR

Unless you're doing reproduction work, the main aim is visually pleasing color, which may not be the same as perfectly accurate color due to the way the camera captures the scene. While you can make artistic choices, there are a couple of things to look out for...

Is there a color cast?

A color cast is an unwanted tint in the image, often caused by an incorrect White Balance setting. It makes the photo look muddy and hazy like you're viewing it through a colored film. We're most sensitive to color casts in lighter tones. If you remove the tint, the other colors usually fall into place.

Do the memory colors look natural?

Some colors are burned forever into our memory. Think about skin tones. We recognize when someone looks jaundiced or ashen or when they've applied fake tan because the color of their skin doesn't match the color we expect to see. In the same way,

KEEP COLORS NATURAL

What's wrong with this image? memory colors need to be accurate!

A color cast makes the photo look muddy

CHECK THE DETAIL

This was a grab shot, and the camera focused on the grass instead of his eyes, so it's not perfectly sharp but it sums up Charlie too well to throw away

High noise levels are usually found on high ISO photos

we expect the sky to be blue, grass to be green, and bananas to be yellow.

As long as the memory colors remain natural, you can take liberties with other colors for artistic effect without the photo looking "wrong".

We'll use the tools in the Color panel to make these adjustments (page 225).

moiré pattern

DETAIL

If we have 20/20 vision, everything we look at is perfectly sharp, and our eyes automatically adjust to see detail in the shadows without any noise. Cameras have come on leaps and bounds over the last few years, but they're no match. Whether it's softness caused by imperfect optics or focusing or noise caused by low light hitting tiny digital sensors, there's room for improvement in the detail of our photos.

Is it sharp?

We all grab photos that aren't perfectly in focus, and most will be removed when ranking the photos, but occasionally, there's just "something" about them that's worth keeping. You can't fix out-of-focus photos in Lightroom, but you can certainly improve them.

Is there noise?

If you shot in low light, used a high ISO, your camera has a tiny sensor, or you need to brighten the photo significantly, then there's likely to be noise in the photo, making it look very grainy. This can be reduced in

Lightroom.

Is there moiré patterning?

Moiré (pronounced mwa-ray) is a rainbow-like pattern often seen when photographing fabrics. It's caused by two patterns combining—in this case, the weave in fabric and the grid of the camera sensor—which creates a new pattern.

Sharpening and noise reduction can be optimized using the tools in the Detail panel (page 265), and moiré can be removed using the Brush tool (page 344).

OPTICAL DISTORTIONS

The way the light passes through the camera's lens can result in distortions that can distract from the content of the photo, so it's worth taking a moment to correct them.

Is there vignetting?

Vignetting is a darkening around the photo's edges, especially in the corners.

Is there barrel/pincushion distortion?

Pincushion distortion causes straight lines to curve inward, while barrel distortion causes straight lines to curve outward. It's particularly noticeable when there are straight lines in the photo.

Is there chromatic aberration or other fringing?

Chromatic aberration (often shortened to CA) is the little fringes of color that can appear along high-contrast edges, where the red, green, and blue light wavelengths are unable to focus at the same point. It's most noticeable around the corners of photos taken with a lower-quality wide-angle lens and doesn't appear in the center of the image.

Compact and mirrorless cameras often fix these issues automatically, but where these distortions are still visible, we'll use the tools in the Optics panel to make these corrections (page 279).

GEOMETRIC DISTORTIONS

When you look around in real life, horizontal lines look horizontal, and vertical lines look vertical, and even if you tilt your head, your brain compensates. However, the resulting photo looks wonky if your camera sensor isn't perfectly aligned with those horizontal and vertical lines.

Is the horizon straight?

Most of us have trouble getting horizons perfectly straight at the time of shooting, and since the edge of the photo acts as a point of comparison, they stand out like a sore thumb.

Are the vertical lines straight, or do they converge?

If you're shooting buildings, have you noticed that they sometimes seem to lean backward? This is called keystoning, and it's caused by tilting the camera to get the whole building into the frame. Some keystoning can look natural, as we're used to looking up at buildings, but you may want to reduce excessive keystoning.

The horizon can be straightened using the Crop tool (page 181), and we'll use the tools in the Geometry panel to make more complex corrections (page 139).

OPTICAL & GEOMETRIC DISTORTIONS

Horizons should be horizontal!

Pincushion distortion curves inward Barrel distortion curves outward

Due to the camera angle, the building appears to be leaning backwards

Halos of opposing colors (green and magenta here) are caused by chromatic aberration

RETOUCHING

Removing distractions from the photo allows your viewer to focus on the content. Some unnatural distractions, such as sensor dust spots, stand out more than the litter we see around us every day.

Are there any sensor dust spots?

Small spots that are most noticeable in the sky are caused by dust on the sensor. If you have a camera with interchangeable lenses, it's worth keeping your camera's sensor clean. Spots on blank areas of the sky are easy to clean up in Lightroom, but when they fall on more detailed areas, they can be tricky to remove.

We'll use Lightroom's Healing tool (page 297) to remove these distractions or pass the photo to Photoshop for more

advanced retouching (page 398).

LOOK FOR SPOTS

Dust spots on the sensor can be distracting

OUTPUT

Finally, the intended output will affect some of your editing choices, such as...

Does the photo need to fit a specific aspect ratio, for example, a frame?

If a photo will be placed in a specific frame, the aspect ratio used when cropping will be important. You'll need to bear in mind the shape of the frame when cropping the photo (page 184).

Does it need to match the color of another photo?

If the photo is part of a collection that will displayed together on the wall, consistency across the group will be a high priority.

How big is the photo going to be?

If it's a quick snap to email to Granny, you may decide to spend less time editing than you would for a poster-sized print.

ANALYZING THE IMAGE—ARTISTIC INTENT

Photography is a form of visual communication. It's not "just a pretty picture." It's up to you to decide what you're trying to communicate through your photo and ensure the viewer gets the right message.

The composition, the lighting, and the subject of the photo are essential, of course. You can't make a bad photo great through editing, but thoughtful editing can enhance a good photo and turn it into a great photo.

It's easy to look at a photo and say, "I like it," but ask yourself WHY you like it. Once you've answered that question, you're well on the way to knowing what needs to be enhanced to ensure that your viewer sees it the same way. Not sure how to answer? Let's break it down into a series of questions about the purpose of the photo, the story you want to tell, the mood you want to convey, and where you want the viewer's eye to go.

THE PURPOSE

Why did you capture the photo? Or why did you keep the photo? What was it you wanted to show the viewer? For example:

- To capture a specific moment in time.

- To tell a story.

- A specific subject caught your eye.

- The way the light was falling caught your eye.

- Someone commissioned you to shoot it. (What was their purpose?)

- Something else?

What's important in the photo? What's interesting about it? For example, in a photo of a thunderstorm, the clouds are most important, or in a portrait, it's the eyes.

THE STORY

They say a picture speaks a thousand words, so what are you trying to communicate through this photo? What kind of story are you trying to tell? What do you want the viewer to think of when they see it? If it's a portrait, does it show the subject's personality?

For example, a portrait of an older man can be edited as a gritty B&W to accentuate the weathered wrinkles on his face, showing that he's worked hard outdoors all his life, or as a soft, low-contrast color image, showing his softer side.

THE MOOD/EMOTION

How did you feel when shooting the photo, and how do you want the viewer to feel? What emotion are you trying to communicate? And then, how can you communicate that mood through your editing?

For example, a high-contrast B&W shot of stormy seas may communicate drama, power, and a feeling of awe. In contrast, the colorful blue sky and yellow sand on a paradisaic beach make us think of relaxation.

Or a country village looks better in peaceful, calm tones, whereas edgy architecture looks great with a strong, contrasty look, and a factory can look great with a gritty, grainy look.

Think of words you'd use to describe the photo and the brightness, contrast, and colors you associate with those words.

Was it a bright sunny day at the beach?

Or would you prefer a more moody look?

Or do you want to emphasize the drama of the crashing waves and rocky cliffs?

Words to Describe the Feel of a Photo

Light	airy, bright, clear, dainty, fluffy, glowing, hopeful, radiant, shining, sunny	dark, dull, gloomy, heavy, hopeless, mysterious, sinister, somber
Contrast	dramatic, energetic, gritty, hard, stormy, turbulent, wild	calm, delicate, gentle, mellow, mild, peaceful, smooth, soft
Color	cozy, fresh, happy, summery, rosy, upbeat, warm, yellow	bleak, blue, cold, frosty, icy, miserable, wet, wintry
Saturation	bright, cheerful, colorful, excited, gaudy, lively, loud, rich, vibrant, vivid	calm, dull, delicate, faded, mellow, muted, pale, pastel, sober, subdued

SIMPLIFYING THE SCENE

So far, we've been talking about the overall feel of the image, but now, let's think about the content.

In a confused scene, your eyes don't know where to look, so it's important to simplify the scene.

What caught your eye, making you take the photo—and is that the first thing that will catch your viewer's eye? Or will their eye wander off to distractions?

If the eye doesn't go straight there, careful cropping and masking can draw the viewer's eye away from the distractions to the right spot.

DRAWING THE EYE USING VISUAL MASS

Once you've removed everything that isn't necessary, think about how your eyes move around the photo. Consider:

• Where does the eye go currently, and in what order?

• Where do you want the viewer's eye to go?

• How can you use editing to draw your viewer's eye along that same path?

In the world of photography and art, there's a concept called Visual Mass. It simply means that some elements attract the eye more than others, and you can use that to draw your viewer's eye around the photo. For example, we're drawn to:

People (especially faces, particularly eyes)— Even in landscapes, having a person in the scene creates a sense of scale or draws your eye to a specific spot. This also applies to animals to a lesser extent.

Size—We look at large objects before small ones.

Contrasts of Brightness—We're drawn to light things in a mainly dark image or dark things in a main light image.

Color—We drift towards warm colors before cool colors (unless the scene is primarily warm, then we're drawn to the contrasting cool color) and saturated colors before dull colors.

Recognizable Objects—We look at recognizable objects before those that are less recognizable.

Sharpness—We see sharp objects before soft ones (which is why out-of-focus backgrounds work so well).

Lines—We follow diagonal or curved lines before straight lines. Diagonal lines are more dynamic, whereas our eyes meander along curved lines.

Text—We always try to read it!

This is massively over-simplified, and these elements are often combined, but you can use this concept to your advantage when editing, as well as when shooting.

We'll learn to use the Masking tools (page 309) to enhance these contrasts, but for now, just start noticing where your eye goes in photos and where you want the viewer's eye to go to tell your story.

VISUAL MASS TO DRAW THE EYE

People first

Large before small

Bright spots in a dark scene

Sharp before soft

Warm before cold

Diagonal or
curved lines
before horizontal/
vertical ones

DEVELOPING YOUR OWN STYLE

One of the most significant differences between seasoned and newer photographers is consistency in editing. Would all of your pictures look good hung on the wall together, or are they "all over the place"? Could someone identify a photo as yours just by looking at it?

THE IMPORTANCE OF EDITING STYLES

If you look at the work of any famous photographer, you may know who the photographer is long before you see their name. As you scroll through their website or Instagram feed, all of their photos work together as a consistent set.

This is partly due to their choice of subject, lighting, posing, lens, composition, and so forth, but their editing style can make or break the consistency. If they applied a different preset to every photo, the photos would no longer be identifiable as theirs.

Professional photographers gradually develop a style, and they stick to it. It may change over time, but it's a gradual shift.

If you're an amateur photographer, you don't have to go that far, but any improvement in consistency will make your photos look better together.

HOW DO YOU START TO DEVELOP YOUR STYLE?

To start to define your own preferences, look at lots of people's photos. Notice what you consistently like and what you consistently don't like, but don't just copy them because you're unique.

Experiment with different presets to help you learn, but remember that they're someone else's style.

Start to analyze *what* you like or don't like about a photo. Look out for things like:

• Do you love high contrast or prefer photos that look soft and dreamy?

• Do you like highly saturated colors or softer muted shades?

• How important are creamy skin tones?

• Do you prefer specific color palettes like muted greens and blues?

• Do you prefer the darkest tones blocked to pure black or more shadow detail?

When you edit a photo and love the result, add it to a "my style" album. Over time, a theme will start to become apparent. The style you prefer for landscapes may not be identical to the style you prefer for portraits, but there will be similarities.

It won't happen overnight, and as you start to improve your editing, you might find your photos even become a little more inconsistent for a while as you're experimenting. That's part of the learning process. I've edited more than a million photos for professional photographers in their own styles, but I'm still figuring out my own preferences, too. That's part of the fun of editing!

EDITING TOOLS

10

In the previous chapters, we discussed the theory of photo editing. Now let's get down to the practicalities of editing in Lightroom.

THE TOOLSTRIP & EDIT SLIDERS

To **show the Edit tools**, open a photo in Detail view. The Edit tools are in the Toolstrip at the bottom of iPhone/Android or on the right on iPad/desktop. The main tools are Presets, Crop, Edit (sliders), Masking, and Healing.

The Editing tools work essentially the same way regardless of the device you're using, but the layout is a bit different to suit each screen size. Some advanced editing tools are only available on the desktop, but the edits are still applied to the photos when they're viewed on other devices.

The Edit sliders are grouped into panels... Light, Color, Detail, etc.

The Edit Toolstrip: iPhone/Android (top), iPad (far left), Desktop (center)

The main sliders are immediately visible in each panel, but more advanced sliders are tucked away in sub-panels, such as Tone Curve and Color Mix. If you opened all of the panels and sub-panels, the number of sliders would be completely overwhelming, so we'll work through them one panel at a time. Remember, you don't have to use every tool and slider!

Tap/click the Edit sliders button, or press the E key (desktop) to show the Edit panels.

On the iPhone and Android devices, tapping the Edit button shows a second line of buttons that open the panels. When you tap on one, the sliders appear above, and if some sliders are hidden, you can scroll up and down to see additional sliders. Tapping the buttons within the panels opens the advanced sub-panels, and you just press the *Done* button to return to the main panels. If you rotate an Android device horizontally, the Toolstrip and panels move to the right. (iPhone diagram: page 148 / Android diagram: page 149)

On iPad and desktop, tapping/clicking the Edit button displays the panels on the right of the screen. Tapping/clicking a panel name opens and closes the panel, and tapping/clicking the buttons within the panels opens and closes the advanced sub-panels. On iPad, opening a panel automatically closes

EDIT PANELS (IPHONE)

Share menu

Tap on photo to
hide all controls

Undo/Versions
menu

Sync Status incl.
download full size
original (if available)

Back to
Grid view

Two finger tap
anywhere to switch
between metadata
overlay, histogram
or neither. One
finger tap on
metadata cycles
metadata views

... menu

Double-tap anywhere
or pinch/spread to
zoom in and out

Swipe left <> right on
the photo with one
finger to view the
next/previous photo

Scroll up/down to
show additional
sliders

Sub menus:

Drag left <> right on
slider to adjust value

Double-tap slider
handle to reset slider

Edit panels

Presets | Sliders | Healing
Crop Masking

Swipe panel row
left <> right to show
all sets of sliders

Tap Toolstrip button
to view Edit panels

Hold panel icon to
temporarily hide the
panel's adjustments

Hold finger on photo to
preview without edits

To view clipping
warnings, hold one
finger on photo while
dragging slider handle

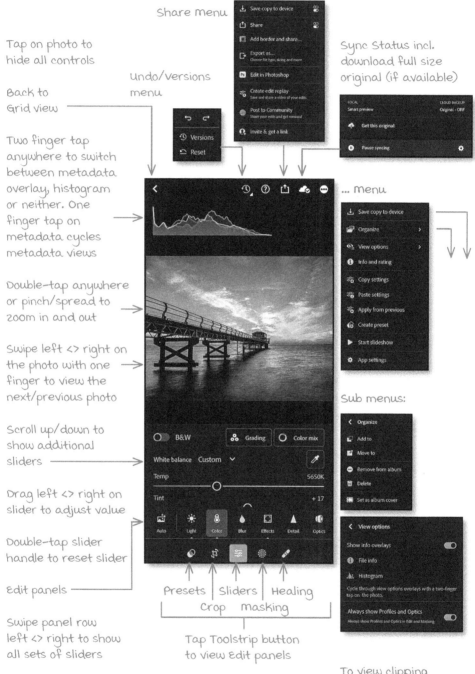

EDIT PANELS (ANDROID)

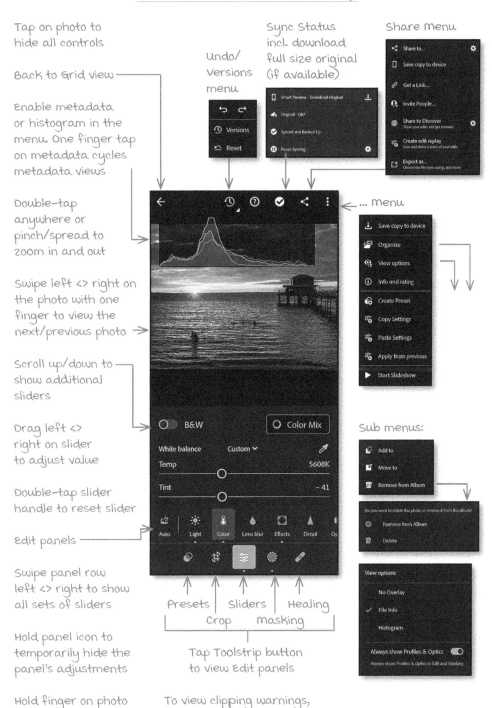

Tap on photo to hide all controls

Back to Grid view

Enable metadata or histogram in the menu. One finger tap on metadata cycles metadata views

Double-tap anywhere or pinch/spread to zoom in and out

Swipe left <> right on the photo with one finger to view the next/previous photo

Scroll up/down to show additional sliders

Drag left <> right on slider to adjust value

Double-tap slider handle to reset slider

Edit panels

Swipe panel row left <> right to show all sets of sliders

Hold panel icon to temporarily hide the panel's adjustments

Hold finger on photo to preview without recent edits

Sync Status incl. download full size original (if available)

Undo/ Versions menu

Share menu

... menu

Sub menus:

Presets Crop Sliders Masking Healing

Tap Toolstrip button to view Edit panels

To view clipping warnings, hold one finger on photo while dragging slider handle

EDIT PANELS (IPAD)

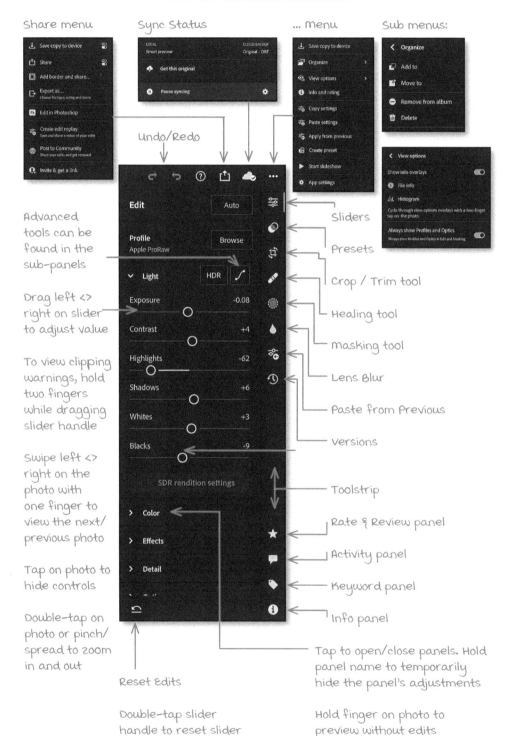

Share menu

Sync Status

... menu

Sub menus:

Undo/Redo

Advanced tools can be found in the sub-panels

Drag left <> right on slider to adjust value

To view clipping warnings, hold two fingers while dragging slider handle

Swipe left <> right on the photo with one finger to view the next/ previous photo

Tap on photo to hide controls

Double-tap on photo or pinch/ spread to zoom in and out

Sliders

Presets

Crop / Trim tool

Healing tool

Masking tool

Lens Blur

Paste from Previous

Versions

Toolstrip

Rate & Review panel

Activity panel

Keyword panel

Info panel

Reset Edits

Double-tap slider handle to reset slider

Tap to open/close panels. Hold panel name to temporarily hide the panel's adjustments

Hold finger on photo to preview without edits

EDIT PANELS (DESKTOP)

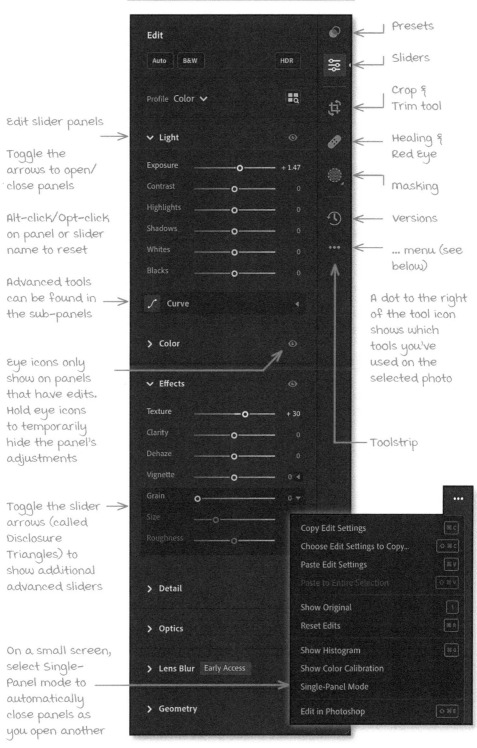

Presets

Sliders

Crop &
Trim tool

Healing &
Red Eye

masking

Versions

... menu (see
below)

Edit slider panels

Toggle the
arrows to open/
close panels

Alt-click/Opt-click
on panel or slider
name to reset

Advanced tools
can be found in
the sub-panels

A dot to the right
of the tool icon
shows which
tools you've
used on the
selected photo

Eye icons only
show on panels
that have edits.
Hold eye icons
to temporarily
hide the panel's
adjustments

Toolstrip

Toggle the slider
arrows (called
Disclosure
Triangles) to
show additional
advanced sliders

On a small screen,
select Single-
Panel mode to
automatically
close panels as
you open another

the previous one, so you're only looking at one panel at a time. To get the same behavior on the desktop, go to the ... menu in the Toolstrip and enable **Single-Panel Mode**. (iPad diagram: page 150 / Desktop diagram: page 151)

EDITING VIDEOS

Although Lightroom's Edit tools are primarily focused on photos, some can also be used on videos. Panels and sliders that don't work on video are dimmed. Presets may not look the same when applied to videos as they do on photos, as only some edits can be applied. You can also rotate and flip videos and trim off the ends (page 190).

NON-DESTRUCTIVE EDITING

Lightroom's editing tools are non-destructive. This simply means that the edits

Panels/sliders unavailable for videos: mobile (top), Desktop (bottom)

are saved as a series of text instructions. If you make an edit one day in Lightroom and change your mind the next day, you can simply move the slider back without degrading the image quality.

OPTIMAL EDIT WORKFLOW

Non-destructive editing also means you can make adjustments in whatever order you like, skipping from one tool to the next. However, there are more efficient ways of working. For optimal performance, Adobe recommends the following order:

1. Denoise (page 274), Merge to HDR (page 216), or Merge to Panorama (page 292)

2. Healing (page 297)

3. Optics panel: Remove Chromatic Aberration and Enable Lens Corrections (page 279)

4. Profile (page 172)

5. Global Adjustments: Light panel, Color panel, Effects panel, Detail panel, Geometry panel

6. Local Adjustments, for example, Masking (page 309) or Lens Blur (page 254)

Don't worry if you're not familiar with these tools yet; we'll cover them all in the coming pages. But why do they recommend that order? Let's consider a few examples:

• If you're going to merge multiple exposures into a single HDR image (page 216), there's no point editing those photos until you've done the merge, so HDR merge is best done early in the workflow.

• If you're going to use the Denoise tool on

a photo, you'd have to go back and change any sharpening and update any AI-based tools that use build masks from the image data, as the existing masks would still be noisy, so Denoise is worth doing early in your workflow.

• If you build an AI-based mask, for example, a Sky mask, but then you use the Healing tool to remove a bird in the sky, the Sky mask has to be updated, so it's more efficient to do Healing early in your workflow.

• If you're going to send a photo to Photoshop for advanced retouching, it'll be sent as a rendered image with all of your Lightroom edits applied to the pixel data, so you won't be able to go back and change any of your Lightroom edits unless you go back to your original file. It's worth finishing everything you need to do in Lightroom before you send the photo to Photoshop.

In practice, you'll find your own editing workflow that suits your photographic style. There will be some tools you use on most photos and others you rarely use. But if you run into performance issues or get unexpected results, just bear these suggestions in mind.

There's a suggested Edit Workflow diagram on page 154.

WORKFLOW TOOLS

As you start to get better at editing, Lightroom offers tools that can help improve efficiency and consistency over groups of photos and allow you to experiment with more freedom. For example, how to undo your edits or copy and paste them to other photos. These are handy to know about before you get started, so we'll discuss these tools next.

IN THIS CHAPTER, WE'LL CONSIDER:

• How to undo and reset edits.

• How to compare the photo with the unedited original.

• How to create multiple versions of the same photo.

• How to copy edits to other photos.

• How to edit videos.

EDIT WORKFLOW

ANALYZE & PREPARE THE IMAGE

Look for technical faults

Consider your artistic intent

Apply Enhance > Denoise if
the photo is too noisy

merge multiple images
for HDR / Panorama

Heal any distractions early to avoid
creating ghosts in AI-based masks

Apply your starting point preset,
which might set the Camera Profile,
enable Lens Corrections & HDR, plus
any other settings you usually use

Roughly crop

\downarrow

BASIC CORRECTIONS

Light & Effects panels:
Exposure,
Highlights & Shadows,
Whites & Blacks,
Clarity & Dehaze

Color panel:
White Balance,
Vibrance,
Saturation,
B&W

Effects & Detail panels:
Texture,
Sharpening,
Noise Reduction

\downarrow

FINE-TUNE THE CORRECTIONS

Light panel:
Contrast,
Tone Curve

Color panel:
Color/B&W mixer,
Point Color

Optics panel:
Remove CA &
Defringe

Geometry panel:
Upright & manual
Transforms

\downarrow

ADD EFFECTS

Light panel:
R,G & B Tone Curves
for effect

Color panel:
Color Grading

Effects panel:
Add Grain,
Add Vignette

\downarrow

MAKE LOCAL ADJUSTMENTS

masking

Lens Blur

Finalize Crop

\downarrow

FINISH OFF

Adjust for SDR
Display (if HDR)

Photo menu > Update AI Settings
if they might be out of date

Edit in Photoshop

UNDOING MISTAKES & RESETTING EDITS

We've already learned that Lightroom is a non-destructive editor. It doesn't apply the settings to the original image data but stores your edits as a list of text instructions (*Exposure* +1.2, *Highlights* -40, *Shadows* +40, etc.). This means you can easily undo any edits you've made to your photo in Lightroom, even if it was edited months ago, so you can experiment without fear and try new things. It's a great way of learning.

If you don't like a slider setting, the most obvious solution is to move the slider to a new value, but there's also a variety of undo and reset options.

UNDOING / REDOING ACTIONS

To **undo your last edit** (or the one before that, or the one before that...) on iPhone/ Android, tap the undo button to show the pop-up, then tap the undo or redo buttons. On iPad, undo and redo are separate buttons at the top of the screen. On mobile, undo/redo only apply to the edits you've made since you last switched photos.

Undo → ↰ ↱ ← Redo

Versions → ⏱ Versions

↩ Reset ← Reset

On the desktop, undo doesn't just apply to edits on the selected photo. It remembers most things you've done in chronological order—including adding star ratings, flags, metadata, and even switching photos—for as long as Lightroom's open. When you quit Lightroom, the undo history is cleared. To undo your last action, just keep hitting Ctrl-Z (Windows) / Cmd-Z (Mac) to step back in time. If you go too far, use Ctrl-Y

(Windows) / Cmd-Shift-Z (Mac) to redo the last undone action.

RESETTING THE EDITS

If you made the change you want to undo some time ago, then the reset options are a better choice. These reset a single slider, a whole section of sliders, or all of the edits applied to a photo back to their default settings (page 180).

To **reset a single slider** on mobile, double-tap on the slider handle. On the desktop, float over the slider label, which changes to a ***Reset*** button, then click on it.

To **reset a whole panel of sliders** (desktop only), hold down the Alt key (Windows) / Opt key (Mac) and click on the panel name.

To **reset the entire photo** back to default settings on iPhone/Android, tap the Undo button to show the pop-up, then tap the ***Reset*** button. On iPad, tap the Reset button at the bottom of the Edit panels.

← Reset button

It offers a series of options:

Adjustments resets everything except the Crop.

All resets all settings to the default settings.

To Import resets all of the settings to the settings selected when the photo was first imported to the mobile device or synced to

the cloud.

To Open resets the photo to the settings used when you switched to the photo.

On the desktop, click the ... menu in the Toolstrip to show the fly-out menu, then select ***Reset Edits***, or use the keyboard shortcut Ctrl-R (Windows) / Cmd-R (Mac).

COMPARING VERSIONS & CREATING COPIES

While you're learning how to edit your photos, you'll want to compare your edits against earlier versions and experiment without losing the edits you're happy with. Lightroom provides the tools you need.

VIEWING A BEFORE/AFTER PREVIEW

While you're working on editing your photos, you can **compare your edited version with the original default settings**. It retains your current crop and geometry settings to make it easy to compare your other edits.

To display the Before view on mobile, hold your finger on the photo in Detail view to display the Before view. On the desktop, click the *Show Original* icon in the toolbar beneath the photo, press the \ key on your keyboard, or use the **Show Original** command in the ... menu in the Toolstrip. Repeat to show the edited version again.

To **temporarily hide a panel's adjustments** on iOS, hold your finger on the panel name.

On the desktop, hold down the eye icon. (This feature isn't currently available on Android.)

SAVING VERSIONS

Sometimes you'll want to create different edits of the same photo. Perhaps you want to try it in color and in B&W, or you can't decide between a few different presets.

Versions are like snapshots. They capture the slider settings at the moment of their creation. They're automatically synced to the cloud, so they're available on all of your devices. As they're purely an additional set of edit instructions, they don't take up much extra space in your cloud storage. They only appear in the Versions panel.

To **show the Versions panel** on iPhone or Android, tap the Undo/Versions button at the top of the screen, then select Versions.

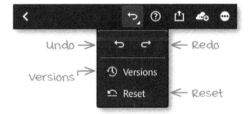

On iPad or desktop, tap/click the **Versions** button in the Toolstrip or use the keyboard shortcut Shift-V (desktop only).

To **create a version**, tap/click the **Create Version** button, then give the version a name to help you remember why you saved it. These are shown in the **Named** tab of the Versions panel. On the desktop, the keyboard shortcut Shift-M creates a new version even if the panel is hidden.

Lightroom also **creates versions automatically** when you switch to a different photo or switch back to Grid view.

These are shown in the **Auto** tab of the Versions panel.

You can **convert an Auto version to a Named version** by tapping/clicking on the ... menu next to the *Apply* button (mobile) / to the right (desktop) and selecting **Save as Named Version**.

To **preview a version**, tap on the version thumbnail (mobile) / float the cursor over the version name (desktop). The effect is previewed on the photo in the main preview area, and on the desktop, the sliders move temporarily to their saved positions.

To **apply the saved settings** on mobile, tap on the version thumbnail and then tap the *Apply* button. On the desktop, simply click on the version name.

To **rename a version**, tap/click on the ... menu next to the *Apply* button (mobile) / to the right (desktop) and select *Rename*.

To **delete a single version**, tap/click on the ... menu next to the *Apply* button (mobile) / to the right (desktop) and select *Delete* (but take care as it will be deleted from all of your devices). You can't delete the *Original* version.

To **clear all of the versions**, tap/click on the ... menu near the thumbnails (iOS/Android) / at the top of the panel (iPad/desktop) and select *Delete > All Named Versions* or *Delete > All Autosaves*.

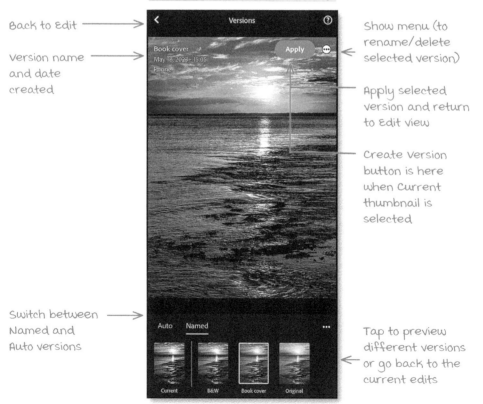

VERSIONS (MOBILE)

Back to Edit

Version name and date created

Switch between Named and Auto versions

Show menu (to rename/delete selected version)

Apply selected version and return to Edit view

Create Version button is here when Current thumbnail is selected

Tap to preview different versions or go back to the current edits

To **export a copy of a single version** (desktop only), click on the ... menu to the right and select *Export with these settings* to show the Export dialog. We'll come back to export settings (page 397).

To **export a copy of all versions** (desktop only), click on the ... menu at the top of the panel and select *All Named Versions (Small JPEG)* or *(Large JPEG)*. This can be useful if you want to compare multiple versions side by side in other software or send them to someone else for their opinion. The exported photos include the version name, so you can identify them again later.

To **close the Versions panel** on iPhone/Android, tap the back button. On an iPad or desktop, tap/click the X in the corner or the *Versions* button again.

CREATING DUPLICATES ON THE DESKTOP

Duplicates are real copies of the photos. They take up additional cloud storage space and appear in the Grid view as separate photos.

To **create a copy of a photo** (desktop only), right-click and select **Duplicate 1 Photo**. You'll also find it in the *Edit* menu. At the time of writing, you can't create a duplicate using the mobile apps.

The duplicate is entirely independent of its original, so you can add different metadata or delete it, just as any other photo.

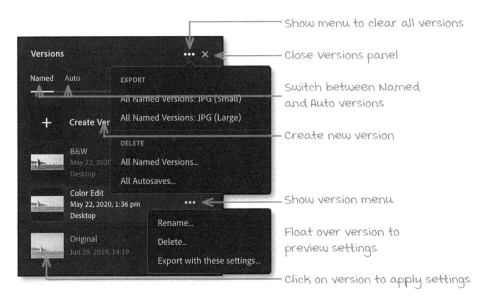

VERSIONS (DESKTOP)

Show menu to clear all versions

Close versions panel

Switch between Named and Auto versions

Create new version

Show version menu

Float over version to preview settings

Click on version to apply settings

COPYING & PASTING EDITS

If you're shooting a series of photos in a similar light, they will likely need similar edits. You can copy and paste the settings to save time and improve consistency.

COPY/PASTE ON MOBILE

To **copy and paste settings** to one or more photos using a mobile device:

1. In Detail view, tap the ... menu and select *Copy Settings*.

2. In the Copy Settings menu, check the groups of settings you want to copy or tap the arrow to check/uncheck individual sliders. Tap the checkmark to copy the settings to the clipboard.

3. If you only want to paste to a single photo, stay in Detail view. Switch to the next photo, tap the ... *menu*, and select *Paste Settings*.

If you want to apply the settings to multiple photos, switch back to the Grid view, select the photos, and select *Paste Settings* from the buttons below (iOS) / ... menu (Android). Turn back to (page 30) for a reminder of how to quickly select multiple photos. (On iOS, you can also copy the default settings to the clipboard from that multi-select Grid view.)

On mobile, there's an additional *Apply from Previous* option in the ... menu (iPhone/Android) / Toolstrip (iPad), which **copies edits from the previously selected photo** onto the current photo without going through the Copy Settings dialog. It asks whether to copy *All* or *Adjustments*, which excludes the Crop and Healing edits.

COPY SETTINGS (MOBILE)

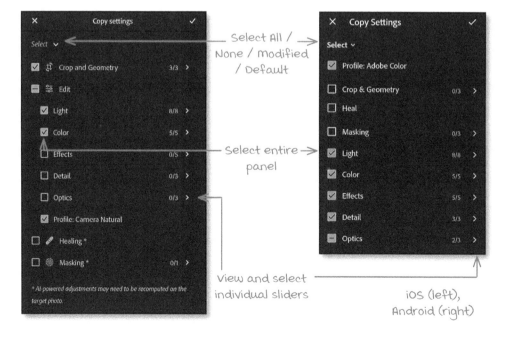

Select All / None / modified / Default

Select entire panel

View and select individual sliders

iOS (left), Android (right)

 ← Previous button

COPY/PASTE ON THE DESKTOP

To **copy the default edits** to the clipboard, click the **Copy Edit Settings** button in the toolbar under the photo or use the shortcut Ctrl-C (Windows) / Cmd-C (Mac). (We'll come back to deciding which settings are included by default in a moment.)

To **copy specific edits** to the clipboard, click the cog icon next to the *Copy Edit Settings* button. In the Copy Settings dialog, check the specific panels, sliders, or tools you want to copy to the clipboard. The pop-up above the checkboxes automatically checks specific sliders/tools for you:

All obviously checks all of the checkboxes, and **None** unchecks everything.

Default checks the tools/sliders Adobe thinks you'll want to include or the checkboxes you've set as copy defaults (page 162).

Modified checks only the sliders you've edited and tools you've used.

If you always want to see this Copy Settings dialog when copying settings, check **Show this every time you copy**.

Click **Copy** to place the checked settings on the clipboard.

To **paste the edits** to one or more photos, click **Paste Edit Settings** or use the shortcut Ctrl-V (Windows) / Cmd-V (Mac).

COPY SETTINGS (DESKTOP)

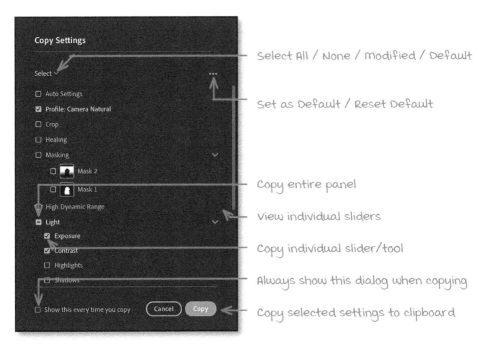

Paste Edit Settings X

If you're in Grid view, the edits are applied to all selected photos.

If you're in Detail view, they'll only be applied to the active photo. (It is possible to paste to multiple photos from Detail view by going to the ... menu > *Paste to Entire Selection*, but be careful if your Filmstrip is hidden, as you might not realize how many photos are selected.)

To **clear the clipboard**, click the X icon next to *Paste Edit Settings* or use the keyboard shortcuts to copy new settings.

DEFAULT COPY SETTINGS ON THE DESKTOP

When you copy edit settings without visiting the Copy Settings dialog, Lightroom chooses which settings to copy. By default, it copies everything except the Crop, Healing, Masking, and Geometry edits, as these are likely to be in different positions on different photos.

You can **change the copy defaults** by checking your chosen checkboxes in the Copy Settings dialog, clicking the ... icon on the right, and then selecting **Set as Default**.

COPY/PASTE MASKS

If you include Masking (page 148) when copying settings, and there are already masks applied to the target photo, Lightroom asks whether to **Replace** or **Merge** the mask settings. *Replace* removes the existing masks and replaces them with the pasted ones, whereas *Merge* keeps the existing masks and adds the pasted ones on top.

SELECTING A STARTING POINT

11

Over the last few years, presets and filters have become a popular way of editing photos. In an earlier lesson (page 125), we said they can be a bit of a blunt instrument when used alone. However, combined with other editing skills, they can be a valuable addition to your workflow.

FILM STOCK

Building your photo from a base profile isn't a new concept. In the world of film photography, each film has its own characteristics, and a photographer chooses their film stock based on the kind of look they desire.

Kodak's Portra range is popular for portraits, with its natural skin tones, realistic color saturation, and fine grain, whereas their Ektar film offers much more vivid and highly saturated colors.

Slide films like Kodak's now-retired Kodachrome and Ektachrome and Fuji's Provia and Velvia have long been popular with landscape photographers for their vibrant, punchy colors and high contrast.

For B&W, the iconic Kodak Tri-X has lots of contrast and distinctive grain, making it popular for street and documentary photography. In contrast, Kodak's T-Max had a finer grain for a cleaner look.

In the same way, you can build your photo edits from a specific base profile, depending on the look you desire.

PROFILES VS. PRESETS

Lightroom uses three different types of profiles and presets, each with advantages and disadvantages:

Presets save sets of slider values and masks to easily apply to other photos, and they're found in the Presets panel. They can be used to apply a specific style, but because they move the sliders, you can study the results to learn how to create that look yourself. You can also create your own presets to improve efficiency. For example, you might save the edits you use on most photos to apply as default settings or create a set of AI-based masks to retouch portraits with a single click.

Camera-specific profiles only work on raw files and are designed to be a starting point for your editing. They're found in the Profile panel.

Creative profiles are created by artists and can apply more advanced adjustments than presets. They add a distinctive look and are designed not to require much editing beyond corrections for exposure, lens distortion, sharpening, etc. These are also found in the Profile panel.

WHEN TO APPLY PROFILES & PRESETS

You'll generally need to select your profile or preset before you start moving sliders, as profiles change the overall look, and presets move sliders, overwriting any existing edits. The exception is presets that only move a few sliders, such as your favorite vignette settings.

IN THIS CHAPTER, WE'LL CONSIDER:

• How to preview and apply presets.

• How to download presets or create your own.

• How to preview and apply profiles.

DIFFERENCES BETWEEN PRESETS & PROFILES

Presets	Camera-Specific Raw Profiles	Creative Profiles
.lrtemplate or .xmp file extension	.dcp or .xmp file extension	.xmp file extension
Work on all photo formats, unless they call a raw-only profile	Work on raw files only (usually camera-specific)	Most work for all photo formats
Create them yourself using Lightroom	Mostly created by third-party developers using DNG Profile Editor (.dcp format) or Profiles SDK (.xmp format)	Mostly created by third-party developers using Profiles SDK
Moves sliders, so you can see how the adjustments were created	Separate layer of adjustments, which doesn't move visible sliders, so they're more difficult to learn from	Separate layer of adjustments, which don't move visible sliders, so they're more difficult to learn from
Can only adjust visible Lightroom tools such as sliders	Applies normal Lightroom edits behind the scenes, plus 3D LUT's for more advanced color adjustments	Applies normal Lightroom edits behind the scenes, plus 3D LUT's for more advanced color adjustments
Exaggerate/fade effect using *Amount* slider, then edit from there	Can't be faded	Exaggerate/fade effect using *Amount* slider, then edit from there
Best for your own settings, to improve consistency and efficiency	Best as a starting point, like film stock	Best for special effects

SAVING SETTINGS AS PRESETS

Presets can help you to:

Discover Your Editing Preferences—By playing with presets supplied by Adobe or downloaded from the web, you can learn more about what you like and don't like when editing your photos and then learn how to create those effects yourself.

Improve Efficiency—For example, you may find yourself selecting a camera-matching profile, decreasing *Highlights*, increasing *Shadows*, and adding a little *Clarity* and *Vibrance* to most photos. Rather than having to move multiple sliders, you can select a single preset.

Improve Consistency—Presets (especially those you've created yourself) can help ensure consistency over a group of photos or your entire portfolio by saving and applying the same settings.

Presets move visible sliders, so unlike profiles, you can apply multiple presets that do different things. For example, you may apply a preset as a starting point, another that adds facial retouching masks, and another that applies your portrait sharpening settings.

THE PRESETS PANEL

To **show the Presets panel**, tap/click the *Presets* button in the Toolstrip or use the keyboard shortcut Shift-P (desktop only).

← Presets button

The Presets panel has three tabs: *Recommended*, *Premium*, and *Yours*.

Recommended presets are AI-based suggestions for the selected photo, made using edits shared by the Lightroom community (page 380).

Premium presets are provided by Adobe and handcrafted by skilled photographers. They're only available for paid subscribers.

Yours includes some additional presets provided by Adobe, and any presets you import or create yourself.

PREVIEWING & APPLYING PRESETS

In the *Recommended* tab, the presets show as thumbnails. You can **filter the**

Presets panel > Recommended tab:
mobile (left), Desktop (right)

*Presets panel > Yours tab:
mobile (top left & right),
Desktop (bottom right)*

recommended presets by style using the buttons above the thumbnails. When you find a preset you like, tap on it (mobile) / float over it (desktop) to see additional options. The *More Like This* button displays similar presets. If you tap/click the preset's ... button, you can save the preset to your own preset library, save a Version (page 157) of your photo with the preset applied (desktop only), and see information about the photographer who created the preset.

To **show the presets** in the *Premium* and *Yours* tabs, tap/click the arrows to open/close the preset groups.

Some presets in the *Premium* and *Yours* tabs may be hidden from view, depending on the selected photo type. For example, by default, a preset that includes an Adobe Raw profile does not show for a JPEG image because the Adobe Raw profile is not available for

JPEG images and would create a different result. To **show the partially compatible presets**, tap/click the ... button at the top of the Presets panel and toggle *Show Partially Compatible Presets* (mobile) / *Hide Partially Compatible Presets* (desktop).

To **preview a preset** on mobile, tap the preset thumbnail; the preset isn't applied on mobile until you confirm. On the desktop, float the cursor over the preset name. The effect is previewed on the photo in the main preview area, and on the desktop, the sliders also move temporarily to their preset positions.

To **apply a preset to the selected photo** on mobile, tap on the preset and then tap the checkmark/*Done* button. On the desktop, click on the preset thumbnail or name.

Applying a preset moves any sliders that were checked when the preset was created,

overwriting their existing settings. The exception is Masking (page 148), which adds any masks included in the preset on top of any existing masks rather than replacing them.

To **close the Presets panel** on the desktop, click the *Presets* button again. On mobile, it automatically closes when you tap the checkmark/*Done* button or the *X/Cancel* button closes without applying the preset.

Toolstrip and select *Reset Edits*). Next, apply the preset. Without making any further changes to the edits, right-click on the preset, select *Update with Current Settings*, and then *Update*. If the preset's settings are scalable, the next time you apply the preset, the *Amount* slider will be available. (It is possible to update the preset on mobile, but the desktop automatically checks the sliders that the preset adjusted rather than overwriting all settings.)

SCALING PRESETS

To **scale (fade or amplify) a preset** you've just applied on mobile, tap the preset thumbnail to access the **Amount** slider. On the desktop, the slider appears below the preset name.

The default setting of *100* applies the preset as it was created. *200* doubles the effect of the preset, and *0*, of course, removes all of the scalable settings. Some edits, such as *Auto*, lens corrections, or geometry, aren't scalable, so these are always applied using the original preset settings. The *Amount* slider is dimmed if none of the preset's adjustments are scalable.

The *Amount* slider may also be dimmed on some older presets, but you can update them on the desktop. To do so, reset the photo to defaults (click the ... menu in the

IMPORTING & SYNCING PRESETS

A large cottage industry has grown around Lightroom, with a vast number of free and paid presets and profiles available. Develop presets designed for Lightroom 4-6, Lightroom Classic, or Camera Raw will work with the Lightroom ecosystem. These may be marked as PV2012/PV2017 or PV3-PV6. (Other types of presets, for example, those marketed as Local Adjustment Presets or Brush Presets, don't currently work with the Lightroom ecosystem.)

To **install presets on Android**, tap the ... button at the top of the Presets panel and select **Import Presets**. You can import presets from your device's storage (such as the Downloads folder) or Google Drive. Select the individual presets, or a whole zip file containing multiple presets to start the import.

Preset Amount slider:
mobile (left), Desktop (right)

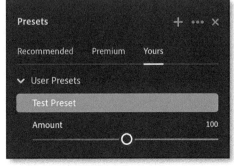

To **install presets on the desktop**, go to *File menu > Import Profiles & Presets* or click the ... icon at the top of the Presets panel and select *Import Presets*. Navigate to the folder or zip file containing the presets and click *Import*.

Preset import is not yet available on iOS or the Web. However, any profiles or presets you import on the desktop (or create on any of your devices) are automatically synced to the cloud, so they're available everywhere.

CREATING PRESETS

As you start finding combinations of sliders you like or use frequently, you can create your own presets.

To **create a preset**, tap/click the ... button at the top of the Presets panel, select **Create Preset**, then give the preset a name. If there's already another preset by that name in the same group, Lightroom asks whether to replace the existing preset or keep both, adding an extra number to your chosen preset name.

In the *Preset Group* (mobile) / *Group* (desktop) pop-up, select an existing preset group or select *Create New Preset Group* (mobile) / *New Group* (desktop) to create a new one.

Check the panels or individual slider values you want to include in your preset, and then tap the checkmark (mobile) / click *Save* (desktop).

If you frequently save the same sliders in presets, click the ... button in the Create Preset dialog (desktop only) and select **Set as Default** to check those sliders automatically in the future.

If you later change the sliders and want to **update the preset**, you can tap on the ... menu to the right of the preset (mobile) / right-click on the preset (desktop), and select *Update with Current Settings*.

ORGANIZING PRESETS

Over time, your preset collection will grow, so you'll need to organize them. It's easy to end up with too many presets, and you can't see the wood for trees.

To **rename a preset**, tap on the ... menu to the right of the preset (mobile) / right-click on it (desktop) and select *Rename*.

To **delete a single preset**, tap on the ... menu to the right of the preset (mobile) / right-click on it (desktop), and select *Delete* (but take care as it will be deleted from all of your devices).

To **move a preset into another group** on Android, tap the ... menu to the right of the preset (mobile), select *Move To*, and then select a different group. On the desktop, right-click on the preset and select *Move to Group > [the name of the new group]*. While moving or creating a preset, you can also **create a new group**. (Moving presets is not currently possible on iOS.)

To **rename an existing preset group** (desktop only), right-click on it and select *Rename Group*.

To **delete an entire preset group** (desktop only), right-click on it and select *Delete Group* (but it will be deleted from all your devices).

To **hide a preset group** without deleting it, tap/click the ... menu at the top of the Presets panel and select *Manage Presets*. Uncheck the preset group and click the *Done/Back* button to return to the Presets panel. To show them again, repeat the

PRESETS PANEL (MOBILE)

Show AI-based preset suggestions

Tap thumbnail to preview preset on photo

Tap to apply the preset or cancel (Done/Cancel buttons on iPad)

Show Premium presets (only if paid subscriber)

Show your presets plus free Adobe preset groups

Tap to view a preset group

Tap to view a preset group

Tap thumbnail to preview preset on photo

On your own presets, tap ... to rename, update or delete preset. On Android, you can also move to a new preset group.

Tap ... at the top to create new presets, show/hide preset groups and Show/Hide Partially Compatible Presets

Save new preset

New preset name

Set preset group

Select All / None

Select Modified / Default
also available on Android

Include entire panel of sliders

View checkboxes for
individual sliders

Back to Presets panel

Show/Hide Preset Groups

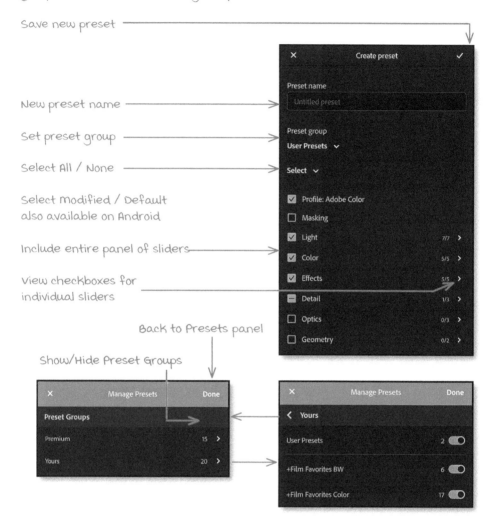

process and check the preset group. On the desktop, you can also right-click on the preset group and select *Hide* or *Reset Hidden Presets*. This visibility status is local, so you can have all of your presets available on the desktop but only your favorite groups visible on the smaller screen of your mobile device.

SHARING PRESETS ON THE DESKTOP

As your preset creation skills improve, you may want to **share a preset** with other photographers. To do so (desktop only), right-click on a preset or preset group, select *Export / Export Preset Group*, and then navigate to a folder on your hard drive. Preset groups are automatically zipped and ready for sharing.

PRESETS PANEL (DESKTOP)

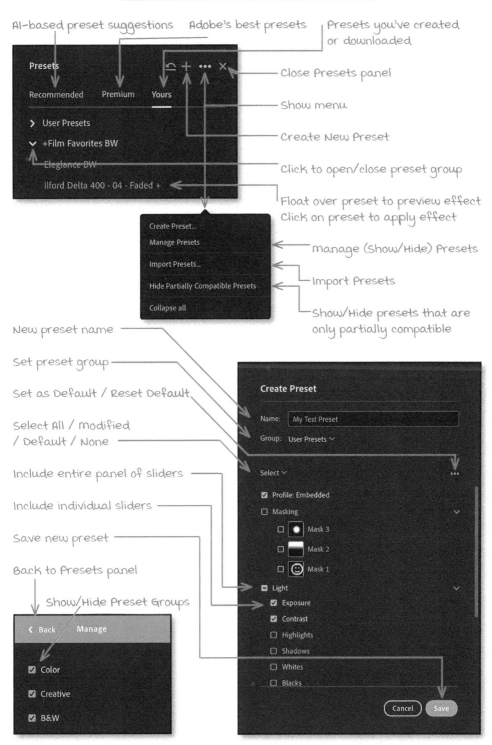

AI-based preset suggestions

Adobe's best presets

Presets you've created or downloaded

Close Presets panel

Show menu

Create New Preset

Click to open/close preset group

Float over preset to preview effect
Click on preset to apply effect

Manage (Show/Hide) Presets

Import Presets

Show/Hide presets that are only partially compatible

New preset name

Set preset group

Set as Default / Reset Default

Select All / Modified / Default / None

Include entire panel of sliders

Include individual sliders

Save new preset

Back to Presets panel

Show/Hide Preset Groups

BROWSING, APPLYING & IMPORTING PROFILES

Camera-specific and Creative profiles are found in the Profile panel. You'll find that in the Edit panel buttons (iPhone/Android) / at the top of the Edit slider panels (iPad/desktop).

By default, the **Profiles panel is hidden** on iPhone/Android. To add it to the Edit panels, go to the Detail view's ... *menu > View Options > Always show Profiles and Optics.*

To **view the full range of profiles** on iPhone/Android, tap on the pop-up to show other profile groups. On iPad/desktop, tap/click the **Browse** button or use the keyboard shortcut Shift-B (desktop only).

SETS OF PROFILES

When you open the Profile Browser, you'll notice that the profiles are grouped into

Profiles panel:
iPhone/Android (top), iPad
(center) Desktop (bottom)

folders/sets.

The **Basic** set appears for rendered photos (JPEG/TIFF/PSD/PNG format), as they don't have Adobe Raw profiles. There are simple *Color* and *Monochrome* profiles for these file types.

The **Adobe Raw** profiles aim to make photos from different cameras look as similar as possible, so if you change your camera or shoot an event with multiple camera brands, they'll blend well. They're available for raw photos from most (but not all) supported cameras.

Adobe Color is Adobe's default profile. The aim is to look great on a wide range of photos, so it adds a little contrast and saturation while attempting to protect the skin tones.

Adobe Portrait is optimized for a wide range of skin tones, including very pale and very dark skin, so it's ideal for portraits and family shots. It has a little less contrast than *Adobe Color*, but you can add contrast if you prefer a bit more punch.

Adobe Landscape automatically compresses the tones to give a little more headroom for outdoor photos, which often have a wide dynamic range, and the blues and greens are enhanced.

Adobe Vivid has a very punchy and saturated effect. It's great for sunsets and other very colorful photos but may be a little over the top for portraits.

Adobe Neutral is a very flat starting point, ready for you to edit your own way. It's ideal for photos with very tricky colors and gradients that don't quite work with the other profiles.

Camera-Specific Profiles

Creative Profiles

Adobe Standard is an older profile on which all other Adobe Raw profiles are based. It's similar to *Adobe Color* but has a little less contrast and saturation.

Adobe Monochrome is the default profile for B&W photos and is automatically assigned when you click the *B&W* button in the Color panel (mobile) / top of the Edit panels (desktop).

The **Camera Matching** profiles are designed to mimic your camera JPEG, so your raw files more closely match the image you saw on the back of the camera. In addition to the *Camera Default* or *Camera Standard* profiles, these profiles also try to emulate the other picture styles your camera manufacturers offer. The names of these vary by manufacturer; for example, Canon calls them Picture Styles, Nikon names them Picture Control, Fuji has Simulation Modes, Olympus has Picture Modes, and Sony calls them Creative Styles. These camera-matching profiles are available for most current DSLRs but may be missing from compact or older cameras, and they won't be available for rendered files.

The **Profiles** set contains any camera-specific DCP format profiles created using Adobe's DNG Profile Editor tool or the X-Rite ColorChecker Passport plug-in for Lightroom Classic, whether you created them or downloaded them from third parties such as VSCO or RNI Films.

The **Legacy Profiles** set contains B&W versions of some camera-specific profiles. As the set name suggests, these are to maintain compatibility with edits applied using previous Lightroom versions.

The **Creative Profiles** (*Artistic*, *B&W*, *Modern*, and *Vintage*) are primarily designed to apply special effects or a specific "look" to your photo, and they'll work for rendered

files (JPEG/TIFF/PSD/PNG) as well as raw photos.

The **Modern** profiles represent current fashions in photography, while the **Vintage** profiles are designed to look more like film photos. The **Artistic** profiles are designed to be more edgy, with stronger color shifts.

The **B&W** profiles are optimized for high-impact black & white work, offering a range of color channel mixes and tonal adjustments. In addition to the selection of numbered B&W profiles, there are profiles to imitate the effect of a colored filter, which were traditionally used at the time of capture when shooting B&W on film. The B&W profiles are a great starting point for B&W editing.

Creative Profiles can contain any normal slider adjustments to be applied "behind the scenes," but they can also include LUTs (Look Up Tables) for much more advanced color adjustments. 3D LUTs can, for example, tell Lightroom to make this shade of blue yellower and make this shade of blue more saturated and another shade of blue lighter. The tables allow profile developers to apply specific adjustments in precise, targeted ways that are impossible through any of Lightroom's sliders.

BROWSING & APPLYING PROFILES

To **apply a profile** on iPhone/Android, tap on the profile and then tap the checkmark to return to the standard Detail view. On an iPad/desktop, tap/click on it and then click the *Back* button to return to the normal Edit sliders, or on the desktop, double-clicking on the profile will do both at once. If you change your mind, you can return to the Profile panel and select a different profile at any time, but it's worth selecting the profile early in your workflow as it changes the

Desktop Profile
Browser styles:

List (left), Grid (center), Large (right)

whole look of the image.

On the desktop, the thumbnails may be a little small to preview properly, so float your cursor over the profile thumbnail or name to **preview the profile** on the larger preview. Hold down the Alt key (Windows) / Opt key (Mac) to briefly stop previewing the profile and compare it with your current one. You can change the thumbnail Grid view to a List view or Large thumbnail view by clicking the

Profile Amount slider:
iOS (top left), Android (bottom
left pair), Desktop (right)

... icon in the top right corner.

The effect of the **Creative profiles can be faded or exaggerated** using the *Amount* slider. On iOS, the slider shows at the bottom of the large preview image. On Android, tap the thumbnail again to show and adjust the slider, then tap the arrow to return to the thumbnails. On the desktop, the slider appears immediately below the profile thumbnail or in the main Profile panel. 100 applies the effect as the developer intended; moving the slider to the left reduces the effect of the profile, and moving it to the right exaggerates the effect.

SETTING FAVORITES

Over time, you're likely to use some profiles

more than others. This is good because the profile becomes part of your distinctive style. If you mix and match too many profiles, your work will lack consistency.

To **mark/unmark a profile as a favorite** on mobile, hold your finger on the thumbnail. On the desktop, click the star icon in the corner of the thumbnail or to the right in List view.

← Favorite profile

← Profile name

These profiles then show in the Favorites set at the top of the Profile Browser. On the desktop, they also appear in the pop-up, so you don't have to open the Profile Browser every time you want to switch profiles.

MANAGING PROFILES

If you know you want to create a color or B&W photo, you can **temporarily filter the profiles** by tapping/clicking the ... button and selecting *Show Only Color* (Android) / *Color* (desktop) or *Show Only B&W* (Android) / *B&W* (desktop) from the menu. *Show All Profiles* (Android) / *All* (desktop) shows all the profiles again. (This filtering is not currently available on iOS.)

There will likely be some profiles you don't use, and the number of profiles will grow over time as you download new ones, so Lightroom allows you to hide entire sets of profiles.

To **show and hide profiles** on Android, tap the ... menu in the Profile Browser and select *Manage Profiles* to check/uncheck profile sets, then tap the checkmark to return to the Profile Browser. (This isn't currently

available on iOS.) On the desktop, click the ... icon at the top of the Profile Browser panel, select *Manage Profiles*, check or uncheck profile sets, and then click the *Back* button to return. If you right-click on a profile set in the Profile Browser on the desktop, there's quick access to the *Hide* and *Reset Hidden Items* commands.

To **delete profiles** (desktop only), right-click on the profile and select *Delete*. This command is only available for profiles you've imported and only deletes one profile at a time.

IMPORTING & SYNCING PROFILES

Some third-party profiles are available for purchase and download.

To **install downloaded profiles** on Android, tap the ... button in the Profile Browser and select **Import Profiles**. You can import profiles from your device's storage (such as the Downloads folder) or Google Drive. Select the individual profiles or a zip file containing multiple profiles, then start the import.

On the desktop, go to *File menu > Import Profiles and Presets* or click the ... icon at the top of the Profile Browser and select *Import Profiles*. Navigate to the folder or zip file containing the presets and click *Import*.

Profile import is not yet available on iOS or the Web, but once profiles are imported into the desktop app, they sync to your other devices.

MISSING PROFILES

If you've used other versions of Lightroom (such as Lightroom Classic), or you've used Adobe Camera Raw in Photoshop, you may

have used camera-specific profiles (DCP format) without realizing it. For example, VSCO or RNI Films presets automatically select a camera-specific profile. These camera-specific profiles must be imported into Lightroom to be stored safely and synced to other devices.

On the first launch of the desktop app, Lightroom automatically imports any profiles installed on your computer (e.g., by Lightroom Classic or Camera Raw). However, if the profiles can't be automatically imported into Lightroom, it displays a missing profile warning on affected photos to remind you to import the profile or select a different one.

You may also see the Missing Profile error on mobile, as the iOS/Android apps only download profiles the first time they're needed. If it's one of Adobe's built-in profiles or a profile you know has been uploaded to the cloud, go back to Grid view and return to the photo later. The profile should automatically download, although it sometimes takes a little while. Unfortunately, there's currently no way to force a profile download, although force quitting the app and restarting sometimes triggers a download.

PROFILE BROWSER (MOBILE)

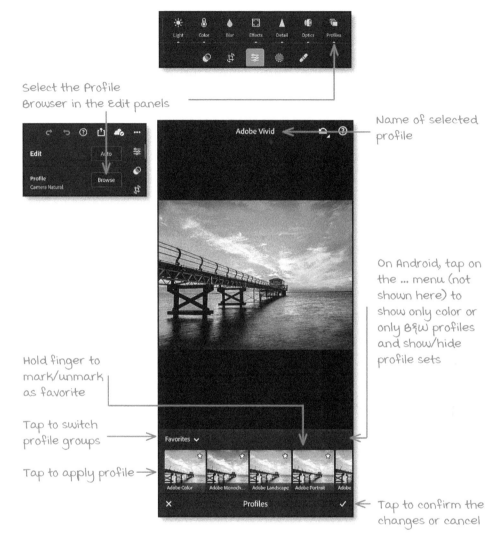

Select the Profile
Browser in the Edit panels

Name of selected
profile

On Android, tap on
the ... menu (not
shown here) to
show only color or
only B&W profiles
and show/hide
profile sets

Hold finger to
mark/unmark
as favorite

Tap to switch
profile groups

Tap to apply profile →

Tap to confirm the
changes or cancel

PROFILE BROWSER (DESKTOP)

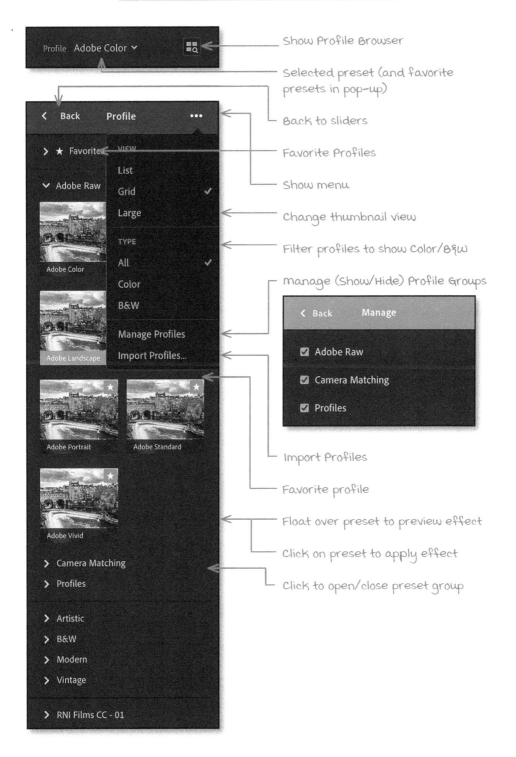

Show Profile Browser

Selected preset (and favorite presets in pop-up)

Back to sliders

Favorite Profiles

Show menu

Change thumbnail view

Filter profiles to show Color/B&W

Manage (Show/Hide) Profile Groups

Manage Profiles

Import Profiles

Favorite profile

Float over preset to preview effect

Click on preset to apply effect

Click to open/close preset group

SAVING TIME WITH RAW DEFAULTS

If you usually use the same preset on your photos, or you like to switch between different camera styles on your camera, then you might want to change the default settings that are applied to new raw photos when you import them.

any sliders are unchecked when creating the preset, Lightroom falls back on the Camera Settings as a default for these sliders. Adobe has provided a few default presets to get you started, including presets that apply specific profiles and enable lens corrections and noise reduction.

SETTING DEFAULTS

To **set your defaults**, go to *App Settings > Import (mobile) / Preferences > Import (desktop)* and select your chosen default from the **Raw Default** pop-up. Your new defaults automatically sync to your other devices. These are the choices:

Adobe Default is Adobe's own default setting, which uses the *Adobe Color* profile, with most sliders set to 0.

Camera Settings recognizes the picture style you selected in the camera and applies the camera matching profile if available. This is particularly useful if you use a compact or mirrorless camera since the picture style is what you see in the viewfinder or screen. Some recent cameras write additional Lightroom settings (such as custom sharpening) into the image metadata, so these settings are also applied.

Preset applies the preset of your choice (page 165). This is useful if you frequently apply the same settings to your photos. If

APPLYING DEFAULTS

The settings apply to any unedited raw files you import. They don't overwrite edit settings already stored with the file by Lightroom, Lightroom Classic, or Camera Raw. The defaults also apply when you reset a slider, panel, or whole photo back to default settings (page 155).

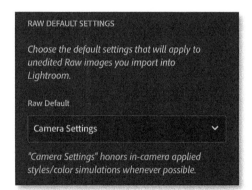

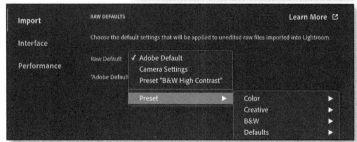

Raw Defaults Preference: mobile (top), Desktop (bottom)

CROPPING & STRAIGHTENING

12

In an ideal world, you'd have the time to ensure a photo was perfectly composed in the camera at the time of shooting. Unfortunately, few of us live in an ideal world, and by the time you've perfected the shot, you've missed the moment.

Cropping is the removal of the outer parts of a photo. Most photos benefit from cropping, whether to remove distractions from the frame, to straighten horizons, to improve the composition, to draw the viewer's eye to the subject, to fit a specific paper or frame shape, or simply to zoom in closer on the subject if you were unable to move closer at the time of shooting.

Any cropping you do within Lightroom is non-destructive. No pixels are deleted from the original files. They're just hidden. If you later change your mind, you can return to the Crop tool to adjust or reset the crop markings.

IN THIS CHAPTER, WE'LL CONSIDER:

• Some basic rules to help your composition.

• How to crop photos to specific aspect ratios to fit standard print sizes or frames.

• How to straighten wonky horizons.

• How to rotate photos by 90° if the camera didn't do it for you.

• How to trim videos.

COMPOSITION BASICS

Entire books are written on the subject of composition, so we won't attempt to cover the subject in detail in this book. However, the principles of composition apply to cropping photos in Lightroom as much as they apply to framing the photo in the camera.

If you're new to photography, there are a few basic principles to remember when learning to crop your photos. They're not hard and fast rules; as you grow in experience, you can break them, but they're a good place to start.

COMPOSITION TIPS

Use the Rule of Thirds to help you decide where to place the subject in the frame

Straighten the horizon, and any other lines that should be vertical or horizontal, especially if they're near the edge of the frame

Crop to fill the frame, to simplify the image and remove distractions

© Deposit Photos / DmitryPoch

Avoid cropping at people's joints as it looks unnatural. Crop mid-way between joints wherever possible

Avoid putting the subject or horizon dead center (unless there's symmetry)

If the subject is moving, leave space for the viewer's eye to follow

If a person or animal isn't looking at the camera, leave space to follow the subject's gaze

The orientation can affect the direction the viewer's eye travels, so select a vertical or horizontal crop with that in mind

Flip a photo if it helps the viewer's eye travel more smoothly from left to right

UNDERSTANDING ASPECT RATIO

Images on screen can be any shape you like, but if you're printing or framing a photo, you'll need to match the photo's aspect ratio to the paper or frame. If you don't crop to the correct ratio, you'll either end up with white paper showing along two edges, or the printer will cut off more of the photo than you intended.

ratios, not just cropping to square. Imagine trying to fit a panoramic photo into a standard rectangular frame, and you'll have the same issue.

We'll learn how to crop to a specific ratio in the next lesson.

WHAT IS ASPECT RATIO?

The aspect ratio is simply the proportional relationship between the width and height of a photo; in other words, it's the shape of the photo. You'll often see it written with a colon (2:3) or x (2x3).

Some aspect ratios are long and thin, whereas others are closer to square. A square is 1x1, which means the height and width are equal, whereas a 16x9 widescreen shape is a long, thin rectangle.

CROPPING FOR PRINTS/FRAMES

Imagine you have a rectangular photo and a square frame. Clearly, it won't fit, so what are your options?

1. Squash the photo to fit. This never looks good, so Lightroom doesn't let you do it.

2. Keep the rectangular shape, but add white borders along the other edges.

3. Crop the top and bottom (or sides) so that it will fit.

4. Buy another frame closer to the photo's aspect ratio so you don't need to crop as much.

The same principle applies to other aspect

STANDARD ASPECT RATIOS

1 x 1

4 x 5 / 8 x 10

8.5 x 11

5 x 7

2 x 3 / 4 x 6

The shape of standard print ratios varies. 4x5 is quite square, whereas 2x3/4x6 is longer and thinner

Screen sizes vary from traditional rectangular ratios to newer widescreen formats

4 x 3
1024 x 768

16 x 9
1920 x 1080

16 x 10
1280 x 800

CROPPING FOR PRINT

A rectangular photo and a square frame... how do you make the photo fit?

Squash it? Add borders? Crop it!

CROPPING & STRAIGHTENING PHOTOS

In the last couple of lessons, we've learned about composition and aspect ratios, but now, let's focus on the practicalities of cropping using Lightroom.

To **select the Crop tool** and show the crop options, tap/click the Crop button in the Toolstrip or press the C key (desktop only).

← Crop tool

STRAIGHTENING WONKY HORIZONS

Logically, our eyes expect the horizon to be horizontal, but most photographers have trouble getting it perfectly level at the time of capture. The Crop tool allows you to correct the rotation in a few different ways:

To let Lightroom attempt to **straighten the horizon automatically**, tap/click the *Straighten* button (mobile) / **Auto** button (desktop).

To **straighten the photo by eye** on a mobile device, drag your finger anywhere outside the bounding box. On the desktop, float the cursor outside the bounding box (the edge of the crop) so the cursor turns into a double-headed arrow, then click and drag to rotate the photo. A grid displays to help you judge the rotation.

To **straighten the photo using the slider**, adjust the *Straighten* slider under the photo (mobile) / in the Crop panel (desktop). While you're dragging the slider, a grid overlay displays to help.

As you rotate the crop, the photo remains level, so you don't have to turn your head to see how it will look once it's cropped.

To **manually draw the correct horizon**

line (desktop only), hold down the Ctrl key (Windows) / Cmd key (Mac), click on the horizon and drag further along the horizon, then release the mouse. Lightroom straightens the line and, in the process, straightens the photo too.

To **reset the rotation**, double-tap the curved slider under the photo (mobile) / click on the *Straighten* slider label (desktop). This only resets the rotation and doesn't expand the crop back to the edges of the original photo.

CROPPING PHOTOS

To **crop a photo**, drag the edges or corners of the bounding box (the edge of the crop). Occasionally, you'll try to drag the edge of the bounding box, but it won't move. This is because the photo is slightly rotated and bumping up against the edge. Move the crop boundary away from the edge of the photo or reset the *Straighten* slider to fix it.

To **crop a vertical rectangle out of a horizontal photo**, or vice versa, tap/click the *Rotate Crop Aspect* button. On the desktop, you can also press the X key or drag the corner of the bounding box at a 45° angle.

← Rotate Crop Aspect

To **move the photo** under the crop overlay, hold (mobile) / click (desktop) on the photo within the crop boundary and drag it.

To completely **reset the crop**, double-tap on the photo (mobile) / click the main *Reset Crop* button at the top of the Crop panel (desktop).

To apply the crop and **close the Crop tool**, tap the checkmark/*Done* button (mobile) / switch to a different tool in the Toolstrip (desktop).

CROP TOOL (MOBILE)

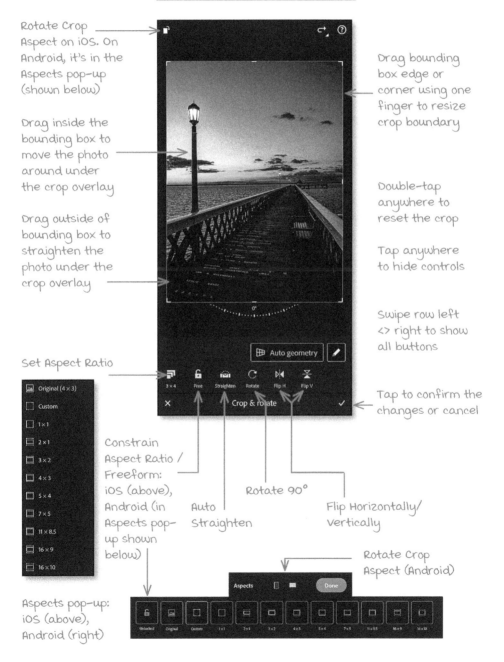

Rotate Crop Aspect on iOS. On Android, it's in the Aspects pop-up (shown below)

Drag inside the bounding box to move the photo around under the crop overlay

Drag outside of bounding box to straighten the photo under the crop overlay

Drag bounding box edge or corner using one finger to resize crop boundary

Double-tap anywhere to reset the crop

Tap anywhere to hide controls

Swipe row left <> right to show all buttons

Set Aspect Ratio

Tap to confirm the changes or cancel

Constrain Aspect Ratio / Freeform: iOS (above), Android (in Aspects pop-up shown below)

Auto Straighten

Rotate 90°

Flip Horizontally/ vertically

Rotate Crop Aspect (Android)

Aspects pop-up: iOS (above), Android (right)

SELECTING AN ASPECT RATIO

If you plan to print your photo using a standard print size or mount it in a standard shape frame, you'll need to crop the photo to the correct ratio, as we learned in the previous lesson (page 184). Lightroom offers the most frequent ratios as presets in the **Aspect** pop-up. If you need a different aspect ratio, select **Enter Custom** (desktop only) and type your chosen ratio. Lightroom saves your five most recent custom ratios at the bottom of the list.

The **Original** and **As Shot** options are identical for most photos. Some cameras (including Lightroom's own camera) allow you to crop the photos to a specific ratio at the time of shooting or display crop lines on the screen. *As Shot* respects the in-camera crop setting, whereas *Original* uses the full sensor data (where available).

To **constrain your crop** to a specific aspect ratio, tap/click the *Constrain Aspect Ratio* lock icon to close the lock (desktop/mobile) or hold down the Shift key while adjusting the crop (desktop).

 ← Constrain Aspect Ratio

CROP TOOL (DESKTOP)

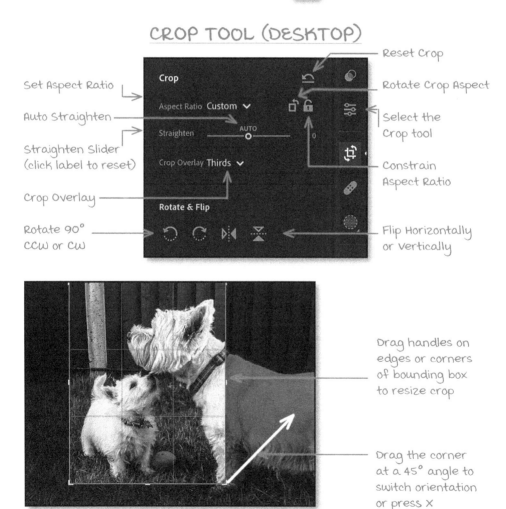

Reset Crop

Set Aspect Ratio

Auto Straighten

Straighten Slider (click label to reset)

Crop Overlay

Rotate 90° CCW or CW

Rotate Crop Aspect

Select the Crop tool

Constrain Aspect Ratio

Flip Horizontally or Vertically

Drag handles on edges or corners of bounding box to resize crop

Drag the corner at a 45° angle to switch orientation or press X

To **allow a freeform crop**, unlock the lock icon.

CROP OVERLAYS ON THE DESKTOP

On the desktop, the Crop Overlay appears when you float the cursor over the photo. It can be helpful as a composition guide. It's set to Thirds by default, named after the Rule of Thirds, but there's a variety of different overlays to choose from: *Grid, Thirds, Fifths, Diagonal, Center, Triangle, Golden Ratio, Golden Spiral,* and *Aspect Ratio.*

You can select a different crop overlay in the Crop panel or press the O key to cycle through the overlays. Shift-O changes the orientation of the overlays.

You may find you only use some of the overlays, so you can hide the others by going to *View menu > Edit Tools > Show Overlay > Choose Overlays to Cycle.*

ROTATING & FLIPPING PHOTOS

If your camera doesn't automatically rotate vertical photos, you can manually **rotate by 90°** using the circular arrow buttons.

 ← Rotate

You can also **rotate multiple photos by 90°** on the desktop by selecting the photos in Grid view and going to *Photo menu > Rotate Left/Right.*

Occasionally, you may want to flip a photo horizontally or vertically because we read photos from left to right. To **flip the photo**, tap/click the *Flip Horizontal* or *Flip Vertical* buttons.

 ← Flip

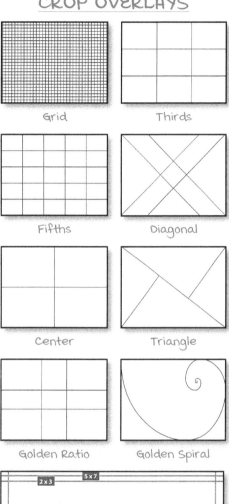

CROP OVERLAYS

Grid Thirds

Fifths Diagonal

Center Triangle

Golden Ratio Golden Spiral

Aspect Ratios

ROTATING, FLIPPING & TRIMMING VIDEOS

You can trim the ends of a video to reduce it to its most important section. It's not currently possible to cut sections out of the middle of a video or join multiple clips together.

To **select the Trim tool**, tap/click the Trim button in the Toolstrip or press the C key (desktop).

 ← Trim tool

To **trim the ends of the video**, drag the yellow trim handles (**in point** and **out point**) toward the center. The easiest way to select the best trim position is to drag the position marker or pause the video in the right spot. When you drag the trim handles, they snap to the selected frame, or on the desktop, you can use the buttons in the Trim panel to move the In/Out point to the cursor.

The trimmed sections of the video aren't removed from the original file, but they're hidden when playing the video in Lightroom and are excluded when you export the video to a new MP4 file.

To **rotate videos by 90°** tap/click the circular arrow buttons. **Flip the video** using the *Flip Horizontal* or *Flip Vertical* buttons.

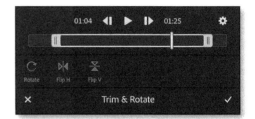

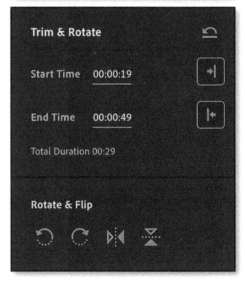

Trim panel:
mobile (top), Desktop (bottom)

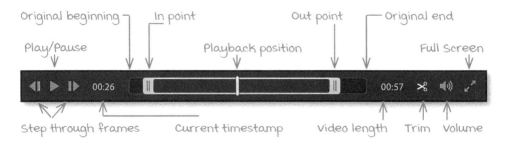

VIDEO TRIMMING (DESKTOP)

Original beginning — In point — Out point — Original end

Play/Pause — Playback position — Full Screen

00:26 — 00:57

Step through frames — Current timestamp — Video length — Trim — Volume

BALANCING LIGHT & CONTRAST

13

Photography is all about balancing light, shade, and the contrast between them. These adjustments are made using the sliders in the Light and Effects panels and are the focus of this chapter.

IN THIS CHAPTER, WE'LL CONSIDER:

• The best order to adjust the Light panel sliders.

• How to set the *Exposure* slider to optimize the overall image brightness.

• How the *Contrast* slider increases or decreases the overall (or global) contrast.

• When to use *Highlights* and *Shadows* to lighten or darken the highlight or shadow tones in your photo.

• How the *Whites* and *Blacks* sliders can increase the dynamic range or clip the highlight and shadow tones.

• How to use *Clarity* to add local contrast, giving the photo punch without compressing the highlight or shadow detail.

• How to use *Dehaze* to reduce or emulate atmospheric haze.

• When to use the Tone Curve instead of, or along with, the Light panel sliders.

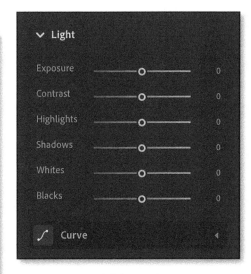

Light panel:
mobile (left), Desktop (right)

ADJUST FROM THE TOP... MOSTLY

You may have read articles and watched videos by numerous Lightroom users on editing photos, and they all have different opinions.

Some will tell you to start at the top of the Light panel and always work down. Others will tell you to always set *Whites* and *Blacks* first. Some will tell you to skip the Light panel (a.k.a. the Basic panel in Lightroom Classic) and use a Tone Curve instead. So, who is right?

They're all right—and they're all wrong. Setting hard and fast rules is impossible because Lightroom's Light sliders are image-adaptive (intelligent). The range and effect of the sliders change based on the content of the photo and the values of the other Light panel sliders.

This book discusses how the sliders were *designed* to work, as explained by the engineers who created them because they know the tools better than anyone.

WORK TOP DOWN... SORT OF

The Light sliders were designed to be used top down because the first few Light sliders affect the range of the lower Light sliders. For example, the sliders won't move far enough if you change *Highlights* and *Shadows* before *Exposure*. Little tweaks will be fine, but you'll want to get *Exposure* in the right ballpark first.

The *Contrast* slider is the exception. It can be used anytime as it doesn't affect the slider range, and it's usually easiest to set it after you've set the other Light sliders.

SKIPPING SOME SLIDERS

The top-down principle doesn't mean you have to adjust every slider. For example, a photo with a low dynamic range (one that doesn't stretch to pure white/black but should do so) is still best adjusted from top to bottom, but skip the *Highlights/Shadows* and go straight from *Exposure* to *Whites/Blacks*.

In the following lessons, we're going to look at the principles behind the "normal" use of each slider, as well as examples of when you might want to do things slightly differently, for example, if specific tonal ranges are more important than others, or where you want a softer look (without adding local contrast).

APPLYING AUTO ADJUSTMENTS

If you need a quick way to improve photos, try the **Auto** button. You'll find it on the left of the Edit panel buttons on iPhone/Android or at the top of the Edit panels on iPad/Desktop. On the desktop, the shortcut Shift-A applies the *Auto* adjustments, and if you hold down the Shift key while floating over the slider label, you can apply *Auto* settings to that single slider.

Light panel:
mobile (top), Desktop (bottom)

Like your camera's exposure meter, it's not as intelligent as you, so it doesn't know what's in the photo or how it's meant to look. Sometimes, it works great; sometimes, it's a reasonable starting point for adjusting sliders further; sometimes, the result is awful.

If you're going to crop the photo heavily, it's worth cropping before you use *Auto*, as the result is calculated based on the current crop area.

LIGHT PANEL WORKFLOW

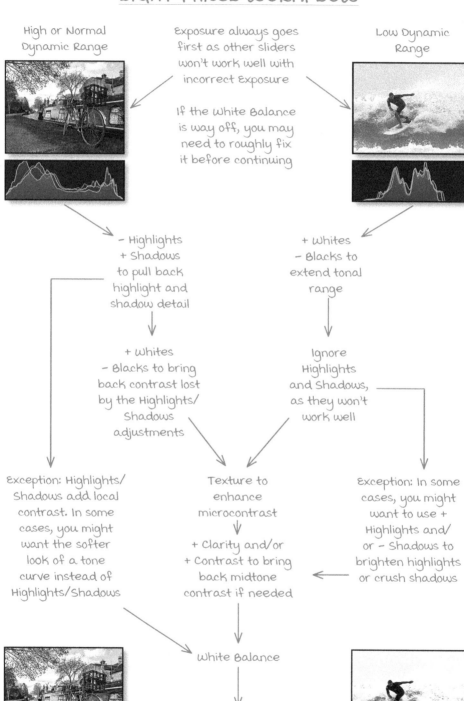

High or Normal
Dynamic Range

Exposure always goes
first as other sliders
won't work well with
incorrect Exposure

If the White Balance
is way off, you may
need to roughly fix
it before continuing

Low Dynamic
Range

– Highlights
+ Shadows
to pull back
highlight and
shadow detail

+ Whites
– Blacks to
extend tonal
range

+ Whites
– Blacks to bring
back contrast lost
by the Highlights/
Shadows
adjustments

Ignore
Highlights
and Shadows,
as they won't
work well

Exception: Highlights/
Shadows add local
contrast. In some
cases, you might
want the softer
look of a tone
curve instead of
Highlights/Shadows

Texture to
enhance
microcontrast

+ Clarity and/or
+ Contrast to bring
back midtone
contrast if needed

Exception: In some
cases, you might
want to use +
Highlights and/
or – Shadows to
brighten highlights
or crush shadows

White Balance

Adjust Vibrance
/ Saturation

SETTING OVERALL EXPOSURE

At the top of the Light panel, the **Exposure** slider sets the overall image brightness. It uses the same f-stop increments as your camera, so +2.0 of *Exposure* is the equivalent of opening the aperture on your camera by two stops.

The *Exposure* slider attempts to maintain a gentle transition to pure white to avoid harsh digital clipping.

Clipped Gentle Transition

It's important to get the *Exposure* setting about right before moving on to the other Light panel sliders, as the range of other sliders is affected, and they won't work well if your *Exposure* slider is set incorrectly.

SETTING EXPOSURE

How do you know where to set the *Exposure* slider? Try these tips:

Squint Your Eyes—If you screw your eyes up, you won't be able to see the detail in the photo, and you'll be left with the overall impression of how bright it is. You're aiming for a mid-gray.

The Only Slider—Pretend it's the only control you have available. How bright would you make the photo if there weren't any other sliders?

Confuse Your Brain—Your eyes adjust to the original camera exposure, making it difficult to judge the correct exposure. It can help to confuse your brain by swinging the *Exposure* slider to the left and right like a pendulum and then settling somewhere in the middle, wherever it looks right.

Focus on the Midtones—Don't worry if the highlights are a bit bright or the shadows a bit dark or if there are clipped highlights or shadows at this stage (white/black areas with no detail), as you'll pull them back using the *Highlights* and *Shadows* sliders.

You can hold down two fingers (mobile) / the Alt key (Windows) / Opt key (Mac) to view the clipping warnings, but don't worry about them at this stage.

To illustrate the effect of the Exposure slider, let's start with a photo set to 0. It's a little dark

Set to Exposure −2.5, we can see there's loads of detail available even in the brightest clouds, which can be pulled back using the Highlights slider, but it's way too dark overall

Set to Exposure +2.5, it's way too bright and we've lost all the detail in the clouds, but we can see there's loads of detail in the dark areas, which can be pulled back using the Shadows slider

I've settled on +0.43 as a good overall Exposure value, and I'll pull the clouds back later using the Highlights slider

GLOBAL VS. LOCAL CONTRAST

Contrast is defined as the difference in tone or color that makes an object distinguishable from its surroundings. In real terms, this means that all of the detail we see in the world around us—or in a photo—depends on contrast.

Contrast also affects the feel of a photo, with high contrast adding drama and excitement, commanding your attention. Since our eyes are drawn to the highest contrast, you can use it to draw the viewer's eye away from distractions and toward the subject.

Enhancing these contrasts is, therefore, one of the most important things we can do when editing photos.

The second slider in the Light panel is called **Contrast**, so it would be an obvious choice, but it's a bit of a blunt instrument, and there are better tools to use. Why?

INCREASING MIDTONE CONTRAST

Usually, to increase midtone contrast, you have to make light pixels lighter and dark pixels darker. This is called global contrast,

and it's what the *Contrast* slider does. The problem is you lose highlight and shadow detail in the process.

Fortunately, our eyes are more interested in local contrast—slight contrasts in similar tones—than significant global contrasts. Local contrast adjustments look for small changes in contrast and enhance them. This adds contrast without sacrificing as much detail in the highlights and shadows. Lightroom mainly adjusts local contrast using the *Clarity* slider, but it's also affected by the *Highlights*, *Shadows*, and *Dehaze* sliders.

It can sound complicated, so let's illustrate the difference using the step wedges and photos. (The step wedge is just an image created in Photoshop, with 21 blocks of gray in different shades, ranging from pure black to pure white, which makes it easier to see the differences.) Notice that both have gained contrast in the midtones. However, in the second step wedge, which used global contrast, you can no longer see the difference between some steps, especially in the shadows. These details are still clearly visible in the third step wedge, which added

Adding midtone contrast using the Contrast slider loses the highlight and shadow detail

Adding local contrast using the Clarity slider, enhances the highlight and shadow detail

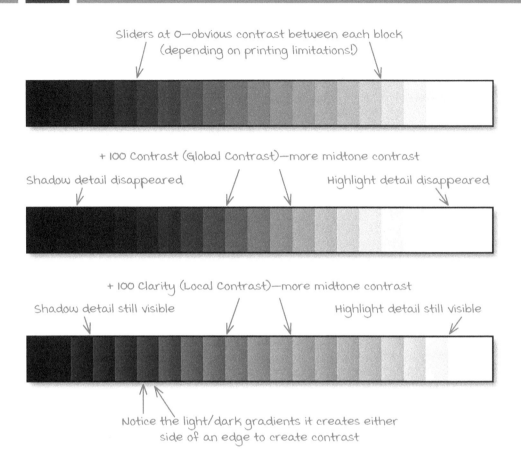

Sliders at 0—obvious contrast between each block (depending on printing limitations!)

+ 100 Contrast (Global Contrast)—more midtone contrast

Shadow detail disappeared

Highlight detail disappeared

+ 100 Clarity (Local Contrast)—more midtone contrast

Shadow detail still visible

Highlight detail still visible

Notice the light/dark gradients it creates either side of an edge to create contrast

local contrast.

Once you've adjusted all of the other Light panel's sliders, you can tweak the midtone contrast using the *Contrast* slider, but in many cases, it won't need adjusting at all.

DECREASING GLOBAL CONTRAST

But what if you have the opposite problem? If a photo has too much contrast (too wide a dynamic range), you can darken highlights and lighten the shadows using -*Contrast* to see more detail in those tones, but then you lose midtone contrast, making the photo look flat. The *Highlights/Shadows* sliders are usually better at reducing dynamic range

as they add local contrast at the same time, so it's often best to skip the *Contrast* slider altogether if you have too much contrast.

There may be exceptions, however. The extra local contrast may not be desirable on a soft, dreamy image, so you might want to use a negative *Contrast* adjustment instead. Or if the *Highlights/Shadows* sliders don't go far enough, some negative *Contrast* can be helpful to compress the tones.

CONTRAST VS. TONE CURVE

But what if local contrast doesn't give you quite the result you're looking for? Perhaps you're willing to sacrifice some detail in the highlights or shadows to retain a softer

Reducing contrast using the Contrast
slider recovers the highlight and
shadow detail, but the whole photo
ends up really dull and flat

– Highlight brings back the cloud
detail and + Shadows brings back
the shadow details, but the photo
still retains its punch thanks to
the local contrast it applies

look. You could use the *Contrast* slider,
but the Tone Curve is better because it
allows you to control which tones gain or
sacrifice contrast. We'll come back to how
to use curves to add or reduce contrast
(page 206).

RECOVERING HIGHLIGHT & SHADOW DETAIL

After setting *Exposure*, the **Highlights** and **Shadows** sliders are next in line for adjustment.

The *Highlights* slider mainly adjusts the brighter tones in the photo and barely touches the darker tones. It's generally intended to be dragged to the left (-) to recover highlight details, such as fluffy clouds in the sky or detail on a bride's dress.

Shadows does the opposite, mainly affecting the darker tones in the photo. It's generally intended to be moved to the right (+) to lighten shadow details, such as shadowed areas on people's faces or details in a groom's suit.

Brightening shadows and darkening highlights usually comes at the cost of midtone contrast, making the photo look flat. Unlike a simple highlights or shadows control, Lightroom's *Highlights* and *Shadows* also add local contrast (page 197) and saturation to help compensate for the loss of global contrast.

In most cases, the additional local contrast is beneficial, but you don't have any control over how much is added. For average photos, that's not a problem, but for some photos, you may want a softer look, so you might

– Highlights brings back cloud detail without darkening the shadows

+ Highlights lightens the highlight tones without affecting the shadows

– Shadows darkens the shadows without affecting the highlights

+ Shadows lightens the shadow tones without lightening the highlights

prefer to use the Tone Curve to reduce the contrast in those cases (page 206).

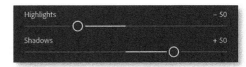

SETTING HIGHLIGHTS/SHADOWS

How do you know where to set the *Highlights* and *Shadows* sliders?

Amount—How much highlight and shadow detail you choose to recover will depend on the results of your photo analysis. For example, if the photo is of a stormy beach, the detail in the clouds will be essential, so you'll use more highlight recovery. Likewise, if the photo is a woodland scene, you'll need more shadow detail in the leaves and bark. You won't need as much shadow recovery if the shadow detail is unimportant, such as the bushes in the background of a portrait.

Clipping—While you're moving the *Highlights* slider, hold down two fingers (mobile) / the Alt key (Windows) / Opt key (Mac) to see the clipping warnings to ensure your adjustment is recovering any clipped highlights.

Keep It Natural—The effect on local contrast gets stronger as you move the sliders further. Both sliders look fairly natural up to 50, but beyond that, the effect becomes more surreal, and halos can become noticeable, which can make photos look over-processed if not used carefully.

Slider Direction—Due to the local contrast and saturation changes applied by the *Highlights/Shadows* sliders, they usually work best when they're fairly symmetrical, for example, -50 *Highlights* and +50 *Shadows*. There are always exceptions; for example, you may only want local contrast in the clouds but softer shadows.

If you need to swing both sliders in the same direction, it's usually (but not always) a sign that the *Exposure* slider needs to move in that direction.

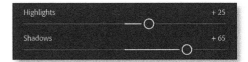

Follow with Whites/Blacks—Darkening highlights and lightening shadows decreases the midtone (global) contrast, so you'll usually need to adjust the *Whites/Blacks* sliders after *Highlights/Shadows*. We'll look at these sliders in the next lesson.

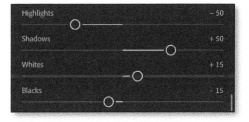

CONTROLLING WHITE & BLACK CLIPPING

The **Whites** and **Blacks** sliders affect the clipping point and roll off at the extreme ends of the tonal range. If you've used other image editing software, they're similar to the black and white points in Levels.

In most cases, the *Whites* slider is pulled to the right (+), and *Blacks* is pulled to the left (-) to expand the tonal range.

If a photo was captured in flat light and therefore has a low dynamic range (page 135), use +*Whites* and -*Blacks* to stretch image data to fill the entire histogram, making a few pixels black and a few pure white.

The sliders adapt to the range of the photo, so even a foggy white photo can be stretched to fill the entire tonal range. This becomes even more useful when working with scans of old faded photos, as it allows you to create a bright white and deep black point in even the lowest contrast photos if you need to do so.

Use + Whites and − Blacks to stretch the histogram to the ends to fill the whole dynamic range

SETTING WHITES & BLACKS

So, how do you know where to set the *Whites* and *Blacks* sliders?

Auto Adjust—On the desktop, hold down the Shift key and click on the slider name to automatically set the clipping points. This is an automatic setting that Lightroom often calculates correctly.

Check the Clipping Warnings—Hold down two fingers (mobile) / the Alt key (Windows) / Opt key (Mac) while dragging the *Whites* or *Blacks* sliders to view the clipping warnings,

+ Whites clips light pixels to pure white, but we've pushed it too far and lost detail in the clouds. Try to only clip small specular highlights like the shiny mudguard

− Blacks clips dark pixels to pure black. We've pushed it way too far and lost too much detail in the shadows. It's ok to clip dark pixels to black, but avoid creating large areas of solid black like this

so you can check you're not clipping important details (making large areas pure white or pure black). The colored overlay shows whether the clipping only affects one, multiple, or all channels.

What to Clip—Turn back to (page 136) for a reminder of what's okay to clip and what to avoid.

Deep Blacks—Deep blacks, caused by clipping larger numbers of dark pixels, are a popular choice to enhance contrast. Just be careful not to clip too far and lose important shadow detail. This is frequently done with a tone curve (page 206), as it compresses the dark tones with gentler transitions.

Clipping Studio Backgrounds—If you're shooting against a white studio background, which you want to keep pure white, the *Whites* slider allows you to clip highlights

that the *Exposure* slider's gentle roll-off would otherwise protect. If the photo was correctly exposed, with the whites close to clipping, a small value such as +15-25 is enough to blow the white background without having a noticeable impact on the overall exposure. The same principle applies using the *Blacks* slider with a black studio background.

After –100 Highlights and + 100 Shadows, the full range of detail is back but the photo looks very flat

If we use +21 Whites and –61 Blacks (below left), we can add back contrast without losing it anywhere important

On the Blacks clipping warning we can see we're just clipping the blacks in areas where the detail doesn't matter

ADDING 'POP' USING CLARITY

The **Clarity** slider is found in the Effects panel, but as it affects brightness and contrast, we're including it in this chapter.

As we learned in an earlier lesson (page 197), *Clarity* creates local contrast in the midtones by searching for edges and other areas of local contrast and enhancing that contrast. You might also use words like definition, punch, or pop.

The *Texture* slider (page 206) does something similar on smaller details.

In the past, negative *Clarity* was used to soften faces, but the *Texture* slider gives a more realistic effect.

SETTING CLARITY

Positive Clarity is very good at emphasizing large details, so it works well on architecture and landscapes, adding a distinctive crisp feel, and it can also look great on high-contrast B&W photos.

Use a very low setting for portraits, if you use it at all, as it can accentuate lines and wrinkles.

Although the slider goes to 100, that's almost always too strong, as it can create wide halos. *Clarity* can quickly make your photos look over-processed, so be conservative with the amount you apply.

It doesn't increase saturation, so you may find that the colors start to look a little muted. Adding a little *Vibrance* or *Saturation* (page 230) can make the effect look more natural.

Negative Clarity creates a diffuse, soft-focus, dreamy effect. It adds a gentle glow to the photo, similar to the well-known Orton effect, so it can look good on B&W, vintage style, or infrared photos.

Wrinkles on faces create local contrast, so avoid adding more using the Clarity slider. I know of very few women who appreciate having their wrinkles exaggerated!

The Clarity slider helps to add 'pop' to buildings, landscapes and other textured scenes, which naturally have small contrasts between similar tones

REMOVING HAZE USING DEHAZE

Like *Clarity*, the **Dehaze** slider is found in the Effects panel. It's designed to remove (or add) haze, for example, atmospheric haze over a landscape or city smog. It also works well on photos of the night sky, backlit photos, underwater photos, reflections, scans/photographs of old faded photos, and more. It's also brilliant for adding a high-contrast, gritty feel to B&W photos.

It runs complex calculations to try to estimate the light lost as it passes through the atmosphere, adapting to the content of each photo to get a good result as quickly as possible.

SETTING DEHAZE

To get the best result, adjust the white balance first (page 226), as it uses the color of the light in its calculations, then adjust the *Dehaze* slider until your photo looks great.

It's best used in combination with the other Light panel sliders. Use *Dehaze* to remove

the worst of the haze, and then use the other sliders as usual to finish editing the photo.

Dehaze is a magical slider, but it can have adverse side effects such as unwanted color shifts and halos, stronger noise, and more noticeable sensor dust and lens defects. As a result, you may need to adjust the Light panel sliders, *Vibrance* or *Saturation*, *Noise Reduction*, and *Vignette* and remove additional sensor dust spots after applying the *Dehaze* slider. It has fewer side effects when applied to a localized area using the Masking tools (page 148).

Because *Dehaze* adapts to the content of each photo, it's best avoided when doing timelapse photography.

Atmospheric haze
can be reduced
using the other
Light and Color
sliders, but
it's far easier
with Dehaze!

USING TONE CURVES

Tone curves are primarily used for controlling brightness and contrast in specific tonal ranges, but you can do that with the Light panel sliders, so why use a tone curve?

In the Contrast lesson (page 197), we said that when you add contrast in one tonal range (e.g., the midtones), you lose contrast in other tonal ranges (e.g., the highlights and shadows). There's always a trade-off.

The Light panel sliders adjust broad ranges of tones, whereas a tone curve lets you carefully control where you're willing to sacrifice contrast to gain it in other areas.

For example, the *Contrast* slider adds contrast using a simple S curve, with almost equal compression in the highlights and shadows. However, you may decide you're willing to lose more shadow detail in the deepest shadows, but you want to keep more contrast in the highlights.

Likewise, if you have a photo with too much contrast, if you lighten the shadows and darken the highlights to see more detail, you lose contrast in the midtones. The *Highlights* and *Shadows* sliders compensate by adding local contrast, but the resulting halos can be too strong, especially on photos that benefit from a softer look. The tone curve doesn't

Highlights and Shadows (left) add local contrast, which may not be desirable in a photo shot in lovely soft light, whereas the Tone Curve (right) allows you to reduce excessive contrast without adding local contrast

READING A TONE CURVE

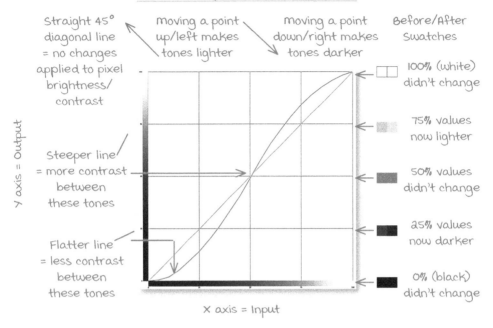

Straight 45° diagonal line = no changes applied to pixel brightness/ contrast

moving a point up/left makes tones lighter

moving a point down/right makes tones darker

Before/After Swatches

100% (white) didn't change

75% values now lighter

Steeper line = more contrast between these tones

50% values didn't change

25% values now darker

Flatter line = less contrast between these tones

0% (black) didn't change

Y axis = Output

X axis = Input

add local contrast or saturation, leaving you to decide whether to add it yourself.

As a rule of thumb, the Light and Color panel sliders are designed for the heavy lifting—the major adjustments—and the Tone Curve is usually used for fine-tuning, but rules are made to be broken, so feel free to experiment!

READING A TONE CURVE

Along each axis are all the possible tones, with pure black (0%) in the bottom left and pure white (100%) in the top right. The tone curve starts as a straight 45° diagonal line, with no changes applied to the photo. Moving the line up/left makes the tones lighter, and moving down/right makes the tones darker. The line getting steeper means contrast increases, and getting flatter means contrast is reduced.

PARAMETRIC VS. POINT CURVES

To **show the Tone Curve** in Lightroom, tap/ click the button in the Light panel.

Tone Curve button: mobile (top), Desktop (bottom)

Lightroom offers **two different types of tone curve**: a parametric curve and a series of point curves. These are toggled using the circles below the curve grid (iPhone/ Android) / in the Light panel (iPad) / above the curve grid (desktop).

The parametric tone curve is the simpler option, and it allows you to adjust four different regions of the curve called *Highlights, Lights, Darks,* and *Shadows,* rather than individual points. This protects the

photo from extreme adjustments, so it's a great way to start experimenting with curves.

The point curve interface, represented by the colored circles, is usually used by more advanced users or those familiar with Photoshop's curves dialog. It gives you complete control over the curve, including the individual RGB channels.

Point curves aren't necessarily an alternative to parametric curves. You may be more comfortable with one or the other, but both curves are active simultaneously, and the effect is cumulative.

USING THE PARAMETRIC CURVE

Let's experiment with the parametric curve by selecting the parametric tone curve icon.

 ← Parametric Tone Curve

The most frequently used curve is a **basic contrast curve**, an S shape. Tap/click on the white line in the *Shadows* or *Darks* regions (bottom left four squares) and drag down to darken the shadow tones, then tap/click on the white line in the *Lights* or *Highlights* section (top right four squares) and drag upwards to lighten the highlight tones.

How far you drag away from the center line controls how much you brighten or darken those tones. As you drag, the highlighted section shows the maximum range of movement for that region of the curve. It's limited in order to maintain smooth transitions between tones and protect your photo from banding/posterization.

If you change your mind and want to **reset the curve** on mobile, double-tap on the parametric curve icon. On the desktop, there are a few more reset options: double-click

on the line to reset a section of the curve or right-click and select *Reset* to reset the whole parametric curve. To reset both the parametric and point curves at once, use the *Reset All* option in that right-click menu or hold down the Alt key (Windows) / Opt key (Mac) and click on the Tone Curve label.

You can **fine-tune the curve using the split point markers** at the bottom.

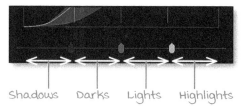

Shadows Darks Lights Highlights

They define the tonal range for the regions. For example, if you've used the *Shadows* and *Highlights* regions to create strong midtone contrast, you may move the 25% and 75% split points out to restrict the flattened contrast to the lightest highlights and the deepest shadows. They're also helpful if you've got the shape of the curve about right, but it's a bit light or dark overall. On the desktop, double-clicking on any of those split points resets it to the default position at 25% / 50% / 75%.

USING THE TARGETED ADJUSTMENT TOOL ON THE DESKTOP

When adjusting the tone curve, you have to guess the right spot on the line, which takes some experience. On the desktop, a handy tool called the Targeted Adjustment Tool (TAT tool) removes this guesswork.

To **activate the TAT tool**, click the icon in the Tone Curve panel or use the keyboard shortcut Ctrl-Alt-Shift-T (Windows) / Cmd-Opt-Shift-T (Mac).

 ← Targeted Adjustment Tool

PARAMETRIC TONE CURVE (MOBILE)

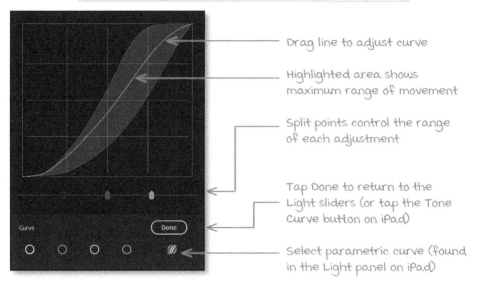

Drag line to adjust curve

Highlighted area shows maximum range of movement

Split points control the range of each adjustment

Tap Done to return to the Light sliders (or tap the Tone Curve button on iPad)

Select parametric curve (found in the Light panel on iPad)

PARAMETRIC TONE CURVE (DESKTOP)

Select parametric curve

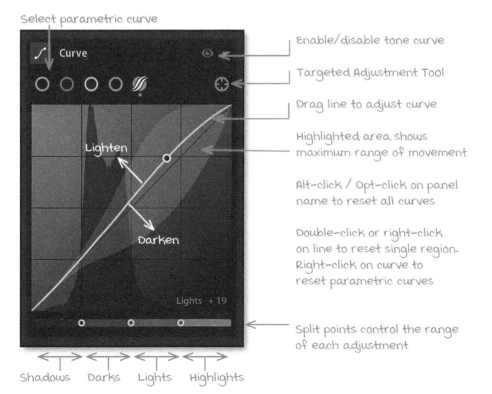

Enable/disable tone curve

Targeted Adjustment Tool

Drag line to adjust curve

Highlighted area shows maximum range of movement

Alt-click / Opt-click on panel name to reset all curves

Double-click or right-click on line to reset single region. Right-click on curve to reset parametric curves

Split points control the range of each adjustment

Shadows Darks Lights Highlights

POINT TONE CURVE (MOBILE)

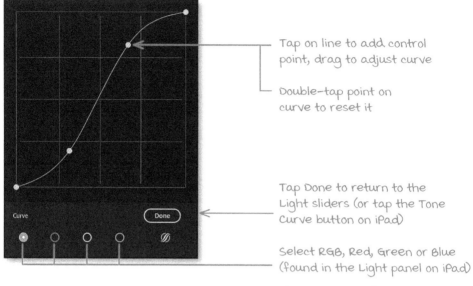

Tap on line to add control point, drag to adjust curve

Double-tap point on curve to reset it

Tap Done to return to the Light sliders (or tap the Tone Curve button on iPad)

Select RGB, Red, Green or Blue (found in the Light panel on iPad)

POINT TONE CURVE (DESKTOP)

Hold to temporarily disable tone curve

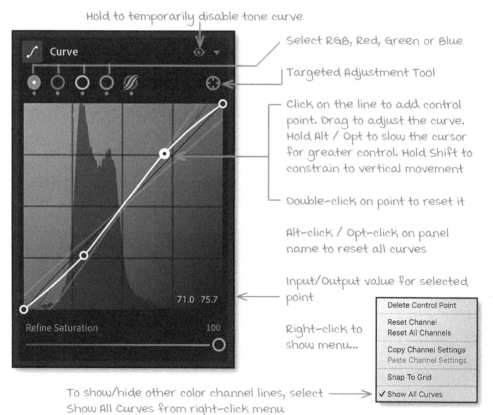

Select RGB, Red, Green or Blue

Targeted Adjustment Tool

Click on the line to add control point. Drag to adjust the curve. Hold Alt / Opt to slow the cursor for greater control. Hold Shift to constrain to vertical movement

Double-click on point to reset it

Alt-click / Opt-click on panel name to reset all curves

Input/Output value for selected point

Right-click to show menu...

| Delete Control Point |
| Reset Channel |
| Reset All Channels |
| Copy Channel Settings |
| Paste Channel Settings |
| Snap To Grid |
| ✓ Show All Curves |

To show/hide other color channel lines, select Show All Curves from right-click menu

PARAMETRIC SPLIT POINTS

 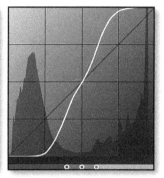

The shape of the curve changes depending on whether the split points are at their defaults (left), far apart (center) or close together (right), so you can use it to fine tune the curve

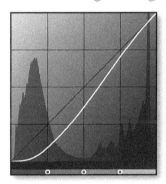 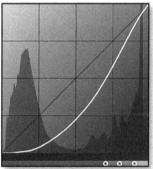

Dragging all of the split points to the left or right can change the overall brightness without changing the relative shape of the curve

As you float the cursor over the photo, the circle moves along the Tone Curve line, showing the affected tonal range.

Click and drag left/right on the photo to **lighten or darken the selected tonal range**. For example, to darken the shadows, click and drag to the left on a shadowy area of the photo until you're happy with the result. As you drag, a slider displays on the photo, and you'll also see the tone curve update.

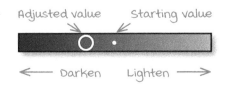

Adjusted value Starting value

⟵ Darken Lighten ⟶

For greater control, float the cursor over the

tones you want to change and tap the up/down arrow keys on your keyboard. Holding the Shift key moves in larger increments, or holding the Alt key (Windows) / Opt key (Mac) moves in tiny increments.

To **switch the TAT tool** from the Parametric Curve to an RGB, Red, Green, or Blue Point Curve, click the circles in the Tone Curve panel or the floating TAT panel.

Drag here to move floating panel
⬇

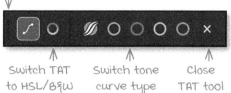

Switch TAT Switch tone Close
to HSL/B&W curve type TAT tool

When you're done, click the X in the floating panel or the icon in the Tone Curve panel, or just hit the Escape key.

USING THE POINT CURVE

If you need greater control, tap/click the gray circle to display the RGB point curve.

RGB, Red,
Green & Blue
Point Curves

Tap/click anywhere on the curve line to add a control point, then drag it up or down to adjust the curve, or use the Targeted Adjustment Tool. Control points can make adjustments or lock the curve in position so that you can adjust other tonal ranges without those changing.

You'll usually want to keep the curve to a smooth line without any sharp bends; otherwise, you may introduce posterization (banding).

On the desktop, holding down the Alt key (Windows) / Opt key (Mac) slows down the movement for greater accuracy, or holding the Shift key constrains the movement to vertical only. If you like everything perfectly lined up, a *Snap to Grid* option in the right-click menu locks the control points to the intersections of a 20x20 grid rather than the standard 4x4 grid.

If you change your mind, you can **delete a control point** by double-clicking/double-tapping on it. To reset the selected channel or the whole point curve, right-click on the curve (desktop only).

The point curve

interface also gives you access to the **red, green, and blue channels** that make up your photo. Tap/click on the red, green, or blue circles. These are often used for cross-processing effects or for correcting scans or other tricky white balance situations. For example, where color casts differ between the highlights and shadows—perhaps where the overall color is correct, but the shadows have a magenta tinge—normal white balance adjustments would be unable to fix it, but RGB curves allow you detailed control over each channel.

Here are some example point curves to give you some ideas of how they can be helpful:

REFINING THE SATURATION OF RGB POINT CURVES ON THE DESKTOP

When viewing the RGB point curve on the desktop, there's an additional **Refine Saturation** slider. At 100, which is the default, the tone curve also affects the saturation of the colors, which usually results in the most visually pleasing result. However, in some cases, you may want to

Be careful not to place too many points as extreme twists and turns in the curve can create posterization (banding) in the photo

SAMPLE POINT CURVES

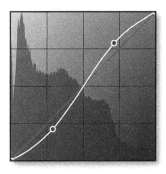

A standard S-curve adds midtone contrast, like the Contrast slider

To roughly correct color casts in scans, move the ends of the point curve to the ends of the histogram on each color channel

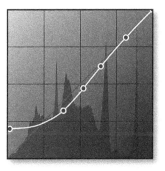

Locking most of the curve in place and then lifting the deepest shadows creates the flat shadows effect popular in film-effect presets

Reversing the tone curve inverts scanned negatives, although it doesn't remove the orange mask of color film, and the Light panel sliders go "the wrong way"

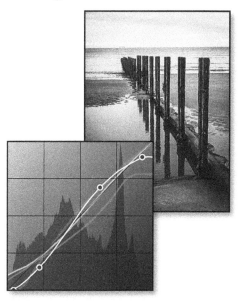

RGB point curves are used for cross-processing effects, creating a different result to the color grading controls

reduce the saturation change.

For example, when using the RGB point curve to increase the contrast of the scarves below, the default setting of 100 loses some detail in the reds and pinks (first image). Reduced to 0, the detail is retained (second image).

CURVES FOR ILLUSTRATING SLIDERS

Once you're familiar with reading tone curves, they're also helpful to illustrate and compare the effect of different Light panel sliders on the brightness and contrast of different image tones.

When using the RGB point curve to increase contrast, the reds and pinks in this image have become overly saturated and lost some detail (left). Reducing the Refine Saturation slider to 0 prevents this increase in saturation (right).

CURVES ILLUSTRATING LIGHT PANEL SLIDERS

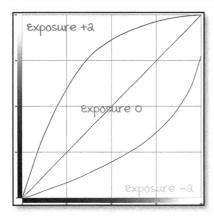

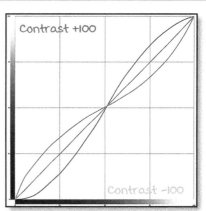

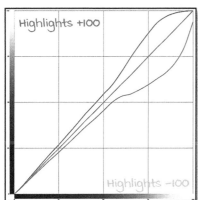

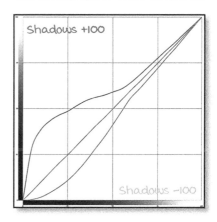

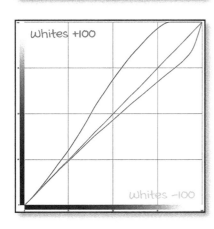

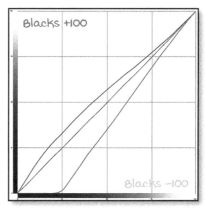

MERGING HDR IMAGES ON THE DESKTOP

Many photographers use the term HDR to describe a specific surreal editing style, but think about the letters HDR... they stand for high dynamic range. (We already discussed dynamic range while analyzing our images: page 135.)

WHY USE HDR?

Camera sensors have difficulty capturing the full range of detail in very high-contrast scenes. If you expose for the highlights, the shadows become very noisy, but if you expose for the midtones or shadows, the highlights burn out.

To solve this problem, you can shoot a series of identical shots with bracketed exposures and merge them using Lightroom. The result is a high dynamic range (HDR) file that retains detail in both the lightest and darkest tones. It's currently only available on the desktop apps. (Lightroom mobile's camera also has an HDR mode to capture and merge the photos in one go.)

If the source photos are raw files, the

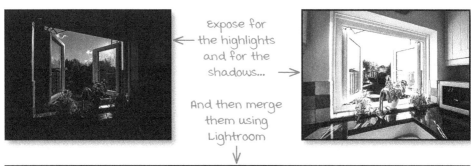

Expose for the highlights and for the shadows...

And then merge them using Lightroom

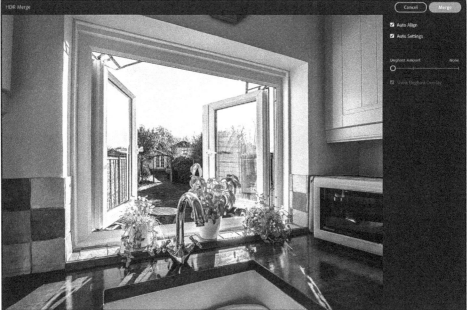

resulting 16-bit floating point HDR data is stored using the linear DNG format. This simply means that the raw data is partially processed (demosaiced) but retains the editing flexibility of a raw file. This is a significant advantage over other HDR software, which has to convert the raw data before merging, limiting the dynamic range and white balance flexibility.

Having created the high dynamic range file, you can use the HDR editing tools for display on an HDR screen (page 219) or use the standard sliders to tone map the image, compressing it into a lower dynamic range suitable for viewing on a screen or print.

SHOOTING FOR HDR

To successfully merge, the source photos must all be the same file type, captured on the same camera. For the best quality, shoot in your camera's raw file format. In an ideal world, using a tripod to ensure the photos are correctly aligned is best.

Many DSLR, mirrorless, and advanced compact cameras have a built-in automatic exposure bracketing (AEB) mode, automatically adjusting the exposure and capturing the photos in a quick burst to minimize movement.

SELECTING THE SOURCE IMAGES

Unlike most HDR software, Lightroom works best with as few source images as possible. In most cases, this is only two raw files—one correctly exposed for the highlights and one correctly exposed for the shadows. As Lightroom's working with the raw data, it doesn't need the exposures in between. Additional photos increase the risk of misalignment, resulting in a double

image (ghosting).

If the photos are more than three stops apart, add one or more additional photos in between to reduce noise, for example:

-1.5 to 1.5 = 2 photos (-1.5, 1.5)

-3.0 to 3.0 = 3 photos (-3, 0, 3)

-4.5 to 4.5 = 4 photos (-4.5, -1.5, 1.5, 4.5)

-6.0 to 6.0 = 5 photos (-6, -3, 0, 3, 6)

MERGING PHOTOS

There's no need to edit the photos before you merge them, but if you've already been experimenting, Lightroom automatically copies some of the edits from a source photo onto the merged photo.

To **merge your photos**, select them, right-click on one, and choose *Photo Merge > HDR Merge*. You'll also find it under the Photo menu. Lightroom automatically downloads the originals from the cloud. If the originals are unavailable, perhaps because you're offline, then Smart Previews will be used (where available) to create a smaller (2560px) HDR image.

The preview shows how the photo will look after merging. It's a low-resolution preview that updates quickly as you adjust the settings.

The *Auto Align* checkbox is worth checking if the photos were shot handheld and may not be perfectly aligned. If the photos were shot using a tripod and remote release, with no risk of movement, you could leave it unchecked.

Auto Settings can be applied to the preview to give you an idea of the tonal range before

merging. Once the photo is merged, you can edit it using Lightroom's editing tools.

The **Deghost** options are needed if there's a moving subject in the photo, for example, water or trees, as these can create ghosts (double images) or softness when photos are merged. There are three levels to choose from—*Low*, *Medium*, or *High*—and they control how sensitive Lightroom is to movement in the photo. The *High* setting is much more aggressive, whereas *Low* just picks up significant ghosting. Because deghosting uses the image detail from a single photo, it can introduce noise or sharp edges, so use the lowest setting possible.

Check the **Show Deghost Overlay** checkbox to see which areas are affected by the deghosting (highlighted in red). Remember to check these areas in the finished photo to ensure you're happy with the resulting image detail.

When you press *Merge*, the merge happens in the background so you can continue working on other photos. If your computer is of a high enough specification, you can run multiple merges simultaneously; however, it's very memory intensive.

EDITING THE RESULTING HDR PHOTO

Once the merge completes, you'll find the HDR file next to the originals. The filename ends in -HDR, and the thumbnail has a

badge to help you identify it. If you were viewing an album, the source photos are automatically stacked.

To edit the photo, switch to the editing tools and edit as usual. You'll notice that the *Exposure* slider runs from +10 to -10 (usually +5/-5), and the *Highlights* and *Shadows* sliders have a stronger effect.

STEP-BY-STEP

There's a pair of bracketed photos in the demo images download in the Members Area, so let's give it a try:

1. Select a series of bracketed photos. In most cases, select just two photos—one for the highlights and one for the shadows.

2. Right-click on the photos and select *Photo Merge > HDR Merge*.

3. Check the *Auto Align* and *Auto Settings* checkboxes.

4. If there's movement in the photo (e.g., water), try the *Deghost* options until you find the one that gets the best result. If there's no movement, leave it set to *None*.

5. Press *Merge*.

6. Switch to the Edit sliders and edit the photo as usual.

HDR EDITING

In the last lesson, we learned how to merge multiple images into an HDR file to increase the shadow and highlight detail. When you edit it using Lightroom's standard editing tools, the tones must be compressed (tone-mapped) to fit into the limited range that can be displayed on a standard display (SDR) or print.

However, with the introduction of much brighter displays, it's now possible to display a much wider dynamic range. HDR technology has been used in movies for a few years, but it's early days for HDR image editing.

Adobe describes photos edited for HDR displays as having "increased depth and realism with brighter highlights, deeper shadows, improved tonal separation, and more vivid colors." You and I might describe it as a "wow factor." They really do seem to sparkle! I'd love to show you examples, but there's no way to replicate the effect in print or on a standard screen.

So what's the downside? Editing for HDR sounds great, and when the photo is displayed on an HDR display, it looks incredible. The glitch is this is early days. While the number of HDR screens is growing, and many mobile devices now have HDR displays, desktop and laptop screens are still mostly SDR. And even if you have an HDR display, many web browsers don't support HDR yet.

The result is that when you try to share your HDR-edited photos, they look a bit drab on SDR screens. Technology is catching up fast and changing on a daily basis, but at this point, it's only really helpful when you have control of how the photos are displayed.

HARDWARE REQUIREMENTS

To use the HDR editing features, you need a supported GPU and an HDR-capable display, ideally 1000 nits or brighter. Technically, you can still use the HDR sliders on a lower-specification device, but you don't see the benefit.

On **iOS**, recent iPhones and iPads on iOS16 or later will work, but screen brightness varies by device. For example, my iPad Pro 12.9" 4th generation maxes out at 600 nits, so the difference isn't very noticeable. In contrast, the 6th generation's XDR screen has a peak of 1600 nits, making the images almost jump off the screen.

On **Android**, only the Google Pixel 7 Pro running Android 14 is currently supported.

On **Windows**, you need a supported GPU, and Adobe recommends a VESA Certified DisplayHDR level 1000 or higher (https://www.Lrq.me/hdrdisplays). You also need to enable HDR in Windows Settings: https://www.Lrq.me/hdrwin.

On **macOS**, you need an XDR display, available on a MacBook Pro 14" or 16" (2021 or later), or the separate Pro Display XDR.

SUPPORTED FILE FORMATS

You can apply HDR editing to any photo, but it works best on files that have a wider dynamic range, such as:

• Raw files, including Apple ProRAW and Google Pixel DNG files.

• Photos merged to HDR using Lightroom's own camera (page 216) or Lightroom on

the desktop (page 51).

• HEIF photos captured by Apple iPhone, Canon, Nikon, and Sony cameras.

EDITING IN HDR MODE

To **enable HDR Editing** on mobile, toggle the **Edit in HDR mode** switch at the bottom of the Light panel. On the desktop, click the **HDR** button at the top of the Edit (Sliders) panel.

You can also turn it on by default for HDR photos by enabling **HDR edit mode for new photos** in *App Settings > Import* (iOS) / *Preferences > Photo Import Options* (Android) or **Enable HDR editing by default for HDR photos** in *Preferences > Import* (desktop).

Once HDR mode is enabled, you may immediately notice the highlights are much brighter than before and brighter than any white UI elements. Even on low-contrast photos, you may notice that the highlights are more colorful than the SDR version. (Note that the HDR preview currently only works in the main Detail view, not the Grid thumbnails or dialog boxes.)

You can edit the photo to look its best using all the regular sliders. The Tone Curve becomes more important in HDR editing as it offers greater control over the

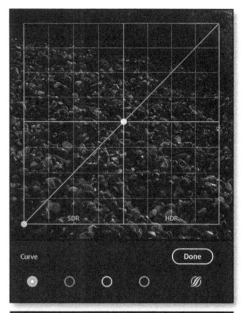

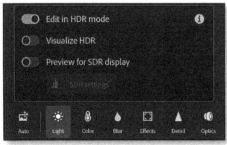

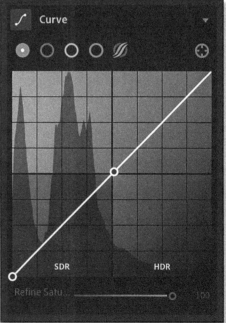

Enable HDR Editing:
mobile (top), Desktop (bottom)

HDR Tone Curve:
mobile (top), Desktop (bottom)

distribution of tones. The Tone Curve splits into four quadrants, with the lower left quadrant affecting the SDR range and the other quadrants covering the HDR range.

Remember, you don't have to push every photo to the limits. Most photos look best with just 1-2 stops of extra highlight detail. Most of your image should still fit within the SDR range.

On the desktop, you can forcibly clip the highlights at 1-4 stops over SDR using the **HDR Limit** pop-up. Setting a low value may be useful when you know you'll display the photos on an HDR screen with relatively low brightness, as anything past the limit clips to pure white. There's no way to turn it off again on mobile, so if in doubt, leave it alone and use the histogram to guide you instead.

VISUALIZING HDR EDITS

The histogram (page 134) is particularly important when editing in HDR because it gives you information that may not be possible to display on your screen. If you can't see it on mobile, tap the HDR Histogram button to turn it on.

On the desktop, click the ... button in the Toolstrip and select *Show Histogram*.

You'll notice that the histogram splits into an SDR section and four additional sections of HDR. The solid line in the middle of the histogram is the SDR limit, in other words, the brightest white used in the user interface.

Initially, the bottom row shows a white bar, showing what can be accurately displayed on your screen at the current brightness. If you change the brightness of your screen, or it automatically changes based on the lighting conditions, you'll see this bar move. For example, my MacBook Pro can show two stops of additional highlight detail at full brightness, but it can show four stops when the brightness is decreased.

If you see the red HDR error, Lightroom can't preview HDR tones because your system doesn't meet all the requirements.

If you turn on the clipping warnings by dragging a Light panel slider with two fingers (mobile) / using the histogram triangles or J key (desktop), this changes to a yellow/red split, and it's also shown as an overlay on the image preview. The yellow range of the histogram is over SDR but can be displayed accurately on your screen, and the red area is too bright.

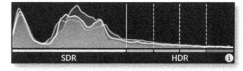

If you enable the **Visualize HDR** checkbox, colored overlays show how far outside the SDR range the highlights fall. The first stop is turquoise, then blue, then purple, then magenta. These are particularly useful for editing an HDR range on an SDR display when you can't actually see how the photos will appear on the target display.

Clipping warnings show as yellow (over SDR but visible on this display) and red (too bright to show on this display)

Visualize HDR shows the HDR data in different colors for each stop over SDR – turquoise, blue, purple and magenta.

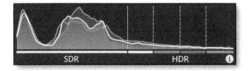

PREVIEW FOR SDR DISPLAY

On mobile, if you check the **Preview for SDR Display** checkbox, an **SDR Settings** button appears. On the desktop, it's the other way around: when you open the SDR Settings sub-panel, the *Preview for SDR Display* checkbox activates the sliders.

The SDR preview shows how the photo will look when the HDR data can't be displayed. This includes Lightroom's thumbnails and any SDR exports from Lightroom, which is important because we'll use this rendering as a fallback when exporting the photo in a moment.

When you initially turn it on, all of that sparkly HDR data gets squashed back into an SDR range, and the immediate result can be pretty disappointing. However, you can adjust the image using the SDR sliders to make it look good in SDR. You're essentially creating two slightly different edits of the same photo, each optimized for the dynamic range you have available.

The SDR version of an HDR-enabled photo never looks quite as good as a standard SDR edit, so for photos you're going to print, you may prefer to save your SDR edit as a Version (page 157) and then turn on HDR and create your HDR edit as a separate Version.

EXPORTING HDR PHOTOS

When you come to export HDR photos

(page 401), an AVIF file in the HDR P3 color space is a good choice as long as you have control over how the photo will be displayed.

To share on the web, however, an sRGB JPEG is the best choice at this point

The SDR Settings allow you to control how the photo will look when it can't be displayed in HDR: mobile (top), Desktop (bottom)

(although it's likely to change in the future as other formats gain browser support). If you export as AVIF format, the file contains the HDR data, and the web browser would have to tone map it to display on SDR screens. Clearly, you can do a far better job creating a good SDR version in Lightroom, so you don't want to leave that up to a web browser.

When you export as a JPEG, the base image is the SDR version you've already previewed, so you can predict how it'll look on an SDR display. The file also includes a gain map to tell supported web browsers how you want to render the HDR image so your viewers can see it how you intended on their HDR screen. Web browsers that don't currently display HDR content, such as Safari, fall back to the SDR version, so the result is still predictable.

There is one potential issue with gain maps to be aware of... when you upload to a website like Facebook or Instagram, the gain maps are currently stripped, so people only get to see the SDR version. Remember, the SDR version of an HDR image never looks quite as good as a non-HDR image, so if you're uploading to a website that reprocesses your images, you're better off sticking with normal SDR.

Alternatively, you could post a link to a shared Lightroom album (page 385), which shows HDR on Chrome on HDR-capable desktop monitors and falls back to your SDR rendition on unsupported browsers and displays.

As we said at the outset, this is still relatively early days for this technology, so support should improve over the coming months and years.

PERFECTING COLOR & B&W

14

We see the world around us in color, and since the advent of color film, it's been an important part of photography. The Color panel allows us to correct colors to match the scene we remember or to make more creative artistic choices.

IN THIS CHAPTER, WE'LL CONSIDER:

• How to use the White Balance sliders to correct color casts, which can cause the photo to look dull and muddy.

• How to adjust the saturation of the colors throughout the whole photo to influence the viewer's mood.

• How to enhance contrasts between colors when converting to B&W.

• How to use the Color Mixer to optimize the brightness and saturation of specific color ranges to draw the eye.

• How to use Point Color to target specific color ranges, for example, reducing ruddy cheeks or tweaking memory colors.

• How to use Color Grading to paint a particular mood.

• How to use advanced Color Calibration sliders to create special effects.

Color panel:
mobile (left), Desktop (right)

PERFECTING WHITE BALANCE

The color of light varies depending on its source. It can range from cool (blue sky) to warm (candlelight or tungsten), and the color temperature is measured using the Kelvin scale.

Our eyes and brain automatically compensate for different lighting conditions, so a white object looks white to us, whether viewed in sunlight, shade, or indoors using artificial lighting.

Cameras aren't quite so smart. A camera's auto white balance works pretty well in a narrow range of daylight with "average" image content, but it doesn't take much to confuse it. Capture a scene of autumn leaves, and the camera's likely to make the photo a little cold and blue. Shoot a snow scene, and the camera will probably try to warm it up.

Lightroom's White Balance sliders are designed to compensate for the color of the light in which the photo was taken. When you get the white tones right, everything else falls into place.

Most of the time, you'll want the colors in the scene to be rendered as accurately as possible, but sometimes, you'll want to warm or cool the scene to suit the mood of the photo.

If you look outside on a cold winter's day, the light is cool and blue, but during a beautiful sunset, it may be warm and orange. If you neutralize these colors, you lose the atmosphere.

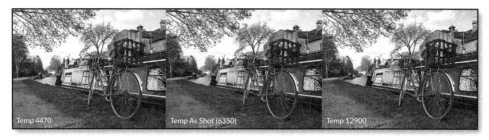

Temp 4470 Temp As Shot (6350) Temp 12900

- Temp makes the photo cooler/bluer

↑ The camera's auto white balance did pretty well on this photo! ↓

+ Temp makes the photo warmer/yellower

- Tint makes the photo greener

+ Tint makes the photo more magenta (pinker)

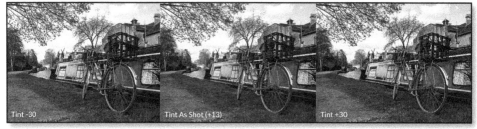

Tint -30 Tint As Shot (+13) Tint +30

SETTING WHITE BALANCE

White balance adjustments are made using the **Temp** *(Temperature)* and **Tint** sliders in the Color panel, but there are a few ways of deciding on the best values.

Auto—In the *White Balance* pop-up, select **Auto**. It attempts to neutralize the photo, but like the camera's auto white balance, it's not as intelligent as your eyes, so the results may not be perfect.

Presets—If you're working on a raw file, the **White Balance** pop-up includes presets for standard lighting conditions. They include *As Shot, Daylight, Cloudy, Shade, Tungsten, Fluorescent,* and *Flash* settings. Select the right preset for the lighting conditions; for example, if the photo was captured on a cloudy day, select the *Cloudy* preset.

Eyedropper—For more control, the White Balance Selector allows you to click on the photo to neutralize any color cast automatically.

← White Balance Selector

On a mobile device, tap the eyedropper icon in the Color panel, then drag the eyedropper on the photo to something that should be

White Balance controls:
mobile (top), Desktop (bottom)

neutral, such as this lighthouse, and tap the checkmark to confirm your selection. On a small screen, it may help to zoom in before selecting the eyedropper.

On the desktop, click the eyedropper icon in the Color panel or press the W key, then click on something in the photo that *should be* neutral, for example, the shadows on a white t-shirt. When you've finished using the eyedropper, return it to its base or hit Enter or Escape.

Using white or light gray subjects gives a more accurate result than darker shades, but avoid whites that are too bright, as some of the color data may be clipped.

When you tap/click with the eyedropper, the pop-up changes to *Custom*, and the sliders automatically adjust. If it still doesn't look right, click somewhere else to try again or tweak the sliders by eye. The eyedropper's often a good way to get the white balance in the right ballpark before fine-tuning the sliders.

If you regularly shoot in difficult lighting or struggle to select the correct white balance, a WhiBal, ColorChecker, or other calibrated neutral light gray card is an easy way to guarantee the correct white balance. Simply shoot a photo of the card in the same lighting conditions as the subject and click the eyedropper on that photo to get an accurate white balance setting. You can copy these values to other photos shot in the same conditions.

Adjust Sliders By Eye—As you gain

SETTING WHITE BALANCE USING THE EYEDROPPER

Select the White Balance eyedropper and click on something that SHOULD be white or light gray, like this lighthouse

Oooops, clicking on the stone path turned the photo too blue

Clicking on the window made it a bit too warm and pink because it's reflecting the surroundings

What else might be neutral in this picture?

Darker areas of clouds may work if they weren't partially clipped (white with no detail), but results can vary depending on where you click

The satellite dish gave the best result, but it's still a bit cold, so try an extra 200K-400K on Temp

Paintwork and white fabrics often yellow over time

Shiny objects are no good, as they'll reflect surroundings

Stone sometimes works, but it's rarely perfectly neutral

experience, you can go straight to the *Temp* and *Tint* sliders. If the photo's too yellow or warm, move the *Temp* slider to the left to compensate, and if it's too blue or cold, move the slider to the right. Likewise, the *Tint* slider adjusts from green on the left to magenta on the right.

If you're working on a raw file, the *Temp* slider uses the Kelvin scale to measure the color of the light. For JPEGs and other image formats, the scale runs from -100 to 100 because the white balance compensation has already been applied to the image data (e.g., by the camera), and now you're simply warming or cooling the photo.

ADJUSTING FOR MOOD

Once you've made the photo neutral, you can tweak the white balance to enhance the mood. For example, indoor photos often look better with a *Temperature* value 200-400K higher than neutral to bring back a pleasant warmth. Or a sunset shot may need warming up to reflect the lovely warm light usually seen at that time of day.

HANDLING MIXED LIGHTING

Sometimes, your photos will be shot with light from two or more sources. For example, a photo shot at night may have moonlight and street lighting, a photo shot near a window may have warm tungsten light and cooler daylight, or a photo shot outdoors may have bright sunlight and shade.

In this case, you have three choices:

• Pick a white balance in the middle that looks okay for both.

• Get the lighting right for one light source, and don't worry about the other.

• Use Lightroom's Masking tools to apply a different white balance to each area of the photo (page 341).

Candlelit photos look better warm. Some photos just aren't meant to be perfectly neutral!

Photos shot in mixed lighting can be tricky to correct

VIBRANCE VS. SATURATION

Saturation describes the intensity or purity of a color. Lightroom offers two different global saturation controls with slightly different behaviors:

Saturation is quite a blunt instrument that adjusts the saturation of all colors equally. This can result in some colors clipping as they reach full saturation.

Vibrance is more intelligent as it adjusts the saturation on a non-linear scale, increasing the saturation of lower-saturated colors more than highly saturated colors. It also aims to protect skin tones from becoming over-saturated.

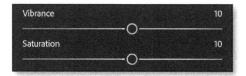

heavily saturated.

The saturation of colors also affects the mood of the photo. For example, you may want bright, saturated colors for a kid's party, but calm, muted colors may better suit a newborn photo.

In practice, you may use a little of both sliders or just stick to the *Vibrance* slider for more natural colors.

If you need even more control over the saturation of specific tones, you can use the Color Mixer tool (page 236), Point Color tool (page 240), or Masking tools (page 322).

SETTING VIBRANCE OR SATURATION

Our eyes are drawn to vivid, saturated colors, but it becomes garish and cartoon-like if you go too far. This is particularly true of skin tones, which look ridiculous when

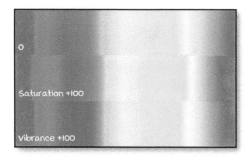

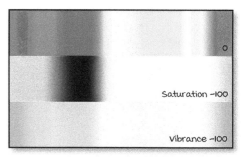

| + Vibrance enhances the blue tones (sky!) more than Saturation | + Vibrance keeps reds/oranges (skin!) looking more natural than Saturation | − Saturation completely desaturates to B&W (but there are better B&W tools) | − Vibrance is much more gentle, fading colors to pastel tones |

GREAT B&W CONVERSION

Black and white photography is an art in its own right. Some photographers consider it more creative than color photography because it doesn't match the reality we see around us.

In the days of film, you generally had to decide at the time of capture and add filters to change the appearance. For example, you'd use a red filter to create a dark, dramatic sky. Today, you can make the decisions while editing the photos.

Lightroom offers great control over the contrast between light and dark and between the different colors that made up the original scene.

HOW DO YOU DECIDE WHICH PHOTOS TO CONVERT TO B&W?

A good color photo usually also makes a good B&W photo, so how do you decide which photos to convert? Do you have to test a B&W conversion on every single photo?

If you're unsure, think back to the decisions you made while analyzing the photo, and ask yourself...

• Does the color add anything to the photo? For example, if the photo is of a sunset, the answer is probably yes, but in bad weather, the photo may be better without color.

• Is the color distracting? For example, is the color drawing your eye to the wrong spot?

• How would conversion to B&W affect the story and mood of the photo? How we respond emotionally to color may conflict with the story we're trying to tell.

Also, look out for a few features that make particularly good B&W photos, including:

• Contrasts of brightness, especially the beams of light and strong shadows caused by directional light.

• Contrasts of color (light vs. dark, saturated vs. unsaturated, warm vs. cold.)

• Shapes, textures, patterns, and compositional features like leading lines. By removing the color, your eye is drawn to these elements.

Photos that don't have much color often look more striking in B&W

Color can be a distraction, drawing your eye to the wrong spot, like the warm tones in this photo. By removing the color, we notice the lines and textures

The bright colors in this photo detract from the somber story of homelessness

CORRECT COLOR FIRST

Before you convert a photo to B&W, roughly adjust the photo in color. This removes any color cast or other problems, so you can accurately judge the best B&W settings. You may even want to create a named version (page 157) to retain your color version and the B&W rendition.

There are numerous ways to convert a photo to B&W, including:

• Shoot using the B&W mode on your camera with the JPEG/HEIC file format. This isn't a great option as it limits your editing options later. (Shooting in B&W mode in raw, however, can help visualize how a photo would look in B&W. As it's raw,

it'll retain all the color data ready to convert to B&W yourself.)

• Move the *Saturation* slider to -100. It's a very limited way of converting to B&W because you can't control how the color channels are mixed.

• Select a B&W profile from the Profile Browser or a preset from the Presets panel. These profiles and presets are "pre-mixed," so you can pick one that suits your photo and tweak it from there.

• Enable the B&W button in the Color panel (mobile) / above the Edit panels (desktop) and manually mix the color channels to suit the photo. Let's look closer at this option, as it offers the most control.

UNDERSTANDING B&W CHANNEL MIX

Before you convert the photo to B&W, closely examine the subtle contrasts between the different colors in your photo. These different shades become varying levels of brightness in the B&W photo, and by mixing the colors to make some colors lighter and others darker, you can control the contrast (or tonal separation) in your B&W photo.

In the color wheels below, you can see that the first B&W conversion makes all of the tones a similar brightness, and it lacks contrast as a result. You don't know where to look first. However, when adjusting the brightness of the different colors, we can create some interesting contrasts and start to control how the viewer's eye travels around the photo.

The way you mix the colors can add contrast and draw your eye to different areas of the photo

Now, let's put this into a simple real-world situation. If you look at a landscape on a sunny day, the sky may be vibrant blue and the grass and bushes a vibrant green, so there's an interesting contrast; however, the default conversion may make them a similar shade of gray. Instead, you might darken the blue sky to contrast with the fluffy white clouds and lighten the greens and yellows to move these into the midtones, enhancing the texture and details.

CONVERTING TO B&W

The B&W Mix sliders determine how the color channels are mixed when converting to B&W, offering the most control over the

The default B&W conversion (center) lacks contrast, but adjusting the B&W mix (right) allows you to lighten some colors and darken others

conversion.

First, **convert the photo to B&W** by tapping the button in the Color panel (mobile) / above the Edit sliders. This automatically selects the default *Adobe Monochrome* profile for raw photos or the default B&W profile for rendered (JPEG/HEIF/TIFF/PSD/PNG) photos.

B&W button:
mobile (top),
Desktop (bottom)

To **show the B&W Mix panel**, tap/click its button in the Color panel.

B&W panel button:
mobile (top),
Desktop (bottom)

On the desktop, there is an **Auto** button, and while the computer can't evaluate the scene as accurately as your eyes and brain, it can be a good starting point.

There's a slider for each color range: red, orange, yellow, green, aqua, blue, purple, and magenta. **Adjust the sliders** for each color range; for example, move the blue slider to adjust the sky. As you move a slider to the left, the color channel is darkened, and as you move to the right, the color channel is lightened. The color ranges overlap; for example, adjusting the orange slider also affects the red and yellow tones in the photo.

As you adjust the sliders, concentrate on increasing tonal separation (the contrast between different colors), and don't worry about the overall brightness and contrast initially. Ansel Adams, famous for his B&W photos, frequently used a dark sky to contrast with white fluffy clouds and lightened the greens and yellows. Lightening the skin in portraits can make it seem smoother, whereas darkening enhances wrinkles.

As with most things, moderation is key. Pushing the blue tones too far can introduce noise into your photo, and extreme adjustments between contrasting colors can create halos.

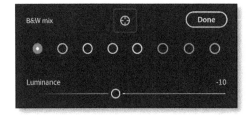

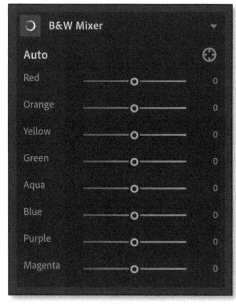

B&W mix panel:
mobile (left), Desktop (right)

USING THE TARGETED ADJUSTMENT TOOL

Rather than trying to remember the exact shade of each object in your photo, there's a handy tool called the Targeted Adjustment Tool (TAT tool). When used with the B&W sliders, it allows you to adjust the brightness of different color ranges by dragging directly on the photo.

To **activate the TAT tool**, tap/click the icon in the B&W Mix panel.

 ← Targeted Adjustment Tool

To **adjust the luminance** on mobile, hold your finger on the photo, on the tone you wish to adjust (e.g., the blue sky), and drag up/down to move in large increments or left/right to move in smaller increments.

On the desktop, click and drag left/right on the photo to adjust the selected color range. For greater control, float the cursor over the tones you want to change and tap the up/down arrow keys on your keyboard. Holding the Shift key moves in larger increments, or holding the Alt key (Windows) / Opt key (Mac) moves in tiny increments.

For example, to make the blue sky darker, tap and drag down (mobile) / click and drag to the right (desktop) on the blue until you're happy with the result. You'll see the sliders update as you drag.

When you're finished with the TAT tool, tap/click the icon in the B&W Mix panel again. On the desktop, you can also click the X in the floating panel or just hit the Escape key.

FINE TUNING B&W

Most B&W photos need a full range of tones, from a deep black with detail to a bright white with detail and all the shades in between, so once you've adjusted the B&W mix, you'll likely need to fine-tune the overall contrast using the Light panel sliders (page 191) or the Tone Curve (page 206).

Traditionally, sepia (a brown tone) or selenium (a blue tone) were used to tone B&W photos to increase the longevity of the prints, and while this is no longer the aim, these tones are still popular choices, adding a soft, warm look or a crisp cool look.

You can create the toned monochrome effects using the Color Grading tool, which we'll explore later in this chapter (page 245). For a Sepia effect, set the *Shadow Hue* to around 40-50 and adjust the *Saturation* to taste. For a Selenium effect, try a *Shadow Hue* of around 215-225 and adjust the Saturation sliders to increase or decrease the strength of the effect. A mix of these tones can also look great, perhaps using sepia highlights and selenium shadows, or you can create your own combinations.

Sepia tone Selenium tone Split tone

ENHANCING COLOR RANGES USING THE COLOR MIXER

When your white balance is perfect, you can enhance specific colors using the Color Mixer. As these are more advanced sliders, they're hidden away in a sub-panel.

There are some examples of ways you might use Color Mixer below.

Color mix panel button: mobile (top), Desktop (bottom)

SETTING THE COLOR MIX

To **show the Color Mix panel**, tap/click its button in the Color panel.

The Color Mix panel can look slightly

daunting to start with, as there's a multitude of sliders covering different color ranges. You may also hear these referred to as HSL sliders:

H stands for *Hue*, which is the shade of a color; for example, a red jumper may lean

memories—Imagine you've been shooting on the coast, but in your photos, the sea's just not as turquoise as you remember. Try moving the Aqua Hue slider to the right, and perhaps add a little Aqua Saturation

Blue Skies—unless it's truly overcast, there's often some blue sky hidden among the clouds. Try reducing the Blue Luminance and increasing the Blue Saturation to enhance it. Don't go too far on either slider, as you'll start to introduce noise

Fix Colors—Due to allergies, Charlie isn't quite as white as he should be. Reducing the Saturation and increasing the Luminance of the orange tones reduces the brown tones without losing the color in his tongue

Changing Colors—The Hue slider allows you to shift the colors toward a nearby color, for example, from red toward pink or orange. If you need to completely change colors, you'll need the masking tool

Sunsets—If the sunset isn't quite the color you need for your room's color scheme, shifting the Hue and Saturation of colors can create a whole new look

towards orange or pink.

S stands for **Saturation**, which is the purity or intensity of the color.

L stands for **Luminance**, which is the brightness of the color.

The default view (and the only view on mobile) is *Color*. It displays circles for each color range and the *Hue*, *Saturation*, and *Luminance* sliders for the selected color range below. On the desktop, you can also select *Hue*, *Saturation*, or *Luminance* in the **Adjust** pop-up. They're exactly the same sliders, just presented in a different format.

The sliders are tinted to help you remember how the color will change. For example, moving the *Red Saturation* slider to the left reduces the saturation of the reds in the photo.

On the desktop, if you hold down the Alt (Windows) / Opt (Mac) key while adjusting the sliders (or using the Targeted Adjustment Tool), the active hue is shown in color, with the rest of the photo in grayscale. It makes it easier to identify which hues are being adjusted.

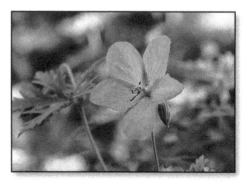

Color mix panel:
mobile (top), Desktop (center & right).
On the desktop, the Color mixer can
be displayed in two different ways

USING THE TARGETED ADJUSTMENT TOOL

Rather than trying to guess which colors

make up a particular shade of turquoise, the Targeted Adjustment Tool (TAT tool) allows you to adjust the Color Mix visually by dragging directly on the photo while it figures out which sliders to move.

To **activate the TAT tool**, tap/click the icon in the Color Mix panel.

 ← Targeted Adjustment Tool

Select *Hue, Saturation,* or *Luminance* mode in the Color Mix panel (mobile) / floating panel (desktop).

Drag here to move floating panel

Switch TAT to Switch HSL Close
 Tone Curve mode TAT tool

To **make adjustments** on mobile, hold your finger on the photo, on the tone you wish to adjust (e.g., the blue sky), and drag up/down to move in large increments or left/right to move in smaller increments.

On the desktop, click and drag left/right on the photo to adjust the selected color range. For greater control, float the cursor over the tones you want to change and tap the up/down arrow keys on your keyboard. Holding the Shift key moves in larger increments, or holding the Alt key (Windows) / Opt key (Mac) moves in tiny increments.

For example, to make the blue sky darker, switch to *Luminance* mode, tap and drag down (mobile) / click and drag to the right

(desktop) on the blue until you're happy with the result. You'll see the sliders update as you drag.

When you're finished with the TAT tool, tap/click the icon in the Color Mix panel again. On the desktop, you can also click the X in the floating panel or just hit the Escape key.

ADJUSTING SPECIFIC COLORS USING POINT COLOR ON THE DESKTOP

The Point Color tool is an even more advanced version of the Color Mixer panel.

Whereas the Color Mixer selects a wide hue range regardless of its saturation or luminance, Point Color allows you to pinpoint the exact color you want to adjust. For example, Color Mixer can adjust a general skin tone range, but Point Color allows you to make different adjustments to light skin tones and dark skin tones.

Furthermore, Point Color is cumulative, so you might make one adjustment to even out patchy red skin and then another to adjust the overall skin tone. With that level of power, of course, comes a little more complexity.

SETTING POINT COLOR

To **show the Point Color panel**, click its button in the Color panel.

Point Color evens out this patchy grass without affecting other yellow tones in the image.

Point Color is ideal for toning down this little girl's red cheeks without affecting the rest of the skin tones, especially when used with a skin mask that protects the lips.

POINT COLOR (DESKTOP)

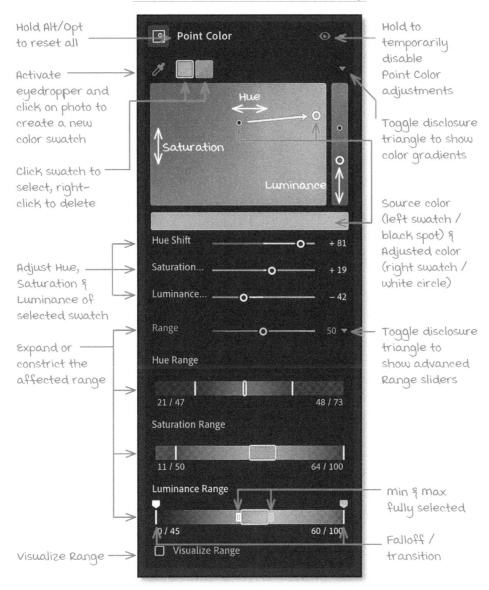

Hold Alt/Opt to reset all

Activate eyedropper and click on photo to create a new color swatch

Click swatch to select, right-click to delete

Adjust Hue, Saturation & Luminance of selected swatch

Expand or constrict the affected range

Visualize Range

Hold to temporarily disable Point Color adjustments

Toggle disclosure triangle to show color gradients

Source color (left swatch / black spot) & Adjusted color (right swatch / white circle)

Toggle disclosure triangle to show advanced Range sliders

min & max fully selected

Falloff / transition

To add your first color swatch, click the eyedropper and then click on the color you want to adjust. If you try to pick a color that's too neutral or too dark, Lightroom warns you.

Select a color in the photo

Under the resulting color swatch, adjust the **Hue Shift**, **Saturation Shift**, and/or **Luminance Shift** sliders to **adjust that color**. The swatch splits, showing the original color on the left and the new color on the right.

If you prefer a visual interface, click the disclosure triangle to the right of the

swatches to show the gradients. The black spot is the original color, and the white circle determines the new color.

To **add additional color swatches**, click the eyedropper, then click on the photo again, and repeat the process. You can add up to 8 swatches; if you need more, Point Color is also available in Masking.

To **select a different color swatch** to make further adjustments, click on its small square swatch.

To **delete one or more swatches**, right-click on it and select *Delete Swatch* or *Delete All Swatches*.

FINE TUNING THE COLOR RANGE

To **fine-tune the color range** you want to adjust, move the **Range** slider. The easiest way to see the difference is by viewing the gradients. At 100, you can see that the affected color range is much wider than 0.

The default ranges are usually spot-on, but if you need to target an even more specific color range, click the *Range* slider's disclosure triangle to show the **Hue Range**, **Saturation Range**, and **Luminance Range** multi-sliders.

On each of the multi-sliders, the range is selected using the box handles in the center. For example, moving the box to the right on the *Luminance Range* slider selects the lighter pixels matching that hue. The smoothness of the transition (or falloff) from selected to unselected is controlled by the outer handles.

If you were to reduce the multi-sliders to their smallest range, only a tiny color range is targeted, but you're unlikely to do that in real life.

The **Visualize Range** checkbox makes it easier to see which pixels are selected by showing only the affected pixels in color and the rest of the photo in B&W. Don't forget to turn it off when you're done!

STEP-BY-STEP

Pictures speak louder than words, so let's give it a try:

1. The grass is obviously patchy due to the dry weather, so select the eyedropper and click on a yellow patch.

2. Turn on *Visualize Range* to see which areas of the photo are affected. Even without making adjustments, we can see that the default range is affecting too much of the green grass as well as the buildings. Try the *Range* slider, but it doesn't help in this photo, so click the disclosure triangle to show the individual range sliders.

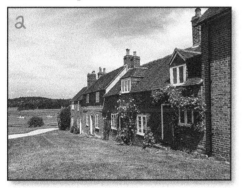

3. Adjust the range boxes until you're happy that mainly the yellow grass is selected. It's mainly the *Hue Range* that needs shrinking to target that specific yellow tone. We'll leave the outer handles alone to keep a smooth transition in this case.

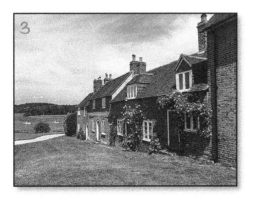

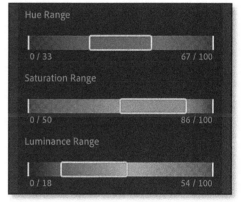

Hue Range

0 / 33 67 / 100

Saturation Range

0 / 50 86 / 100

Luminance Range

0 / 18 54 / 100

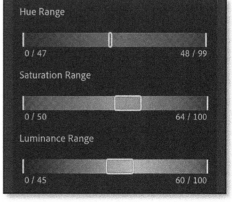

Hue Range

0 / 47 48 / 99

Saturation Range

0 / 50 64 / 100

Luminance Range

0 / 45 60 / 100

4. Disable *Visualize Range* to see the photo and then adjust the *Hue Shift*, *Saturation Shift*, and *Luminance Shift* sliders until the patches blend nicely into the rest of the grass.

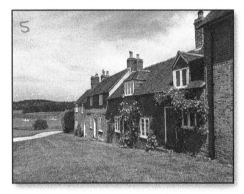

5. The color of the grass overall isn't quite right for my taste, so click the eyedropper to create another sample on the green grass. Turn on *Visualize Range* to check it's selecting the right range of greens, and yes, they're fine without tweaking, so turn it off again.

6. Finally, adjust the *Hue Shift* to warm the grass up a bit. That'll do!

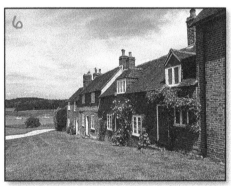

COLOR GRADING FOR CREATIVE EFFECT

Whereas the White Balance and HSL tools are primarily used for color correction, Color Grading is designed for color effects. It can be used for toning monochrome photos (page 235), but it also works well for influencing the viewer's mood, applying cross-processed color effects, or simply enhancing the lighting.

For example, slightly warming the highlights on a portrait can make it feel like your person has the sun on their face without the overall warming of a white balance adjustment. Likewise, adding blues and purples to the shadows can make your nighttime photos crisp and clean.

You may have heard of cinematic color grading, which movie editors often use to convey a specific look or mood. Next time you're watching a movie, especially summer blockbuster movies, look out for the color palette they've used and how it makes you feel, or Google *movie color palettes* to see some examples.

An orange and teal/blue combination is popular in Hollywood because the teal shadows contrast with people's skin tones, making the actors stand out from the background. This is an effect you can replicate on your own photos, but you have to be quite subtle with the orange saturation if there are people in the photos, or you'll make them look seriously ill.

Color Grading can also be helpful when mimicking certain film styles; for example, Kodak Portra has blue shadows and yellow highlights, whereas expired film has red shadows and blue highlights.

COLOR GRADING CONTROLS

To **show the Color Grading panel**, tap/click its button in the Color panel. Let's take a quick look around the controls before we put them to use...

Color Grading panel
button: mobile (top),
Desktop (bottom)

There are several color wheel views, which are selected using the circle icons at the top of the panel. The **Global** wheel applies a single tint to the entire photo, for example, adding a golden hour feel. The **Shadows**, **Midtones,** and **Highlights** wheels apply the tint to individual tonal ranges.

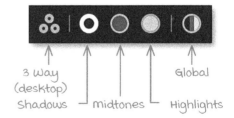

3 Way
(desktop)
Shadows — midtones — Highlights

Global

On the desktop, the **3 Way** view shows a smaller version of the *Shadows*, *Midtones*, and *Highlights* color wheels. It's useful for

COLOR GRADING (MOBILE)

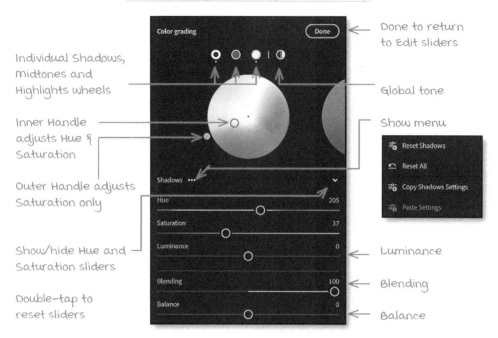

Done to return to Edit sliders

Individual Shadows, midtones and Highlights wheels

Global tone

Inner Handle adjusts Hue & Saturation

Show menu

Reset Shadows

Reset All

Outer Handle adjusts Saturation only

Copy Shadows Settings

Paste Settings

Show/hide Hue and Saturation sliders

Luminance

Double-tap to reset sliders

Blending

Balance

seeing existing settings, but they're a bit small to make fine adjustments.

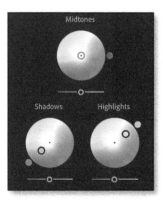

To **adjust the color**, tap/click on the central handle and drag it towards the color tint you want. If you don't get it right the first time, you can go back and fine-tune the color using the handles or sliders. The inner and outer handles are used to adjust the **Hue** and **Saturation**. It's often easiest to pull the inner handle to the edge for maximum *Saturation* and use the outer handle to select

just the right *Hue*. Then, you can reduce the *Saturation* to taste by dragging the inner handle. If you make gentle movements, Lightroom constrains the movement so the *Hue* doesn't change. On the desktop, holding down the Shift key also constrains the movement.

The numeric *Hue* and *Saturation* values show beneath the color wheels (except in the 3 Way view), and on the desktop, you can click and type directly in these fields. If you prefer to use sliders to adjust the *Hue* and *Saturation*, tap/click the disclosure triangle to show the sliders.

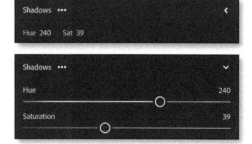

COLOR GRADING (DESKTOP)

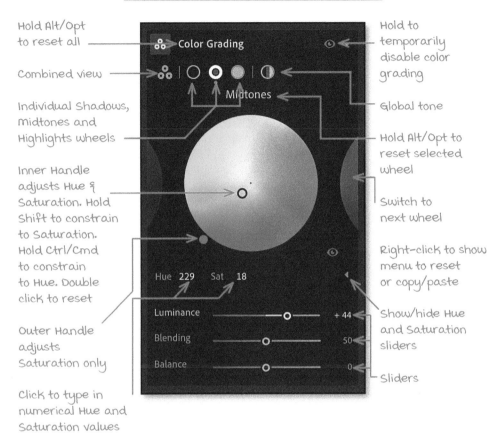

Hold Alt/Opt to reset all

Combined view

Individual Shadows, midtones and Highlights wheels

Inner Handle adjusts Hue & Saturation. Hold Shift to constrain to Saturation. Hold Ctrl/Cmd to constrain to Hue. Double click to reset

Outer Handle adjusts Saturation only

Click to type in numerical Hue and Saturation values

Hold to temporarily disable color grading

Global tone

Hold Alt/Opt to reset selected wheel

Switch to next wheel

Right-click to show menu to reset or copy/paste

Show/hide Hue and Saturation sliders

Sliders

You can also adjust the tint's **Luminance** (or brightness) using the slider below the color wheel.

If you're adjusting the *Highlights*, *Midtones*, or *Shadows* wheels, the **Blending** slider controls how much the highlight and shadow tones blend into each other. To illustrate, if we give the shadows a blue tint and the highlights a red tint, you can see that the midtones remain neutral at 0 (unless there's a midtone tint, of course), whereas red and blue blend into purple at 100.

If a midtone tint is applied, such as the green applied here, that tint is also blended into the highlight and shadow tints.

This can be useful, for example, if you only want a tint to apply to the highlights but don't want it to affect the midtones too much. Imagine you're adding a tint to the sunset, but you don't want to significantly

affect the building in the foreground. Depending on the range of tones in a photo, the effect may be more or less noticeable.

The **Balance** slider defines the range of tones affected by each color wheel. To illustrate, if we set the shadows to blue, the midtones to green, and the highlights to red, you can see that at the default of 0, each color wheel affects approximately 1/3 of the tonal range. Moving to -100 results in the shadow tone affecting most of the tonal range, with just a small amount of midtones, and moving to +100 primarily applies the highlight tint.

On the desktop, holding down the Alt (Windows) / Opt (Mac) key while moving both the *Blending* and *Balance* sliders temporarily sets the *Saturation* of the tints to 100, making it easier to see the effect.

To **reset the color wheels** on mobile, tap the ... button under the wheel to show the menu and reset just the selected wheel or all of the wheels. On the desktop, click on the wheel name or double-click on the central spot to reset the selected wheel.

STEP-BY-STEP

Let's give it a try:

1. Select the *Highlights* color wheel and drag the central handle to your chosen color, perhaps a yellow or orange hue. Try a *Saturation* value between 20 and 35.

2. Repeat for the *Shadows* color wheel, selecting a hue on the opposite side of the color wheel, perhaps blue or teal. Try a

Saturation value between 10 and 25 because the darker you go, the more intense and saturated the colors will look.

3. (Optional) If you're setting a midtone tint, try a hue similar to the shadows and a *Saturation* value between 15 and 30.

4. (Optional) Adjust the *Blending* and *Balance* sliders to suit the photo.

OPTIMAL COLOR COMBINATIONS

So, how do you know which colors to use? There are no set rules, but some combinations typically go well together.

Pairs of complementary colors—those opposite each other in the color wheel—look great together. Here are a few other traditional color schemes that also work well.

While there can be exceptions, you generally want warm tones in the highlights and cool tones in the shadows, as this reflects how we see the world around us. For example, yellow highlights and blue shadows are flattering to a range of photos if not overdone, or a softer combination of sepia (brown) and selenium (blue) can add a little color contrast without being obvious.

Usually, the midtones are assigned the same color as the shadows, but you're free to do it differently if you keep the Color Theory as a guideline in mind. Watch out for memory tones in the images and ensure these remain natural. We're particularly quick at spotting unnatural skin tones.

Be subtle! Although I've exaggerated the effects in this book so you can see the difference, the key in real life is to be subtle, enhancing the existing colors rather than blowing them away (unless you're aiming for

a quirky cross-processed effect). Of course, rules are made to be broken, but as we said in the Developing Your Own Style lesson (page 146), it's best to be consistent.

monochromatic schemes use a single dominant color across the range of tones. These are popular for tinting B&W photos

Complementary color schemes use colors directly opposite each other on the color wheel, such as warm vs. cool

Triadic color schemes use three equally spaced colors

Split complementary color schemes use the two colors adjacent to the exact complementary color, for a more subtle effect

Analogous color schemes use colors adjacent to each other. It looks much like the monochromatic color scheme but with more colors

COLOR CALIBRATION EFFECTS ON THE DESKTOP

Color Calibration is a very advanced tool so it's only available on the desktop and is completely hidden by default. If the Color Calibration panel button doesn't appear in the Color panel, click the ... menu in the Toolstrip and select **Show Color Calibration**.

THE HISTORY OF THE CALIBRATION PANEL

When you read the word calibration, you may think (quite rightly!) of monitor calibration, which involves measuring and adjusting a monitor to match a defined standard.

Likewise, many years ago, the Calibration sliders were designed to fine-tune the color interpretation of individual cameras. For example, your camera may have had slightly greener shadows than the camera Adobe used to create the default rendering. Or you might have owned two different cameras with slightly different sensors, and you needed to tweak them to match.

Today, more advanced tools like camera profiles (page 172) are available, so the Calibration sliders aren't usually needed. However, they can still be used for their original purpose, saving the result as a preset to apply to all raw photos captured using that camera.

CREATIVE USE OF CALIBRATION

In addition to their original purpose, some photographers choose to use the calibration sliders for creative purposes. Each of Lightroom's tools works in a slightly

different way, so they create a different look.

TWEAKING THE SHADOWS

The first of the sliders only affects the **Shadow Tint** of raw images, making the darkest tones more green or more magenta. If you've already corrected the white balance (page 226) to make the highlights and midtones neutral, but the shadows still have a slight color cast, a tiny adjustment of this slider may help.

It can also be used for creative effects on raw images, but the *Shadows* Color Grading wheel (page 245) generally offers more control.

ADJUSTING THE PRIMARIES

The other sliders are grouped into pairs of *Hue* and *Saturation* under headings of *Red Primary*, *Green Primary,* and *Blue Primary*. These sliders can be tricky to understand. Logically, you might expect the red sliders to affect the reds in the photo, like the HSL sliders in the Color Mix panel (page 236), but they don't. They affect the entire photo. Why?

Every pixel in a photo is made up of red, green, and blue values. You may have seen them written in groups of three in a 0-255 scale or 0-100%. For example, a particular shade of blue might be made up of 10 red, 70 green, and 150 blue. (There's no way of seeing these numerical values in Lightroom, so don't worry too much about them!)

Because every pixel is made up of red, green, and blue, every pixel is affected when you adjust the red, green, and blue primaries.

For example, the *Blue Primary* sliders have a greater effect on colors that include a lot of blue (like blues and purples) than colors with very little blue (like yellows and oranges), but they'll all shift. The same principle applies to the other sliders, too.

The changes are even more obvious when adjusting the *Hue* sliders, which result in large color shifts, as shown in the color wheels.

EXPERIMENT!

The best way to learn to use the Calibration tool is simply to experiment and see what effect the sliders have on different photos. Here are a few tips to get you started...

• If you're going to use Calibration, adjust the sliders early in your edits, as they affect the look of the entire image.

• Try the sliders at their extremes to get a feel for the effect they'll have on the image before settling on a more moderate value.

• Try adjusting Calibration to tweak skin tones. For example, if the skin is a little too pink, try increasing the *Red Primary Hue* a little. If the skin tones are a bit red, try reducing the *Red Primary Saturation* and increasing the *Blue Primary Saturation*. Don't go too far, though.

No Edits

Blue Primary Saturation -100

The entire image is affected when you adjust any of the Calibration sliders. For example, with Blue Primary Saturation at -100, blues are desaturated the most, but all of the colors have shifted, because they all contain some blue.

• For landscapes, try increasing the *Blue Primary Saturation* to make the yellows and greens pop. If there are blues in the image, they might become a little oversaturated, but you can pull them back selectively using the *Blue Saturation* slider in the Color Mix panel (page 236).

• For sunsets, play with the *Red Primary Saturation* slider, and perhaps *Green* too, but look out for colors that become too saturated. You can change the color of the sunset using the *Primary Hue* sliders, too.

• If you're trying to correct colored lighting used in concerts and theaters, fixing the white balance and then using the Calibration sliders can result in more natural skin tones, but only when working with raw files.

• If you like the Cinematic Orange and Teal look, which we already mentioned in the lesson on Color Grading (page 245), reducing the *Blue Primary Hue* slider is another way of creating that color combination. The result is slightly different, so try both and see which you prefer.

Experimentation is key with Color Calibration... try it and see what you like!

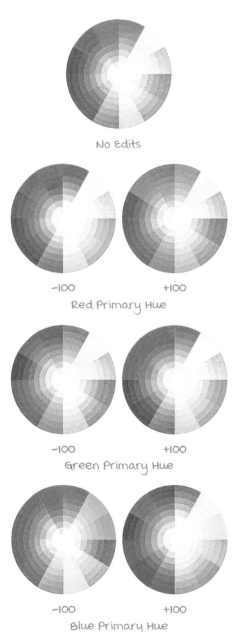

No Edits

−100 +100
Red Primary Hue

−100 +100
Green Primary Hue

−100 +100
Blue Primary Hue

ADDING LENS BLUR & EFFECTS

15

The Lens Blur panel appears as an Edit panel on iPhone/Android and desktop, whereas on iPad, it has a separate icon in the Toolstrip on the right. The Effects panel is split into three tabs on iPhone/Android to save too much scrolling, whereas it's a single panel on iPad and desktop.

We've already discussed the *Clarity* (page 204) and *Dehaze* (page 205) sliders with the Light panel sliders, as they affect the tone and contrast in the photos. We'll come back to *Texture* (page 266) in the Detail chapter because it's similar to sharpening.

IN THIS CHAPTER, WE'LL CONSIDER:

• How to add a lens blur effect.

• How to add a vignette to draw the viewer's eye into the photo.

• How to add grain for a film-like old-fashioned look.

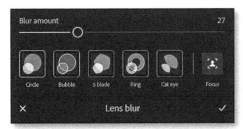

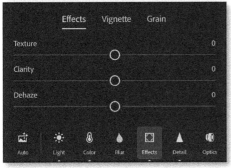

Lens Blur & Effects panels:
mobile (left), Desktop (right)

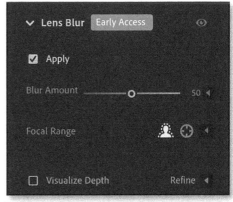

FAKING A LENS BLUR

Using a shallow depth of field to create a beautiful background blur helps the subject stand out and creates a 3D effect. To create the perfect creamy bokeh in-camera, you need fast lenses and a wide aperture, so that effect is impossible to create using a mobile device, other than using software to simulate the effect. That's where Lightroom's AI-based Lens Blur primarily comes into play, but it can also be used for photos captured on other cameras when you didn't have the right lens to hand or didn't select the optimal aperture.

LENS BLUR VS. MASKING

Even without Lens Blur, you can create a simple lens blur effect using Masking, which we'll discuss later in the book. You'd create a Linear Gradient (page 318) and then subtract (page 335) a Subject mask (page 311) so it only applied to the background, and perhaps reduce *Sharpness* and *Clarity* to blur the masked area. That's how it's been done for years, so what's the difference between Masking and Lens Blur? There are two main differences:

Firstly, the tools in Masking can only blur the selected area. The resulting effect doesn't look anything like the lovely creamy bokeh that's so sought after. Lens Blur mimics the bokeh shapes created by physical lenses. I suspect it's only a matter of time before the Bokeh effect is available in Masking, but there's still some work to be done.

Secondly, and probably more importantly, Masking creates a 2D mask. If you're shooting a photo with a clear subject and the background fades off into the distance at the top of the frame, a 2D mask works fine. However, imagine your subject is framed by a tree... if you use a Linear Gradient from the top of the frame, the tree will be blurred even though it's the same distance away from the camera as the subject. That's no good! Or what if there are multiple objects in the frame at different distances? Then, you have to create multiple masks to apply different amounts of blur to different areas of the photo.

This is where a depth map comes in. You need a 3D mask, identifying which elements are at different distances from the camera, so the amount of blur changes depending on the distance from the focal point, just like it would when creating a shallow depth of field in-camera. Some mobile devices use multiple lenses to create this kind of depth map at the time of capture, like the iPhone in Portrait mode, so Depth Range Masking (page 326) and Lens Blur make good use of this technology. If a depth map isn't available, however, Lightroom's Lens Blur tool uses AI to try to estimate the distances.

AI can work well in some situations, but there's still a lot for it to learn. At the moment, it works great on some photos, but it doesn't do a very good job with masking hair, fur, or other fine details, which is why the panel has an *Early Access* badge. This means Adobe is still working on it, but they want to get feedback from the community on a broader range of photos. With all that said, let's take it for a spin...

APPLYING LENS BLUR

To **show the Lens Blur tools**, open the Blur panel (iPhone) / Lens Blur panel (Android/ desktop) or tap the Blur icon in the Toolstrip (iPad).

 ← Lens Blur (mobile)

The photographs that benefit most have a clearly defined subject and background. For example, portraits or macro images of flowers work well. Photos with small bright highlights in the background, such as the dappled light falling through trees or colored holiday lights, create a particularly pleasing effect.

MAIN LENS BLUR CONTROLS

There are more controls on the desktop than mobile, so we'll look at the main options and then apply them to a photo on different devices.

The **Blur Amount** slider obviously changes the amount of lens blur applied. Going to 100 on every photo can be tempting, but lower values usually look more realistic.

In camera, the **Bokeh** characteristics depend on the shape of the lens aperture, but in Lightroom, you have a choice.

Circle Bubble 5 blade Ring Cat eye

Circle emulates a modern circular lens, and it's the default shape.

Bubble is a standard spherical shape with over-corrected spherical aberration.

5 Blade is commonly seen in vintage lenses.

Ring is commonly seen in reflex or mirror lenses.

Cat Eye is an effect commonly caused by optical vignetting in certain lenses.

The **Focus** (mobile) / **Focal Range** (desktop) settings determine which part of the photo is in focus and which parts are blurred. The default *Subject* creates an AI-based subject selection, like that used in AI-based Masking (page 311). *Point* displays an eyedropper so

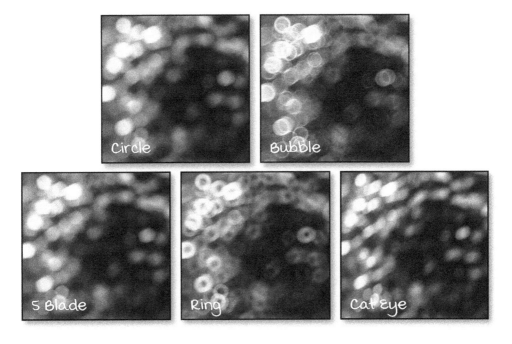

LENS BLUR (MOBILE)

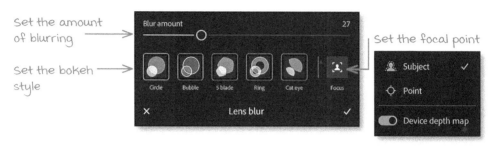

Set the amount of blurring

Set the bokeh style

Set the focal point

LENS BLUR (DESKTOP)

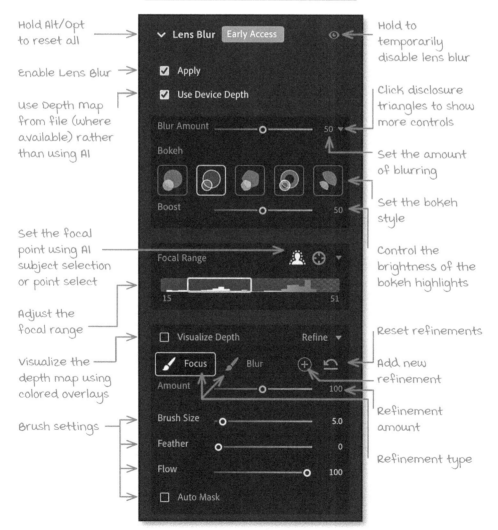

Hold Alt/Opt to reset all

Enable Lens Blur

Use Depth map from file (where available) rather than using AI

Set the focal point using AI subject selection or point select

Adjust the focal range

Visualize the depth map using colored overlays

Brush settings

Hold to temporarily disable lens blur

Click disclosure triangles to show more controls

Set the amount of blurring

Set the bokeh style

Control the brightness of the bokeh highlights

Reset refinements

Add new refinement

Refinement amount

Refinement type

you can select where to focus in the photo.

For most photos, Lens Blur uses AI to estimate a depth map. However, if the photo has a Depth Map created by the device (for example, in Portrait mode on an iPhone with multiple lenses), that's used by default. If you want to turn it off and use an AI depth map instead, tap *Focus*, then toggle the **Device Depth Map** switch on mobile. On the desktop, disable the **Use Device Depth** checkbox.

STEP-BY-STEP ON MOBILE

1. Open the Lens Blur panel by tapping it in the Edit toolbar (iPhone/Android) / Toolstrip (iPad).

2. Adjust the *Blur Amount* slider to change the amount of lens blur applied.

3. Set the Bokeh shape using the buttons.

4. (Optional) Tap *Focus* if you want to change the point of focus. By default, the subject is identified automatically, but if you select *Point*, Lightroom displays an eyedropper so you can select where to focus in the photo.

STEP-BY-STEP ON THE DESKTOP

1. Check the *Apply* checkbox and then adjust the *Blur Amount* slider to change the amount of lens blur applied.

2. A disclosure triangle hides the Bokeh

buttons, so click the triangle to choose your Bokeh style. Set the **Boost** slider to brighten or dim the bokeh highlights.

3. (Optional) Click the *Focal Range* buttons to change the point of focus. By default, the subject is identified automatically using AI. In *Point* mode, you can click on a single point in the photo or drag a range. The wider the range you drag, the wider the imaginary depth of field.

If you click the disclosure triangle, the *Focal Range* slider allows you to fine-tune the range. The box determines what's in focus, and the further away from the box, the more the pixels are blurred. Moving the whole box left or right changes the point of focus, and changing the width of the box determines the depth of field.

When you check the **Visualize Depth** checkbox, areas of the photo that will remain in focus are displayed in white while dragging the slider box. Pale yellow is nearest to the camera, fading to deep purple as you get further away.

REFINING THE DEPTH MASK ON THE DESKTOP

In many cases, the AI does a pretty good job, but it often needs a little fine-tuning. Perhaps it's missed a bit that should be blurred, or it's blurred an area that should be in focus.

To correct these areas, click the **Refine** disclosure triangle to access the brush tools. The brush settings—*Size*, *Feather*, *Flow*, and *Auto Mask*—are identical to the controls used for Masking Brush, so turn to page 315 for a detailed explanation of these sliders.

By painting with a **Focus** brush, you're telling Lightroom that the area you're painting is the same distance from the camera as other areas that should be in focus. The **Blur** brush does the opposite, telling Lightroom that the brushed area is further away from the camera, so it should be more blurred.

The **Amount** slider adjusts the strength of the current refinement, so it allows you to correct the distance from the camera in the depth map. The easiest way to see this in action is to turn on *Visualize Depth* and adjust the *Amount* until the brushed area is the same color as other objects the same

distance from the camera.

For example, in this train station, the AI couldn't tell that the view through the window should be the same depth as the scenery, not the same depth as the building. When we turn on *Visualize Depth*, the window should be a shade of purple rather than a shade of orange, so let's fix it.

1. Select a small *Blur* brush with a moderate feather so the edge isn't too harsh, and brush carefully over the glass in the window. If you make a mistake when painting, hold down the Alt (Windows) / Opt key (Mac) to switch to an eraser and paint back over the mistake.

2. Adjust the *Amount* slider so that the shade of purple is similar to other elements at the same distance; in this case, the hedge and field.

3. Turn off *Visualize Depth* to check the image and adjust further if needed.

The **+** button creates additional brush strokes to apply different amounts to different strokes. For example, the area between the handrails on the steps could also do with adjusting, but you'd create a different brush stroke as it may need a different amount. Unlike Masking, there's no way to reselect specific brush strokes, so they're not easily editable. There's definitely room for Adobe to make improvements here.

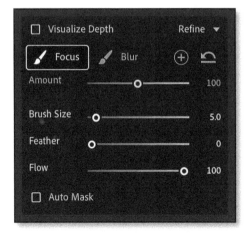

AI was unable to accurately identify the depth through the windows and handrails, so these need to be corrected using the Refine brush.

ADDING A VIGNETTE

Vignetting is the darkening or lightening of the corners of a photo. It's usually caused by the lens not being able to distribute light across the entire sensor evenly, but many photographers use a vignette for creative effect. It can help to draw the viewer's eye into a photo and focus on the main subject rather than being distracted by the edges.

It may seem strange to remove the vignetting created by the lens and then add it back using the sliders in the Effects panel, but these sliders are tied to the crop boundaries, whereas any lens vignetting may be partially cropped away.

VIGNETTE SLIDERS

The main **Vignette** slider controls how dark or light the vignette should be, with 0 not

applying a vignette at all. Most photos look better with a dark vignette rather than a white one.

For many photos, the main *Vignette* slider is the only one you'll need to adjust, but if you want more control, there are additional

A vignette helps to draw the eye to the center of the photo

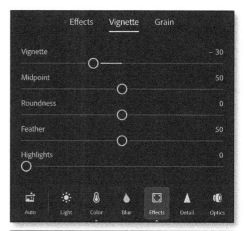

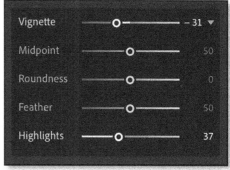

Effects panel > Vignette sliders: mobile (top), Desktop (bottom)

sliders. On iPhone/Android, they only appear when you've adjusted the main *Vignette* slider. They're visible but dimmed on iPad and may be hidden behind a disclosure triangle on the desktop.

The **Midpoint** slider controls how close to the center of the photo the vignette affects. The vignette created by the Effects panel is always centered within the crop boundaries, but if you need an off-center vignette, you can use the Radial Gradient instead (page 320).

The **Roundness** slider controls how round or square the vignette is. -100 is almost rectangular and barely visible, whereas +100 is circular. Most vignettes look great with the default of 0, which matches the ratio of the photo.

The **Feather** slider runs from 0 to 100, with 0 showing a hard edge and 100 being so soft it almost disappears. The default of 50 is a great starting point, with most vignettes ranging from 35 to 65.

The **Highlights** slider runs from 0, which has no effect, to 100, which makes the highlights under a dark vignette brighter. This allows you to darken the edges without the photo becoming too flat and lacking in contrast.

STEP-BY-STEP

Ready to give it a try? You can use the sliders in any order, but this works well:

1. Move the *Amount* slider to -100 so you can easily see the effect of the other sliders.

2. Adjust the *Midpoint* slider so the vignette doesn't cover important areas of the photo.

3. Adjust the *Feather* slider so the edge of the vignette disappears.

4. Move the *Vignette Amount* back towards the center until you're drawn into the photo, but the vignette isn't immediately apparent.

5. Adjust the *Highlights* slider if the corners look too flat and lack contrast.

ADDING GRAIN

We spend a lot of time trying to reduce the noise in our photos... and then put grain back! However, some photos look great with a little extra grain, particularly if they're B&W, toned, or have a film emulation preset applied. It can also help to hide the plasticky look that results from high noise reduction.

disclosure triangle on the desktop.

GRAIN SLIDERS

The main **Grain** slider in the Effects panel affects the amount of grain applied. The noise is applied equally across the photo, giving a much more film-like quality than digital noise, which tends to be heavier in the shadows.

There are additional sliders for fine-tuning the quality of the grain. On iPhone/Android, they only appear when you've adjusted the main *Grain* slider. They're visible but dimmed on iPad and may be hidden behind a

Size affects the size of the grain, just as grain on film comes in different sizes, and it gets softer as it gets larger. More expensive film usually has a smaller grain. (This may be hard to see in the paperback!)

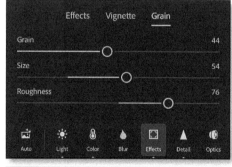

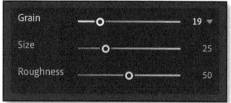

Effects panel > Grain sliders:
mobile (top), Desktop (bottom)

Roughness affects the consistency of the grain, so 0 is uniform across the photo, whereas higher values become rougher and less "digital."

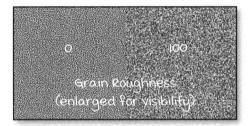

You'll need to zoom into 100% view for an accurate preview. Grain is very sensitive to resizing, sharpening, and compression, so if you're going to downsize the photo when saving it, you'll need stronger grain than looks right on screen.

OPTIMIZING DETAIL

16

Our eyes can see incredible detail in our surroundings (at least when we're young!) and adjust to very low-light conditions.

Cameras have made incredible progress but still can't match the human eye. A little editing is required to optimize the detail in a photo, allowing the viewer to focus on the content of the photo rather than being distracted by false detail (noise). These adjustments are made using the Detail panel. We'll also investigate the *Texture* slider from the Effects panel because it's most similar to sharpening.

IN THIS CHAPTER, WE'LL CONSIDER:

• How to enhance the texture in your photo to make it look three-dimensional.

• How sharpening works.

• How to sharpen your photos effectively but without over-sharpening.

• How to reduce digital noise without creating a plastic effect.

• How to use the Enhance tool to extract additional detail.

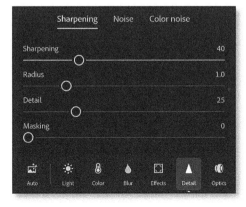

Detail panel:
mobile (left), Desktop (right)

ENHANCING TEXTURE OR 'STRUCTURE'

The **Texture** slider, found in the Effects panel, is designed to enhance mid-size details in your photo. You might describe the effect using words like structure, micro-contrast, bite, crispness, a 3D look or, of course, texture.

This might remind you of the *Clarity* slider (page 204), and for good reason, as there are similarities. Both increase local contrast along edges.

Clarity enhances larger details and has a significant effect on overall contrast, whereas *Texture* primarily affects mid-size details, and the effect is much more subtle. *Sharpening*, which we'll discuss in the next lesson (page 268), targets even smaller details.

You can see these differences illustrated in the photo of the archway. This photo is available to download from the Members Area (page 440), as the effect is easier to compare at 100% zoom on your own screen.

SETTING TEXTURE

Positive Texture can be used for many different purposes, but it's particularly good for landscapes, nature photography, architecture, and B&W photography. It adds a crispness without looking over-sharpened and without adding unnatural levels of contrast.

Because the effect is subtle, you may need to zoom in to 100% (double-tap/click on the photo), especially on very high-resolution photos. Artifacts are rare, even when pushed to 100, but watch out for small halos that can occasionally be created. It can make Chromatic Aberration (color fringing) more obvious, but we'll learn how to fix this

fringing in a later lesson (page 280).

As with *Clarity*, be careful adding texture to people's faces, as it will enhance wrinkles but can be brushed over the eyes to define the eyelashes.

Negative Texture is ideal for softening skin. Because *Texture* primarily affects mid-size details and ignores the smallest details, it retains some of the skin texture, minimizing the smooth plastic appearance that can happen with skin smoothing. Rather than applying it globally, use the Masking tools (page 345) to apply only to the face.

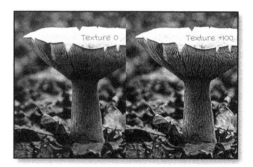

The Texture slider enhances medium sized details without affecting the overall contrast

Negative Texture is ideal for smoothing skin without making the person look like a plastic doll

SHARPENING VS. TEXTURE VS. CLARITY

Sharpening 150, others at default—While you can experiment with the settings, extreme sharpening just makes the photo look "crunchy" rather than defining structures in the image

Texture +100—The archway stones are more defined and the rocks have greater depth, but the overall contrast remains the same and there's no sign of over-sharpening

Clarity +100—While it's added punch and definition to the larger objects, notice the strong shift in overall contrast

SHARPENING PHOTOS

Most photos benefit from some sharpening because it highlights the detail in the photo and makes edges look more defined by adding local contrast on a very small scale.

It's easy to get carried away and apply too much sharpening, especially if the photo is slightly out of focus. No amount of sharpening will recover the detail lost in a blurry photo. It can only enhance the detail that has been captured.

Over-sharpening can often look worse than too little sharpening. In this lesson, we'll learn how to adjust the Sharpening sliders to get the balance just right.

TYPES OF SHARPENING

Digital image sharpening works in two ways:

USM, or unsharp mask, works by creating small halos along the edges to make them appear sharper. On the dark side of an edge, it creates a darker halo, and on the light side, it makes a lighter halo.

Deconvolution sharpening attempts to calculate and reverse the cause of the blurring.

Lightroom uses both kinds of sharpening, balanced using the *Detail* slider.

SHARPENING SLIDERS

Lightroom has four sharpening sliders, three of which may be hidden initially. Although most of the hidden sliders in Lightroom can remain hidden, these sliders are important. On iPhone/Android, they only appear when you've adjusted the main *Sharpening* slider. They're visible but dimmed on iPad and may be hidden behind a disclosure triangle on the desktop.

The number of Sharpening sliders can look overwhelming to start with, but the principles are simple:

- Only sharpen real detail, not noise.

- Avoid making the sharpening halos obvious.

Detail panel > Sharpening sliders:
mobile (top), Desktop (bottom)

- Always judge sharpening at 100% zoom.

Let's take a closer look at how the individual sliders work, and then we'll put it into practice:

Sharpening works like a volume control, running from 0-150. The higher the value, the more sharpening is applied. If you're shooting JPEG/HEIF, the photos are usually sharpened by the camera, so you'll need less sharpening than a raw file.

You won't usually want to use the slider at 150 unless you're combining it with the *Masking* or *Detail* sliders, which suppress the sharpening.

Use two fingers to drag (mobile) or hold down the Alt key (Windows) / Opt key (Mac) while dragging the *Sharpening* slider to see the amount of sharpening being applied without being distracted by color.

Radius affects the width of the sharpening halo. It runs from 0.5-3, with a default of 1.0.

Photos with fine detail need a smaller radius, as do landscapes, but a slightly higher radius can look good on portraits.

Use two fingers to drag (mobile) or hold down the Alt key (Windows) / Opt key (Mac) while dragging the *Radius* slider to see the width of the halos.

Detail and *Masking* are both dampening sliders, allowing you to control which areas of the photo get the most sharpening applied and which are protected, but there's a difference in how they behave.

Detail is very good at controlling the sharpening of textures. Under the hood, low values use the USM sharpening methods, and as you increase the slider, it gradually switches to deconvolution methods. In the real world, this means your *Detail* setting will depend on the content of the photo.

The default of 25 is a good general *Detail* setting for most raw files. A low value is ideal for large smooth areas, such as

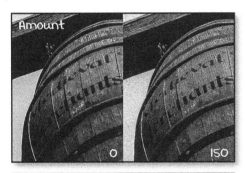

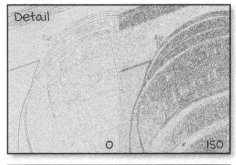

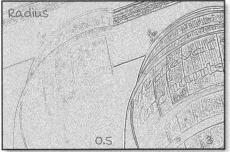

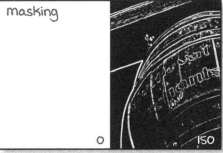

portraits (skin) or sky, where you don't want to sharpen pores or noise. A high value works well for landscapes or other shots with lots of fine detail, where you want to sharpen details like the leaves on the trees.

As you increase *Detail*, it also starts to amplify the noise in the image, so you may need to reduce the *Sharpening* slider and increase the *Masking* and *Luminance Noise Reduction* sliders (page 271) to compensate.

Use two fingers to drag (mobile) or hold down the Alt key (Windows) / Opt key (Mac) while dragging the *Detail* slider to preview the effect in more detail. The white areas of the mask will be sharpened, and the gray areas will be protected. (It's much easier to see on screen than in print.)

The **Masking** slider creates a soft edge mask from the image so that only the edge details are sharpened. Use two fingers to drag (mobile) or hold down the Alt key (Windows) / Opt key (Mac) while dragging the *Masking* slider to see the mask it's creating.

The aim is to move the *Masking* slider until only the detail you want to sharpen is white, and everything else is black.

STEP-BY-STEP

That's all very interesting, but how do you know where to set the sliders to get a crisp result without over-sharpening? Try this:

1. Zoom out to Fit view so you can see the entire photo.

2. Use two fingers to drag (mobile) or hold down the Alt key (Windows) / Opt key (Mac) while dragging the *Masking* slider to the right. You're aiming to make areas of low detail, such as the sky, turn black so the

noise in these areas will be protected from your sharpening.

3. Zoom into 100% to accurately preview your further adjustments. (On mobile, double-tap on the photo to zoom in, but remember it won't be a perfectly accurate 100% zoom if the original is not available/downloaded.)

4. Increase the main *Sharpening* slider to easily preview the effect of your adjustments. Try around 75-100 temporarily.

5. Use two fingers to drag (mobile) or hold down the Alt key (Windows) / Opt key (Mac) while dragging the *Detail* slider to the left for portraits or to the right for detailed shots such as landscapes. The aim is to enhance the detail, shown in white, without sharpening the noise, protected in gray.

6. Use two fingers to drag (mobile) or hold down the Alt key (Windows) / Opt key (Mac) while dragging the *Radius* slider to the left for detailed shots such as landscapes or slightly to the right for portraits. Watch the size of the black and white halos you're creating along the edges, as you don't want them to overwhelm the image detail.

While viewing the *Radius* mask, note where the halos are most visible. You'll usually notice them most along high-contrast edges.

7. Use two fingers to drag (mobile) or hold down the Alt key (Windows) / Opt key (Mac) while dragging the *Sharpening* slider to the left until the halos almost disappear.

REDUCING NOISE

Noise in your photos can be distracting. You'll particularly notice it in photos shot at a high ISO, for example, shot without flash in a darkened room or with a small sensor. If you've increased the exposure considerably within Lightroom, that can also increase the appearance of noise. Fortunately, Lightroom's **Manual Noise Reduction** tools are very good, and for the most important photos, there's the AI-based *Denoise* tool on the desktop (page 275).

NOISE REDUCTION SLIDERS

The *Noise* and *Color Noise* are separate tabs in the Detail panel on iPhone/Android. To **show the Manual Noise Reduction panel** on the desktop, tap/click its button in the Detail panel.

There's an array of noise reduction sliders, but just because they exist doesn't mean you need to use them on every photo. Most photos only require the main *Noise Reduction* slider and perhaps the Color Noise slider. Additional sliders are available for more extreme cases and can be left at their default settings most of the time. On iPhone/Android, they only appear when you've adjusted the main *Noise Reduction* and *Color Noise Reduction* sliders. They're visible but dimmed on iPad and may be hidden behind a disclosure triangle on the desktop.

The **Noise (Noise Reduction)** slider controls the amount of luminance noise reduction applied. 0 doesn't apply any noise reduction, but at 100, the photo has a soft, almost painted effect. Use two fingers to drag (mobile) or hold down the Alt key (Windows) / Opt key (Mac) while dragging the *Noise Reduction* slider to see the amount of noise reduction being applied without being

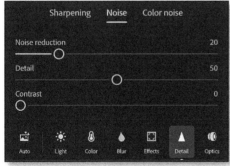

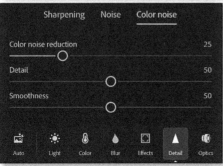

Detail panel > Noise sliders:
mobile (left), Desktop (right)

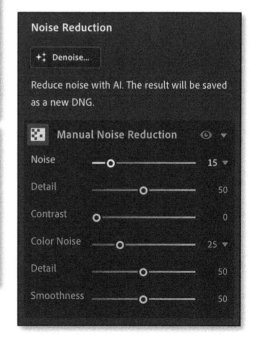

distracted by color. The aim is to reduce the noise without losing the detail or making the subject look like plastic, so don't push it too far.

The **Color Noise (Color Noise Reduction)** slider tries to suppress single pixels of random noise without losing the edge detail. I've zoomed in on Charlie's eye to make the small colored pixels more visible, but you'll see them more clearly at 100% zoom in your own photos.

EXTREME NOISE REDUCTION

The other noise reduction sliders only make a noticeable difference to extremely noisy images, such as those produced by your camera's highest ISO rating or where a high ISO file is extremely underexposed. You're

unlikely to see a difference at lower ISO ratings, for better or worse, so you won't need to change these settings from their defaults in most cases. I haven't included screenshots because the difference is so small you wouldn't be able to see it. Like the main *Noise Reduction* slider, dragging the slider using two fingers (mobile) or while holding the Alt key (Windows) / Opt key (Mac) shows a grayscale preview.

The luminance **Detail** slider sets the noise threshold, so higher values preserve more detail, but some noise may incorrectly be identified as detail.

The luminance **Contrast** slider at 0 is a much finer grain than 100. Higher values help to preserve texture but can introduce a mottling effect, so lower values are usually a better choice.

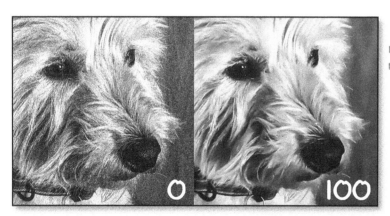

Luminance Noise Reduction

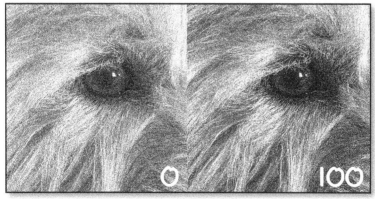

Color Noise Reduction

The color **Detail** slider refines any fine color edges. At low values, it reduces the number of color speckles in these edges but may slightly desaturate them, whereas, at high values, it tries to retain the color detail but may introduce color speckles in the process.

The color **Smoothness** slider is similar to the main *Color Noise Reduction* slider, but it aims to remove larger areas of color mottling or splotchiness. You're most likely to see this on very underexposed images, where you've brightened an area considerably, or extreme contrast images that you're tone-mapping (using maximum - *Highlights* and + *Shadows* adjustments). The default is 50, which works very well on most images. Moving the slider to the right increases the smoothing but can slow Lightroom down.

STEP-BY-STEP

Let's put this into practice on an "average" photo:

1. Zoom in to 100%, as this provides the most accurate preview.

2. Check for color noise. For most raw files, the default *Color Noise Reduction* setting of 25 is spot on. It's set to 0 for JPEGs/HEIFs, but if there's still colored noise in your photo, particularly in the dark shadows, try increasing it slightly.

3. Adjust the *Noise Reduction* slider to reduce the noise without losing too much detail. If you're working on raw files, try a setting of around 15-20 on the main *Noise Reduction* slider as a starting point.

4. Leave the other sliders at their defaults unless you have an extremely noisy photo that will be printed as a billboard!

ENHANCING DETAIL ON SPECIAL PHOTOS ON THE DESKTOP

While Lightroom's Detail panel sliders are ideal for most photos, sometimes you'll come across a special photo that deserves the very best. Using advanced machine learning and millions of photos, the Enhance tool (desktop only) extracts the finest details from your raw data and then reduces artifacts and noise or intelligently increases the resolution of your photos.

It's not a tool you'll need or want to use on every photo, as it creates additional DNG files and takes extra time to run, but it's handy to have in your toolbox for special occasions. The Enhance dialog currently has three options: *Raw Details*, *Denoise*, and *Super Resolution*.

RAW DETAILS ADVANCED DEMOSAIC

Most digital cameras use a color filter array over the sensor, made up of red, green, and blue pixels in a mosaic pattern.

Bayer Sensor Fuji X-Trans

The mosaic pattern must be converted into a full-color image before it can be viewed, and this process is called demosaicing. When you're shooting JPEG, this is done in the camera, but when you're shooting in a raw file format, Lightroom looks after this demosaic process.

Lightroom's default demosaic happens silently in the background whenever you open a raw photo. It's fast and usually does an excellent job; however, in some cases, there may be a little more detail in the file that can be extracted using **Raw Details**.

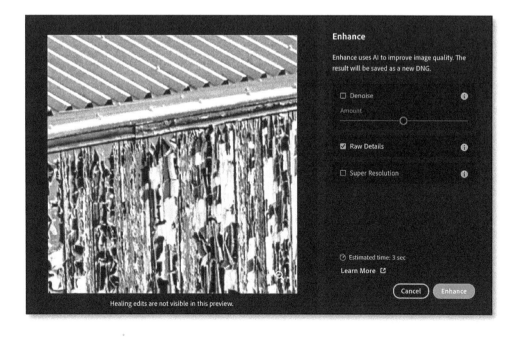

It's beneficial if:

• You're affectionately known as a pixel peeper because you like to view your photos at 100% zoom or greater and eke out every last bit of detail.

• You're a Fuji X-Trans photographer who notices "worm" artifacts when sharpening your photos.

• You're shooting with a high-quality Bayer sensor without a low pass filter and using a very sharp lens.

To see any changes, you'll need to zoom in to 100% or greater, and you'll probably need to flick back and forth a few times. If the standard demosaic is already extracting all of the available detail, you won't be able to see a difference.

In most cases, the changes will be tiny details, so it helps to know where to look for improvements. Look out for:

• **Very fine details**, less than 1px wide, especially if they're diagonals or curves, for example, hair or fur.

• **Edges of different colors** (especially orange against blue), such as a field of flowers, autumn leaves against the sky, or neon signs.

• **Moiré patterns** that may be reduced.

Raw Details is only available for raw photos captured using a Bayer or X-Trans sensor (which most cameras use). It's automatically applied when using *Denoise* or *Super Resolution* on supported raw files.

DENOISE

The **Denoise** tool uses artificial intelligence to remove more noise from your photos while preserving more fine detail than the *Manual Noise Reduction sliders* (page 271). It can compete with the very best third-party noise reduction tools.

Denoise works on mosaic raw data from a Bayer or X-Trans sensor, which means

On this extremely noisy photo (top), the Denoise tool (bottom right) preserves more fine detail than the Manual Noise Reduction sliders (bottom left).

it works on most standard raw files from most cameras. It won't work on raw files that have already been demosaiced (such as sRAW or ProRAW) or rendered files (such as JPEG, HEIF, or TIFF). If you're an iPhone photographer, it will work with the raw files created by Lightroom mobile's camera but not the linear DNG's created by Apple's camera app.

SUPER RESOLUTION

The final option in the Enhance dialog is **Super Resolution**. We'll learn more about file resolution in a later chapter (page 412), but in short, when you enlarge a photo, it usually becomes more blurry because it's having to create new pixels. *Super Resolution* uses the intelligence gained through analyzing thousands of pairs of photos to preserve greater detail while doubling the size of your photo.

It's particularly useful if:

- You're creating huge prints.

- You've had to crop heavily.

- Your camera has a low megapixel count, for example, a mobile phone camera or most older cameras.

The resulting photo has twice as many pixels in each direction, so four times as many pixels overall. For example, a 16MP photo becomes a 64MP photo. Huge!

The enhanced DNG must still fit within Lightroom's maximum file size, so the original can be no more than 32,500 pixels along the longest edge and no more than 128 megapixels. You're unlikely to hit these limits unless you enhance a large merged panorama. If you do hit the limit, Lightroom displays an error message.

You'll see the most significant benefits when using a raw photo captured with a sharp lens. Enhance automatically uses the *Raw Details* demosaic to extract extra detail before increasing the resolution.

Super Resolution also works on other image file formats, such as JPEGs, TIFFs, and PSDs, but if the original is poor quality or has compression artifacts, these defects may be enhanced.

Using the standard Bicubic Sharper interpolation (left) to increase the file resolution results in much softer details than using Enhance Raw Details & Super Resolution (right).

Although you can't use *Super Resolution* at the same time as *Denoise*, there is a workaround. Run *Denoise* first on the raw file, do all your other edits, export that new file as a TIFF, and run *Super Resolution* on the TIFF.

ENHANCING PHOTOS

To use Enhance, select one or more photos, right-click, and choose **Enhance**. You'll also find it under the Photo menu or as a *Denoise* button in the Detail panel. The keyboard shortcut is Ctrl-Alt-E (Windows) / Cmd-Opt-E (Mac).

There are checkboxes for *Raw Details*, *Denoise*, and *Super Resolution*.

The Enhance dialog includes a small preview window so you can check that the extra processing will be beneficial before running the conversion. Click on the preview to show the "before" version or drag the preview to view a different area of the photo.

If you're using *Denoise*, adjust the **Amount** slider to change the amount of noise reduction applied. It's relative to the minimum and maximum noise reduction the AI has calculated for that specific photo, so the amount you decide to apply may vary between images.

If multiple photos are selected, the dialog only shows a preview for the first photo but still processes them all. You can skip the dialog and reuse the previous settings by adding Shift to the keyboard shortcut.

THE RESULTING FILE

This advanced processing is very processor intensive and takes much longer than the standard demosaic, so the Enhance tool saves the result as a separate linear DNG file. If you use it frequently, a fast GPU optimized for Windows ML (Windows) / Core ML (Mac) can significantly improve processing times.

The resulting DNG file is automatically stacked on top of the original, with *-Enhanced* and the tool's initials added to the file name. The initials are RD for only enhancing *Raw Details*, NR for *Raw Details + Denoise*, or SR for *Raw Details + Super Resolution*.

Lightroom automatically copies all the metadata and edits already applied from the original to the new enhanced file, except for any manual noise reduction. AI-based Healing and Masks are automatically updated based on the new image pixels. You may need to tweak your *Sharpening* (page 268), *Noise Reduction* (page 271), and *Texture* (page 266) settings, especially if you've used *Denoise* or *Super Resolution*.

In earlier Lightroom versions, the resulting file sizes were huge. Enhance now uses a more effective compression algorithm, so newly enhanced files are much more reasonable sizes.

FIXING DISTORTION

17

Distortions caused by lens imperfections and the camera angle are quick and easy to fix and can make a big difference to the quality of your photos.

Optics is a standard Edit panel on all devices, but Geometry varies a little. On iPhone/ Android, the pencil icon in the Crop panel opens the main Geometry panel, whereas on iPad and desktop, it's a standard Edit panel.

IN THIS CHAPTER, WE'LL CONSIDER:

• How to remove chromatic aberration and other fringing.

• How to use lens profiles to remove vignetting and barrel/pincushion distortion.

• How to correct geometric distortions automatically or by drawing lines.

• How to manually warp the photo.

Optics panels:
mobile (top), Desktop (bottom)

On iPhone/Android, Auto Geometry and the Geometry panel are accessed via the Crop panel, not the normal Edit panels

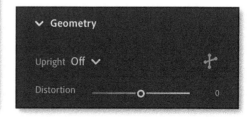

Geometry panel (cropped):
Desktop

REMOVING CHROMATIC ABERRATION & FRINGING

Chromatic aberration, or CA, refers to the little fringes of color that can appear along high-contrast edges in your photo. They're caused by the red, green, and blue light wavelengths being unable to focus at the same point.

There are two types of chromatic aberration, with slightly different causes and treatments.

Lateral chromatic aberration creates opposing colored fringes, whereas Axial chromatic aberration fringing is a single color

LATERAL CHROMATIC ABERRATION

Lateral or transverse chromatic aberration results from color wavelengths hitting the focal plane next to each other. It causes two different colored fringes (purple/green) on opposite sides of your image details. It's most noticeable around the corners of photos taken with a lower-quality wide-angle lens and doesn't appear in the center of the photo.

This type of chromatic aberration is fixed using the **Remove CA** (mobile) / **Remove Chromatic Aberration** (desktop) checkbox in the Optics panel. It's turned off by default as it can slow Lightroom down slightly and, in rare cases, may introduce new fringing, but if you find any chromatic aberration in the

corners of your photo, simply check the box.

AXIAL CHROMATIC ABERRATION & PURPLE FRINGING

Axial or longitudinal chromatic aberration results from the color wavelengths focusing at different lengths. It causes a halo of a single color—purple in front of the focal plane or green behind it—which can be present anywhere in the photo.

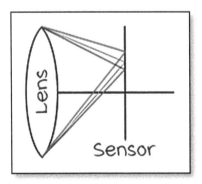

Cause of Lateral (Transverse) Chromatic Aberration

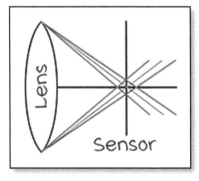

Cause of Axial (Longitudinal) Chromatic Aberration

DEFRINGE (DESKTOP)

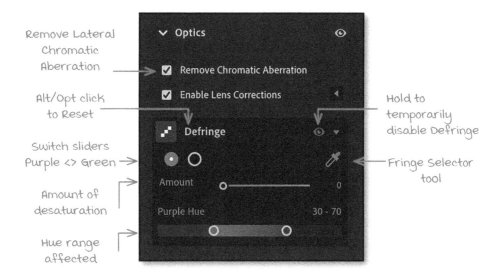

Remove Lateral Chromatic Aberration

Alt/Opt click to Reset

Switch sliders Purple <> Green

Amount of desaturation

Hue range affected

Hold to temporarily disable Defringe

Fringe Selector tool

Flare and sensor issues can also cause fringing, usually along high-contrast backlit edges, but the treatment of these fringes is the same regardless of the cause.

This type of chromatic aberration is fixed using the **Defringe** sliders and Fringe Selector Tool, which are currently only available on the desktop. These allow you to target specific hues to remove the fringing. On mobile, you may be able to remove this fringing using the *Defringe* slider in Masking, which we'll come back to shortly (page 282).

USING DEFRINGE ON THE DESKTOP

The easiest way to select the right hue is using the eyedropper, called the **Fringe Selector** tool (desktop only).

Click on the eyedropper in the Optics panel and float the cursor over the purple and green fringes. The edge of the magnified view becomes purple or green, depending on the color of the pixels below. If the edge is white, clicking won't do anything.

Cursor

magnified

The outside of the Fringe Selector changes to purple or green based on the color of the underlying pixels

Click on the purple fringe to automatically remove it, then repeat on the green fringe. When you sample the fringes using the eyedropper, the *Defringe* sliders are automatically adjusted. When you're done, return the eyedropper to its panel (or hit the Escape key).

If a small amount of purple or green fringing is still showing, you can fine-tune

the selection further using the **Defringe** sliders. There are two pairs of sliders; you can switch between them by clicking on the purple and green circles.

The **Amount** sliders affect the strength of the adjustment, and the **Hue** sliders affect the range of colors being corrected. As you move the *Hue* sliders further apart, the fringe removal affects a wider range of colors.

At first glance, you may be tempted to simply set the *Amount* to the maximum (20) with the widest *Hue* range possible, but doing so would also desaturate the edges of other objects in your image. To avoid this, use the lowest *Amount* and narrowest

Use the Alt/Opt key to check you've removed all of the fringes

Hue range possible while still removing the fringing.

If you're tweaking the sliders manually, the easiest way to check that you've captured all the fringe pixels is to hold down the Alt key (Windows) / Opt key (Mac) while dragging the *Defringe* sliders. The aim is to turn the purple/green fringes black on the masked image.

BRUSH AWAY FRINGING USING MASKING

Another way to avoid this accidental edge desaturation is to limit the correction to a selected area using the Masking tools (page 282), which are available on mobile and desktop.

If the **fringing is limited to a small area** of the photo, use a + *Defringe* slider with the Brush tool (page 315) to brush away the fringing instead of using the global *Defringe* sliders. Positive values on the Masking *Defringe* slider remove fringing of any color, not just purple and green.

If the **fringing affects more of the photo**, use the *Defringe* sliders in the Optics panel to remove the fringing, and then use a negative *Defringe* brush to protect areas like

Defringe correction can desaturate other edges in your photo (left), so it must be used with caution (right)

the edge of the building from desaturation.

STEP-BY-STEP ON MOBILE

1. On iPhone/Android, if the Optics panel isn't available in the Edit panel buttons, go to the ... *menu > View Options > Always Show Profiles and Optics*.

2. Enable the *Remove CA* checkbox to remove the purple and green fringing that's still visible in the corners of the photo.

3. Correct any lens distortion by checking the *Enable Lens Corrections* checkbox in the Optics panel.

4. Look around the photo to see whether there's any leftover fringing. If there is, select the Brush tool (page 315), set it to + *Defringe*, and roughly paint the fringe away.

STEP-BY-STEP ON THE DESKTOP

Let's put these steps into practice on a real photo...

1. Correct any lens distortion by checking the *Enable Lens Corrections* checkbox in the Optics panel, as the distortion corrections can affect the chromatic aberration. We'll investigate this checkbox thoroughly in the next lesson (page 284).

2. Enable the *Remove Chromatic Aberration* checkbox to remove the purple and green fringing that's still visible in the corners of the photo.

3. After removing the lateral chromatic aberration, this photo still exhibits purple fringing along the backlit edges. To clearly see the fringe pixels, zoom in to 200% using the pop-up in the toolbar.

4. Look around the photo to see whether the fringing is localized (perhaps to a backlit area) or covers most of the photo.

If the leftover chromatic aberration is limited to a small area or the fringe is not purple/green, select the Masking Brush tool, set it to + *Defringe*, and roughly paint the fringe away.

If the leftover fringing is purple or green and appears across the photo, select the eyedropper from the Optics panel and click on the purple and green fringes. Fine-tune the corrections using the *Defringe* sliders if needed, then check for any edges that need painting back using the brush tool set to - *Defringe*.

FIXING OPTICAL DISTORTION & LENS VIGNETTING

The physical limitations of lenses can create distortion in your images. Lightroom corrects three types of optical distortions— vignetting (darkening around the edges of the photo), barrel and pincushion distortion (curved lines that should be straight), and chromatic aberration (colored halos, which we fixed in the previous lesson: page 280). JPEGs/HEIFs are usually corrected by the camera, so these corrections mainly apply to raw files.

BUILT-IN LENS CORRECTIONS FOR MIRRORLESS CAMERAS

Most compact and mirrorless cameras have lens profile information embedded in the raw file by the manufacturer and applied by Lightroom. To check which corrections are being automatically corrected, tap/click on **Built-in Lens Profile Applied** at the bottom of the Optics panel on an Android device or desktop computer. (The information isn't visible on iOS, but the built-in lens profiles are still applied).

The built-in profile can apply corrections for distortion, chromatic aberration and/or vignetting. For example, the Sony RX100 applies corrections for distortion and chromatic aberration behind the scenes, but you might still want to apply a lens profile to remove vignetting.

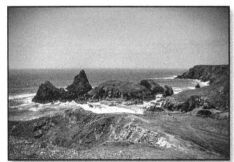

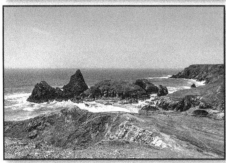

This photo (top) has vignetting in the corner and barrel distortion but these distortions can be removed (bottom) using Lightroom's Optics panel

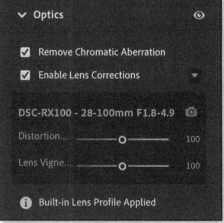

Optics panel:
mobile (top), Desktop (bottom)

Sony DSC-RX100
28-100mm F1.8-4.9

This raw file contains a built-in lens profile for correcting distortion and chromatic aberration. The profile has already been applied automatically to this image.

OK

LENS CORRECTIONS FOR DSLR'S

If you're shooting with a DSLR or another camera that doesn't embed lens data, you can apply a lens profile by checking the **Enable Lens Corrections** checkbox.

Lightroom checks the EXIF metadata to try to identify the lens. If it finds a matching profile, it automatically selects the right profile and fixes the distortions.

Lens metadata standards are relatively new, so Lightroom may need help identifying the right lens. If so, it says **Manually select a profile...** (Android) / **Change profile...** (desktop). (This option isn't currently available on iOS.)

☑ Enable Lens Corrections ▼

Change profile... 📷

Distortion... ──────○────── 100

Lens Vigne... ──────○────── 100

Click on that text to show the Select Lens Profile dialog, then select the correct lens profile in the **Make**, **Model**, and **Profile** pop-ups.

Select a Lens Profile

Make Canon ⬍
Model Canon EF-S 18-200mm f/3.5-5.6 IS ⬍
Profile Adobe (Canon EF-S 18-200mm f/3.5-5.6 IS) ⬍

Auto-Select Cancel OK

Some newer mirrorless cameras (added after August 2020) also use the *Enable Lens Corrections* checkbox, even though the lens profile is embedded in the files. This makes it possible to turn off the built-in lens corrections on the desktop. Applicable cameras show *Camera Settings* as the profile name when lens corrections are enabled.

NO PROFILE AVAILABLE

To create a profile, Adobe must have access to the lens, or the manufacturer can create the profile and send it to Adobe. This means that profiles are available for many current lenses, but older lenses may not have profiles.

If your lens doesn't appear in the Lens Profile pop-up menus and it isn't built into the image file, you have a couple of different options:

• Wait for Adobe to create a profile for that lens. Lens profiles are being added gradually in each dot release.

• (Advanced users) Switch to the Geometry panel's *Manual Transforms* and adjust the sliders manually (page 287).

Many of the lens profiles are built for raw files only. If a profile is usually available for your lens, check the format of your selected photo in the Info panel (page 98), as it may be a JPEG, TIFF, or another rendered file format.

REDUCING THE EFFECT

In some cases, you might want to use some of the profiled corrections, but not all of them. For example, if you're using a fisheye lens, you might want to remove the vignetting automatically but keep the

fisheye distortion. The **Distortion Correction** and **Lens Vignetting** sliders (not currently available on iOS) act as volume control, increasing or decreasing the amount of profile correction applied. 0 doesn't apply the correction at all, 100 applies the profile as it was designed, and higher values increase the effect of the correction.

FIXING GEOMETRIC DISTORTIONS

If you've ever shot a photo of a building, you've probably noticed it seems to be leaning backward. This is called keystoning.

To avoid it, you'd have to keep the camera sensor perfectly aligned with the subject, but unless you like to go around climbing trees or carry an expensive tilt-shift lens, that's probably not realistic. Instead, Lightroom helps you fix the distortion using a tool called *Upright*. It's found in the Crop tool on iPhone/Android: the **Auto Geometry** button applies *Auto Upright*, and the pencil button displays the rest of the controls. Upright is found in the Geometry panel on iPad/desktop.

UPRIGHT OPTIONS

Upright offers a range of automatic adjustments:

Off is simple—*Upright* is disabled, so no adjustments are made.

Guided allows you to draw lines directly on the image to show Lightroom which lines should be horizontal or vertical. We'll come back to this option shortly.

Auto is the most artificially intelligent option. It not only tries to level the photo and correct converging horizontal and vertical lines, but it also takes into account the amount of distortion created by the correction. It aims to get the best visual result, even if that's not perfectly straight.

Level only tries to level the photo, fixing tilted horizons or vertical lines. It's similar to straightening the photo when cropping. It doesn't try to adjust for converging lines.

Vertical not only levels the horizon but also fixes converging verticals.

Full is the most extreme option. It levels the photos and fixes converging horizontal and vertical lines, even if that means using very strong 3D corrections that distort image features.

More often than not, the *Auto* button gives the best fully automated result.

Auto Upright Correction

Full Upright Correction

USING THE GUIDED UPRIGHT TOOL

Upright's Guided mode allows you to draw lines on the image so you can decide which lines should be vertical or horizontal. The resulting correction is usually better than automatic Upright corrections.

iOS/Android

1. First, enable the lens profile in the Optics panel (page 284). This results in a more accurate correction.

2. On iPhone/Android, tap on the Crop tool, then the pencil icon. On iPad, open the Geometry panel.

3. Enable the *Upright* switch and select *Guided* from the pop-up.

4. Drag your finger across the photo to **draw the first line**. It's easiest if you zoom in so you can see the line. The two-finger pinch/spread gestures work while the Guided Upright tool is active, or you can turn the *Add Line* button off to move around the photo without drawing accidental lines.

5. Repeat to add additional lines: a maximum of two horizontal and two vertical. As you

add the second and any subsequent lines, Lightroom updates the image's perspective so you can preview the effect.

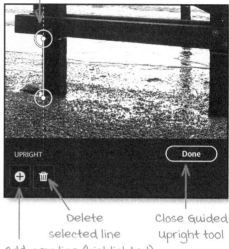

Tap and drag to draw a line

*Add new line (highlighted)
or view only (+ sign only)*
*Delete
selected line*
*Close Guided
Upright tool*

6. When you're finished, tap the *Done* button (iPhone/Android) / select a different panel (iPad).

To **adjust an existing line**, tap on the line to reselect it, then drag the circles at the end of the line and move them to a new position. If you've already closed the Guided Upright tool, tap on *Guided* in the pop-up to show the lines again.

To **delete a line**, tap on it to select it and tap the Delete (trashcan) button.

Crop panel on iPhone/Android: Auto Geometry (top), Upright (bottom)

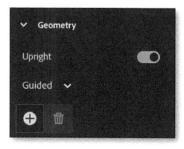

Geometry panel > Upright: iPad

Windows/Mac

1. First, enable the lens profile in the Optics panel (page 284). This results in a more accurate correction.

2. In the Geometry panel, click the **Guided Upright Tool** button, which looks like a hand-drawn + symbol.

← Guided Upright Tool

3. To **draw a line**, click at the beginning of your vertical or horizontal line (for example, the wall of a building) and drag to the end of the line.

As you float over the photo, the floating Loupe tool displays a zoomed section to help you make an accurate selection. Hold down Alt (Windows) / Opt (Mac) to slow down the Upright cursor for greater accuracy.

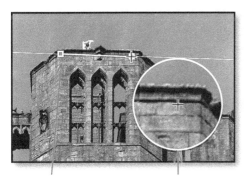

Click and drag to draw a line

Zoomed section helps you draw accurately

4. Repeat to add additional lines—a maximum of two horizontal and two vertical. As you add the second and any subsequent lines, Lightroom updates the image's perspective so you can preview the effect.

5. When you're finished, click on the *Guided Upright Tool* button again to hide the tool.

To **adjust an existing line**, click on the

square at the end of the line and move it to a new position.

To **delete a line**, click on it to select it and press the Delete key on the keyboard. To remove all of the lines, right-click on the photo and select *Reset Upright Guides*.

REDUCE THE EFFECT

We're used to seeing converging verticals in everyday life, so a full correction can look unnatural. Using the *Manual Transforms* sliders, you can adjust individual axes of rotation, reducing their effect. For example, setting the *Vertical* slider to +10 reintroduces some converging verticals, giving a more natural appearance.

CONSTRAIN CROP

When you pull the pixels around to fix the geometry of a photo, white areas appear. You can crop these white areas away manually using the Crop tool (page 186),

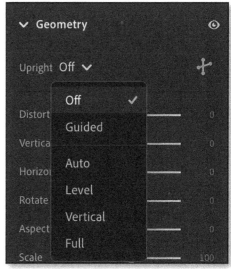

Geometry panel > Upright: Desktop

but the **Constrain Crop** checkbox does it for you automatically. Unchecking the *Constrain Crop* checkbox doesn't remove the crop, but if you don't like the result of the automatic crop, you can adjust it using the Crop tool.

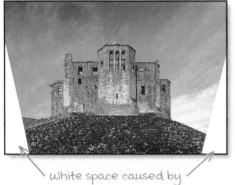

White space caused by distortion correction

FIXING GEOMETRIC DISTORTION MANUALLY

The *Manual Transforms* sliders in the Geometry panel are not often needed; however, they can be useful for slimming people, and recovering pixels pushed out of the frame by other lens and perspective corrections.

The **Distortion** slider corrects for barrel or pincushion distortion, which can be helpful if you don't have a lens profile. It can also be used to create a fisheye-type effect.

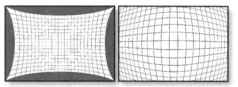

The **Vertical** and **Horizontal** sliders adjust for perspective. They're most helpful in reducing the effect of Upright corrections to make it look more natural.

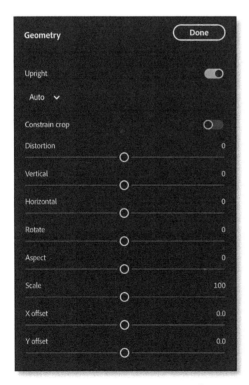

Geometry panel > Manual Transforms: mobile (left), Desktop (right)

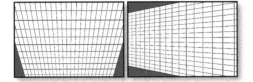

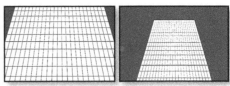

The **Rotate** slider adjusts for camera tilt. It's applied at a much earlier stage in the processing than the crop, with a different result. *Rotate* pivots on the center of the uncropped photo instead of the center of the crop.

If you're using these *Manual* sliders to correct perspective and your camera wasn't level, it's better to use *Upright* or the *Rotate* slider to level the camera rather than *Straighten* in the Crop tool. In other words, don't worry about this slider if you're not using the other *Manual* sliders!

The **Aspect** slider squashes or stretches the photo to improve the appearance. Strong keystone corrections (such as the *Upright* tool) can make a photo look unnatural, especially when the photo includes people. The slider direction depends on the image rotation, but in most cases, dragging the slider to the left makes things look wider, and dragging the slider to the right makes them look taller and thinner.

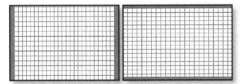

Even if you haven't used the other perspective corrections, moving the *Aspect* slider slightly (usually to the right) slims down the subject, reversing "the camera adds 10 lbs!"

The **Scale** slider shrinks the image within the frame to recover pixels that have been pushed out of the frame by geometric corrections.

Lightroom has to interpolate the data (create new pixels based on surrounding pixels) to resize the image within the frame, which can reduce image quality, so it's best avoided where possible.

Scale can also "zoom in" to remove blank areas of the photo caused by the lens and perspective corrections. However, using the Crop tool (page 186) to remove these blank areas maintains the quality and is a better choice.

The **X Offset** and **Y Offset** sliders shift the photo left/right/up/down. This is useful when a geometric adjustment has pushed the important section of the photo out of the frame. The *Offset* sliders move the important section of the photo back into the frame without interpolation, retaining the best image quality possible.

STITCHING PANORAMIC PHOTOS ON THE DESKTOP

When you see the most incredible view, you may be frustrated that you can't fit it into a single photo.

One option is to use an ultra wide-angle lens. However, this can introduce distortion and often leaves far too much foreground and sky to crop out, reducing the size of the final photo.

Lightroom's Panorama Merge tool allows you to shoot a series of photos and merge them into a single large photo. It's currently only available on the Windows/Mac apps.

If the source photos were captured in the raw file format, other stitching software has to convert the raw data before merging, reducing the dynamic range and applying the white balance color adjustments to the

image data. Lightroom's Merge tool, on the other hand, retains the editing flexibility of the original raw files for the best image quality.

SHOOTING FOR PANORAMIC PHOTOS

Before you can start merging, you need to **shoot some photos**. They must all be the same file type and ideally captured at the same time using the same camera.

It's best to use a **standard-length lens** to minimize distortion, for example, around 20mm-50mm. Don't zoom in or out between photos if using a zoom lens.

Remove filters from your lens, especially polarizers, because they can leave gradients

Shoot multiple photos and merge them using Lightroom

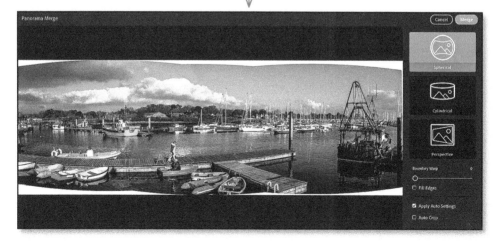

across the finished photo.

You can use the camera's auto/assisted modes to work out the best exposure for the lightest part of the scene, but then, if you can, switch the camera to manual mode so the exposure doesn't change for each photo. If you forget, Lightroom does try to normalize the exposures when you merge.

If you can set your camera to **manual focus**, this also helps to maintain the sharpness throughout the photo.

For the best quality, shoot in your camera's **raw file format**. This gives you some flexibility when merging, especially if you've forgotten to switch to Manual mode.

Most photographers shoot from left to right or right to left, depending on whether they're right or left-handed. Some even capture a photo of their hand pointing in the direction of travel to make it easy to identify the photos they intend to merge later.

As you shoot the pictures, **overlap them** by around 30% so they blend smoothly. Use a tripod to ensure the photos are correctly aligned for the best results. If you're shooting hand-held, leave extra space at the top and bottom to crop out later.

Panoramas don't have to be horizontal. You may shoot a vertical panorama of a tall building or multiple rows to create a super-size image for huge prints.

If you're shooting in a very high contrast situation, you can use your camera's **auto exposure bracketing** to capture multiple exposures for each image (page 217) and then merge these into a panoramic HDR file to retain detail in both the highlights and the shadows.

This huge panorama was created using 24 very roughly captured photos, and is now ready to be edited. As a linear DNG, it retains the editing flexibility of the original raw files.

PREPARING TO MERGE

There's no need to edit the photos before you merge them, with two exceptions: lens corrections and sensor dust.

Lightroom applies the default **lens profile** and chromatic aberration correction to the raw data before merging the panorama to get the best result, whether you've enabled it for the selected files or not.

Dust or sensor spots appear in the same place on every image, and retouching them individually can take a long time on a huge panorama. If they're in a simple area like the sky, you can fix your dust spots on one photo (page 303), paste the corrections to the other photos (page 160), and they'll be applied during the merge process.

One thing to note is that these spot corrections are 'baked in' to the resulting merged image data, so you can't go back and

edit them in the finished panorama. Other spots that only need to be removed on a single image are best left until the finished merged image is available.

If you choose to edit the photos before merging, Lightroom automatically copies the edits from one of the photos onto the merged photo. It skips things like the crop, geometry corrections, and masking, as these would affect the merged photo differently.

Finally, select the photos, right-click, and choose *Photo Merge > Panorama Merge* or *HDR Panorama Merge* to open the Panorama Merge dialog. You'll also find these commands under the Photo menu.

Lightroom automatically downloads the originals from the cloud. If the originals are unavailable, perhaps because you're offline, then Smart Previews will be used instead, and the resulting panorama will be smaller.

SELECTING THE PROJECTION

In the Panorama Merge dialog, there are three projection options to choose from:

Spherical aligns and transforms the photos as if they were mapping the inside of a sphere. This is often the best choice for 360° panoramas.

Cylindrical displays the images as if on an unfolded cylinder, using the middle image as the reference point and transforming the photos where they overlap. It reduces the bow-tie type of distortion you can get with *Perspective* mode. It's a good choice for most photos, especially wide panoramas.

Perspective uses the middle image as the reference point and transforms the other images where they overlap, but it can result in a bow-tie type distortion. It's better at keeping vertical lines straight, so it's often used for architectural photography.

There's no right or wrong choice here, so select the one that looks best on your photo. If one projection mode fails to merge, sometimes another one will work.

FILLING THE EDGES

Unless every source photo was perfectly aligned at the time of capture, there will be **blank white areas** around the edges.

One option is to crop the photo to remove these white areas, and the **Auto Crop** checkbox will do this automatically for you. All pixel detail is retained, and you can reset or edit the crop later using the standard Crop tool.

Alternatively, you can adjust the **Boundary Warp** slider. This analyzes the photo and warps/stretches it to fill the empty space, but straight lines in the image can become a little wavy.

The **Fill Edges** checkbox uses content-aware fill technology to create new pixels to fill the gaps, but its artificial intelligence is limited,

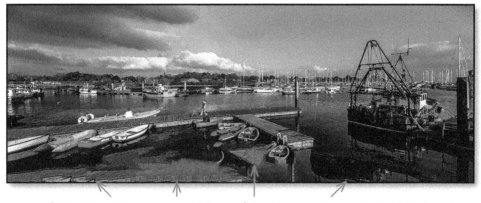

When filling the white gaps, a mixture of tools generally works best. Only using Fill Edges on this Perspective merge made a complete mess of the foreground.

so it may create artifacts and blending problems, especially when there are larger areas to fill.

The best solution is often a mix of tools: bend it a little using *Boundary Warp*, fill in what's left with *Fill Edges*, and manually crop away any leftover distorted areas.

THE RESULTING IMAGE

The resulting panorama is saved as a 16-bit DNG file. Lightroom automatically adds -pano to the end of the filename to help identify it and displays a thumbnail badge. If you were viewing an album, the source photos are automatically stacked, with the merged panorama at the top.

There is a limit to the file size that Lightroom can handle. Photos must be no more than 65,000 pixels along the longest edge or no more than 512 megapixels, whichever is smaller. Large panoramas can sometimes hit these limits, but Lightroom automatically

shrinks them to fit, so you don't have to think about it.

The photo can be edited using standard editing tools. Lightroom may feel slower to respond due to the size of the image.

STEP-BY-STEP

There's a set of photos in the demo images download in the Members Area, so let's give it a try:

1. Select a series of photos. The order of the photos in the Filmstrip doesn't matter, as Lightroom matches the photos visually.

2. Right-click on the photos and select *Photo Merge > Panorama Merge* or *HDR Panorama Merge*.

3. Select a projection mode that looks good.

4. Check the *Auto Crop* checkbox to remove the blank white space, drag the *Boundary Warp* slider to warp the photo to fill the white space, check the *Fill Edges* checkbox, or combine settings for the best result.

5. Click *Merge* to create the stitched file.

RETOUCHING DISTRACTIONS

18

Retouching has long been the domain of pixel-based photo editors such as Photoshop, but Lightroom has advanced healing tools that can remove many distractions without a round trip to Photoshop.

There are pros and cons to retouching in Lightroom. Being able to edit the raw file in Lightroom means you don't need another large TIFF file taking up space in the cloud or on your hard drive, and it's non-destructive, so you can go back and change your edits again later.

On the downside, Lightroom is a parametric editor, which means it has to re-run text instructions constantly, so it gets slower with the more local adjustments (masks, healing) you apply.

The point where a pixel editor becomes more efficient than Lightroom depends on your computer hardware and the retouching you're trying to do. As a rule of thumb, stop and switch to Photoshop when it gets frustrating!

IN THIS CHAPTER, WE'LL CONSIDER:

• How to retouch spots as well as larger distractions using Lightroom.

• How to fix red eye using Lightroom.

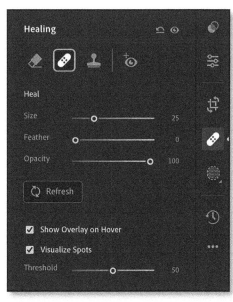

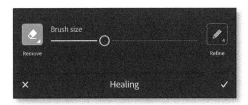

Healing panel:
mobile (left), Desktop (right)

HEALING TOOL BASICS

The Healing tool can remove sensor dust spots in the sky, litter on the ground, raindrops on the lens, acne on faces, or even more complex distractions.

The workflow slightly differs depending on whether you work on a mobile or desktop computer. To avoid repetition, we'll look at the primary tool options in this lesson before we put them to use.

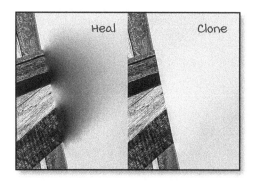

Against hard edges, Heal mode can smudge, so Clone is a better choice

HEALING MODE

Lightroom can do three different kinds of repairs:

Remove uses Photoshop's Content-Aware technology to analyze the surrounding area to remove entire objects, distractions, or blemishes. It works best in areas of similar texture and tone, whether sky, grass, seaweed, or stone.

Heal attempts to intelligently match the texture, lighting, and shading to blend the repaired pixels seamlessly into the surrounding area. Unlike the AI-based *Remove* mode, you can select the source of the pixels, so it works well in situations *Remove* can't handle.

Clone simply copies the pixels and pastes them in another location, so it's best for repairing patterns, moving birds to a different location in the sky, or retouching along hard edges.

For most repairs, the *Remove* or *Heal* modes work best. However, if you're trying to retouch a spot along an edge in the photo, like a roof line against the sky, these tools can smudge, in which case the *Clone* option may work better.

BRUSH CHARACTERISTICS

There are two or three brush options, depending on your selected mode:

Size obviously affects the size of the brush stroke. Ideally, you want to make as few strokes as possible so you don't accidentally end up with holes in your repair.

The **Feather** slider only applies to *Heal* and *Clone* modes and adjusts the softness of the brush edge.

A *Clone* spot stands out if it has hard edges, so you'll usually want to select a higher feathering value, such as 90-100. The *Heal* mode works best with *Feather* set to a low value (e.g., 0-15) as it automatically blends the edges into the surroundings.

Most of the time, you'll want the *Opacity* slider set to the maximum of 100. However, there are occasions when you might want to reduce it; for example, you may not want to

remove the lines on a person's face entirely but just fade them slightly.

WHICH HEALING MODE?

Remove works great for these people, who are in fairly simple surroundings, or try Heal mode if you want to pick the source area.

Want a few more seagulls? That's a job for the Clone mode.

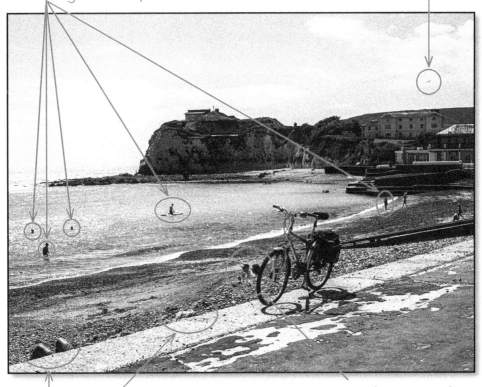

Remove gets confused by the multitude of textures, but Heal allows you to pick a source further along that concrete edge.

Remove may work if you're careful tracing along the tyre, but a combination of Clone along the edge then Heal or Remove for the rest will likely work better.

HEALING ON MOBILE

On mobile, the Healing tool is split over two views. Let's call them the Add and Refine views. In the Add view, select the healing mode and the brush size. Then, in the Refine view, you can edit the repairs, adjusting the size (circular spots only), the feathering, the opacity, and changing the source. You can also delete repairs that you no longer need.

To **open the Healing tool**, tap the Healing icon in the Toolstrip.

If the distraction is small, you may need to **zoom in before brushing** over the distraction so that you can see the photo in detail. Use pinch and spread gestures to zoom, then drag the photo around using two fingers.

BRUSH OVER THE SPOTS

Using the **Mode** pop-up, select the healing mode you think will suit the distraction best.

Then, it's time to **set the brush size** using the **Size** slider. A red preview displays in the center of the screen as you adjust the slider so you can see how big the brush will be.

If the distraction is circular, such as sensor dust, simply tap on the distraction to remove it. Unlike brush strokes, these circular spots can be resized later.

For all other distractions, drag your finger across the screen to brush over the distraction. (Fingers can be a bit big, so if

your device supports it, you might find a stylus or Apple Pencil easier.)

REFINE THE SETTINGS

Because Lightroom is a non-destructive editor, you can refine your repairs immediately after creation or return to them later. On iPhone/Android, the Healing tool stays in the Add view until you switch to the Refine view, whereas the iPad switches to the Refine view immediately after placing a Heal or Clone spot.

To manually switch to the Refine view, tap the **Refine** button. The tiny number on the button indicates how many repairs there are in the photo.

If you've just added a repair, that repair is automatically selected. Your existing repairs are marked with the healing mode icon so you can tell which is which. To **select a different repair**, tap on one of the icons.

You'll notice from the quick reference diagram that the Refine view buttons vary depending on which mode was used to create the repair.

If a repair doesn't blend well into its surroundings, you can change the source

HEALING BRUSH (MOBILE)

"Add" View

Repair mode
(Remove/Heal/Clone)

Brush Size

Enter Refine View

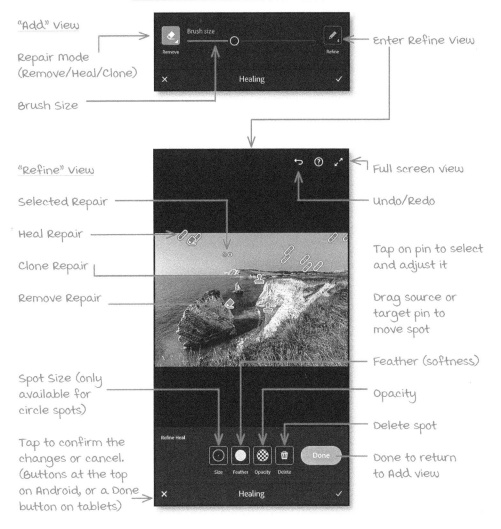

"Refine" View

Selected Repair

Heal Repair

Clone Repair

Remove Repair

Full screen view

Undo/Redo

Tap on pin to select
and adjust it

Drag source or
target pin to
move spot

Feather (softness)

Spot Size (only
available for
circle spots)

Opacity

Delete spot

Tap to confirm the
changes or cancel.
(Buttons at the top
on Android, or a Done
button on tablets)

Done to return
to Add view

Size Feather Opacity Delete

Refresh (Remove mode only)

Arrow shows source > target.
Drag source selection to select
a different source of pixels

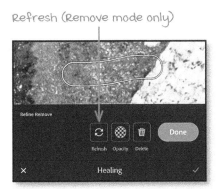

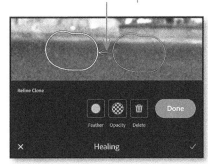

of the pixels. For a *Remove* repair, tap the **Refresh** button to try a different source. In *Heal* or *Clone* mode, drag the source overlay to a better location.

Source of new pixels Retouched area

To **resize a circle spot**, tap the **Size** button and adjust the slider. (Remember, you can't resize non-circular brush strokes.)

In *Heal* and *Clone* modes, you can adjust the **Feather** slider. Remember, if it's a *Heal* repair, you'll need a low amount of feathering, but if it's a *Clone* repair, you'll probably want a higher value.

In most cases, you can leave the **Opacity** slider at its default setting, but occasionally, you may want to reduce it to fade the retouching, such as softening the lines on a person's face.

If the placement isn't quite right, you can **move a repair** by dragging the overlay.

To **delete a repair**, select the pin and then tap the Delete button. As each spot is deleted, another is selected, so to **delete all repairs**, just keep tapping the *Delete* button until they're all gone.

When you've finished refining your repairs, tap **Done** to return to the Add view.

When you've finished retouching, tap the checkmark/*Done* button to save your changes and close the Healing tool.

HEALING ON THE DESKTOP

To **open the Healing tool** and show the Healing panel, click the icon in the Toolstrip or press the H key.

 ← Healing tool

If the distraction is small, you may need to **zoom in before brushing** over the distraction so that you can see the photo in detail. Hold down the Spacebar while clicking and dragging to pan around the photo without accidentally creating extra spots.

SELECT THE HEALING OPTIONS

Select the healing mode you think will suit the distraction best using the buttons at the top of the Healing panel. (You can change it again later.)

Remove Heal Clone

Then, it's time to **select your brush characteristics**. The current brush size and feathering are previewed on the cursor, with two lines close together for minimal feathering and further apart for greater feathering.

Select the right size brush using the **Size** slider in the Healing panel. You can also use the [and] keyboard shortcuts or your mouse scroll wheel to adjust the size. If you're removing a circular spot, make the inner circle big enough to cover the spot. For a non-circular object, a brush size that

HEALING TOOL (DESKTOP)

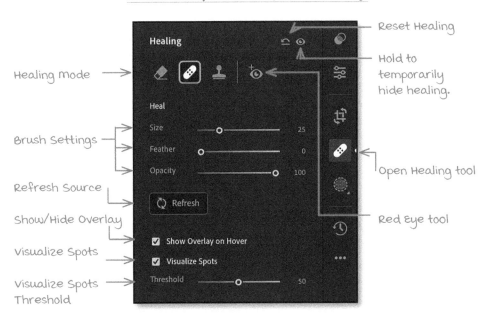

Healing mode →
Brush Settings
Refresh Source
Show/Hide Overlay
Visualize Spots
Visualize Spots Threshold

Reset Healing
Hold to temporarily hide healing.
Open Healing tool
Red Eye tool

Healing

Heal

Size — 25
Feather — 0
Opacity — 100

Refresh

☑ Show Overlay on Hover
☑ Visualize Spots
Threshold — 50

will cover the object without too many strokes is ideal.

If you're using the *Heal* mode, set the **Feather** slider to around 0, but if you're using the *Clone* mode, you'll need a much higher value. The Shift-[and Shift-] keys also adjust the feathering.

Set the **Opacity** slider to 100 unless you want to fade the retouching, such as softening the lines on a person's face. If you do want to reduce the opacity, it's often easier to adjust the slider after drawing the repair.

BRUSH OVER THE SPOTS

If the distraction is circular, such as sensor dust or a pimple, simply click on the distraction to remove it. Unlike brush strokes, these circular spots can be resized later.

For all other distractions, hold down the mouse button and drag the cursor across the photo to **brush over the distraction**. A brush stroke appears, then is replaced by two white outlines showing the source and target.

One more trick while we're removing spots... to draw perfectly straight lines, such as for power or telephone lines, click

at the beginning of the line, then hold down the Shift key and click at the end of the line. Lightroom automatically joins the two points with a straight line.

Lightroom automatically searches for a good source of replacement pixels. The result may be perfect from the initial click, but if the suggested source pixels don't match the surroundings, press the **Refresh** button or / key to make Lightroom try again, or click and drag the source pin to a more suitable area.

Source of new pixels Retouched area

Continue clicking or brushing over the distractions to **add more repairs** using the same healing mode. If you want to change to a different mode, press the Escape key first; otherwise, the mode of the selected repair gets changed, too.

EDITING EXISTING SPOTS

Because Lightroom is a non-destructive editor, you can come back and change your retouching later.

To **find existing repairs**, you'll need to see the overlays. Check **Show Overlay on Hover** (or the O key) and float the cursor over the photo if they're not showing.

To **select a repair**, click on its overlay. They look slightly different, depending on whether it's a resizable circle spot or a brush stroke.

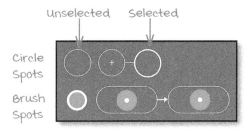

To **resize a circle spot**, adjust the *Size* slider or hover over the edge of the outline so the cursor changes to a double-headed arrow, then drag the edge to adjust the size.

Drag the source or target pin to a new location to **move a repair**.

To **delete a repair**, click on the overlay to make it active, and then press the Delete key on your keyboard, or right-click on the repair to delete using the context-sensitive menu.

To **delete multiple repairs**, hold down the Alt key (Windows) / Opt key (Mac) so the cursor changes to a pair of scissors, then drag a box around the pins to delete them.

To **delete all repairs**, press the *Reset* button in the Healing panel.

DON'T MISS A SPOT

If you're checking the entire photo for

sensor dust, enable the **Visualize Spots** checkbox in the Healing panel. Lightroom displays a black-and-white edge mask of your photo, which makes it easier to spot any dust spots, and you can adjust the **Threshold** slider to increase or decrease the number of white borders displayed.

There's one more handy trick to check the entire photo at 100% zoom without missing any spots... Zoom into 100%, view the top left corner, and press the Page Down key (Windows) / Fn down arrow key (Mac). Lightroom divides the photo into an imaginary grid, so when you reach the bottom of the first column, it automatically returns to the top of the photo and starts on the next column. By the time you reach the bottom right corner, you'll have checked the entire photo.

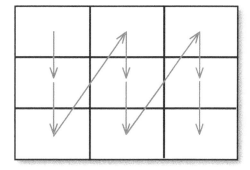

ADVANCED RETOUCHING USING LIGHTROOM

In the previous lessons, we learned how to remove simple distractions using the Healing tool, but it gets more complicated when the distraction isn't on a plain background or borders against something else.

REMOVING LARGE DISTRACTIONS AND EDGES USING HEAL AND CLONE

Complicated distractions are often quicker and easier to retouch using a pixel-based editing tool such as Photoshop, but with patience, it is possible to do it in Lightroom. The trick is to chop the distraction into bite-size pieces and handle each section individually.

The duck photo-bombed this photo of a pelican, so let's remove him...

If we just brush up to the edge of the beak and sign using *Heal* mode, it leaves a dark smudge, but using *Clone* mode doesn't match the texture and leaves harsh edges. *Remove* mode creates an odd effect on this photo as the surroundings are too complex.

Retouching against an edge using Heal mode leaves a dark smudge

What we need is the best of both worlds. We'll use the *Clone* and *Heal* modes to remove the duck.

1. Use two thin *Clone* lines along the edge of the beak and sign. When you then paint a large *Heal* stroke over the duck's head and body and slightly overlap the *Clone* strokes, you'll get a much cleaner result, as there won't be any adjacent dark pixels to smudge. Depending on the photo, you could also try *Remove* mode rather than *Heal*.

Retouch the edge using Clone lines to create a clean boundary

2. In this case, there's only one suitable small clone source to the right of the duck's head, which isn't big enough to repair his whole head and body. To solve this, we'll divide him up using additional *Clone* strokes.

Add additional Clone lines to divide the area into smaller chunks if it's too big

3. Brush over the individual duck sections one at a time using a *Heal* brush, slightly overlapping the clone dividers. This step can be tricky because Lightroom tries to select the existing brush strokes when you get close to them. Disable *Show Overlay on Hover* if they're getting in the way.

Use Heal brush strokes to fill each individual section, overlapping the clone strokes

4. Additional strokes can be used to heal any leftover artifacts. Repeat the same process for the duck's body and legs to remove him altogether.

RETOUCHING FACES

Faces also need slightly more advanced retouching. For softening skin, brightening eyes, whitening teeth, and similar retouching, you'll need to use the Masking tools (page 148). The Healing tool, however, can help reduce wrinkles and bags under the eyes and remove pimples and scars.

Completely removing bags and wrinkles looks unnatural, so try a brush set to *Clone* mode and reduce the *Opacity* to around 20-25. Select a source that's similar in tone and texture, such as the skin immediately underneath.

To remove skin blemishes, select a *Heal* brush slightly larger than the pimple and set to full *Opacity*. (Severe acne may still need the power of Photoshop.)

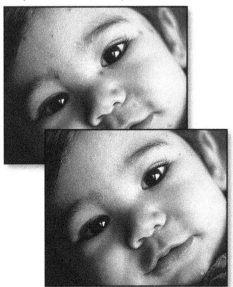

FIXING RED EYE ON THE DESKTOP

Red eye is caused by light from a flash bouncing off the inside of a person's eye. Many cameras use a pre-flash to reduce red eye, but if you find a photo with red eye, you can quickly fix it using Lightroom on the desktop. (It's not currently available on mobile.)

To **open the Red Eye tool** on the desktop, click the Healing icon in the Toolstrip or press the H key.

← Healing tool

In the Healing panel, switch to the Red Eye tool.

← Red Eye tool

INITIAL CORRECTION

If you click the **Auto Correct** button, Lightroom uses artificial intelligence to search for faces with red eyes and tries to fix them automatically by desaturating and darkening the pupil.

To **manually correct a red eye**, click and drag from the center of the eye to draw an oval around the whole eye. Lightroom searches for the red eye within the selected area and fixes it.

FINE TUNING REPAIRS

Lightroom often selects the red area accurately, but if the repair isn't quite right, you can fine-tune the corrections using the overlay and sliders.

To **reselect a correction area**, click on its overlay.

To **change the size or shape of a correction area**, drag the handles on the edge of the overlay.

If the size of the gray spot isn't quite right, adjust the **Pupil Size** slider. Adjust the **Darken** slider to darken or lighten the pupil.

To **delete a red eye repair**, select the overlay and press the Delete key. To **delete all red eye repairs**, click the *Reset* button in the Red Eye panel.

RED EYE (DESKTOP)

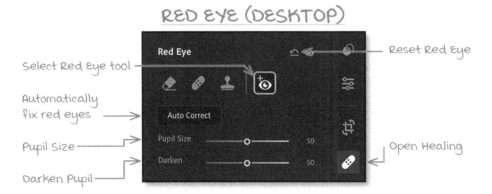

Select Red Eye tool

Automatically fix red eyes

Pupil Size

Darken Pupil

Reset Red Eye

Open Healing

MASKING

19

Most of Lightroom's sliders apply to the whole photo, but the masking tools allow you to apply settings to specific areas. This isn't a new concept. Photographers have been dodging and burning photos in the darkroom for years. The masking tools can be used for things like:

Dodging & Burning—The *Exposure* adjustment is similar to dodging and burning in a traditional darkroom, lightening and darkening areas of the photo.

Enhancing Faces—Settings such as *Sharpness*, *Texture*, and *Noise Reduction* can soften the skin on portraits without softening the eyes.

Mixed Lighting—*Temp* and *Tint* are helpful when adjusting for mixed lighting situations or changing the color of specific regions.

Enhancing Sunset Skies—Settings can be combined, so combining - *Exposure*, + *Saturation*, and + *Clarity* can enhance a sunset.

But how do you decide what to adjust and where to draw the eye? It comes back to the decisions you made when you were analyzing the photo (page 131). Did you find any distractions that need to be minimized, for example, bright areas in a dark scene or warm saturated colors in the wrong spot? And what did you decide to enhance to draw the viewer's eye around

masking allows to you apply edits to specific areas of the photo, such as lightening the shadow area on this lion's face (highlighted in red).

the photo?

CREATING YOUR FIRST MASK

To **select the Masking tool** on mobile, tap the Masking icon in the Toolstrip and then press the blue + button to select a masking tool. On the desktop, click the Masking icon in the Toolstrip or press the M key. If you haven't already added a mask to the selected photo, Lightroom asks what type of mask you'd like to create.

← masking tool

As you can see from the list, there's a wide range of selection tools, so we'll explore them one at a time. Some of the AI-based Masking tools are currently only available

on the desktop.

Once you've created your selection, you can adjust the sliders in the right panel. We'll come back to the kinds of adjustments you might like to make later in the chapter (page 339).

Creating multiple masks allows you to apply different edits to different photo areas.

IN THIS CHAPTER, WE'LL CONSIDER:

• How to use AI-based automated selections to select specific areas of the photo.

• How to paint using the Brush for complete flexibility.

• How to draw Linear & Radial Gradients.

• How to create selections based on Color, Luminance, or Depth Ranges.

• How to manage masks using the Masks panel.

• How to use overlays and pins to identify your masks.

• How to combine multiple selections for advanced masking.

• How to apply slider adjustments and what you might use them for.

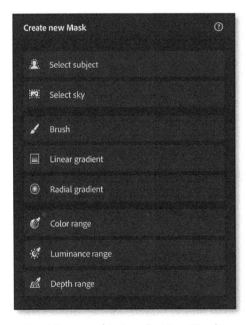

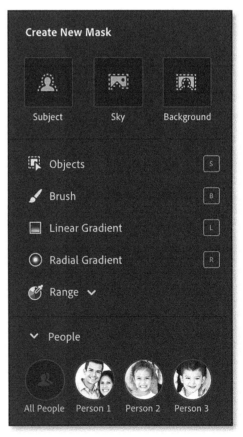

masking panel > Create New mask:
mobile (top), Desktop (bottom)

MAKING AI-BASED SELECTIONS

The *Subject, Sky, Background, Objects,* and *People* tools are the most straightforward tools in the Masking toolbox because they use artificial intelligence to automatically select elements in the photo, with varying results.

AI-based masks require a lot of processing power. Only the *Subject* and *Sky* AI-based selections are currently available on mobile, and support is dependent on the device specification. All the tools are available on the desktop if you have a supported GPU, but they may be slow on low-specification hardware.

A Background selection selects everything except the subject, highlighted here in red.

SUBJECT, BACKGROUND & SKY MASKS

Subject selection attempts to select the subject, whether a person, an animal, a flower, or a bicycle. Perhaps you want to lighten a black dog selectively or add a little *Texture* to its fur.

A *Sky* selection makes it easy to add *Clarity* to highlight the clouds or make it the shade of blue you remember. Inverted, you might apply *Sharpening* or *Texture* to the foreground without making the sky too noisy.

A *Background* selection isn't actually just the background; it also includes the foreground! It selects everything except the subject.

To **create a Subject, Sky, or Background selection**, select the *Subject, Sky,* or *Background* buttons from the list of masking tools. Lightroom searches the photo and creates a selection. That's it, there is nothing else to do!

OBJECT MASKS ON THE DESKTOP

The **Objects** tool is like *Subject* selection, except you choose the subject. It uses AI to select whatever item you roughly scribble over or draw a box around.

To **create a user-guided object selection**, select *Objects* from the list of masking tools or press the S key.

In the right panel, you can select the brush or box selection mode or use the S key to toggle.

If you're using the brush, simply brush over the object, completely covering it with the red overlay. You don't need to be too careful. You can change the brush size using the slider or the [and] keys.

If you prefer the box selection mode, drag a

box roughly around the object.

You can continue to brush over or draw boxes around additional objects to add them as additional selections in the same mask. For example, if three dogs all need a little *Texture*.

PEOPLE MASKS ON THE DESKTOP

The **People** selection automatically selects entire people or specific body parts. It's a real timesaver when retouching portraits!

To **create a People selection**, start by deciding who to select: *All People* or a single person.

If you want to select more than one person, click on one initially, then click *View All* at the top of the next screen to check the others.

If you can't identify people's faces, float the cursor over the *Person* icons to show the overlay on the main preview.

One detail to note... at the time of writing, selecting one person and adding others

results in a more accurate selection than the *All People* option. I hope this is a bug that will be fixed in a future release, but at least it has a good workaround for now!

Next, decide whether to **select the *Entire Person* or individual parts** of their body: *Facial Skin, Body Skin, Eyebrows, Eye Sclera* (the whites of the eyes), *Iris and Pupil, Lips, Teeth, Hair, Facial Hair* and/or *Clothes*.

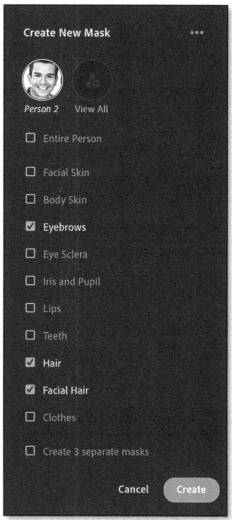

If you check *Create X separate masks*, Lightroom creates multiple masks rather than placing all of the selections in a single mask. This allows you to apply different

adjustments to the different body parts, such as softening facial skin, reducing saturation on bloodshot eyes, and whitening teeth.

If multiple people are in the photo, and you want to apply the same skin smoothing settings to everyone's faces, click *View All* at the top and then check the other people.

Finally, click *Create* to allow Lightroom to create the masks.

EDITING AI MASKS

To **invert the selection**, for example, to select everything except the sky, tap/click the **Invert** button.

There are no other controls to refine the selections, but you can use the other Masking tools to add to or subtract from the mask. We'll come back to combining selections (page 335).

UPDATING AI MASKS FOR IMAGE CONTENT

When you paste masks (page 162) or apply presets (page 165) that include AI-based masks, the masks are automatically recomputed based on the current photo.

However, there are a few occasions when you might need to **update AI masks manually**. For example, if you're applying a preset that includes an AI mask as your raw default settings (page 180), it's not automatically recomputed.

Any masks that need updating display a warning triangle on the thumbnail to remind you to select and update the mask.

You can **update the AI masks on a single photo** using the *Update* (mobile) / *Update AI Settings* (desktop) button in the Masks panel. If the button doesn't show, none of the masks need updating for new image content.

On the desktop, you can also **update all AI masks on a batch of photos** by selecting them in the Grid view and going to the *Photo menu > Update AI Settings in X Photos*.

UPDATING AI MASKS AFTER HEALING

The other reason you may need to update a mask manually is if you've used the Healing tool (page 298) after creating an AI-based mask. For example, imagine a seagull in the photo when you create a Sky mask. If you then use the Healing tool to remove the seagull, the mask isn't automatically updated, so you're left with a ghost of the seagull.

At the time of writing, Lightroom doesn't warn that you've used the Healing tool in an AI-masked area other than displaying an **Update** button above the Masking sliders when the mask is selected. The *Photo menu > Update AI Settings in X Photos* command also updates the masks on all selected photos.

There isn't an *Update* button on mobile, so you must delete and recreate the AI mask.

The easiest way to avoid this issue is to make your Healing tool adjustments before creating AI-based masks rather than afterward.

MAKING SELECTIONS USING THE BRUSH

The Brush tool allows you to create a freeform selection by painting on the photo. It's not constrained to a specific shape, so it's very flexible.

CREATING BRUSH SELECTIONS

To **create a brush selection**, select *Brush* from the list of masking tools or press the B key (desktop only).

To **paint with the brush** on mobile, drag your finger or stylus/pen across the photo. On the desktop, hold down the mouse button, drag the cursor across the photo, and then release the mouse. Holding down the Shift key while you paint draws the stroke in a straight vertical or horizontal line (desktop only).

If you make a mistake when brushing, it's not a problem. To **erase part of the selection**, select the *Eraser* from the icons (mobile) / Brush panel (desktop).

On the desktop, you can also hold down the Alt (Windows) / Opt (Mac) key to select the eraser temporarily and brush away the selection. Of course, if you've only just painted a stroke, undo button (mobile) / Ctrl-Z (Windows) / Cmd-Z (Mac) will also undo your last action.

To **invert the brush selection**, to affect everything except your brushed area, tap/ click the *Invert* button.

The brush allows you to paint a freeform selection, such as the areas highlighted in red here.

CHOOSING THE RIGHT BRUSH

If you're doing some painting at home, you'll pick the right brush for the job. Perhaps a large brush for the wall and a small brush to paint along the edges. Lightroom offers similar controls.

On mobile, hold your finger on the *Size, Feather,* or *Flow* icon and drag up or down to increase or decrease the slider value. The numeric value displays at the top of the screen, and a red preview displays in the center of the screen so you can see how big or hard the brush will be.

On the desktop, these are selected using sliders in the Brush panel (some are hidden under a disclosure triangle), and the size and feathering are previewed on the cursor, with two lines close together for minimal feathering and further apart for greater feathering.

BRUSH (MOBILE)

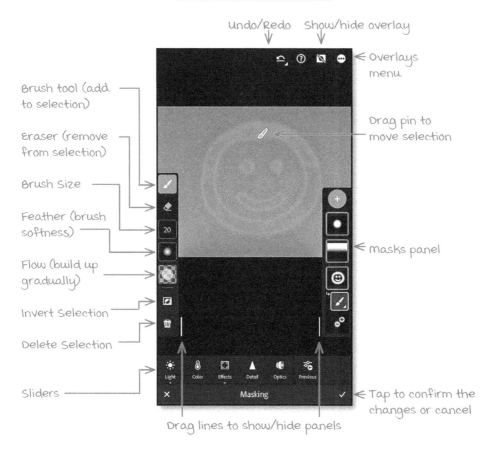

Undo/Redo Show/hide overlay

Overlays menu

Brush tool (add to selection)

Drag pin to move selection

Eraser (remove from selection)

Brush Size

masks panel

Feather (brush softness)

Flow (build up gradually)

Invert Selection

Delete Selection

Sliders

Tap to confirm the changes or cancel

Drag lines to show/hide panels

Size runs from 0.1, which is a tiny brush, to a maximum size of 100. You can use multiple brush sizes on the same selection, perhaps using a large brush to cover a large area and then a small brush for detailed edges. On the desktop, you can also use the [and] keyboard shortcuts or your mouse scroll wheel to adjust the size.

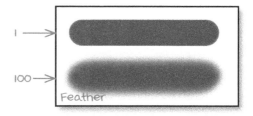

Feather

Feather runs from 1, a hard-edged brush, to 100, a soft brush. A harder-edged brush is helpful when brushing up against the edge of an object in the photo, whereas a soft brush is better for blending your adjustments into the rest of the photo. The Shift-[and Shift-] keys also adjust the feathering on the desktop.

Flow controls the rate at which the adjustment is applied. With *Flow* at 100, the brush behaves like a paintbrush, laying down the maximum effect with each stroke. With *Flow* at a lower value, such as 25, the brush behaves more like an airbrush, building up the effect gradually.

Density (desktop only) limits the maximum strength of the stroke. Regardless of how

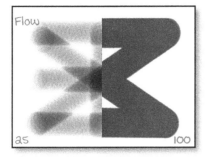

many times you paint, the mask can never be stronger than the maximum density setting. Unless you need the *Density* control for a specific purpose, I'd suggest leaving it set at 100.

If you're brushing over the photo and nothing seems to be happening, it's usually because the *Flow* or *Density* sliders are too low.

Some photographers like to use an Apple Pencil (iPad) / stylus (Android) / graphics tablet and pen (desktop) to paint on the photo. It can take some practice, but it's a more natural and accurate way of drawing. The flow/opacity of the stroke is controlled by how hard you press, just like drawing with a pencil on paper.

The **Auto Mask** checkbox (desktop only) confines your brush strokes to areas of similar color based on the tones that the center of the brush passes over. This helps prevent your mask from spilling over into other areas of the photo; for example, you can paint over a child's shirt to selectively adjust the color without brushing around the edges carefully.

It can cause halos. For example, trying to darken a bright sky with a silhouette of a tree in the foreground may leave a halo around the edge of the tree.

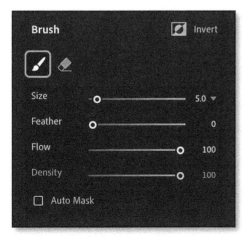

Brush panel: Desktop

MAKING SELECTIONS USING A LINEAR GRADIENT

The Linear Gradient helps darken the sky in a sunset photo or blur a distracting foreground. It can also be helpful if the lighting on one side of the photo differs from the other.

DRAWING A LINEAR GRADIENT

Select **Linear Gradient** from the list of masking tools to **create a linear gradient,** or press the L key (desktop only).

To **draw a linear gradient** on mobile, drag your finger or stylus/pen across the photo

The linear gradient fades as it stretches across the photo, so it's ideal for enhancing sunsets.

LINEAR GRADIENT (MOBILE)

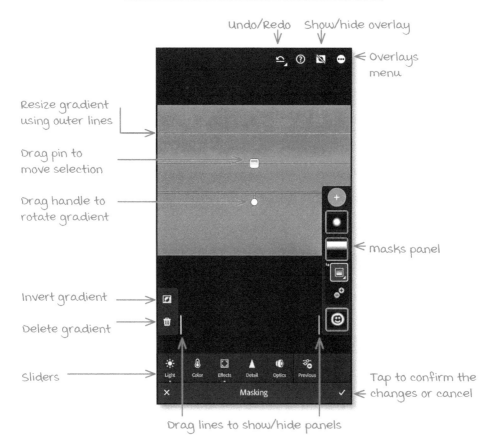

Undo/Redo Show/hide overlay

Overlays menu

Resize gradient using outer lines

Drag pin to move selection

Drag handle to rotate gradient

masks panel

Invert gradient

Delete gradient

Sliders

Tap to confirm the changes or cancel

Drag lines to show/hide panels

LINEAR GRADIENT (DESKTOP)

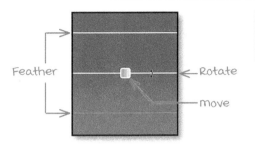

Feather · Rotate · Move

Linear Gradient ☑ Invert

from the gradient's start to the end.

On the desktop, click at the gradient starting point and drag to the gradient endpoint before releasing the mouse button. To drag out from the gradient's center, instead of setting the start/end points, hold down the Alt (Windows) / Opt (Mac) key while dragging. The gradient then expands equally from both sides of your starting point. If the horizon is straight, hold down the Shift key while creating the gradient to constrain it to a 90° angle.

To **edit an existing linear gradient**, you need to be able to see the lines, called the tool overlay. Turn to (page 332) if they're hidden.

Drag the outer lines further apart to **feather/stretch a linear gradient**. Moving them closer together reduces the feathering.

To **rotate a linear gradient** on mobile, drag the central line or the outer handle. On the desktop, float over the ends of the central

line until the cursor changes to a curved double-headed arrow, then click and drag to adjust the rotation of the gradient.

If the gradient is the wrong way round, for example, the effect is applied to the top of a linear gradient instead of the bottom, **invert the linear gradient** by tapping/clicking the *Invert* button.

ADDING TO OR ERASING PART OF THE GRADIENT

Sometimes, you may want to prevent parts of the photo from being affected by a gradient. For example, if you're darkening the sky, you may not want to darken the building on the horizon. In this case, you can brush away part of the gradient. You can do this by combining different types of masks. We'll come back to this in detail later (page 335).

MAKING SELECTIONS USING A RADIAL GRADIENT

The Radial Gradient is particularly useful for off-center vignettes to draw the eye to a specific area of the photo. It can also be used to lighten faces in photos or put a "spotlight" on one area of the photo, among other things.

DRAWING A RADIAL GRADIENT

Select **Radial Gradient** from the list of masking tools to **create a radial gradient,** or press the R key (desktop only).

To **draw a radial gradient** on mobile, drag

A radial gradient puts a soft "spotlight" on the subject or creates a vignette to draw the eye.

RADIAL GRADIENT (MOBILE)

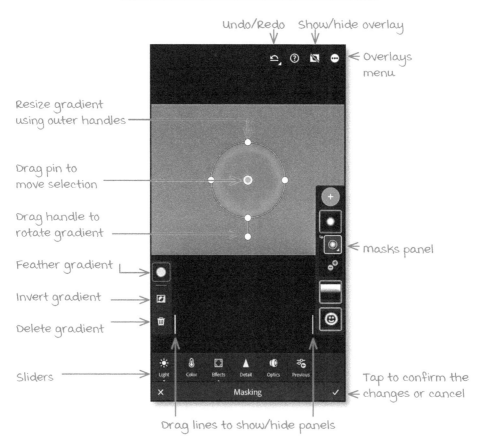

Undo/Redo Show/hide overlay

Overlays menu

Resize gradient using outer handles

Drag pin to move selection

Drag handle to rotate gradient

Feather gradient

Invert gradient

Delete gradient

masks panel

Sliders

Tap to confirm the changes or cancel

Drag lines to show/hide panels

RADIAL GRADIENT (DESKTOP)

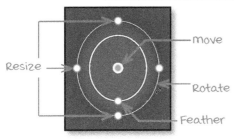

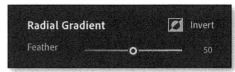

your finger or stylus/pen out from the center of your radial gradient. On the desktop, click in the center of your new circle/oval and drag out toward the edge of the photo before releasing the mouse button.

To **edit an existing radial gradient**, you need to be able to see the lines, called the tool overlay. Turn to (page 332) if they're hidden.

To **resize a radial gradient**, drag the handles on the oval line.

Drag the oval line or the outer handle to **rotate a radial gradient** on mobile. On the desktop, float over the outer oval line. The cursor changes to a curved double-headed arrow, then click and drag to adjust the rotation of the gradient.

To **feather a radial gradient**, hold your finger on the *Feather* icon and drag up or down to increase or decrease the slider value (mobile) / adjust the **Feather** slider (desktop).

If the gradient is the wrong way round, for example, the effect is applied to the inside of a radial gradient instead of the outside, **invert the radial gradient** by tapping/clicking the *Invert* button.

MAKING SELECTIONS USING A COLOR RANGE

The Color Range Mask selects an area based on sampled colors: skin tone, a blue sky, or a child's t-shirt. The steps are slightly different, depending on whether you're using a mobile device or desktop, so we'll investigate each in turn.

SELECTING A COLOR RANGE ON MOBILE

To **select a color range**, select *Color Range* from the list of masking tools. The *Select Color* view is automatically selected.

Select the sampler mode using the buttons at the bottom of the screen. It's in point mode by default, so drag the circle to your selected color. If you switch to range mode, drag a rectangle on the photo to select a range of colors.

Tap *Apply* to return to the main Masking tool view. To return to the *Select Color* view later, tap the eyedropper icon on the left.

SELECTING A COLOR RANGE ON THE DESKTOP

To **select a color range**, select *Color Range* from the list of masking tools or press Shift-C (desktop only). The color range sampler is automatically selected.

Click on your chosen color in the photo to sample a color as a point sample, or click and drag a rectangle to select a range of colors. If you make a mistake, just click elsewhere to select a different color.

When using the point sampler, you can Shift-click to add up to five color samples to your color range. Alt-click (Windows) / Opt-click on the samples to remove them, or click on the photo to reset the color range and select a new color.

The magnifier can help you to select the correct color by showing a zoomed view. To enable it, go to the Mask panel's ... menu and select **Show Magnifier**.

FINE TUNING THE COLOR RANGE

Once you've selected the right color range, adjust the **Refine** slider to **adjust the threshold**.

Holding down the Alt (Windows) / Opt (Mac) key while dragging the slider makes it easier to see which pixels are included in the selection.

To **invert the selection**, tap/click the **Invert** button.

COLOR RANGE (MOBILE)

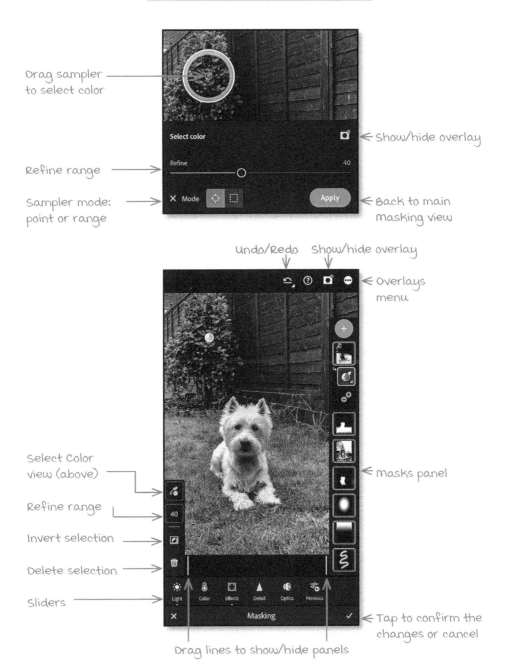

Drag sampler to select color

Show/hide overlay

Refine range

Sampler mode: point or range

Back to main masking view

Undo/Redo Show/hide overlay

Overlays menu

Select Color view (above)

masks panel

Refine range

Invert selection

Delete selection

Sliders

Tap to confirm the changes or cancel

Drag lines to show/hide panels

MAKING SELECTIONS USING A LUMINANCE RANGE

The Luminance Range Mask selects pixels based on their brightness. This makes it much easier to select detailed objects such as trees or just the shadow or highlight tones in an image.

SELECTING A LUMINANCE RANGE

To **create a luminance range selection**, select *Luminance Range* from the list of masking tools or press Shift-I (desktop only). The luminance range sampler is automatically selected.

On mobile, select the sampler mode using the buttons at the bottom of the screen. It's in point mode by default, so drag the circle to your selected brightness. If you switch to range mode, drag a rectangle on the photo to select a brightness range. Tap *Apply* to return to the main Masking tool view. To return to the *Select Luminance* view later, tap the eyedropper icon on the left.

On the desktop, click on your chosen photo brightness or drag a rectangle to select a range. If you make a mistake, click elsewhere to select a different luminance. The magnifier can help you select the right pixels by showing a zoomed view. To enable it, go to the Mask panel's ... menu and select **Show Magnifier**.

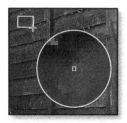

FINE TUNING A LUMINANCE RANGE

The **Select Luminance** multi-slider allows

you to choose or fine-tune which range of pixels should be included in the selection. Like the histogram, the darkest pixels are to the slider's left, and the lightest pixels are on the right.

The range is selected using the box handles in the center; for example, moving the handles to the right selects the lighter pixels. The smoothness of the transition (or falloff) from selected to unselected is controlled by the outer handles.

On the desktop, the **Show Luminance Map** checkbox makes it easier to see which pixels are included in your selection. Hold Alt (Windows) / Opt (Mac) to enable it temporarily.

To **invert the selection**, tap/click the **Invert** button.

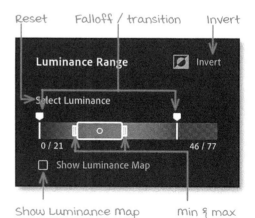

LUMINANCE RANGE
(DESKTOP)

Reset Falloff / transition Invert

Luminance Range Invert

Select Luminance

0 / 21 46 / 77

Show Luminance Map

Show Luminance map min & max brightness

⟵ Darkest pixels on the left, lightest pixels on the right ⟶

LUMINANCE RANGE (MOBILE)

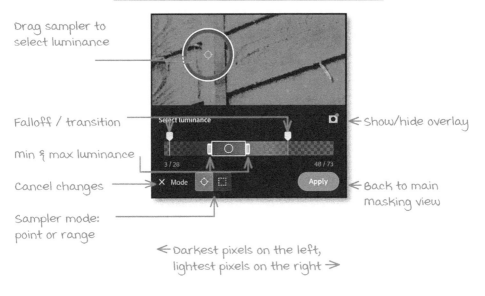

Drag sampler to select luminance

Falloff / transition

Min & max luminance

Cancel changes

Sampler mode: point or range

Show/hide overlay

Back to main masking view

← Darkest pixels on the left,
lightest pixels on the right →

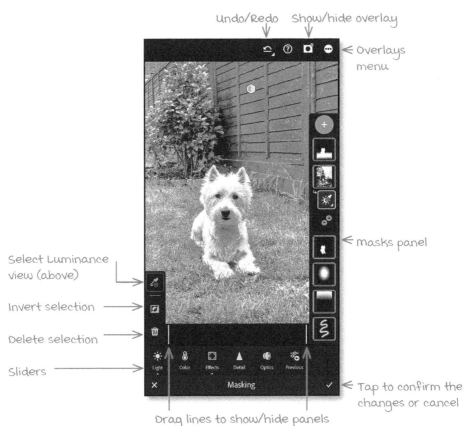

Undo/Redo Show/hide overlay

Overlays menu

masks panel

Select Luminance view (above)

Invert selection

Delete selection

Sliders

Tap to confirm the changes or cancel

Drag lines to show/hide panels

MAKING SELECTIONS USING DEPTH RANGE

If you own an iPhone with two or more lenses, you can create a Depth Range Mask, which can be used for blurring and darkening backgrounds. (Also see the Lens Blur tool on page 254.) It's a quicker way of making a selection based on the distance from the camera.

To **capture a photo with a depth mask**, use the Apple Camera app (or similar) set to Portrait mode with *iOS Settings > Camera > Formats* set to *High Efficiency* mode so it captures in HEIC format.

CREATING A DEPTH MASK ON MOBILE

To **create a depth range selection**, select *Depth Range* from the list of masking tools.

The *Select Depth* view is automatically selected. Select the sampler mode using the buttons at the bottom of the screen. In point mode, drag the circle to your selected depth. In range mode, drag a rectangle on the photo to select a range. Tap *Apply* to return to the main Masking tool view. To return to the *Select Depth* view later, tap the eyedropper icon on the left.

CREATING A DEPTH MASK ON THE DESKTOP

To **create a depth range selection**, select *Depth Range* from the list of masking tools or press Shift-D. The depth range sampler is automatically selected.

Click on your chosen pixels in the photo, or click and drag a rectangle to select a range. If you make a mistake, click elsewhere to select a different depth value.

The magnifier can help you to select the

right pixels by showing a zoomed view. To enable it, go to the Mask panel's ... menu and select **Show Magnifier**.

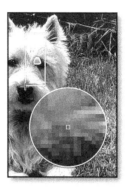

FINE TUNING A DEPTH MASK

The **Select Depth** multi-slider allows you to choose or fine-tune which range of pixels should be included in the selection. The pixels closest to the camera are to the slider's left, and the most distant pixels are

DEPTH RANGE (DESKTOP)

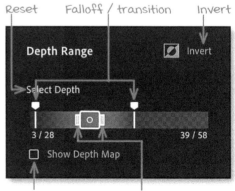

DEPTH RANGE (MOBILE)

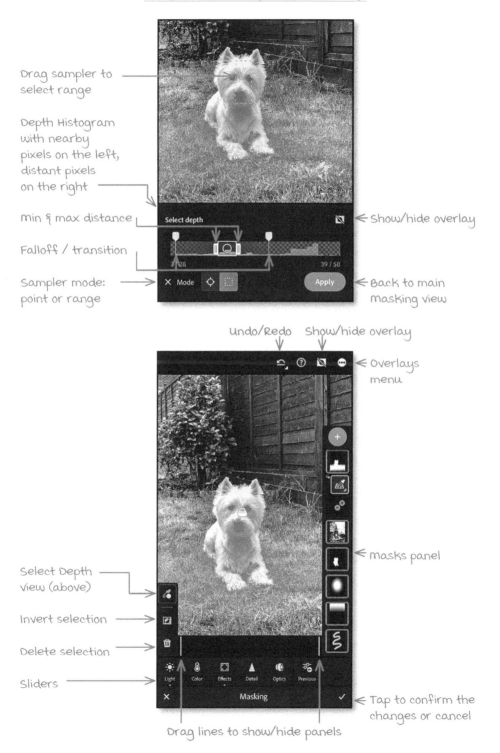

Drag sampler to select range

Depth Histogram with nearby pixels on the left, distant pixels on the right

Min & max distance

Falloff / transition

Sampler mode: point or range

Show/hide overlay

Back to main masking view

Undo/Redo Show/hide overlay

Overlays menu

masks panel

Select Depth view (above)

Invert selection

Delete selection

Sliders

Tap to confirm the changes or cancel

Drag lines to show/hide panels

on the right.

The range is selected using the box handles in the center; for example, moving the handles to the left selects the pixels closest to you. The smoothness of the transition (or falloff) from selected to unselected is controlled by the outer handles.

On the desktop, the **Show Depth Map** checkbox makes it easier to see which pixels are included in your selection. Hold Alt (Windows) / Opt (Mac) to enable it temporarily.

To **invert the selection**, tap/click the *Invert* button.

THE MASKS PANEL

By creating multiple masks, you can apply different edits to different areas of the photo, and they can be overlapped and layered to build up the effect. The Masks panel lists all your masks, making it easy to manage and switch between them.

MANAGING MASKS

To **create additional masks**, tap the + button (mobile) / click the *Create New Mask* button (desktop) at the top of the Masks panel and choose the type of mask.

To **reselect an existing mask**, tap/click on it in the Masks panel.

Several mask management options are available in the menu for each individual mask. To **show the mask menu**, long press (mobile) / right-click (desktop) on the mask thumbnail in the compact Masks panel or tap/click the mask's ... button in the expanded Masks panel.

You can **rename masks** to help identify them if you have many on an image. This is especially useful if you want to copy them to

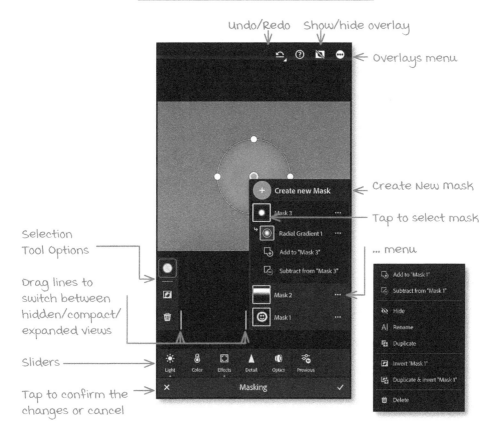

MASKING TOOL (MOBILE)

Undo/Redo Show/hide overlay

Overlays menu

Create New mask

Tap to select mask

Selection Tool Options

... menu

Drag lines to switch between hidden/compact/ expanded views

Sliders

Tap to confirm the changes or cancel

other photos or include them in a preset.

If you've created a mask, perhaps selecting a person in the foreground, but then decide to apply your adjustments to the background instead, you can **invert a mask**.

When you reach the limit of a slider, you can **duplicate a mask** to double the effect. Or, if you want to apply different settings to an inverted copy of a mask, you can select *duplicate and invert*.

To **hide the effect of a single mask**, select *Hide* from the menu or click the mask's eye icon (desktop only). Repeat to show the effect again. On the desktop, holding the mouse button on the eye icon temporarily hides the mask and then shows it again when you release the button.

To **hide the effect of all masks** on the desktop, click the eye icon at the top of the docked Masks panel. (On mobile, you must hide each individually or tap *Reset > Masking*

and *Undo*.)

To **move a mask**, for example, to reposition a radial gradient as a spotlight, tap/click and drag the mask pin. Of course, you must have the pins/tool overlays showing to be able to do this! We'll explore them in more detail in the next lesson (page 332).

To **copy a mask and paste it** onto another photo, use the Copy/Paste tool (page 160). On the desktop, when the Masking panel is open, the keyboard shortcuts Ctrl-C and Ctrl-V (Windows) / Cmd-C and Cmd-V (Mac) only copy the selected mask, which saves a trip to the Copy dialog.

You can **delete a single mask** using the mask menu. You can **delete all masks** on iOS by tapping *Reset > Masking*, whereas on Android, you can only delete them individually. On the desktop, you can also **delete all masks** from the mask menu.

On the desktop, there are two more delete

MASKS PANEL (DESKTOP)

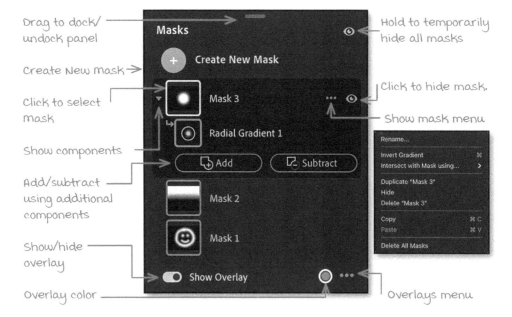

Drag to dock/undock panel

Hold to temporarily hide all masks

Create New mask →

Click to select mask

Click to hide mask.

Show components

Show mask menu

Add/subtract using additional components

Show/hide overlay

Overlay color

Overlays menu

options in the mask's ... menu: **Delete Empty Mask** and **Delete All Empty Masks**. If you copy and paste AI-based masks to other photos or apply presets that include AI-based masks, they may end up empty. For example, a preset that tries to whiten teeth results in an empty mask on a photo that doesn't include people. Empty masks aren't a problem, but deleting them tidies up the Masks panel.

Tapping on the mask thumbnail on mobile or the arrow to the left of the mask thumbnail on the desktop shows the **individual selections that make up the mask**, officially called components. These have the same management tools as the mask itself, including changing the order of the selections within a mask and moving selections between masks. Combining multiple selections in a single mask is a more advanced topic that we'll return to later in the chapter (page 335).

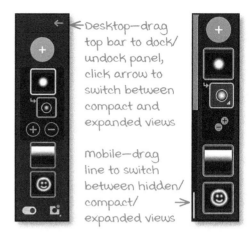

Desktop—drag top bar to dock/undock panel, click arrow to switch between compact and expanded views

mobile—drag line to switch between hidden/compact/expanded views

MASK PANEL VIEW MODES

The Masks panel can **switch between a compact, expanded, and hidden Masks view**, depending on your screen size. The mobile apps default to the compact view, and you can switch by dragging the line on the left of the panel.

The Masks panel can be docked in a fixed location or moved around on the desktop. To **undock the Masks panel**, drag the top of the panel. To **dock the Masks panel**, grab the line again and drag the panel either to the right panel group or to the top right corner of the preview area. When the Masks panel is floating or docked in the preview area, you can shrink it to show only the icons by clicking the arrow in the top right corner.

OVERLAYS & PINS

Lightroom offers several overlays that help to show which areas of the photo are affected by your mask.

MASK OVERLAYS

The mask overlay is most useful when creating a new mask so you can see which area will be affected. On mobile, the mask overlay automatically displays on new masks if you haven't selected any slider adjustments. On the desktop, you can enable **Show Overlay for New Masks** in the Masks panel ... menu to get it to show automatically.

You can also **show the mask overlay manually** by toggling the *Mask Overlay: Show Always* switch in the ... menu (mobile) / **Show Overlay** switch in the Masks panel (desktop) / O key (desktop).

You probably won't want the mask turned on all the time, but if you float over a thumbnail in the Masks panel (desktop only), the overlay for that mask shows temporarily.

If you tap/click the ... menu, several **different mask styles** are available, which are helpful for different purposes.

Color Overlay, *Color Overlay on B&W*, and *Image on B&W* are particularly useful when initially creating a mask, as they allow you to see the photo below.

You can **change the overlay color** depending on the content of the photo, as a red overlay isn't much help when selecting a red flower. On mobile, the choices are limited to red, green, or blue, but on the desktop, if you click the color swatch, you can access a full range of colors and an *Opacity* control. The keyboard shortcut Shift-O cycles through red, green, and your custom color (if you've selected one).

Image on Black, *Image on White*, and my personal favorite, *White on Black*, are most helpful in refining a mask, especially when

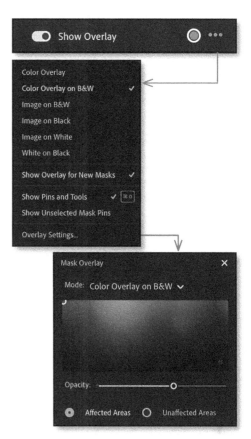

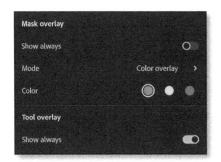

Overlay Options:
mobile (left), Desktop (right)

MASK OVERLAYS

Color Overlay

Color Overlay on B&W

Image on B&W

Image on Black

Image on White

White on Black

filling in gaps in brush strokes.

PINS & TOOL OVERLAYS

Each selection is marked with a small icon called a **pin**. There's a different pin for each type of selection.

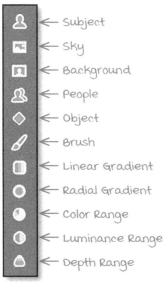

The gradients are controlled using white **tool overlays**. They allow you to adjust the gradient's size, rotation, and position.

To **turn the pins & tool overlays on and off** on mobile, tap the ... menu in the top right corner and turn *Tool Overlay: Show Always* off. On the desktop, select the Masks panel ... menu and enable/disable *Show Pins & Tools*, or use the keyboard shortcut Ctrl-O (Windows) / Cmd-O (Mac).

If the pins & tool overlays are enabled,

you can **temporarily hide the pins & tool overlays** on the desktop by floating the cursor away from the photo.

COMBINING SELECTIONS FOR ADVANCED MASKING

The real power of masking comes in the ability to combine multiple types of selection in the same mask. Before we move on, let's clarify the terms:

Masks are listed in the Masks panel (page 329). Each mask can have a different set of slider adjustments.

Masks contain one or more **selections**, which are officially called **components**. All of the selections within a mask share the same slider adjustments.

The selections are made using the **masking tools**—the AI-based selection tools, the brush, the gradients, and the range mask tools.

VIEWING & CREATING SELECTIONS

To see the selections (or components) that make up each mask and the *Add/Subtract* buttons, tap/click on the mask in the Masks panel. If they don't show, tap/click again.

In earlier lessons, we've only used a single selection per mask, but notice the *Add* and *Subtract* buttons... these allow you to add

selections to an existing mask.

We'll illustrate the differences in behavior using two overlapping radial gradients, with *-2.5 Exposure* applied to the mask.

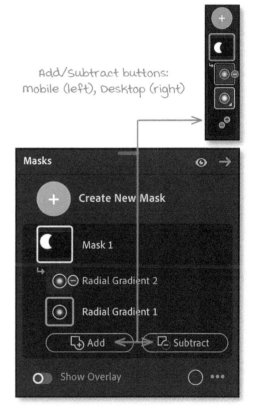

Add/Subtract buttons:
mobile (left), Desktop (right)

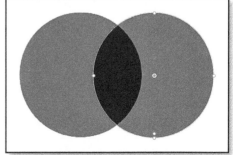

Add combines the selections in a single mask, applying the same adjustments to the combined area (left) whereas overlapping selections on separate masks builds up the effect (right).

ADD

Add, of course, adds to the selection. You'd use it when different selections need the same adjustments, for example:

• You want to brighten both eyes by the same amount.

• You're applying the same amount of skin softening to multiple faces.

• Multiple bridesmaids are wearing the same color dress, but the hue isn't quite right.

• Select Subject or Select Sky missed a bit, so you add to it using a brush or range mask.

You could apply these adjustments as separate masks (if they don't overlap), but combining them in a single mask means you only need to move the adjustment sliders once.

There are also situations where you can't get the same result using multiple masks because the masks overlap, for example, three overlapping linear gradients surrounding a doorway or these overlapping circles.

SUBTRACT

Subtract, as the name suggests, subtracts from the selections below it in the list, for example:

• You've used a linear gradient on a sky but don't want to apply the settings to the person or building in the foreground, so you subtract using a brush or Select Subject.

• Select Subject included something that wasn't part of the subject, so you subtract using a brush.

• You've used a radial gradient to select a person's face, but you want to brush away the skin-softening over the eyes or use a People mask to exclude their beard.

• You've applied a linear gradient to create a fake depth of field but want to exclude the subject from the blur.

• You've painted a mask with a large feathered brush and want to erase detailed areas. You could use the eraser on the same brush selection, but if you make a mistake, it's almost impossible to paint back the right degree of feathering. In contrast, a separate subtracted brush selection can easily be revised.

Subtracting a selection removes it from the mask, like the "bite" that's been taken out of the left gradient.

Create a Reverse ND Grad filter effect using two gradients, with the second narrow one set to subtract.

• You want to create a fake reverse graduated neutral density filter effect so that the gradient is lightest at the top but stops abruptly at the horizon.

INTERSECT

Intersect mode restricts an adjustment to a specific area, for example:

• You want to select a child's green t-shirt but not all of the green in the background, so do a rough brush over the t-shirt and then subtract a color range. This essentially becomes a more accurate Auto Mask tool.

• You use Select Sky to select the sky area, then use a Luminance Range mask to exclude the clouds before changing the hue.

• You apply a Linear Gradient to the sky, but the horizon isn't straight, so you use Select Sky to restrict the area it affects.

On the desktop, when you hold down the Alt (Windows) / Opt (Mac) key, the *Intersect* button replaces the *Add* and *Subtract* buttons. It's also listed in the Mask's ... menu.

There isn't currently an *Intersect* button in the mobile apps, but you can do the same

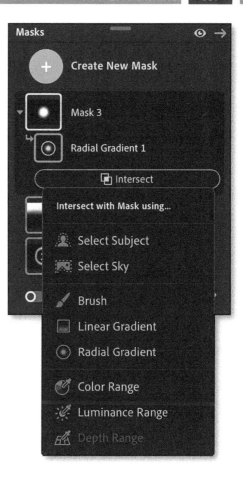

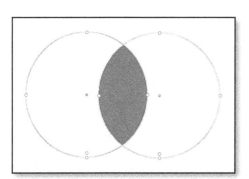

Intersect (or inverting a subtracted selection) only applies the edits to the areas in both selections.

Invert a mask with multiple selections at the mask level, not the individual selections.

thing manually with a bit of mental juggling:

1. Select the entire area you want to affect, for example, using a brush.

2. Subtract the type of selection you're using to refine the mask, for example, luminance range.

3. Invert the subtracted selection.

If you have trouble remembering it, you could create presets (page 165) for the combinations you use most frequently and then tweak the settings.

INVERTING A MASK WITH MULTIPLE SELECTIONS

Imagine you've used a subject selection and then painted the bit it missed using a brush. Now, you want to invert it to affect the background instead. You won't get the desired result if you invert the individual selections.

Instead, to **invert a whole mask**, tap/click on the mask's ... button in the expanded Masks panel, or long-press (mobile) / right-click (desktop) on the mask thumbnail in the compact Masks panel and select *Invert*.

SELECTION ORDER

The order of the masks in the Masks panel doesn't matter; they're just listed in chronological order, and you can't rearrange them.

If you're adding to the selections within a mask, the order makes no difference because the resulting mask is a composite of all of the selections.

However, if you're subtracting from a

selection (or intersecting with a selection), there logically has to be something below it to subtract from.

APPLYING EDITS TO THE MASKED AREAS

Once you've created your mask, you can apply edits using the sliders. You're already familiar with most of the Edit panels and sliders, but we'll consider how you might use them locally in the following pages.

MASKING SLIDER CONTROLS ON THE DESKTOP

On the desktop, a couple of extra controls are specific to Masking sliders...

The **Preset** pop-up has several popular slider combinations, such as *Smooth Skin* and *Whiten Teeth*. You can't add your own presets to the list at this time, but the **Copy Slider Settings** and **Paste Slider Settings** options allow you to copy the settings to the clipboard and then paste them onto a different mask.

To **reset all Masking sliders** to 0, select *Reset All Sliders* from the *Preset* pop-up. On mobile, sliders are automatically reset to 0 for new masks. On the desktop, check the **Reset Sliders Automatically** checkbox below the sliders to automatically reset the sliders to 0 for each new mask you create. If it's

unchecked, new masks use the last-used settings.

To **fade or amplify a mask's edits**, drag the **Amount** slider. The slider runs from 0-200, with a default of 100. 0 completely disables the mask, 1-99 fades the effect, 100 applies the adjustments exactly as listed, and 200

 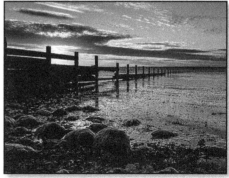

−1 Exposure & −39 Highlights on a linear gradient brings back the detail in the sky without darkening the foreground, like an ND Grad filter. For some skies, we might also add Clarity, Dehaze, Saturation or a different color tint

+0.6 Exposure & +45 Saturation lightens and warms up the cub's face & body

−1.0 Exposure & −80 Highlights darkens the light patch on the cub's face

−40 Temp & +20 Saturation enhances the cub's blue eyes

−3.2 Exposure evens out lighting on wall

amplifies the slider settings. So, for example, if a mask is set to *Exposure +1*, changing the *Amount* to 200 actually applies *Exposure +2*.

LOCAL LIGHT & CONTRAST ADJUSTMENTS (INCL. DODGING & BURNING)

One of the most logical uses for local adjustments is tonal changes—**Exposure, Contrast, Highlights, Shadows, Whites, and Blacks** in the Light panel, as well as **Clarity** and **Dehaze** in the Effects panel. The **Tone Curve** is also available, but only on the desktop. They can be used for darkening skies, brightening shadows, reducing bright highlights, darkening edges like an off-center vignette, and many other adjustments.

The word 'dodging' comes from the darkroom printing process and refers to lightening areas of the image. Many photos

The masking > Light panel is the same on mobile (top) and desktop (bottom) except desktop also has the Point Curve.

benefit from a bit of dodging, for example, lightening faces.

The opposite of dodging is 'burning in' or selectively darkening areas of the photo that are too bright, attracting your attention more than the main subject.

LOCAL COLOR ADJUSTMENTS

In the Color panel, **Temp** makes the selected area warmer or cooler, while **Tint** moves between green and pink, like the main White Balance sliders. This helps compensate for mixed lighting situations, where the white balance differs in specific areas of the photo.

The **Saturation** slider acts like the intelligent *Vibrance* slider when dragged to the right (+). When dragged to the left (-), it behaves like negative *Saturation*, allowing you to desaturate the selected area to B&W. Adjusting the saturation in limited areas of the photo can help to draw the eye towards the subject or away from a distraction. Some like to use *Saturation* for a selective color effect, for example, a B&W or partially saturated photo with a small area of the photo in its original color.

The **Hue** gradient behaves like the *Hue* sliders in the Color Mixer panel but has a much wider adjustment range. Unlike the other sliders, the *Hue* slider is a pair of

Whereas the Color Mixer sliders could only shift the red car toward pink or orange, the local Hue slider can change it to any color.

To create an effect known as B&W with Spot Color or Selective Color, I've used a brush to paint negative Saturation. I've exaggerated the effect for print, but aim for a more subtle touch rather than complete desaturation for a more natural look. Also, avoid desaturating skin when applying this effect, as it always looks odd!

gradients. The bottom gradient shows the color you started with, and the static top gradient shows the resulting color after the hue adjustment. They're just a guide, and it's often easier to see the result on the photo itself.

The *Hue* slider offers an additional helping hand by automatically adjusting its starting point based on the masked pixels. For example, when you've selected something red, the color gradients move along to put red under the slider handle.

You may remember that we used the main *Hue* sliders to change the color of a car (page 236), but we could only shift it from red toward either pink or orange. With the local *Hue* slider and a *Color Range* selection, you could change the car to any color. You might also check the *Use Fine Adjustment* checkbox to make smaller adjustments, such as tweaking the color of the sky without affecting the other blue tones in a photo or reducing ruddy cheeks without changing lip color. **Point Color** is also available (desktop only), allowing you to restrict your adjustments to a specific region.

The **Color** (mobile) / **Colorize** (desktop) option applies a specific color tint of your choice without the brightness changes that

The wires of the enclosure walls in the tiger sanctuary are distracting

−Clarity, −Sharpness, −Saturation and −Exposure tone down the background, focusing attention on the tiger

In this grab shot, the camera focused on the grass at the front, so the eyes are soft

A high sharpness value just made it look "crunchy," but a combination of +35 Texture and +35 Clarity works

would happen with *Temp/Tint*. It's a much more subtle shift than *Hue*, but it can apply color to neutral areas of the photo, whereas *Hue* can only adjust existing color. You might use it to apply a hand-colored effect to old black & white photos.

LOCAL DETAIL, EFFECTS & OPTICS

Brushing on **Sharpness** or **Texture** can help sharpen eyes and other facial features without over-sharpening the skin or enhancing fine texture in specific areas of a photo, such as brickwork.

Moved in the opposite direction, setting the *Sharpness* slider between -50 and -100 applies a blur similar to a lens blur, allowing you to blur the background of a photo. Negative *Texture* creates a slightly different softening effect, which works brilliantly for smoothing skin without losing its natural texture.

The **Noise** (mobile) / **Noise Reduction** (desktop) slider decreases or increases any global manual noise reduction you've applied; for example, the shadows may benefit from extra noise reduction.

Like the local *Noise* slider, the local **Grain**

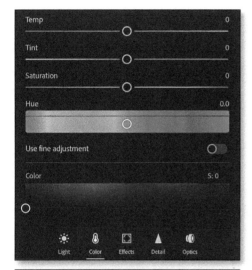

The masking > Color panel is the same on mobile (top) and desktop (bottom) except desktop also has Point Color

The masking > Effects panel is the same on mobile (top) and desktop (bottom) except desktop also has Grain

Amount slider (desktop only) increases or decreases the global *Grain* setting. If there's no global grain applied, minus numbers won't do anything. The other sliders (hidden under the disclosure triangle) are linked to the main *Grain* sliders in the Effects panel, so if you change *Size* and *Roughness*, they change in both locations.

The **Defringe** slider in the Optics panel (mobile) / Detail panel (desktop) can be used to remove color fringes along high-contrast edges or reduce the effect of the Optics panel's Defringe sliders (desktop only: page 280).

REDUCING A MOIRÉ PATTERN

The **Moiré** removal slider in the Brush tool allows you to paint a moiré rainbow away. It can only usually remove the color rainbow, not any luminosity changes, but it works very well. It works on raw and rendered photos, although the additional data in a raw file means it is far more effective on raw files.

To reduce moiré:

1. Temporarily increase the *Saturation* slider in the global Color panel (page 230) to

The same sliders are split across the masking > Detail & Optics panels on mobile (top), whereas they're in a single Detail panel on desktop (bottom)

The rainbow-colored pattern sometimes found on fabrics is called moiré. It can't be removed completely, but it can be reduced

make the moiré easier to see.

2. Open the Brush tool (page 315).

3. Set the *Feather* slider to 0 to create a hard-edged brush, adjust the *Size* to suit, and turn off *Auto Mask*.

4. Set the *Moiré* slider to +100. (If you set the *Moiré* slider to a negative value, it won't do anything. It's only used to reduce the effect of another brush stroke, which already has positive moiré removal applied.)

5. Paint carefully over the photo. If you cross a boundary of another color in the photo, it can blur or smudge.

6. Set the Color panel's *Saturation* slider back to your preferred setting for the photo.

7. Reduce the brush mask's *Moiré* slider if the full +100 setting is too strong.

To darken the **eyebrows**, start with *Shadows* -20 and adjust to taste.

If the subject's **eyes** are bloodshot or would benefit from brightening, set the *Eye Sclera* mask to around *Saturation* -60 and *Exposure* +0.15.

To brighten the **iris of the eyes** (the colored bit!), try settings like *Exposure* +35, *Saturation* +40, and *Clarity* +10. You might also want to adjust the *Hue* slider to change the color slightly.

Try around +0.20 *Exposure* and *Saturation* of -30 to -60 to whiten yellowing **teeth**.

To add **lipstick**, experiment with adjusting *Tint*, *Hue*, or *Colorize*. For a matte effect, try reducing *Texture* and *Clarity*.

ENHANCING PORTRAITS

The AI-based People masks make it quick and easy to retouch portraits. Your favorite settings can be saved as a preset (page 165) for one-click portrait retouching, and sample presets are included in the *Premium Adaptive: Portraits* set to get you started.

When you're ready to try your own settings, return to (page 312) for a refresher on creating People masks. Here are a few examples of slider adjustments to try:

For natural **skin** softening, try setting *Texture* to around -20 and *Clarity* to -10, or a little further for more extreme softening.

Play with the *Texture* and *Clarity* sliders to give the subject's **hair** a little extra texture.

© Kurhan - Fotolia

Facial retouching looks
best when it's subtle

START-TO-FINISH EDITS

20

So far, we've learned how to use the sliders individually and how they interact within their panels.

Now it's time to start putting it all together and edit a series of photos from start to finish, using a range of different tools.

We'll start each lesson with an image analysis and then briefly cover the thought process behind each slider adjustment.

You can download most of these images from the Members Area and follow along on your device or computer.

You might prefer a different result, and that's fine because editing is subjective, and we're all continually learning and changing.

IN THIS CHAPTER, WE'LL CONSIDER:

• How to edit a whole range of photos using different Lightroom tools.

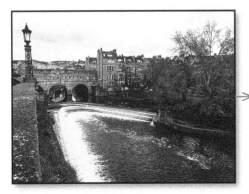 →

SUNNY COAST

Low dynamic range

Purpose

Capture the lovely cove where we stopped for lunch. Loved the turquoise blue sea against the green grass.

Story

A peaceful walk along the coast on a summer's day.

Light

A little too bright, very hazy and lacking contrast.

Color

White balance is about right, but I'd like a little more depth to the color.

Mood/Emotion

Warm, happy, majestic.

Detail

Sharpen to bring out the detail in the stones.

Optical & Geometric Distortion

Some vignetting visible, apply lens profile.

Simplify the Scene & Draw the Eye

Too much sky, crop some out.

Focus on the island outcrop between the two coves.

Highlight the movement in the sea.

Sensor Dust

None found.

Output

Framed print on the wall.

1. Apply **Camera Landscape** profile, because the stones are too red in *Adobe Landscape*.

2. **Enable Lens Corrections** to remove vignetting and distortion.

3. **Dehaze +40** to reduce the atmospheric haze.

4. **Highlights -100** to bring detail back into the waves on the shoreline.

5. **Shadows +40** to increase detail in the rock face.

6. **Auto Whites +17** and **Blacks -56** to expand the tonal range, compressing the deepest shadows.

7. **Brush** over breaking waves and rocks with +100 *Clarity* for impact.

8. **Crop** to 16x9 ratio for panoramic effect.

Steps 1-2 Profile & Lens Profile

Step 3 Dehaze

Steps 4-6 Tonal Adjustments

Step 7-8 Selective Edits & Crop

BLACKBIRD'S BATHTIME

massively underexposed

Purpose

Capture a very sweet
action moment.

Light

Clearly massively underexposed, but
a quick Exposure adjustment shows
there's detail available to recover.

Story

This bird shows no fear, coming
down to enjoy a bath nearby.
It was an unplanned shot,
hence the underexposure.

Color

A little bit cool.

Mood/Emotion

Awe and wonder.

Detail

The motion blur adds to the
feeling of movement.

Simplify the Scene & Draw the Eye

Cropping slightly would draw more
attention to the water droplets.

Optical & Geometric Distortion

Lens profile applied
by raw defaults.

Sensor Dust

None found.

Output

Social media.

1. **Denoise** is used first, as it'll definitely be very noisy as it's so underexposed.

2. **Exposure +4.46**, so we can see what we're doing!

3. **Temp 5400** & **Tint +10** to warm up the image

4. **Highlights -82** to recover some highlight detail in the water.

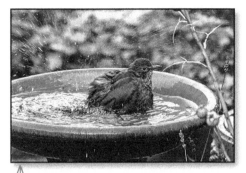
Steps 1-2 Denoise and Exposure

5. **Shadows +65** to bring out the detail in the bird's feathers.

6. **Whites -16** to bring down the brightest highlights slightly, and **Blacks -16** to darken the deepest shadows.

7. **Texture +65** to bring out the detail in the feathers.

8. **Clarity +10** to add a little local contrast.

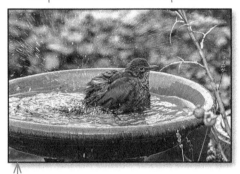
Steps 3-9 Tone, Color & Detail

9. **Vibrance +20** to make it more colorful without oversaturating the yellows, and **Saturation +4** to finish it off.

10. **Tone Curve** is used to increase contrast with greater control than the standard sliders.

11. **Crop** to focus attention on the subject.

12. **Vignette -10** to help draw the eye to the center of the photo.

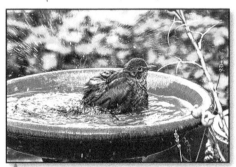
Step 10 Tone Curve

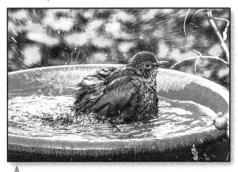
Steps 11-12 Crop & Vignette

VICTORIA, B.C.

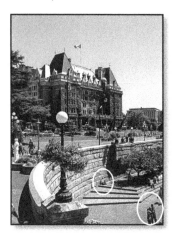

Good distribution of tones
with no notable clipping

Purpose

Capture memories of places
visiting when traveling.

Light

Exposure's about right and
it's a JPEG so we won't mess
around with it too much.

Story

The architecture in this
beautiful city is stunning, and
it feels really well cared for
with the hanging baskets.

Color

Slightly too cool for a
lovely summer's day.

Detail

JPEG, so it's already
sharpened in-camera.

Mood/Emotion

Excitement of visiting new
places, colorful, vibrant. Relaxing
in the beautiful weather.

Optical & Geometric Distortion

JPEG, so already applied in-camera.

Simplify the Scene & Draw the Eye

Like any busy city, there are
plenty of people around. Most are
fine, but a couple are distracting
and would benefit from removal.

Sensor Dust

None found.

Output

Travel photobook.

1. Warm it up slightly using **Temp +14** and **Tint +22**.

2. Add a little saturation using **Vibrance +20**.

 *Steps 1-4 Light, Contrast →
 and Color adjustments*

3. **Shadows +20** and **Blacks -10** to bring back a little shadow detail without losing contrast.

4. Add a little extra punch using **Clarity +20**.

5. **Crop** slightly to improve composition.

 Step 5 Crop ————————→

6. The sky was a little dull, but there's nothing else blue in the photo, so **Color Mixer > Luminance Blue -10** is a quick fix.

 Step 6 Color Mixer →

7. Remove the boy on the steps, the people in the bottom right corner, and the litter using the **Healing** tool.

 Step 7 Healing ————————→

SUNSET AT STEEPHILL COVE

Full range of tones, but not
a lot in the midtones

Purpose

Capture this pretty hidden
cove at sunset.

Story

This perfect little cove can't be
reached by road, so at the end
of the day, when everyone's gone
home, it's a beautiful little spot.

Mood/Emotion

Relaxed and peaceful, but wonder
at the power of the waves
and beauty of the sunset.

Simplify the Scene & Draw the Eye

Start with the eye on the setting
sun (warmth, brightness), then go
to the warm reflection, then the
buildings (bright) then run round
the curve of the rocks (lines,
contrast, reflected warmth).

Light

Shadows need brightening, while
retaining highlight detail.

Color

The sun had already set, so
light was cool, but clouds in the
sky would look great warmer.

Detail

Slight noise on the rocks,
but it just adds texture.

Optical & Geometric Distortion

Some barrel distortion. Chromatic
aberration visible along tree line.

Sensor Dust

Spots in the sky on the right.

Output

Framed print on the lounge wall.

1. Change the profile to **Adobe Vivid**, as we want to enhance the sunset.

2. **Straighten 0.80**, using *Straighten* tool to draw line down central building.

3. **Healing** tool (*Heal, size 46, feather 0, opacity 100*) to remove spots in sky.

4. **Enable Profile Corrections** (Canon 18-200) to remove barrel distortion and check **Remove Chromatic Aberration**.

⌐ Steps 1-6 incl. Highlights & Shadows

5. **Highlights -100** to recover and enhance the detail in the sky and **Shadows -80** to bring out detail in rocks and houses.

6. **Whites +14** so the sun is just short of clipping and **Blacks -26** blocks the darkest shadows in the rocks, where I'm willing to sacrifice the detail to increase the overall contrast.

⌐ Steps 7-8 Clarity & Saturation

7. **Clarity +100** is an extreme adjustment, but it's just flat and boring, and using too much *Contrast* would lose sky/rocks detail. The local contrast created strong halos along the tree line, so I'll reduce it with a soft **-Highlights -Whites brush mask**.

8. **Saturation +70** to make it much more colorful. *Vibrance* would have enhanced the blues on the building and protected the yellows, whereas I want to pump up the yellow tones. Doing this before white balance will help me set *Temp* & *Tint* to taste.

⌐ Steps 9-10 White Balance & Vignette

9. **Temp 5450** and **Tint +18** to warm it up.

10. **Vignette -30** with **Feather 70** to bring down the brightness of the corners, especially on the left.

11. It's still a little flat and dark, so **Contrast +20** and **Exposure +0.20** to finish.

⌐ Step 11 Contrast & Exposure

TIGER'S LUNCH

Brightest whites are a little dull

Purpose

Capture the beauty of these incredible animals.

Light

Exposure's about right but it's lacking contrast.

Color

White balance is good.

Story

These are rescued ex-circus tigers who can't be released into the wild, but they live a happy life at the wildlife sanctuary.

Detail

It's sharp but using Texture would bring out that beautiful fur.

Mood/Emotion

Those eyes are piercing. I don't fancy being his next meal, but he's an awesome creature.

Optical & Geometric Distortion

Micro four thirds, so already applied.

Simplify the Scene & Draw the Eye

The wire fence in the background distracts from the main focus, but blurring it would help.

Sensor Dust

None found.

Output

Framed gift for a friend.

1. **Dehaze +47** for immediate impact.

 Steps 1-3 Dehaze, Exposure & Clarity →

2. **Exposure +0.29** to brighten it slightly.

3. **Clarity +17** to increase local contrast slightly further.

4. **Crop** to focus more on the tiger.

5. **Sharpening Amount 78, Radius 0.7, Detail 59, Masking 20** to bring out the detail in his fur and dinner.

 Steps 4-7 Crop & Detail adjustments incl. mask →

6. **Noise Reduction Luminance +11** to reduce the noise slightly. Not much is needed as it was shot at low ISO.

7. Add a **Subject Mask** with **Texture +86** to make his fur really crisp while leaving the background softer.

 Step 8 Vignette →

8. **Vignette -31** to draw attention to the subject.

9. **Lens Blur 74** using the **Bubble** bokeh style, which does the best job disguising the fencing.

 Step 9 → *Lens Blur*

NIGHTTIME COBBLES

↑
Blue channel clipping in the shadows

Light

Overall exposure is ok but enhance shadow detail.

Color

Yellow street lighting doesn't add anything. B&W would enhance lines of cobbles and texture of brickwork.

Detail

No notable noise, but sharpen to enhance local contrast.

Optical & Geometric Distortion

Micro four thirds, so already applied.

Sensor Dust

None found.

Output

Wall with other B&W photos.

Purpose

To illustrate the timeless beauty of the historic English town of Bath, with its detailed architecture and cobbled streets.

Story

Welcome home!

Mood/Emotion

A quiet street in the middle of town, but still felt quite safe.

Simplify the Scene & Draw the Eye

Enhance the diagonal lines of the wet cobbles, leading toward the light and doorway.

Crop to remove some of the blank wall on the right to draw the eye to light at the end of the alleyway and the doorway.

Darken the light slab on the left.

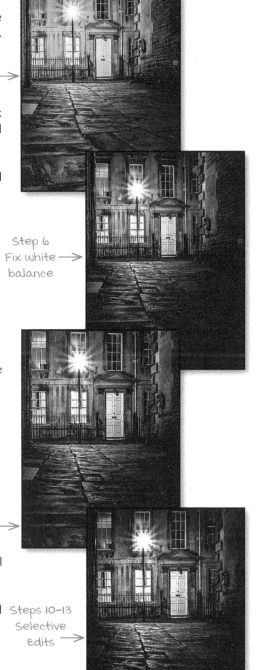

1. **Highlights -34** to reduce the glare.

2. **Shadows +100** to bring out the detail in the cobbles & brickwork.

 Steps 1-5 Brightness/
 contrast adjustments

3. **Whites +56** and **Blacks -3** to bring back the contrast lost by *Highlights* and *Shadows*.

4. **Clarity +100** to enhance the local contrast further.

5. **Contrast +22** to add a little more global contrast.

 Step 6
 Fix white
 balance

6. **Temp 2500** and **Tint +34** to remove the worst of the strong yellow color cast.

7. **Upright Auto** to straighten it.

8. **Crop** to remove the brickwork on the right.

9. Switch to **B&W** mode. I like the default **Adobe Monochrome** conversion, and playing with the B&W mix doesn't improve it due to the lack of different colors in the original capture.

 Steps 7-9 Geometric corrections,
 crop and B&W conversion

10. **Dehaze +13** to add a little more local contrast.

11. **Vignette -21** to darken the corners and draw the eye into the photo.

 Steps 10-13
 Selective
 Edits

12. **Healing** tool to remove alarm on wall.

13. **Brush mask** (*Highlights -100, Whites -100*) to darken slab on left that stands out.

KIDS LOVE BOXES!

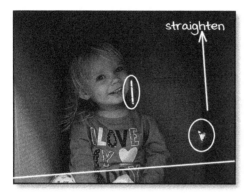

Data to left of histogram
= photo is dark

Purpose

Capture the little girl having fun.

Light

It's underexposed and lacking contrast.

Color

White balance isn't great, and the color doesn't really add to the photo, so try in B&W.

Detail

Very high ISO (6400 on a micro four thirds sensor) so lots of noise reduction needed.

Optical & Geometric Distortion

Profile applied automatically but needs straightening.

Sensor Dust

None found.

Output

Framed shelf portrait.

Story

Every child loves a cardboard box!

Mood/Emotion

Cute, mischievous.

Simplify the Scene & Draw the Eye

Remove distraction of tear and slot so eye goes to her face instead of the bright spots.

1. **Exposure +0.50** as underexposed.

2. **Auto Whites +15** and **Auto Blacks -22** to expand to fill tonal range.

 Steps 1-4 →
 Brightness
 & color

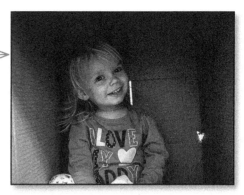

3. **Clarity +20** to add contrast. No wrinkles to worry about here, and it'll enhance the lines in the box.

4. **Temp 3050** and **Tint -1** to improve white balance to give a cleaner starting point for the B&W conversion.

5. Convert to **B&W** by selecting the **B&W Orange Filter** profile, because red/orange filters traditionally lightened skin tones.

 Step 5 B&W →

6. **Linear Gradient mask** diagonally from bottom left corner, set to *Exposure -1.27* and *Clarity +88* to even up the lighting. **Brush** to lighten and define eyes slightly, set to *Exposure +0.3* and *Clarity +10*.

7. **Healing** tool set to *Clone* mode to retouch the top and bottom of bright line, as *Heal* mode would smudge where it meets other image detail. Then use *Heal* mode for the rest of the bright line and tear in the box. (Due to the noise levels, Photoshop would work better.)

 Step 6-7 →
 Selective
 edits &
 retouching

8. **Noise Reduction 35** to reduce high ISO noise. (*Color Noise Reduction* is fine at the default of 25.)

9. **Crop** to straighten lines and remove bright knees.

 Steps 8-9 →
 Noise Reduction
 & Crop

UNDERGROUND HOSPITAL

Slight spike of white strip light,
and some blocked blacks

Purpose

Capture the eerie feeling
and interesting lines.

Story

This was an underground hospital in
Guernsey used to care for German
soldiers during World War 2.

Mood/Emotion

It was cold, damp and eerie.
I'd have hated to be a
patient there! Enhance that
feeling using cool blues.

Light

Exposure's not bad, but enhance
the shadow detail in the walls. Light
is clipped, but that's expected.

Color

Adjust white balance to cool blues.

Detail

It was shot at ISO 800 on a small
sensor, so it is noisy, but that adds
to the gritty dramatic feel.

Optical & Geometric Distortion

Micro four thirds, so no
profile needed.

Sensor Dust

None found.

Output

Portfolio?

Simplify the Scene & Draw the Eye

The lines of the tunnel lead the
eye towards the person at the
end, but could do with enhancing.

There's a fire exit sign
which wouldn't have been
there in the 1940's.

1. **Exposure -0.25** because it's a little bright.

 Step 1 Exposure →

2. **Temp 2400** and **Tint +22** to make it a really cool blue.

3. **Clarity +40** to bring out the detail in the brickwork and increase the "wet" look.

4. **Healing** tool used to remove the fire exit sign.

5. **Send to Photoshop**. The man at the end of the tunnel was pulling up his sock, so I'd also take the photo to Photoshop to move his leg too.

 Step 2 White Balance →

 Step 3 Clarity →

 Step 4 Healing Brush →

ORANGE WINDOWS

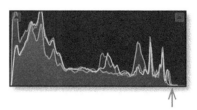

Lacking pure white. After crop, may not have pure black either

Purpose

I was waiting for a bus and noticed these odd orange windows. No time to compose properly, but I thought they could be interesting.

Story

Unusual abstract pattern to these windows. Architect with imagination!

Light

Needs a little more contrast.

Color

White balance is good, but shift orange tones toward red to fit in with office decor.

Mood/Emotion

Hard, clean, repetitive pattern.

Detail

Light noise reduction as small sensor.

Simplify the Scene & Draw the Eye

Needs a heavy crop to emphasize the repetition.

Optical & Geometric Distortion

Major geometric distortions.

Sensor Dust

None found.

Output

Abstract square print for office wall.

1. Draw four **Guided Upright** lines using the windows for guides to correct the geometric distortion.

2. **Crop** to 1:1 ratio.

3. **Whites +34** and **Blacks -41** to extend the tonal range.

4. **Clarity +35** and **Contrast +15** to highlight the clean lines.

5. **Color Mix** to change orange to a deeper red to find in with office decor.
 Hue: Red -20, Orange -60
 Saturation: Red +20, Orange +14
 Luminance: Red +22, Orange -50

Step 1
Guided
Upright

Step 2 →
Crop

6. **Sharpening 45, Radius 2, Detail 11, Masking 50** to emphasize the strong edges without sharpening the panels.

7. **Noise Reduction 10**.

8. **Healing** tool to remove tiny spot in bottom window.

Steps 3-4 →
Brightness
& contrast
adjustments

Steps 5-8 →
HSL and
Detail
adjustments

PULTENEY BRIDGE

High dynamic range

Purpose

Capture the beautiful Georgian architecture in soft evening light, when most of the tourists have gone home.

Story

This is an early evening stroll after a relaxing dinner, enjoying the sunset.

Mood/Emotion

Calm, relaxed, peaceful.

Simplify the Scene & Draw the Eye

There's a little yellow flower bottom left that is slightly distracting.

Light

There is highlight and shadow detail but the contrast is far too high.

Color

The cool white balance doesn't show off the warm Bath stone.

Detail

No noticeable noise, but the textures would benefit from sharpening.

Optical & Geometric Distortion

The lamp on the left leans out of the frame due to perspective.

Sensor Dust

None found.

Output

Hang in the dining room.

1. Select **Adobe Landscape** profile, as we want the extended dynamic range.

2. **Highlights -100** to bring back the detail in the clouds.

Steps 1-5 Brightness →
and Clarity

3. **Shadows +100** to bring back detail in the buildings.

4. **Exposure -0.45** to darken the photo overall.

5. **Clarity +80** for extreme local contrast, to give it that crunchy HDR feel.

Steps 6-7 Color →
adjustments

6. **Temp 9650** and **Tint +30** to warm it up to show off the reflected sunset in the clouds and the warm Bath stone.

7. **Vibrance +68** to enhance the colors.

Step 8 Tone curve →

8. **Tone Curve** (Parametric) set to **Highlights +43, Darks -45, Shadows -7**. This increases the contrast in the buildings and brightest clouds, while sacrificing contrast in the deepest shadows.

9. Use **Upright** to correct the perspective, drawing a line up the center of the light stand and another up the central building.

10. **Crop** to remove the flower in the bottom left corner.

Steps 9&10 →
Upright & Crop

KANIKA THE LEOPARD CUB

Highlights are clipped

Purpose

Create ongoing series of photos of Kanika growing up.

Light

Cub is too dark as in the shadows, but foreground is too bright. Some detail in the leaves is clipped.

Story

This was Kanika's first trip out of her den, so she was shy but also inquisitive and playful.

Color

Needs increase of saturation and warmth to enhance cub's coat.

Mood/Emotion

Excitement of first outing, so use plenty of contrast and punchy colors.

Detail

Sharpen to highlight whiskers. High ISO and heavy crop will make noise more noticeable.

Optical & Geometric Distortion

Not needed.

Simplify the Scene & Draw the Eye

Needs a heavy crop to remove excess background and zoom in on leopard cub.

Reduce brightness of foreground to reduce distraction.

Sensor Dust

None found.

Lighten cub's face to draw the eye toward her.

Output

Square crop to match set.

1. **Crop** first to zoom in on subject.

 Steps 1-5 → incl. Crop & tonal adjustments

2. **Exposure +0.80** to brighten overall.

3. **Highlights -100** to reduce glare of light falling through the tress.

4. **Shadows +80** to bring up the shadow detail.

5. **Blacks -60** to bring back the contrast lost by *Highlights/Shadows* adjustments.

6. **Clarity +54** to add punch and bring out the detail in the cub's coat.

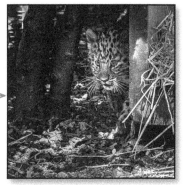

 Steps 6-9 incl. Clarity & color → adjustments

7. **Contrast +8** to add midtone contrast.

8. **Temp 4577** and **Tint +31** to warm it up, as auto white balance left the photo too cool.

9. **Vibrance +48** and **Saturation +9** to bring out the color in her coat.

 Steps 10-12 Selective → edits

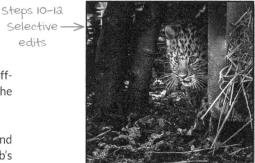

10. **Radial Gradient** set to -1.84 *Exposure*, -73 *Contrast*, -100 *Highlights*, -52 *Clarity* to create an off-center vignette, drawing the eye to the cub.

11. **Brush** set to *Temp +10, Contrast +20* and *Saturation +32*, brushed over the cub's face and legs to warm her up further.

12. **Healing** tool used to patch the light patch on her den to reduce the distraction.

 Step 13 Noise → Reduction

13. **Noise Reduction +25** to minimize noise.

14. **Send to Photoshop**. The leaves at the front were completely clipped, and trying to recover them has just turned them gray, but these could be retouched using Photoshop.

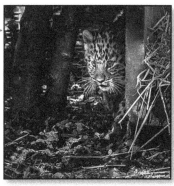

BUCKLER'S HARD COTTAGES

Good range of tones,
very little clipping

Purpose

I loved the beautiful roses
around the doorway.

Light

Exposure is fine as it is.

Color

White balance is good, but the
patchy grass is distracting.

Detail

The detail in the brickwork would
look great if it was a little crisper.

Optical & Geometric Distortion

No lens profile needed
but lines are leaning.

Sensor Dust

None found.

Output

Social media post of day out.

Story

This is an 18th century shipbuilding
village. In addition to the history,
it's a very relaxing place to explore.

Mood/Emotion

Calm, peaceful, dream home!

Simplify the Scene & Draw the Eye

The weather had been hot,
resulting in some patchy dried
grass which is slightly distracting.

The sky is also a little bright and
draws the eye in that direction.

1. **Texture +40** to increase the definition of the bricks.

Step I Texture ⟶

2. Use **Guided Upright** to correct the leaning vertical lines. The window on the left and the drainpipe are ideal for drawing the lines.

Step 2 Guided Upright ⟶

3. Add a **Sky Mask** to make the sky stand out more. Settings were **Exposure -1.20**, **Contrast 18**, **Highlights -5**, **Blacks -5**.

4. Add a **Brush Mask** to darken the reflections in the closest windows slightly. Settings: **Exposure -100**, **Contrast -100**, **Highlights -100**, **Shadows +65**.

Step 3-4 masking ⟶

5. Use **Point Color** on the dry grass to blend it in with the greener grass. On the first attempt to do it using the global Point Color tool, the adjustment also affected the lighter brickwork, so it worked better to use Point Color in a rough Brush Mask. Settings: **Hue Shift +51**, **Sat Shift +24**, **Lum Shift -32**.

6. Use the **Healing** tool to remove the wire under the first window.

Steps 5-6 Point Color in ⟶
a Brush mask & Healing

SQUIRREL'S FEAST

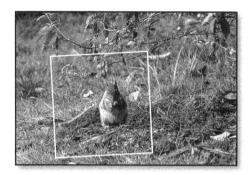

↑
Good range of tones, mostly
midtones as expected

Purpose

I liked the eye contact from
this cheeky little squirrel.

Story

He visits regularly, stopping to
eat the food we put out for the
birds. Part of the family now!

Mood/Emotion

The little squirrel is fearless,
while I'm watching quitely trying
not to disturb his lunch.

Simplify the Scene & Draw the Eye

The branches above his
head are distracting.

A vignette and crop would help draw
the eye directly to the squirrel.

Light

The lighting is flat, it
needs more contrast.

Color

It's fall/autumn, so there
should be warmer browns.

Detail

Texture would work great to
bring out the detail in his coat.

Optical & Geometric Distortion

Lens profile automatically
enabled using Raw Defaults.

Sensor Dust

None found.

Output

Undecided.

1. Make simple Light adjustments to increase highlight and shadow detail and contrast. **Exposure +0.38**, **Contrast +7**, **Highlights -88**, **Shadows +38**.

 Steps 1-4 Light, Color & Texture →

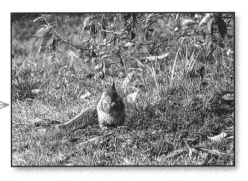

2. **Whites +47** and **Blacks -27** bring back the contrast lost by the large *Highlights* and *Shadows* adjustments.

3. Bring out the fine detail using **Texture +40**, then bump up local contrast further using **Clarity +20**.

 Steps 5-6 masks on squirrel →

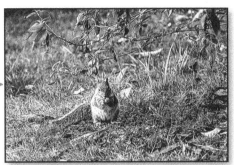

4. Warm it up using **Temp 4950** and **Tint +22**, then bump saturation using **Vibrance +18**, **Saturation +4**.

5. Add a **Subject Mask** to warm the squirrel slightly and increase the detail in his fur. Settings: **Temp +8**, **Texture +38**, **Clarity +56**.

 Steps 7-8 Crop & Vignette →

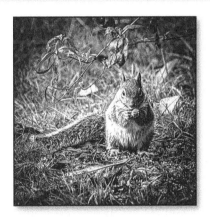

6. Add a **Radial Mask** on his body to lighten it and add extra contrast to draw the eye. Settings: **Exposure +0.30**, **Clarity +40**.

7. **Crop** to focus attention on the squirrel.

8. Add a **-52 Vignette** to draw the eye to the center of the photo.

9. Use **Lens Blur +53** with the **Circle** bokeh style to soften the background and the *Blur* brush to include the branches in the blurred area.

 Step 9 →
 Lens Blur

THE GUY ON THE STEPS

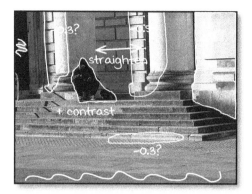

Good dynamic range, no
notable clipping

Light

Needs a little more detail
in his clothes. No pure white
expected in the photo.

Color

Color doesn't add to the photo.
The strong lines and stone
texture would work well in B&W.

Detail

Shot at low ISO in good light, so no
notable noise. Texture of stone can
take some crunchy sharpening.

Optical & Geometric Distortion

Horizon needs straightening
(use bricks in background).

Sensor Dust

None found.

Output

Nothing specific planned.

Purpose

The guy looked small and
insignificant against the huge
pillars of the government building.

Story

Is he homeless? Or just
waiting for a friend?

Mood/Emotion

Very cold day (hat). Feeling lonely?
High contrast B&W with lots of local
contrast for a gritty urban look?

Simplify the Scene & Draw the Eye

Notes scribbled on photo.

Crop to remove the door
and sign on the left.

Even up lighting on the pillars, front
step and bricks in the background
to reduce background contrast.

Increase contrast on face/
clothing of man to draw the eye
in that direction even more.

1. **Crop** to remove dark door at side and excessive foreground.

2. **Exposure 0.71** to lighten photo overall.

3. **Highlights -80** to reduce brightness of pillars.

4. **Shadows +60** to show more detail in his clothes.

5. **Whites +7** and **Blacks -23** to compensate for loss of contrast.

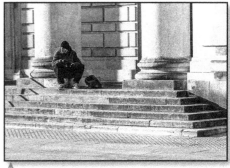

Steps 1-5 Crop & tonal adjustments

6. Convert to B&W using the **Adobe Monochrome** profile. There are no contrasting colors in the photo, so manually mixing the channels won't help much.

7. **Clarity +100** and **Contrast +70** to give a gritty feel.

Steps 6-10 Gritty B&W effect

8. **Vignette -23, Feather 63** to darken the bright edges and draw the eye into the photo.

9. **Exposure** increased to **1.04** as it looked too dark in B&W.

10. **Grain 57** to add to gritty urban look.

11. **Linear Gradient mask** from right side of photo to darken, set to *Exposure -0.80* and *Highlights -36*.

Step 11 multiple brush selections

12. **Brush** used with multiple different strokes, mainly set to varying Exposure values to lighten and darken different areas of the photo.

13. **Noise Reduction 20** as many areas have been significantly lightened and therefore show more noise.

Steps 11-13 Selective edits applied

FAMILY DAY OUT

↑
Good dynamic range, slight
highlight clipping

Purpose

Capture the family together
while the children are still
small (and clean!)

Story

This is a family day out
with the grandchildren.

Mood/Emotion

Happy, relaxed.

Light

The exposure is fine and
this is a JPEG so we're not
going to mess with it.

Color

The color's fine as it is.

Detail

Child bottom right is slightly out
of focus, but otherwise good.

Optical & Geometric Distortion

None as it's a JPEG, so
corrected in-camera.

Sensor Dust

None noted.

Output

Small print on the fireplace.

Simplify the Scene & Draw the Eye

There are some light areas in the
background that are distracting.

Some facial wrinkles to
reduce but not remove.

Draw the viewer's eye to
the people's eyes.

Don't make it look retouched!

1. Using a **Brush** mask set to *Exposure -1.95* and *Highlights -87*, brush over the light areas in the background to stop them competing for the viewer's attention.

Step 1 Brush distractions at back

2. Using the **Healing** tool set to *Clone* mode, *Feather 100*, *Opacity 25*, retouch the bags/lines under the eyes, selecting nearby skin as the source to avoid changing the texture. We don't want to remove the lines, but just lighten them slightly.

3. Open the **Masking** tool and select the younger woman, then click *View All* and select her mother too. Check the *Face Skin*, *Body Skin*, and *Eye Sclera* checkboxes, along with the *Create 6 Separate Masks*. Click *Create* to create the masks.

Steps 2 Healing Brush around eyes

4. Drag all of the skin selections into one mask, and both eye selections into another. (You could skip this step if you want to apply different settings to each mask.) The red overlay shows which areas are included in each mask.

5. Set the eye mask to *Exposure +0.20* and *Saturation -40* to brighten slightly.

6. Set the skin mask to *Texture -30* and *Clarity -10*. This softens the skin a little bit, reducing some of the contrast, but still looks natural.

Step 3&4 Create the masks

BACK TO THE OLD DAYS

Clipped whites

Purpose

Visiting a steam railway, seeing how things were done in the past.

Story

The guy had just hopped out to change the points to go along a different track. No modern technology here!

Mood/Emotion

Historical scene, so go for a sepia toned monochrome with plenty with grain, to imitate photographs of that time period.

Simplify the Scene & Draw the Eye

Remove all the plain white sky at the top.

Might be worth removing the wires in the background.

Draw the eye to the train driver, and retain detail in the train itself.

Highlight the steam.

Leading lines of train tracks.

Light

There's a large expanse of white sky, but the train is lacking shadow detail.

Color

The white balance is fine, but I want a sepia tone to suit the old-fashioned feel.

Detail

Low ISO, so there's no notable noise to worry about.

Optical & Geometric Distortion

Shot on a DSLR, so will need a lens profile.

Sensor Dust

No visible dust.

Output

Vacation album, only a small print.

1. **Enable Lens Profile** to correct the distortion. It's automatically selected the right profile.

 Steps 1-3 Lens profile, →
 Crop and Toned B&W

2. **Crop** the photo to remove the sky, cable and left hand side.

3. Convert to B&W using **Adobe Monochrome** profile, then use Color Grading to add a sepia tone to the shadows (**Shadow Hue 40**, **Saturation 30, Blending 100**).

4. Use **Dehaze +20** to remove some of the atmospheric haze.

 Steps 4-5
 Tonal →
 Adjustments

5. Bring back highlight and shadow detail using **Highlights -90** and **Shadows +80**.

6. In the B&W Mix, set to **Orange +11** and **Yellow +25** to lighten the grass, creating a greater contrast with the train driver.

 Steps 6-7 B&W mix →
 and Tone Curve

7. Adjust the parametric Tone Curve to **Highlights -43**, **Lights -17**, **Darks +4,** and **Shadows -20** to increase the contrast in the steam at the expense of the midtones (which is mainly the background trees).

8. Add a **Vignette -30** to darken the edges, with **Highlights 80** so the sky doesn't get too dark.

9. Add **Grain 38**, **Size 48,** and **Roughness 78** for a really rough grain.

 Steps 8-9
 Vignette →
 and Grain

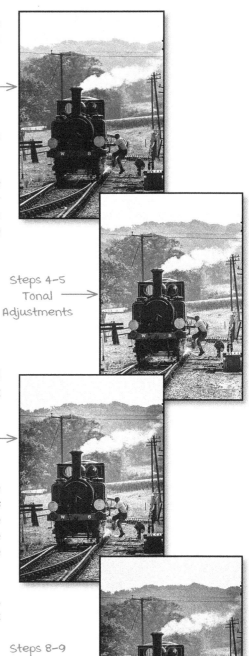

IN-APP TUTORIALS

Throughout the previous chapters, we've learned that there's no right or wrong in editing. While technical issues are generally worth fixing, the artistic choices are up to you.

In Lightroom's Community, you can learn how other photographers edit their photos. The exact settings won't work on your photos, but you can relate what they do to what you learned in the *Analyzing The Image* chapter (page 131) to see how to apply the principles to your own photos.

COMMUNITY EDITS

Community Edits show what the photographer did to a photo, so these are most useful when the photographer has a distinctive style you want to understand and reproduce. To **show Community Edits**, select the **Community** tab at the bottom of the screen (mobile) / in the left panel (desktop/web).

To **display a brief slideshow** of the

Community button:
mobile (top), Desktop (bottom)

different stages of development, tap the **Play Edits** button (mobile) / click on the photo (desktop). On iPhone/Android, adjust the panel's height to display the Remix thumbnails and the list of edits (they're automatically visible on iPad and desktop).

To **view the effect of each individual edit**, scroll through the steps. On the desktop, you can also Ctrl-click (Windows) / Cmd-click on a step to exclude it, so you can see what would have happened if that step wasn't included.

You can tap/click the heart to **mark photo edits you liked** or **save the settings as a preset** to apply to your photos. The Info view also shows the **camera settings** used to capture the photo. You can also tap/click on the photographer's name to **view their profile**.

REMIXING COMMUNITY EDITS

Many of the Community photos allow you to try out your editing skills by remixing the photo. When you tap/click the **Remix** button, Lightroom's editing tools appear, with an extra **Remix From** pop-up at the top, so you can decide whether to start from the *As Shot* photo or improve on someone's edit. When you're happy with your editing, tap/click the checkmark/*Done* button (mobile) / *Next* button (desktop) and add a comment to describe your version.

To **show only photos that you can remix**, tap/click the **Remix** tab on the Community home page or the *Remixes* button in the sidebar (desktop only).

COMMUNITY EDITS (MOBILE)

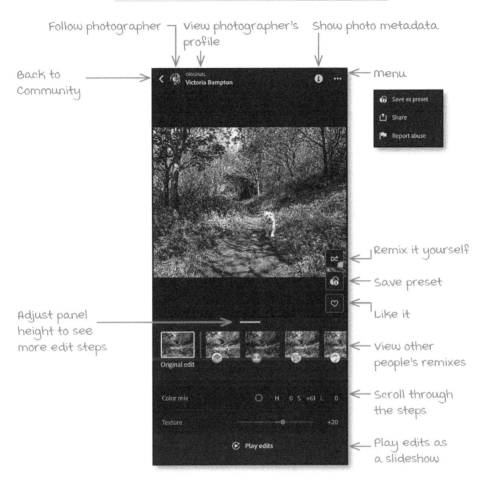

Follow photographer — View photographer's profile Show photo metadata

Back to Community

menu

Remix it yourself

Save preset

Like it

Adjust panel height to see more edit steps

View other people's remixes

Scroll through the steps

Play edits as a slideshow

LEARN TUTORIALS ON THE DESKTOP

Learn Tutorials are interactive tutorials that tell you to move specific sliders to specific values so you can edit the photo yourself. The idea is similar to the start-to-finish tutorials in this chapter, allowing you to follow along with a specific edit and understand why the photographer made that choice. Select **Learn** in the Photos panel on the desktop and follow the on-screen instructions.

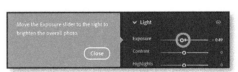

In the same place on the web interface, you'll also find the **Academy**. It includes articles and tutorials on all sorts of photography topics.

SEARCHING TUTORIALS

At the top of the Community and Learn home pages are tabs to display photos that the AI thinks you'll like, such as photos from

COMMUNITY EDITS (DESKTOP)

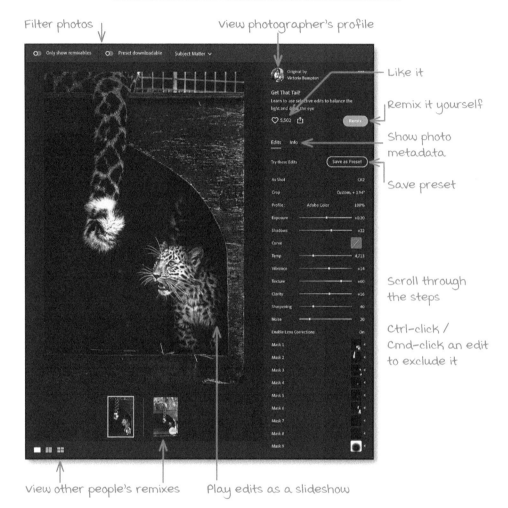

Filter photos

View photographer's profile

Like it

Remix it yourself

Show photo metadata

Save preset

Scroll through the steps

Ctrl-click / Cmd-click an edit to exclude it

View other people's remixes Play edits as a slideshow

photographers you follow or those featured by the moderators.

To **view Community photos by category** (e.g., *Landscape, Food, Nature*), scroll down to the bottom of the Community home page and tap/click on the category buttons.

On Android and desktop, Community Edits

can be **filtered** by *Subject Matter* or only show photos that are remixable or allow preset download. On the desktop, Learn Tutorials can be filtered by *Learning Topic, Tools, Subject Matter,* or *Level.* To view the filters, tap/click the Refine button.

Refine view

Like searching your own photos (page 116), you can **search** the Community Edits or Learn Tutorials using the photographer's name, subject category, type of tutorial,

Filter Community Edits & Tutorials: mobile (left), Desktop (top)

or even the image content. To do so, tap the magnifying glass (Android) / type in the search bar (desktop/web). Searching tutorials is not currently available on iOS.

FOLLOWING OR BLOCKING PHOTOGRAPHERS

If you like a photographer's style, tap/click on their name to view their other tutorials and social media pages. There's also a **Follow** button to **bookmark photographers** you like. To find them again, tap/click on your own avatar or the Following tab in the Community view. You can view my

profile and edit some of my photos at https://www.Lrq.me/lrtutorials

If you don't like a photographer's style, you can **hide their posts** by blocking them. To do so, tap/click the ... icon near the *Follow* button and select **Block**. If their content is inappropriate, you can also **report them** at the same time. When you block someone, you can't see their content, and they can't see yours, but they're not notified that you've blocked them.

If you block someone by mistake, you can't unblock them again for 24 hours. To **unblock them**, tap/click on your own avatar in the top right corner of the Community view. Tap/click on the Edit Profile icon in the top right corner and select *Blocked Users*. In the list of people you've blocked, select *Unblock*.

YOUR COMMUNITY PROFILE

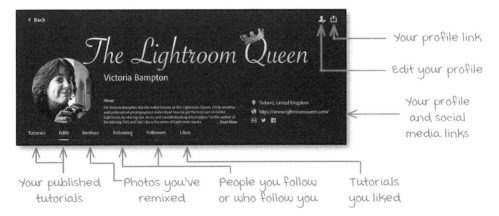

Your profile link

Edit your profile

Your profile and social media links

Your published tutorials — Photos you've remixed — People you follow or who follow you — Tutorials you liked

UPDATING YOUR PROFILE

To **view your own profile**, tap/click on your own avatar in the top right corner of the Community view. To **update your profile** with your bio and social media links, tap/click your own avatar at the top of the Community view and then tap/clickt the *Edit* button at the top.

SUBMITTING YOUR OWN PHOTOS

If you're particularly pleased with how one of your photos has turned out and want to **share your edits** to help others learn, tap/click the Share menu and select ***Post to Community*** (mobile) / ***Share to Community*** (desktop). Fill out the form, giving the photo a name, description, and categories to help others find your Community photos. You can choose whether to let other photographers remix your photos when you submit them. If someone creates a remix you like, you can save it as a version.

There are some rules governing the kinds of photos that can be uploaded, as they may be seen by a wide age range. You can read the guidelines at https://lightroom.adobe.com/lightroom-community-guidelines

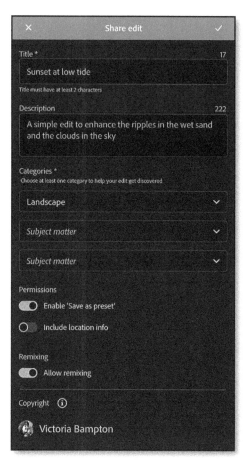

SHARING ALBUMS ON THE WEB
21

Entire albums or smaller groups of photos can be shared with friends, family, or clients by sending them a link to a web gallery. They can then:

- View the photos in Grid or Detail view.

- View the photos as a slideshow.

- Like or comment on the photos (optional).

- Download full-resolution JPEGs (optional).

- Upload their photos to your Lightroom album (optional).

- Edit your photos (optional).

IN THIS CHAPTER, WE'LL CONSIDER:

- How to share albums of photos using Lightroom Web.

- How to allow others to view and comment on your photos.

- How to allow others to contribute photos or edit your photos.

- How to enhance Lightroom web galleries.

- How to share Lightroom albums with other companies, for example, to create a photo book.

SHARING WEB GALLERIES

Let's get started by sharing our first web gallery, and then we'll go back through some of the more advanced settings.

SHARING ALBUMS OR PHOTOS

To **share an album or specific photos** on mobile, select an album in the Albums panel or Grid view, then select the ... menu.

Or, to share individual photos as a web gallery, select them in multi-select mode (page 30) and then tap the Share menu.

Select **Share & Invite** or **Invite & Get a Link** from the menu; the exact name varies depending on the operating system and current view.

If Lightroom asks you to enter an email address, tap the back arrow to access the main Share & Invite dialog for now, as we'll come back to sharing with specific people shortly.

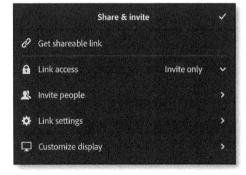

On the desktop, select an album in the Albums panel or one or more photos in the Grid view, right-click, and choose **Share & Invite** to display the Share & Invite dialog.

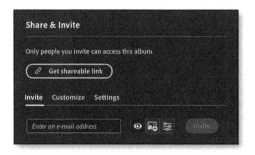

On the web interface, select an album and tap/click on the Share icon in the top right corner. Or, to share individual photos as a web gallery, tap/click the checkmarks in the corners of the thumbnails to select multiple photos. From the blue options bar, choose **Share** and give the new album a name.

← web Share button

web Share selected photos ↓

By default, shared albums are set to *Invite Only*, meaning only invited guests must sign in with their email address to access the gallery. You can revoke their access or change their access permissions at any time.

To **invite someone to view your web gallery**, tap **Invite People** (mobile only) / click in the text field (desktop/web). Enter their email address, decide on their access permissions (page 388), and tap/click **Send** (mobile) / **Invite** (desktop/web) to send an invitation by email.

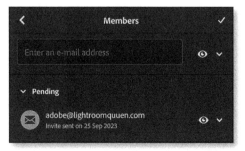

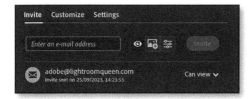

The *Title* and *Author* fields are automatically filled with the album name and your name, but you can change or disable them if you don't want them to show on the web gallery.

To **share the gallery link publicly**, for example, on social media, tap/click the **Get shareable link** button and set the *Link Access* to *Anyone Can View*. Copy the link to the clipboard and send it by email, text message, Facebook, etc. Only people with the link can view the gallery.

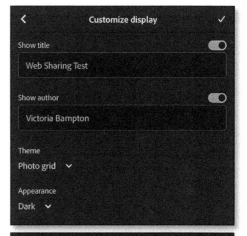

We'll cover additional gallery preferences in detail on the following pages. In addition to setting these options when creating the gallery, you can access the settings later by returning to the Share & Invite dialog.

To **stop sharing an album** on mobile, tap the *... menu > Share & Invite* and choose **Stop Sharing**. On the desktop, right-click on it again and choose **Stop Sharing**. Or set the *Link Access* pop-up to *Invite only* to limit access to those listed below. On the web interface, click the Share button to show the Share & Invite dialog and choose *Stop Sharing*.

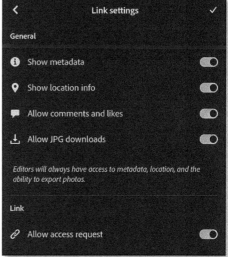

DISPLAY & SETTINGS

You have control over what's visible in your shared gallery, and if you visit the public gallery link, you can see how it'll look to other people.

The layout and exact names of the settings vary slightly by operating system. On mobile, the settings are found under **Customize Display** and **Link Settings** in the Share & Invite screen. On the desktop, there are tabs in the Share & Invite dialog called *Customize* and *Settings*.

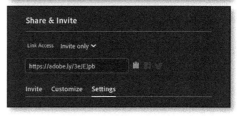

Web Gallery Display & Settings: mobile (top & center), or accessed via tabs on the desktop and web (bottom)

The **Theme**—*Photo Grid, Column,* or *One-Up*—controls the gallery's layout, and the **Appearance** options allow you to switch between a light and dark design. Further customization is available in the Web interface, but we'll come back to these settings in a later lesson (page 393).

Show Metadata and **Show Location** limit the metadata your viewers can see in the Info panel of the web gallery.

Allow Comments and Likes allows your viewers to share their thoughts on your photos.

Allow JPG Downloads displays a download button in the viewer's web gallery, allowing them to download full-resolution JPEGs of the photos.

Allow access request is only available when the link is set to *Invite Only*. So, while we're talking of link access...

LINK ACCESS & INVITATIONS

If the *Link Access* is set to **Anyone Can View**, it doesn't mean your photos are being broadcast across the web, but simply that anyone with the link can view the gallery.

Set to *Invite only*, the gallery is kept private, except for the people you invite by email. To view the photos, they must click the link in their email and sign in using their Adobe ID or Facebook/Google login.

If the gallery is set to *Invite only*, but an uninvited viewer visits the link (perhaps because it was previously shared as *Anyone Can View*), they'll be asked to log in and then be given the option to *Request Access*.

You don't have permission to view this album.

Request Access

This sends you a request by email, giving you the choice to approve or deny their request. They won't be able to view the gallery until you grant access from the Share & Invite dialog.

While inviting someone to a shared album, you can set their access level:

Can View allows them to view the gallery. Their download and comment/like access is set on the Settings tab, like a public gallery.

Can Contribute allows them to upload their own photos to your album using the web interface or even the Lightroom app on their phone. They don't need to be a paid subscriber, as the photos are added to your cloud space. These contributed photos show a small profile photo in the corner, so you know who uploaded them. For example, if you're the designated photographer at a family event, you may invite family members to upload their photos to the shared album so the whole family can enjoy them.

Can Edit and Contribute allows them to add photos to your album and edit your photos.

Their edits are saved as an Auto Version (page 157), badged with their avatar, so you can return to your edits if you don't like their changes. They can also export full-resolution originals. Don't worry; only the album owner can delete photos and edit metadata.

You can change or revoke access permissions for a specific person at anytime.

VIEWING A SHARED GALLERY

When your friends, family, or clients visit a web gallery link, they can **view the photos** in a Grid or Detail view or watch a slideshow of your photos.

Depending on the gallery settings, they may be able to download some or all of the photos.

They can also like and comment on your photos if they sign in using an Adobe ID or a Facebook/Google account.

If their access level is set to *Can Contribute*, they can upload their own photos to your album using the *Add Photos* button. If their access level is set to *Can Edit*, there are additional Edit and Crop tool buttons.

If they've installed the Lightroom app and you've invited them to view the gallery using their email address, the shared gallery also appears in the *Shared with You* section of the Shared Photos panel in their Lightroom app.

PUBLIC VIEW (WEB)

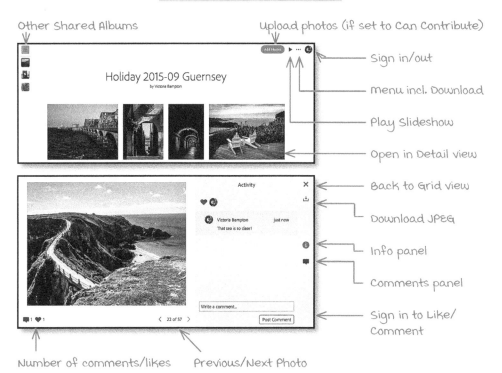

Other Shared Albums

Upload photos (if set to Can Contribute)

Holiday 2015-09 Guernsey
by Victoria Bampton

Sign in/out

Menu incl. Download

Play Slideshow

Open in Detail view

Back to Grid view

Download JPEG

Info panel

Comments panel

Sign in to Like/ Comment

Number of comments/likes

Previous/Next Photo

MANAGING SHARED ALBUMS

The Shared Albums panel allows you to see all your shared albums in one location without having to search through your folders of albums. You can add and remove photos as you would with any other album.

Select the Shared Albums panel using the folder (mobile) / tab (desktop) in the Albums panel.

VIEWING VISITOR'S ACTIVITY

To **view notifications of recent activity**, such as likes and comments, tap/click on the bell icon at the top of the screen. A blue dot on the icon means there are new notifications you haven't seen. You'll receive notifications for any albums you own, plus any photos you've contributed to other people's albums.

Lightroom lists the **recent activity**, and tapping/clicking on a notification opens the photo. When viewing a shared album on mobile, you can go to ... *menu > Activity* to show a list of activity in the selected album.

In the Grid view on the desktop, **thumbnail badges** are automatically displayed on photos with likes or comments. In the iOS Grid view, go to the ... *menu > Info Overlays > Activity* to display the icons on the thumbnails. These icons aren't currently available on Android.

To **view the notifications for a specific photo** on mobile, open the photo in Detail

view, go to ... *menu > Info and Rating*, and select the **Activity** tab. On the desktop, open the Activity panel to see and reply to the likes and comments for the selected photo.

On the desktop, you can filter photos based on likes and comments (page 121).

CONTRIBUTING TO OTHER PEOPLE'S ALBUMS & EDITING THEIR PHOTOS

If **someone has invited you** to view, contribute to, or edit one or more of their albums (page 388), you'll find the albums listed in the Shared Photos panel under the **Shared with You** heading. You can like and comment on their photos directly within the Lightroom app.

If your link access is set to *Can Contribute*, you can **drag your photos to their album** as if you're adding photos to one of your own albums. When you add photos to someone else's album, Lightroom asks which of your metadata you wish to include.

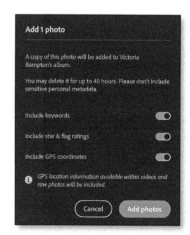

If your link access is set to *Can Edit*, you can also edit their photos using Lightroom's editing tools, and export full resolution originals.

SHARED ALBUMS PANEL (MOBILE)

Select Shared in Lightroom Albums panel

Back to Lightroom Albums

Other people's albums that have been shared with you

Shared Photos

Shared Albums

Sort Albums

Album menu

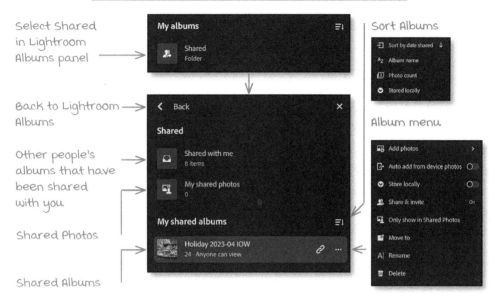

SHARED ALBUMS PANEL (DESKTOP)

Open Shared Photos

You can contribute

You can edit photos

Invite-only album

Anyone with the link can view album

Other people's albums that have been shared with you

Your shared albums

Groups of shared photos not in shared albums

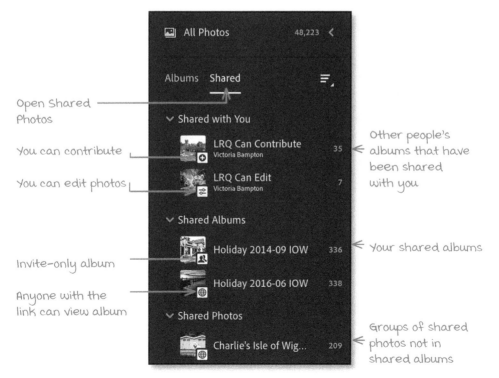

NOTIFICATIONS & ACTIVITY VIEW (MOBILE)

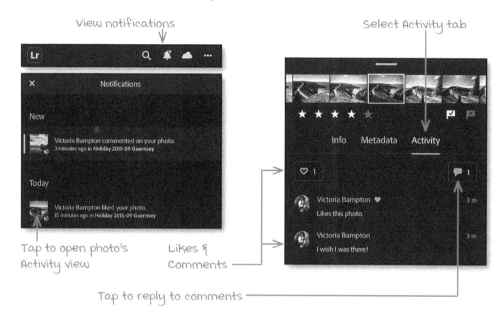

View notifications

Select Activity tab

Tap to open photo's
Activity view

Likes &
Comments

Tap to reply to comments

NOTIFICATIONS & ACTIVITY VIEW (DESKTOP)

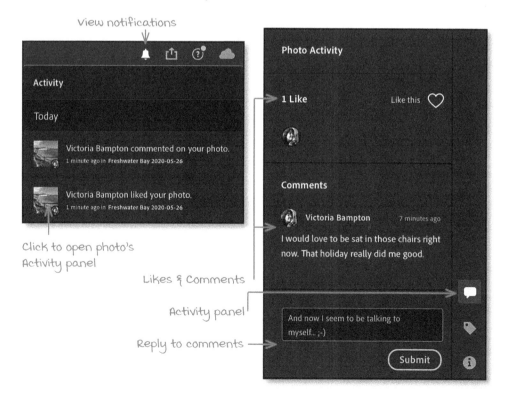

View notifications

Click to open photo's
Activity panel

Likes & Comments

Activity panel

Reply to comments

ENHANCING WEB GALLERIES

To access additional share preferences, visit Lightroom Web at https://lightroom.adobe.com and sign in to your account. Some of these options require a desktop browser rather than a phone/tablet.

ADDING CUSTOM TEXT & LAYOUT

You can create a more interesting web gallery by splitting the grid of photos and inserting descriptive text to tell a story.

Select the **Display** view at the bottom of the album's Grid view and choose your preferred layout, then click between images to split the photos and add text. Further options are available in the floating panel at the bottom of the page, including a cover photo that can be placed at the top of the page or in the background.

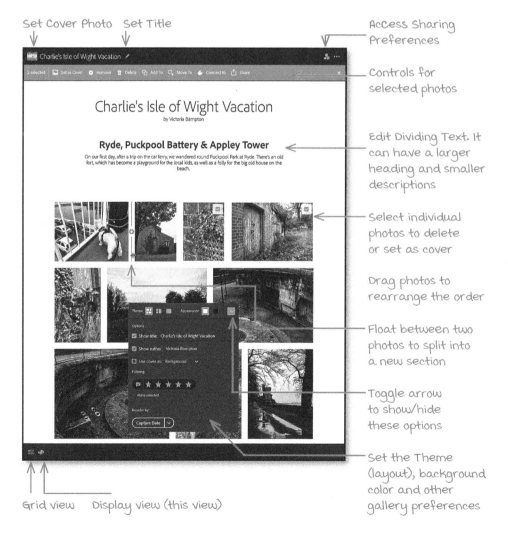

CUSTOM SHARE (WEB)

Set Cover Photo Set Title

Access Sharing Preferences

Controls for selected photos

Edit Dividing Text. It can have a larger heading and smaller descriptions

Select individual photos to delete or set as cover

Drag photos to rearrange the order

Float between two photos to split into a new section

Toggle arrow to show/hide these options

Set the Theme (layout), background color and other gallery preferences

Grid view Display view (this view)

CREATING A GALLERY INDEX PAGE

You can also **create an index page** of chosen shared galleries, perhaps to use as your portfolio.

To do so, click the disclosure triangle to the right of *All Photos* and select **Gallery**. Enable the index, and add the albums of your choice. The link to the index page is displayed at the top.

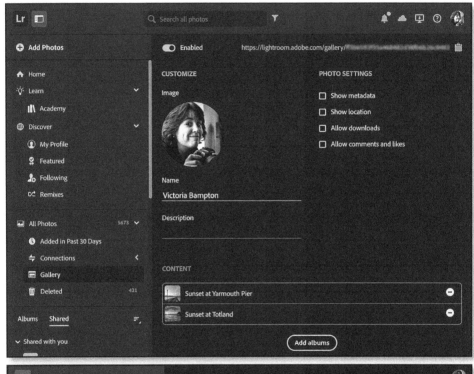

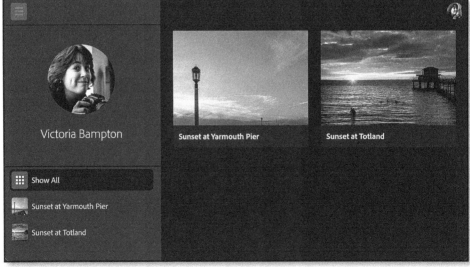

CONNECTING TO OTHER SERVICES ON THE DESKTOP

Under *All Photos* on the desktop is a section marked **Connections**. These are connections to external web services.

Only an Adobe Portfolio connection was initially available, and other options have been added since. There's potential to link to many different companies, for example, to:

- order photo prints

- design & order photo books

- design & order calendars and other photo gifts

- create advanced slideshows

- publish photos on other social media/photo-sharing websites

- publish photos on stock websites

- integrate with your own website

In time, it may even be possible to access advanced metadata manipulation plug-ins for more specialized tasks such as duplicate detection.

These additional options are simply waiting for companies to build these connections using Adobe's API. If you want to see your favorite photo lab or website supported, you may want to email them to encourage their developers to start work on the integration.

CREATING CONNECTIONS

The principles are the same for all connections, so we'll look at the basic setup using Adobe Portfolio as an example. Adobe Portfolio is an advanced portfolio website

that can hold up to 200 images and is free with your Creative Cloud subscription. You can learn about Adobe Portfolio at https://www.myportfolio.com.

To **create or view connections**, click on *All Photos* to show **Connections** on the left of the desktop apps (and in the Web interface, too, for Portfolio connections).

To **add a new connection**, click the **+** button, add the connection(s) of your choice and then close the dialog.

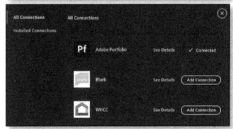

To **share a whole album**, right-click and choose **Share To > [your connection name**, *e.g. Adobe Portfolio]*.

To **share specific photos**, select one or more photos in the Grid view, right-click, and choose **Share To > [your connection name**, *e.g. Adobe Portfolio]*. Decide whether to create a new project (similar to an album,

but specific to that connection) or add them to an existing project.

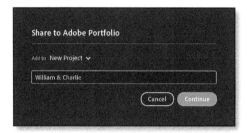

What happens next depends on the specific connection. For Adobe Portfolio, Lightroom automatically opens the project in a web browser so you can customize the layout and appearance.

MANAGING CONNECTED PROJECTS

You can view the connected projects from within Lightroom by returning to the Connections section and clicking on the connection. Lightroom displays a list of your projects.

The connections don't update automatically when you add new photos, remove photos or edit photos, just in case you're experimenting with your photos. To **update a connected project with your changes**, click the **Resend** button. For Portfolio, this updates Portfolio your changes. For some other services, this just adds/removes photos, but doesn't update any edits.

CONNECTIONS VIEW (DESKTOP)

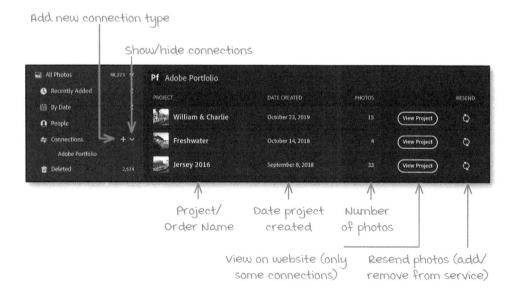

Add new connection type

Show/hide connections

Project/ Order Name

Date project created

Number of photos

View on website (only some connections)

Resend photos (add/ remove from service)

EXPORTING EDITED PHOTOS

22

Having selected all of your best photos and edited them until you're proud of the result, don't keep them to yourself. Share them with the world!

There are numerous reasons you might want to export edited copies of your photos for different purposes. For example:

- To send to other people.

- To upload to photo-sharing websites that don't connect directly to Lightroom's cloud.

- To upload to online labs or take to local photo labs to be printed as photographic prints.

- To upload to online printers to create books, calendars, and other products.

- To print using other software since you can't print directly from Lightroom.

- To open in other software for further editing, such as Nik, On1, Topaz, etc.

There's no need to keep these copies once they've served their purpose, as you can save a new copy at any time.

IN THIS CHAPTER, WE'LL CONSIDER:

- How to send a photo to Photoshop for more extensive editing.

- How to save edited photos to your hard drive.

SENDING PHOTOS TO PHOTOSHOP & OTHER EDITORS

Lightroom offers a wide range of tools to cater to most of your editing needs, but sometimes, you'll need a pixel-based photo editor such as Photoshop. For example:

• Swapping heads, changing backgrounds, and merging photos are jobs for Photoshop.

• Some distractions, such as flare on glasses, can be reduced in Lightroom but removed more effectively in Photoshop.

• Removing some distractions, particularly on a complex or detailed background, is much faster and easier in Photoshop.

• Doing lots of retouching on a single photo is faster in Photoshop, as Lightroom slows down with many edits.

Lightroom and Photoshop handle the color and file management, so you only need to worry about editing skills. Since this is not a Photoshop book, we won't go into detail, but we'll learn how to hand the files off to Photoshop...

LIGHTROOM EDITING COMES FIRST

Lightroom's editing tools work best on raw files because they have the largest amount of data available. For this reason, it's usually best to do most (if not all) of your Lightroom adjustments before moving to Photoshop or other editing software.

There are a couple of exceptions:

• You may prefer to leave cropping until after your external edits, allowing you to non-destructively crop to different ratios without repeating your retouching and other edits.

• If the photo will be in both B&W and color, you may want to retouch the color version and then convert the retouched TIFF to B&W so that you only have to retouch once.

• If your photo was shot in JPEG/HEIF or is a scan, the workflow order isn't as important. For example, you may retouch dust on negative scans in Photoshop before adding them to Lightroom.

The signs, van and people couldn't have been easily removed using Lightroom alone

EDIT IN PHOTOSHOP ON IPAD

On iPad, the **Photoshop** app aims to bring

many desktop features to mobile. It's still early days, but it shows great promise. There's a direct link from Lightroom to Photoshop on iPad.

1. In Detail view, tap on the cloud icon and ensure that *Cloud* says there's a full-size original in the cloud. It's automatically downloaded when you send the photo to Photoshop. If only a smart preview is available, you can still send the photo to Photoshop, but the image will be a maximum of 2560px long edge.

2. Tap on the Share menu and select *Edit in Photoshop*.

3. The image opens in Photoshop, where you can edit to your heart's content.

4. When you've finished editing, you have three choices:

Send to Lightroom saves the file as a PSD file with -*Edit* at the end of the filename and returns the image to Lightroom. If you were viewing the photo in an album, the edited copy is automatically added to the album, too. This is usually the option you'll need.

Cancel asks for confirmation and then closes the document without saving your edits.

... menu > Create Photoshop cloud document saves your edited photo to Photoshop's Cloud Documents storage space (found at https://assets.adobe.com/cloud-documents). This is useful if you want to continue editing the same layered file in Photoshop later before manually adding it back to your Lightroom library.

EDIT IN PHOTOSHOP ON THE DESKTOP

To open a photo in Photoshop (CS6 or later), right-click and select **Edit in Photoshop** or use the shortcut Ctrl-Shift-E (Windows) / Cmd-Shift-E (Mac). You'll also find it in the *File* and right-click menus. The photo opens in Photoshop with your Lightroom edits applied. Leave Lightroom open in the background so it can keep track of the file and automatically add it to your library.

By default, Lightroom opens the photo in Photoshop as a 16-bit ProPhoto RGB file, which it then saves as a TIFF. 16-bit ProPhoto RGB TIFFs are the best choice for quality, retaining the largest amount of data and smooth color gradations (e.g., in the sky). However, they're large files, especially when you add layers, so they'll take up a lot of space in the cloud.

If it's your favorite photo, and you've spent hours working on it in Photoshop, keep the full 16-bit TIFFs because it leaves your options open for the future. However, if you only flipped into Photoshop to quickly remove a distraction, and you're just going to post it on social media, you may decide to **reduce the file size** before saving the photo.

To do so, follow these steps in Photoshop:

1. Go to *Image menu > Convert to Profile > Adobe RGB* (because ProPhotoRGB is too wide a color space for an 8-bit file).

2. Go to *Image menu > Mode > 8-Bits/Channel* to reduce the bit depth.

3. If you no longer need the layers, go to *Layers menu > Flatten Image* to flatten the layers.

To **return to Lightroom after editing in Photoshop**, go to *File menu > Save*. This saves the file back to Lightroom with *-Edit* at the end of the file name. You can use *Save As* to change the file name if you prefer but don't change the file type, or Lightroom will lose track of it.

Close the file in Photoshop and switch back to Lightroom. The edited photo is automatically stacked on top of the original in the selected album and *All Photos*, but not in other albums.

RETAINING LAYERS WHEN SENDING BACK TO PHOTOSHOP

If you open a layered TIFF/PSD in Photoshop again later, the behavior depends on whether you've done further editing in Lightroom. If you haven't edited the TIFF/PSD in Lightroom, it opens in Photoshop with its layers intact. If you've applied edits to the TIFF/PSD in Lightroom, the layers are flattened when you open it in Photoshop, so to retain the layers, you'd need to reset Lightroom's edits (save them as a Version first!) before opening in Photoshop.

OPENING PHOTOS IN OTHER PHOTO EDITING APPS

Photoshop is the only editing app to have a direct link to Lightroom. Plug-ins designed for Lightroom Classic don't work with Lightroom on the desktop. However, you can still open photos in other editing apps. All you need to do is export the photo to the Photos app (iOS) / the Pictures folder (Android) / a folder on your hard drive (desktop) and then open it with the other app.

We'll learn how to export in the next lesson (page 401). Your Export settings will depend on the editor you're using... a 16-bit ProPhoto RGB TIFF retains the most editing flexibility, but some apps will require something simpler, like an sRGB JPEG. Ensure you're exporting the full-resolution photo without a watermark or output sharpening.

When you've finished your editing in the other app, you can save the file and add it to Lightroom as if it's a new photo.

EXPORTING FINISHED PHOTOS & VIDEOS

As Lightroom's edits are non-destructive, they can't be seen in other apps. To share the edited photos with others, we need to use export to save an edited copy of the photo.

SAVING A PHOTO ON MOBILE

To **save one or more photos** to the Photos app (iOS) / Pictures folder (Android) or other file storage space:

1. Go to Grid view, hold your finger on a photo to enter selection mode, then tap or drag across the photos you want to save. Alternatively, open a single photo in Detail view.

2. Tap on the Share menu.

3. Select **Export As...** to access the export options. The next lesson will examine the individual options in more detail (page 406).

4. (iOS) Tap the checkmark to choose where to store the exported photos. You can send the photos to other apps such as Mail, Messages, Facebook, Instagram, or WhatsApp. If your chosen app isn't showing, scroll along the app icons to tap the **More** button. You can also **Save Images** to the Photos app to access the photos directly from other apps. **Save to Files** allows you to select any storage locations you've mounted in the Files app, such as iCloud, Dropbox, or external storage drives.

4. (Android) Tap the checkmark to save the photos to the *Internal Storage/Pictures/*

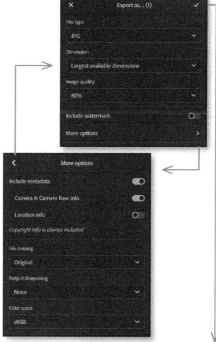

EXPORT (ANDROID)

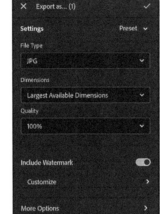

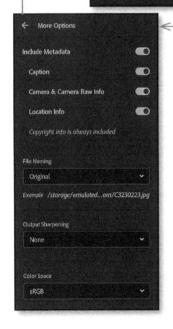

AdobeLightroom folder. They'll appear in the Gallery app.

If you're wondering about some of the **other Share menu commands**, they all do very similar things, with slight variations:

Save Copy to Device saves the exported photo to the Lightroom album in the Photos app (iOS) / Gallery (Android). On iOS, you can tap the Preset button on the right to set the export options. On Android, it always saves a full-resolution JPEG.

Share on iOS is the same as *Export As*, but it allows you to save export options using the Preset button on the right. For example, you may set *Share* to always output a 2048px JPEG with a watermark and no metadata.

Share on Android sends the photos to other apps such as Email, Messages, Facebook, Instagram, or WhatsApp. It allows you to save the photos to cloud storage such as Google Drive or Dropbox. It doesn't offer a choice of file formats, always saving a full-resolution JPEG, but it does allow you to set the metadata and watermark options using the Preset button on the right.

Add border and share (iOS, from Detail view only) saves a 2048px JPEG with a border in the color and shape of your choice (page 403) and then displays the iOS Share sheet so you can save the photo to the Photos app or send it to someone. You can't set any of the export options when adding a border.

SAVING A PHOTO ON THE DESKTOP

To **save one or more photos to the hard drive**:

1. Go to *File menu > Export*, use the shortcut Shift-E or click the Share icon and select

BORDER (IOS)

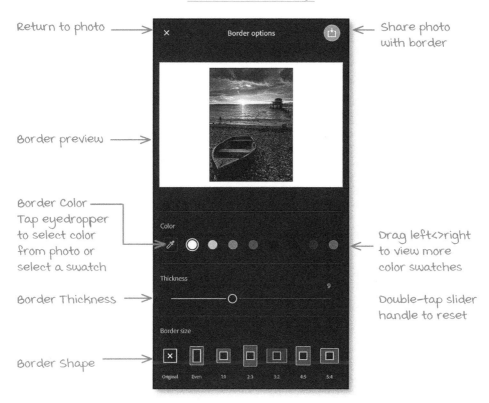

Return to photo →

Share photo ← with border

Border preview →

Border Color —
Tap eyedropper
to select color
from photo or
select a swatch

Drag left<>right ← to view more
color swatches

Border Thickness →

Double-tap slider
handle to reset

Border Shape →

Custom...

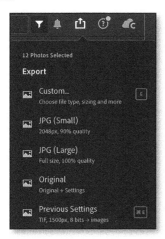

2. In the Export dialog, you have several choices, so we'll look at the individual options in more detail in the next lesson (page 406).

You can preview the effect your settings will have on your photo using the Export dialog's preview area. Below the image is the filename and file size for the selected photo. You can also zoom in to 100% for a more accurate preview.

However, note that the options you select apply to all the photos you're exporting, not just the one you're viewing.

The pop-up also has a few presets for quick exports, which are available in the Share menu and Export dialog. You can't create your own presets at this point. The **Previous Settings** preset provides quick access to your last-used export settings, complete with a keyboard shortcut Ctrl-E (Windows) / Cmd-E (Mac).

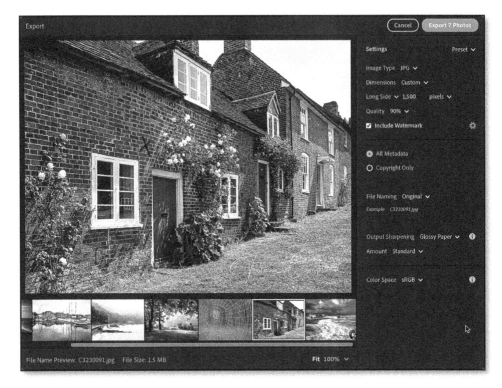

Export dialog: Desktop

3. Once you've set your Export options, click *Export Photo* to choose where to store the exported photos. By default, it saves to *Pictures/Lightroom Saved Photos*.

SHOW OFF YOUR EDITS WITH AN EDIT REPLAY VIDEO ON MOBILE

In an earlier lesson (page 384), we learned how to share your editing skills with Lightroom users worldwide, but what if you want to share them with friends and family?

From the Detail view on mobile, tap the Share icon, then select **Create Edit Replay**. Lightroom automatically creates a time-lapse video and asks how you want to share it. There are all the usual social media options, or if you select the Lightroom app, you can save the video back to your Lightroom library. If you tag @lightroom in your social media share, you might even be featured on Adobe's account!

The resulting videos are only a few seconds long, and they simply compare the unedited photo with the finished settings rather than retracing every step you took in order. For example, the video shows the unedited photo, then cropped, then with Light adjustments, then Color adjustments, then with Masking, and the finished result. They're a great way of showing what Lightroom can do, as well as showing off your editing skills.

EXPORTING VIDEOS

The process for **exporting videos** is the same as photos, which we've already discussed in this lesson. However, the export options are much more limited for

videos.

There are only two export file formats: *Original* is a copy of the unedited video, whereas *MP4* includes your Lightroom edits. And on the desktop, you can also choose to rename when exporting. The other options, such as resizing and watermarks, are not available for videos at this time.

There is one extra share option of note... on the desktop, you can save a single frame as a separate photo. To do so, scroll through the video until you get to a frame you'd like to extract. The step buttons (page 41) are particularly helpful when selecting the best frame. To **save the frame as a photo in Lightroom**, right-click on the video and select ***Save Video Frame***. To export the frame as a photo on the hard drive, click the Share button and select *Current Frame* from the list of presets.

SETTING OPTIMAL EXPORT OPTIONS

The array of export options can be slightly overwhelming, so let's find out what they mean and how you can decide which settings are best for your intended purpose.

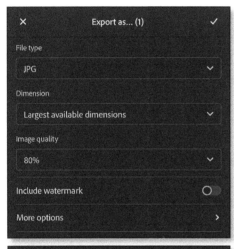

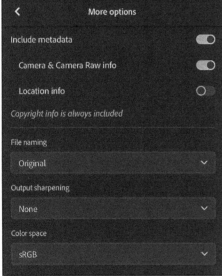

The Export settings are almost identical across all operating systems. These are the export options on mobile, and the desktop settings are embedded in the text.

FILE TYPE

There are a few different file formats to choose from:

Original (mobile only) creates a copy of the photos without any of your updated metadata. This is useful for editing in other apps that can handle raw files.

Original + Settings (desktop only) creates a copy of the photos with updated metadata (flags, stars, keywords, Info panel contents) but doesn't apply any edits to the photo image data. This is useful for editing in other software that can handle raw files.

JPEG and *TIFF* create a copy of the photo with the updated metadata and your edits applied to the image.

JPEG (or JPG) is an excellent choice for emailing or posting photos online. It applies a lossy compression, so the files are much smaller than the TIFF format, but compression artifacts may become visible at lower quality settings.

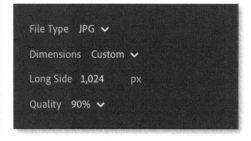

You can control the amount of compression applied using the **Quality** pop-up and check the result by clicking on the Export preview to zoom in to 100%. 100% is maximum quality but has the largest file size, whereas 10% is small, but square compression artifacts may be visible.

TIFF (or TIF) is a lossless format, so it's the

best choice for opening in other photo editing apps for pixel-based retouching and special effects.

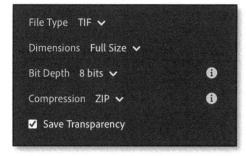

Bit Depth is a trade-off between smoother gradients (16-bit) or a smaller file size (8-bit). You're most likely to notice a difference on smooth gradients, such as a sky at sunset.

You can apply lossless **Compression** when saving a TIFF file. This reduces the file size considerably without any loss of quality.

ZIP is almost always the best choice, but occasionally, you may encounter old software that can't open a ZIP-compressed TIFF. In that case, you might need to select *LZW* compression (an older algorithm that may be supported) or *None*.

TIFF format can also **Save Transparency**, for example, the blank areas around a panoramic photo, rather than filling them with white.

DNG stands for Digital Negative. It's an openly documented file format designed primarily for raw image data. It contains the original image data and most metadata (excluding flags, album and stack membership, and Versions). Since this can include the edit settings, it's a good way of non-destructively sending your images and their edits to Lightroom on another device or backup drive when you can't use Lightroom's cloud sync.

AVIF and **JXL** are relatively new image formats that offer higher bit depths and better compression, resulting in better

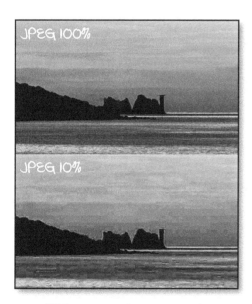

JPEG compression can create square compression artifacts at very low values (enhanced here so you can see them clearly)

Posterization/banding can show up in smooth gradients (enhanced here for visibility)

quality in smaller files. However, because they're so new, they're not widely supported yet. Eventually, JPEG XL (JXL) is expected to replace the JPEG format, but for now, most photographers can ignore these new formats.

MP4 is only available for videos (page 404).

DIMENSIONS

The **Dimensions** pop-up controls the file resolution. We'll learn more about resolution in the next lesson (page 412).

Full Size uses the pixels created by the camera without creating new ones or throwing any away (other than those you've cropped). This is also known as "full resolution" or "native resolution."

Small is 2048px along the long edge. It's a relatively small file, ideal for emailing or posting online.

Custom allows you to determine the size. We'll learn how to calculate custom file dimensions in the next lesson (page 412).

On the desktop, you can specify the length of the long or short edge in pixels or inches/cm with the resolution (PPI) to save you from manually doing the calculations.

The mobile apps only allow you to specify the length of the long edge in pixels.

If you've cropped the photo heavily or you're going to create a huge print, you may want to use the **Enhance Super Resolution**

tool (page 276).

WATERMARKING

Include Watermark allows you to add a text watermark to the photos as they're exported. We'll design your watermark shortly (page 413).

METADATA

The Metadata options (hidden under *More Options* on mobile) control how much information is included with the photos.

All Metadata includes everything: the EXIF data captured by the camera, the metadata you added in the Info and Keyword panels, names added in People view, the GPS location (if available), and the edit settings applied.

Copyright Only just includes the copyright entered in the Info panel and strips the rest of the information. This is useful if you're going to post the photos online and are concerned about privacy.

The mobile apps have an additional option to include or exclude **Camera & Camera Raw Info** too. This is the EXIF metadata, such as the camera model and capture settings, as well as a record of your Lightroom edits.

FILE NAMING

The File Naming options (hidden under *More*

Options on mobile) allow you to rename the photos as you export them.

Original retains the existing filename.

File Naming Original ∨
Example APC_1253-hdr.jpg

Custom Name renames the photos using the custom text you enter in the Export dialog. If you're exporting more than 1 photo, it adds a sequence number, starting with the number you specify. Lightroom automatically adds padding zeros if you have more than nine photos, so the photos sort correctly in other software. This is particularly useful if you've sorted the photos into a custom sort order.

File Naming Custom Name ∨
Custom Name Vacation
Start Number 1
Example Vacation-3.tif

Date-Filename renames the photo using the capture date and then the existing filename.

File Naming Date - Filename ∨
Example 20181112-C3120838.tif

An example filename is shown so you can see exactly how the photo will be named. It also displays beneath the photo preview.

OUTPUT SHARPENING

Output sharpening (hidden under *More Options* on mobile) applies additional sharpening optimized for how the photo will be used on top of the capture sharpening

you've applied using the Detail panel sliders (page 268). It's far smarter than the two simple pop-ups suggest. It calculates the optimal sharpening settings based on the size of the original file, the size of the exported photo, the type of screen/paper, and the strength of sharpening you prefer.

Output Sharpening Glossy Paper ∨ ⓘ
Amount Standard ∨

Screen is optimized for computer monitors, which are very good at showing fine details.

Glossy is ideal for typical glossy, metallic, and luster prints, and **Matte** is designed to compensate for the softer appearance of matte and fine art papers.

The **Amount** setting (*Low*, *Standard*, or *High*) is purely down to personal taste.

If you have no idea how the photos will be used, perhaps because you're giving them to a friend or client, *Glossy Standard* is a good average.

COLOR SPACE

The Color Space pop-up (hidden under *More Options* on mobile) allows you to choose between *sRGB*, *Adobe RGB*, *Display P3*, and *ProPhoto RGB* color spaces. *Rec. 2020* is also available for HDR photos.

We'll explain the differences in more detail in a later lesson (page 417), but if in doubt, use the default *sRGB*. It's the most common color space (although not necessarily the best).

Color Space sRGB ∨ ⓘ

CONTENT CREDENTIALS ON THE DESKTOP

If you've enabled **Content Credentials (Beta) Export Options** in *Preferences > Technology Previews*, there's an additional set of Content Credentials settings.

The Content Authenticity Initiative is a group of more than 200 companies working together to fight misinformation by adding verifiable, tamper-evident signatures to images. This allows anyone to trace the history of an image, including how it's been edited, to help verify its authenticity. You can learn more about it at https://contentauthenticity.org

To include Content Credentials when exporting from Lightroom, select from the pop-up:

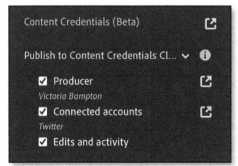

Publish to Content Credentials Cloud sends a thumbnail and the credentials to the official Content Credentials Cloud. This means the credentials are always available even if they're not included in the file, but it's not quite as private as it may appear in search results when someone tries to verify a similar image.

Attach to Files only attaches the credentials to the image. This is more private, but it does increase the file size slightly, and the credentials can be stripped (for example, by uploading to Facebook).

Attach and publish to cloud does both, offering the most security.

Don't include skips the credentials.

If you're including the credentials, you can choose what to include:

Producer is your name, as set in your Adobe account.

Connected accounts allows you to include additional contact details, such as your Twitter, Instagram, or Behance account. Click the arrow to the right to edit these details.

Edits and activity includes some basic editing information.

You can see how this information will appear to others by uploading the exported photo to the Verify website at https://verify.contentauthenticity.org/inspect.

TYPICAL SETTINGS

If you're still not sure which combination of settings to use for different purposes, try these settings:

Email or social media—File type: JPEG, quality 60 for email or 90 for social media (as they're compressed again during upload). Dimensions: custom 2048px. Color Space: sRGB.

4" x 6" digital print—File type: JPEG, quality 70. Dimensions: custom 1800px. Color Space: sRGB (some labs may accept Adobe RGB too).

8" x 10" digital print—File type: JPEG, quality 80. Dimensions 3000px or Full Size. Color Space: sRGB (some labs may accept Adobe RGB too).

Full resolution file—File type: JPEG, quality 90-100. Dimensions: Full Size. Color Space: sRGB.

HDR file for web—File type: JPEG, quality 80-100. Dimensions: 2048px. Color Space: HDR sRGB.

Edit in another color-managed program—File type: TIFF, ZIP compressed. Dimensions: Full Size. Bit Depth: 16-bit (if your software supports it). Color Space: ProPhoto RGB.

UNDERSTANDING FILE RESOLUTION

When it comes to saving files, you need to work out the size you need, and this depends on how the file will be used. For example, you'll need a big file to print a poster, but there's no point sending a file that big if it's only going to be displayed on a computer monitor or mobile device.

WHAT IS RESOLUTION?

When digital photographers speak of image size, they're usually referring to the pixel dimensions—the number of pixels along a photo's width and height.

Pixels don't have a fixed physical size. They expand or contract to fill the space available. If you expand them too far, the photo appears blurry and pixelated (you can see the squares), so the aim is to keep the pixels smaller than or equal to the monitor pixels or printer dots.

For example, this smiley face looks sharp when printed small, but the individual pixels are visible when enlarged too far.

When you set a size in the Save dialog, Lightroom creates new pixels or selectively throws away spare pixels to fit your chosen size. This process is called resampling (but the original file isn't touched!)

CALCULATING THE SIZE YOU NEED FOR PRINT

To work out how many pixels you need for a specific print size, it's a simple calculation. Let's use an 8" x 10" print:

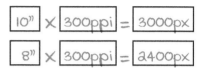

Inches—The length/width of the print size in inches.)

PPI (pixels per inch)—300ppi is traditionally the resolution used for printing. (If you prefer to use cm in your calculations, use 118ppcm instead of 300ppi.) For huge prints, you can get away with a lower value as you view them from a distance, but even then, aim for no less than 200ppi.

Result—The minimum number of pixels you need along that edge to get a high-quality print.

You can reverse the calculation by dividing the number of pixels by 300ppi / 118ppcm to get an idea of how large a print you can make.

SIZES FOR SCREEN IMAGES

For displaying on computer screens, the files can be much smaller. Relatively few screens display more than 2048px along the longest edge, so there's no point sending someone a larger photo unless they're likely to print it. Likewise, Facebook recommends uploading photos that are 720px, 960px, or 2048px along the long edge. Instagram suggests up to 1080px wide and up to 1350px high. Other photo-sharing websites make similar recommendations.

DESIGNING YOUR WATERMARK

Some photographers use a subtle watermark to 'sign' their artwork. Others use it as part of their branding, promoting their website. Many believe a watermark helps discourage people from stealing photographs; however, remember that if it is large enough to be challenging to remove, it can also be a significant distraction for those viewing your photo. Other people feel that a watermark is tacky and should never be used.

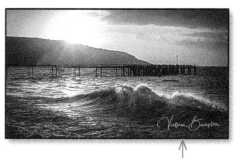

Watermark

Whether you should watermark is the subject of many flame wars online, so I'll leave you to make your own decision!

Lightroom allows you to add a text or graphical watermark to photos as you export them. Your watermark syncs across all your devices, but you can only save a single watermark.

To **design your watermark** on mobile, enable the *Include Watermark* switch in the Export Options (page 408), then tap *Customize* to design your watermark.

On the desktop, enable *Include Watermark* in the Export dialog and click the cog icon to access the watermark settings.

You can select between a text or graphic watermark, and we'll cover the individual options shortly. On the desktop, you can test the watermark on multiple photos in the filmstrip to ensure it works well on a range of photos.

When you're happy with your watermark, **save the settings** by tapping/clicking the back button (mobile) / *Done* button (desktop). On the desktop, you can click *Cancel* to return to the Export dialog without saving your changes.

To **apply your watermark** to photos as you save or share them, ensure that the *Include Watermark* switch is enabled when exporting. Note that watermarks don't display on shared web galleries (page 385).

DESIGNING YOUR TEXT WATERMARK

The text watermark options include:

Text—Depending on your reason for watermarking, you may use your name and copyright symbol, business name, website, social media handle, or any combination. You may find the text less distracting in all capital letters rather than a mix of upper and lower case.

Font & Style—On the desktop, Lightroom can access many of the fonts installed on your system. The mobile apps are more limited, so for consistency, you may want to choose a font that's available on all your devices. You can also choose a bold or italic variant.

WATERMARK (MOBILE)

Include Watermark ⟵ Enable/disable watermark

Customize ⟶ Edit Watermark

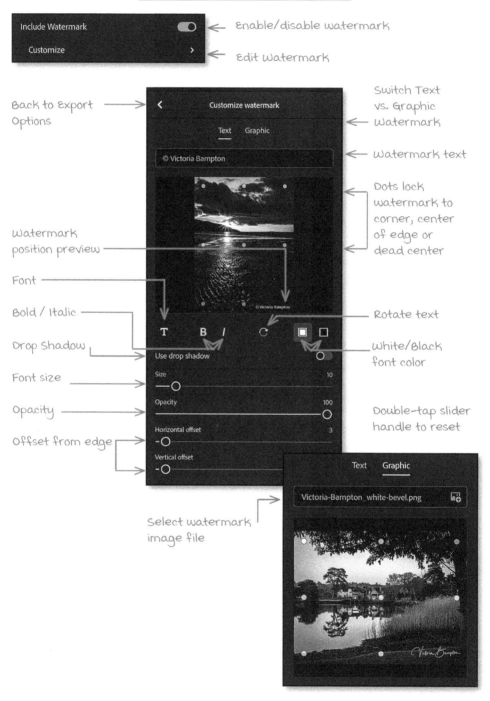

Back to Export Options

Switch Text vs. Graphic Watermark

Watermark text

Dots lock watermark to corner, center of edge or dead center

Watermark position preview

Font

Bold / Italic

Rotate text

Drop Shadow

White/Black font color

Font size

Opacity

Double-tap slider handle to reset

Offset from edge

Select watermark image file

WATERMARK (DESKTOP)

Preview watermark
on selected photo

Ignore changes &
go back to Export

Save watermark &
go back to Export

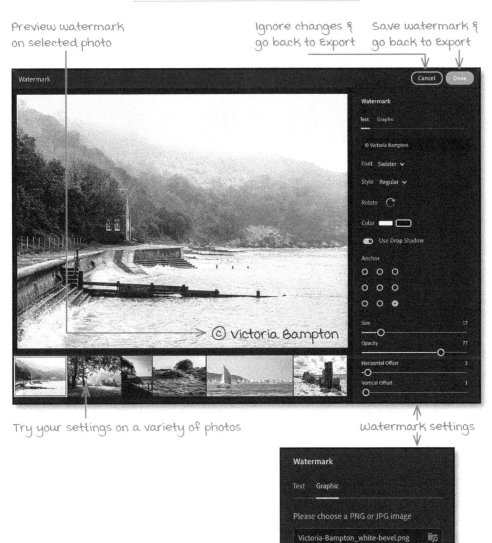

Try your settings on a variety of photos

Watermark settings

Color & Drop Shadow—Neutral tones are less distracting than color, so Lightroom only offers black or white. These can be toned down to shades of gray using the *Opacity* slider. Adding a drop shadow to a white watermark can help it remain legible in a light area of the photo.

DESIGNING YOUR GRAPHIC WATERMARK

The graphic watermark offers additional flexibility because you can design the watermark in other software (such as Photoshop). This means you're not only limited to text, but you may include your logo or a stylized signature such as those created by https://www.photologo.co.

File—You can select a PNG or JPG image as your watermark file. A PNG is usually the most useful, as it contains transparency.

SETTING THE WATERMARK PLACEMENT

Once you've decided on the content of your text or graphic watermark, you can set the size and placement on the photo.

Size—The *Size* slider is relative to the size of the photo, so it automatically adjusts for horizontal and vertical photos. Some watermarks are so small they're illegible, which defeats the purpose. On the other hand, you don't want the watermark to distract the viewer, so set your size carefully for its intended purpose. For example, if you're putting the photo on Instagram, it will probably be viewed on a smaller screen than on your website.

Opacity—Depending on the purpose of the watermark, you may want to reduce the opacity to fade it into the photo, making it less noticeable.

Anchor & Offset—Even if your watermark is small, you're adding a focal point to your photo, so consider the placement carefully. Traditionally, artists have signed their work in the lower left or right corner, inset slightly from the edges of the frame.

Rotation—On (page 144), we learned that text has significant visual mass. By rotating the watermark by 90°, you may find it less distracting, as your viewers will be less inclined to stop and read it.

UNDERSTANDING COLOR SPACE

Color management is a huge topic in its own right, but Lightroom handles most of it for you. It's only when you come to export photos that you need to pick the right color space for your purpose, so we'll just cover a quick introduction to the subject.

We already know that photos are made up of pixels, and each pixel has a number value for each color channel (red, green, and blue). For example, 0-0-0 on an 8-bit scale is pure black, and 255-255-255 is pure white. The numbers in between are open to interpretation. Who decides precisely which shade of green 10-190-10 equates to? That's where color profiles come into play: they define how these numbers should translate to colors.

Some color spaces contain a larger number of colors than others, so we refer to the 'size' of the color space. If a color in your photo falls outside the gamut of your chosen color space, it's automatically remapped to fit into the smaller gamut.

sRGB is a small color space but is the most widely used. It's a great choice for screen output, emailing, or uploading to the web. It's also the safest choice if you don't know where the photos will end up. **HDR sRGB** is the same size color space but designed for HDR images.

Adobe RGB is a slightly larger color space, but it's a good choice if you're sending photos for printing at a color-managed lab, if your editing software can only handle 8-bit files, or if you're saving as JPEG.

Display P3 is a wide gamut color space used on the latest Apple devices. It's a similar size to Adobe RGB, but it's shifted slightly towards reds/oranges and loses some of the greens/blues. It's primarily useful when exporting photos for display on the latest Apple devices. **HDR P3** is the same size color space but designed for HDR images.

ProPhoto RGB is the largest color space, so it's the best choice when transferring photos to Photoshop or other photo editing software, as long as they're color-managed. ProPhoto RGB photos look dull and flat in programs that aren't color-managed, such as web browsers. Likewise, **HDR Rec. 2020** is the largest color space available for HDR images.

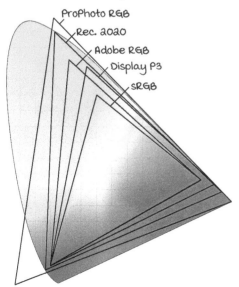

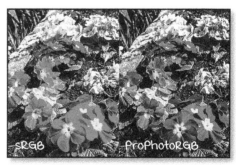

A ProPhoto RGB photo is dull and flat when opened in a program that doesn't understand color management

REFERENCE INFORMATION

23

We'll finish the book with some reference information you may need in the future. There aren't too many preferences, but knowing what they do is handy. Computers don't always behave the way they're designed to work, so we'll also discuss how to handle the most frequent problems.

SETTING PREFERENCES

There aren't too many preferences to worry about, and the default settings are good, but the diagrams on the following pages show what all of the sliders, buttons, and checkboxes do.

IN THIS CHAPTER, WE'LL CONSIDER:

• What the different preference settings do.

• How to solve the most likely problems.

• How to move to a new computer.

APP SETTINGS (IOS)

To open App Settings, go to Lightroom's Grid/Detail view then tap the ... menu and select App Settings.

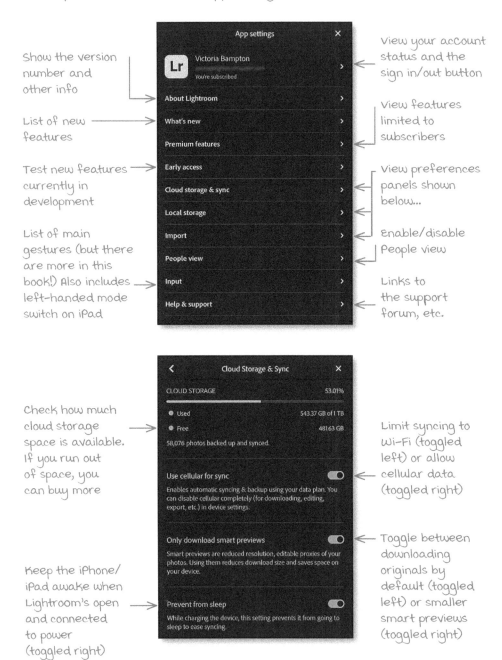

Show the version number and other info

List of new features

Test new features currently in development

List of main gestures (but there are more in this book!) Also includes left-handed mode switch on iPad

View your account status and the sign in/out button

View features limited to subscribers

View preferences panels shown below...

Enable/disable People view

Links to the support forum, etc.

Check how much cloud storage space is available. If you run out of space, you can buy more

Keep the iPhone/ iPad awake when Lightroom's open and connected to power (toggled right)

Limit syncing to Wi-Fi (toggled left) or allow cellular data (toggled right)

Toggle between downloading originals by default (toggled left) or smaller smart previews (toggled right)

Local Storage shows how much space is available on your device ——→

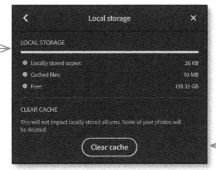

Clear Cache clears space on your device, as long as the photos are safely stored in the cloud. It doesn't clear any albums ←— you've marked for offline use

Automatically add new photos and videos shot with other camera apps

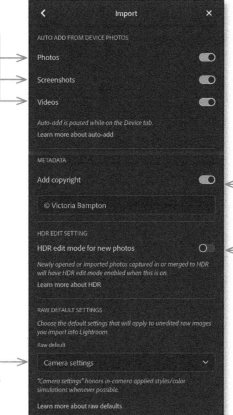

Automatically add your copyright to new photos as ←— they're added

Automatically enable the HDR ←— button for photos with HDR data

Automatically apply your choice ——→ of default settings to new raw photos as they're added

APP SETTINGS (ANDROID)

Tap the menu icon in the Lightroom Grid view to open App Settings

View your account status, amount of cloud storage space available, and the sign in/out button

View features limited to subscribers

Test new features currently in development

List of new features

Show the version number and other info

Links to the support forum, etc.

Preferences screen shown below...

Storage preferences screen shown overleaf...

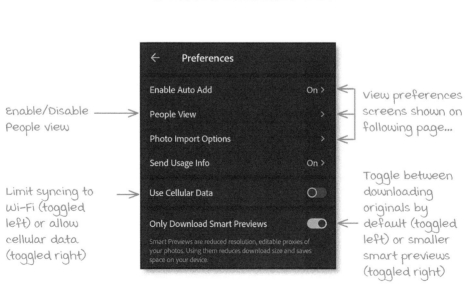

Enable/Disable People view

Limit syncing to Wi-Fi (toggled left) or allow cellular data (toggled right)

View preferences screens shown on following page...

Toggle between downloading originals by default (toggled left) or smaller smart previews (toggled right)

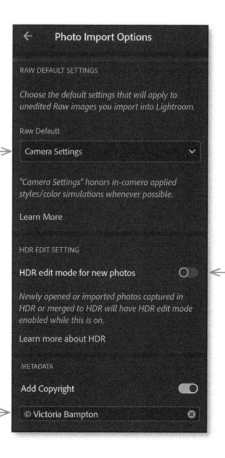

Automatically add new photos of specified file formats shot with another camera app

Automatically add photos from all locations

Specify which device folders are checked to auto add photos

Automatically apply your choice of default settings to new raw photos as they're added

Automatically enable the HDR button for photos with HDR data

Automatically add your copyright to new photos as they're added

Move Lightroom data to expansion storage (SD card) where available ——→

Device Storage shows how much space is available on your device ——→

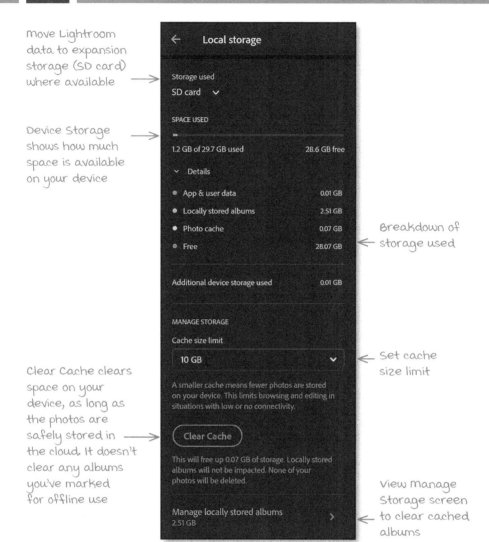

← Breakdown of storage used

Clear Cache clears space on your device, as long as the photos are safely stored in the cloud. It doesn't clear any albums you've marked for offline use ——→

← Set cache size limit

View Manage Storage screen to clear cached albums ←

ACCOUNT PREFERENCES (DESKTOP)

Subscription Status —

Opens the — Adobe website to manage your account

Check how much cloud storage space is available. If you run out of space, you can buy more

Diagnostic Log buttons only show when you hold down Alt (Windows) / Opt (mac). They help Adobe staff figure out sync issues

CACHE PREFERENCES (DESKTOP)

Click to show your local cache location

View the breakdown of space used on your main hard drive

Limit the amount of space Lightroom uses to store photos on your main hard drive

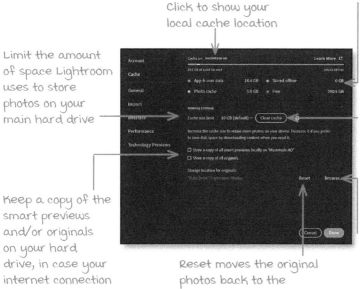

Clear the local cache of smart previews and originals

Keep a copy of the smart previews and/or originals on your hard drive, in case your internet connection goes offline

Reset moves the original photos back to the default library location on the boot drive

Decide where to store the local cache of original image files, for example, an external drive

GENERAL PREFERENCES (DESKTOP)

Prevent system sleep during sync
keeps the computer awake so the
photos can be safely uploaded

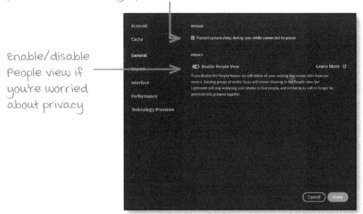

Enable/disable
People view if
you're worried
about privacy

IMPORT PREFERENCES (DESKTOP)

Add your copyright metadata to
new photos, as long as they don't
have existing copyright metadata

Automatically
enable the HDR
button for photos
with HDR data

Set default edit
settings for new
raw photos

INTERFACE PREFERENCES (DESKTOP)

By default, Lightroom uses the operating system language. The language setting also determines the text search language

Use simple gestures to flick through the photos

Change the size of slider labels etc.

On a small screen, change the Edit Panel Layout to Compact to fit more sliders in a smaller amount of vertical space

When you're just getting started with Lightroom, the pop-up tips can be handy, but if you have to reset preferences, turn them off here.

On Auto, when you open a panel on one side, the other side closes. Changing to manual keeps the side panels open until you choose to close them

Bring back any dialogs that you've hidden using the "Don't Show Again" checkbox

PERFORMANCE PREFERENCES (DESKTOP)

Use Graphics Processor allows you to override the default Auto setting to optimize performance or solve problems caused by buggy graphics card drivers.

Selecting Custom displays additional options

OPTIMIZING PERFORMANCE

Earlier in this book (page 6), we discussed which computer hardware components are most beneficial when upgrading.

You can also make a few tweaks to your preferences and workflow to optimize performance. Most are specific to the desktop, but a couple apply to all devices. We've covered many of these options earlier in the book, so we'll summarize them here.

IMPORT SPEED

When importing from a memory card, use a fast card reader rather than a camera cable to speed up the import process.

IMAGE LOADING SPEED

If your internet speed is slow or you want photos to load quicker, it's worth caching them locally (page 76) so they don't have to download from the cloud as you try to edit them. Depending on your available storage space, you may decide only to store specific albums locally rather than all your photos.

HARD DRIVE SPEED ON THE DESKTOP

Lightroom's local database is stored on the boot drive, so ensuring you have a fast boot drive (ideally SSD) and plenty of space available on that drive can help with performance.

The originals can be stored on another drive (page 80). A standard internal or external hard drive is usually better for performance than a NAS (network-accessible storage).

GPU ACCELERATION ON THE DESKTOP

Lightroom can use the GPU (page 7) to speed up specific tasks, such as how quickly the image preview updates on the screen when you switch photos or move an Edit slider. This is called GPU acceleration.

Many possible combinations of graphics cards, drivers, and driver settings exist, especially on Windows. A bad combination can cause slower performance, strange artifacts on the screen, or even crash the entire system.

There are a couple of preference settings in *Preferences > Performance tab* to give you control over how Lightroom accesses your GPU so you can select the best settings for your system.

Auto is the default setting. It only enables GPU performance enhancements that are expected to work well and leaves potentially

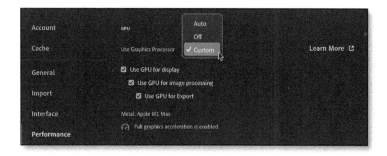

buggy options disabled.

Custom gives you control. If the pop-up is set to *Custom*, there are three options:

Use GPU for display uses the GPU to accelerate the drawing of pixels on the screen. It's the simplest option and works well on most supported graphics cards as long as the driver is updated regularly.

Use GPU for image processing uses the GPU to do the edits themselves, making slider movements smoother. It's much more advanced and is, therefore, more likely to hit bugs in drivers, causing strange artifacts on the screen, slow performance, or even system crashes.

Use GPU for Export uses the GPU to export your photos faster. You'll need at least 8GB of VRAM to benefit or at least 16GB of shared memory. If you enable it on a computer with less memory, performance will likely be negatively affected.

Off disables these optimizations. You might select *Off* if your graphics card is underpowered or continues to have issues (performance degradation, crashes, or artifacts) after you've updated the driver.

SOLVING SYNC PROBLEMS

Syncing between multiple devices is complex, and although it usually "just works," a few hiccups can arise. The most frequent issues have simple solutions, which we'll cover in this lesson, and I've included Adobe's contact details for more complex issues.

FREQUENT SYNC PROBLEMS

If Lightroom says it's syncing, but nothing seems to be downloading, or edits made on other devices aren't showing up, check the other devices have finished uploading.

If edits made in the current version of Lightroom aren't uploading to other devices, check that sync isn't paused.

If you're unsure which device has the sync issue, check the web interface at https://lightroom.adobe.com/ to see whether the photos have been safely uploaded to the cloud. If there's a problem, there may be a **Sync Issues** album on the left, and the thumbnails show which device needs to be opened to allow the photos to finish uploading.

On the desktop, you can also Alt-click (Windows) / Opt-click (Mac) on the *Sync Status* icon in the Info panel to retry sync on a photo that is stuck.

UNABLE TO DOWNLOAD ORIGINAL

If Lightroom says it's unable to download the original photo, there are three likely causes:

• You're offline (no internet connection), or sync is paused.

• The photo was added on another device and hasn't been uploaded to the cloud yet.

• The photo was added on another device, but you've run out of cloud storage space.

OUT OF SPACE

If Lightroom says you've run out of cloud space, click the cloud sync icon and then select the *Upgrade* button on the desktop to pay for additional cloud storage space, or log into your account on Adobe's website. Alternatively, you could delete photos you no longer want (e.g., the rejects or 1-star photos you kept "just in case") to clear some cloud space or save them to a hard drive and then remove them from Lightroom.

If it says you've run out of local hard drive space, you can move the originals to another drive (page 80). If you still don't have enough space, you'll need to clean up your boot drive using Windows/macOS tools or upgrade the size of your boot drive.

TROUBLESHOOTING WITH ADOBE

More unusual sync issues may require a little help from Adobe. This also allows them to investigate and figure out the cause of the problem so they can avoid it in future releases.

To **request support from Adobe**, it's best to post a bug in the *Lightroom Ecosystem* section of https://community.adobe.com.

Don't forget to include your Lightroom version and operating system when posting. The easiest way to find the version number on mobile is in *Preferences > About Lightroom*. On the desktop, go to the *Help menu > System Info* and copy the first text block. And, of course, don't forget to include a detailed description of what's wrong!

Adobe support staff may ask you to create a **Diagnostic Log**, **Sync issues report**, or **Exhaustive Report**.

On iOS, go to *App Settings > Help & Support* and hold your finger on the *Access our Support Forum* button. The diagnostic log is automatically attached to a draft email, ready to send. You can also trigger it by tapping this link: adobelightroom://app/diagnostic/log

On Android, go to *App Settings (hamburger menu)* and hold your finger on the Lr icon to turn on logging. Tap *Send Feedback* at the bottom of the menu to generate the log, then attach it to an email.

On the desktop, go to *Edit menu* (Windows) / *Lightroom menu* (Mac) > *Preferences > Account* tab and hold down the Alt key (Windows) / Opt key (Mac) to display the buttons. Lightroom generates the log and offers to open it in your web browser or show it in Explorer (Windows) / Finder (Mac), ready to email to the support staff.

RESETTING THE LOCAL CACHE

If you're having significant sync problems that Adobe can't solve, sometimes the "nuclear" option is the simplest solution. Obviously, it's essential to ensure all photos

have finished syncing to the cloud or back them up before deleting the local cache.

To clear the local cache on your iOS or Android device, simply delete the app and re-download from the App Store (iOS) / Play Store (Android), then sign in and allow it to sync the photos again.

To reset the local cache on the desktop, delete the following files from the problem computer:

Windows—C: \ Users \ [your username] \ AppData \ Local \ Adobe \ Lightroom CC \ Data \

Mac—Macintosh HD / Users / [username] / Pictures / Lightroom Library.lrlibrary

When you next open Lightroom, it will create a new local cache from the cloud.

DELETING EVERYTHING

If you want to wipe absolutely everything from the cloud and all devices, go to https://lightroom.adobe.com, sign in, click the LR icon in the top left corner, select *Account Info*, and then press the *Delete Lightroom Library* button. But **make sure you have a copy of all your photos and settings** on another disconnected hard drive because it will delete them from everywhere that Lightroom controls (other than Lightroom Classic).

STANDARD TROUBLESHOOTING STEPS

If your issue isn't covered by the previous lessons or in the specific topic area of the book, there are some general troubleshooting steps you can try, whether you're using a desktop computer or a mobile device.

TROUBLESHOOTING ON MOBILE

1. Force Quit the App

If an app misbehaves, one of the first things to try is quitting and reopening the app.

On most iOS devices, double-click the Home button to show your most recently used apps, swipe right or left to find the app you want to close, and then swipe up on the app's preview to close the app.

On Android, go to *Settings app > Apps > Lightroom* and tap *Force Stop*.

2. Reboot the Mobile Device

Like a desktop computer, rebooting a mobile device can often solve odd issues.

On iOS, a hard reset or force restart clears out RAM, which a standard restart doesn't. On older devices, hold down the Home button on the front and the power button, and keep them held down until the Apple logo appears, then let go of the buttons and wait for it to finish restarting. For newer devices without a Home button, hold the power button and volume down key until you see the Apple logo, then let go and wait for it to finish restarting.

On Android, hold down the power button and then press the *Restart* button on the screen.

3. Check for Updates

Check the App Store (iOS) / Play Store (Android) for an updated version of Lightroom, as you may be running into a bug that's already been fixed.

4. Ask for Help

If you're still stuck, post a description of your problem as a bug in the *Lightroom Ecosystem* section of Adobe's forum at https://community.adobe.com/.

Don't forget to include a complete description of the problem and your exact Lightroom version and operating system. You'll find this information under *App Settings > About Lightroom*.

TROUBLESHOOTING ON THE DESKTOP

1. Restart Lightroom

Many issues fix themselves by simply quitting and reopening Lightroom.

2. Reboot the Computer

If you're having odd problems with any computer program, the age-old wisdom "turn it off and turn it on again" still works wonders.

3. Check for Lightroom Updates

Ensure you're running the latest updates, both for Lightroom (by going to *Help menu > Check for Updates*) and your operating system, as the issue you're running into could be a bug that's been fixed in a later release.

4. Check for Driver Updates

Buggy graphics card drivers can cause no end of trouble.

On Windows, check the graphics card manufacturer's website for an updated driver, as Windows Update often has outdated drivers. It's best to uninstall the previous driver before installing the new one.

On macOS, check *System Settings > Software Update* for an operating system update.

5. Turn off the GPU

If you continue to have problems, particularly with artifacts on the screen, slow performance, or crashes, go to *Preferences > Performance tab* and set the *Use Graphics Processor* pop-up to *Off*. If this solves the problem, it's definitely a graphics card conflict. Once you've solved the problem with the graphics card, you can set it back to *Auto*.

6. Reset Preferences

If you're still having problems, resetting Lightroom's Preferences file can solve all sorts of 'weirdness,' so it's a good early step in troubleshooting. If you reset your Preferences file, the main settings you lose are those in the Preferences dialog. Your photos, metadata, edits, presets, and other vital settings are unaffected by deleting the Preferences file.

There's a simple automated way of resetting preferences. Hold down Alt and Shift (Windows) / Opt and Shift (Mac) while opening Lightroom, and it will ask whether to reset the preferences. The timing is crucial—hold them down while clicking/double-clicking on the app/shortcut.

If you need to delete preferences manually, the preferences files are stored in hidden folders at:

Windows—C:\ Users \ [your username] \ AppData \ Roaming \ Adobe \ Lightroom CC \ Preferences \ Lightroom CC Preferences. agprefs

Mac—Macintosh HD / Users / [your username] / Library / com.adobe. lightroomCC.plist and com.adobe. lightroomCC.mcat-daemon.plist. (Reboot the computer before reopening Lightroom, as the old preferences will still be cached if deleted manually.)

7. Uninstall/Reinstall Lightroom

Some problems can be caused by a corrupted installation. To rule this out, uninstall Lightroom by opening the CC app (page 10) in the system tray (Windows) / menu bar (Mac), clicking the ... button to the right of Lightroom, and selecting *Uninstall*. Restart your computer to clear out any gremlins, and then return to the CC app to reinstall Lightroom.

8. Ask for Help

If you're still stuck, post a description of

your problem as a bug in the *Lightroom Ecosystem* section of Adobe's forum at https://community.adobe.com/.

Don't forget to include a complete description of the problem and your exact Lightroom version and operating system. This information is under *Help menu > System Info* on the desktop.

Under the *Help menu*, there's also a **Send Feedback** option. This sends your bug report or feature request directly to the Lightroom team, but unlike the main community forum, it doesn't allow for two-way communication or assistance with troubleshooting.

MOVING TO A NEW COMPUTER OR DEVICE

Since the cloud is the main repository for your photos, moving to a new computer/device is simple, but if you've been managing files in folders on your local hard drive for years, it's a new thought process.

INSTALLING ON THE NEW COMPUTER OR DEVICE

On the new computer or mobile device, install Lightroom and sign in (page 10), and allow Lightroom to download the photos and metadata from the cloud. (Of course, if you use the Local mode on a desktop, you'll need to manually move those photos to the new computer, as they won't be in the cloud.)

If you've cloned your whole boot drive (desktop) or restored from a backup (desktop or mobile), follow the instructions to reset Lightroom's local cache (page 431) so that it syncs as a new device. This prevents sync problems that can result from working off a clone.

DECOMMISSIONING THE OLD COMPUTER OR DEVICE

You can activate Lightroom on two computers at a time (or five if you have the Lightroom 1TB plan). To deactivate on an old computer, go to *Help menu > Sign Out* or uninstall the software.

Mobile devices don't have the same limitations, but if you pass your old device onto someone else, you'll want to wipe your data by resetting your device to factory defaults.

To avoid losing any photos or edits, ensure that your old computer or device has finished syncing with the cloud before you decommission it.

MIGRATING TO LIGHTROOM CLASSIC

If you find that Lightroom is missing some features you can't live without or your internet connection is too slow to upload all of your photos, it is possible to migrate to Lightroom Classic. (That's the traditional desktop-based version of Lightroom.)

It's not as simple as migrating from Lightroom Classic (page 66), as it's not a direction Adobe intended people to take. There are two main options, each with their pros and cons.

SYNCING TO LIGHTROOM CLASSIC

Syncing photos from the cloud works well if you migrated from Lightroom Classic or haven't added keywords or people tags in Lightroom.

1. If you originally migrated from Lightroom Classic, open that migrated catalog. Otherwise, open Lightroom Classic to an empty catalog.

2. In the *Edit menu* (Windows) / *Lightroom menu* (Mac) > *Preferences* > *Lightroom Sync tab*, set a custom location for mobile downloads.

3. Click on the cloud icon and click the *Start* button to begin syncing. This downloads the original photos and metadata from the Lightroom cloud, storing them on your local hard drive. It doesn't sync keywords, versions, or album folders, but it does sync the albums themselves.

SAVING SETTINGS TO FILES ON THE DESKTOP

Saving settings to the files works well if you've added keywords/people's names to your photos and want to retain them when moving to Lightroom Classic (or any other photo cataloging software, for that matter).

1. Filter the photos to show the flagged photos and assign a star rating or a keyword (e.g., flagged) to help identify them later, as Lightroom Classic can't currently read flags that are written into the file metadata. Repeat for rejected photos.

2. Select all the photos in an album and add a keyword to identify the album (e.g., album-vacation 2018), as album membership isn't written to the file metadata. Repeat for each album.

3. Select all photos and go to *File menu > Export* (page 401). Select *Original & Settings* format and save the photos to a folder. If you have any stacks, the hidden photos will need to be exported separately. If you have any unselected Versions you want to keep, you'll need to export them separately, too.

4. Open Lightroom Classic to a new catalog and go to *File menu > Import Photos*, then select *Move* at the top of the Import dialog. This will move the photos from the large single folder into the folder structure you select in the Destination panel.

Lightroom Classic is discussed in great detail in my book, *Adobe Photoshop Lightroom Classic—The Missing FAQ*. If you continue syncing Lightroom Classic with the Lightroom Cloud, I'd strongly recommend reading the Cloud Sync chapter of that book. Lightroom Classic is only a distant cousin of the Lightroom ecosystem. Therefore, some things don't sync (as noted in the workflow diagram on page 17), and some other unexpected behaviors to look out for.

GLOSSARY

Album—a set of photos grouped for a specific purpose.

AI (Artificial Intelligence)—a computer imitating intelligent human behavior.

All Photos—a special album containing all of the photos and videos stored by Lightroom.

Aspect Ratio—the proportional relationship between the width and height of the photo, otherwise known as the shape.

Black Point—small area of the photo that is pure black.

Bokeh—the aesthetic quality and feel of blurring caused by shallow depth of field.

Bounding Box—the edge of the crop.

Brightness—radiated or reflected perception of luminance of a subject.

Cache—a temporary storage location on your computer.

Chromatic Aberration—when a lens cannot bring all wavelengths of color to the same focal plane point, causing fringes of color along high-contrast edges.

Clipping—the loss of either highlight or shadow details when tonal information is driven to pure white or black.

Cloud—the server on the internet where your images are processed and stored.

Color Cast—an unwanted color shift in the photo.

Color Temperature—the color of the light source.

Contrast—the difference in brightness between light and dark areas of a photo.

Crop—to trim a portion of the photo.

Curve—a line graph that illustrates or controls the brightness and contrast of different image tones.

Demosaic—where raw image data is translated into a viewable color image.

Depth Map—an image channel that contains information relating to the distance of surfaces from the camera.

Distortion—a warping or transformation of an object and its surrounding area.

DNG—open-source raw file format.

Dynamic Range—the difference between the brightest and darkest tones in a photo.

ETTR—stands for "expose to the right" and means setting the exposure to be as bright as possible without clipping the highlights to

pure white.

Exposure—a measure of the amount of light in which a photo was taken or the adjustment made in photo editing software.

Facets—used to limit search terms to specific criteria.

Gain Map—an image channel that describes how a photo should be scaled between SDR and HDR rendering, depending on the capacity of the display.

GPS data—the location coordinates captured using the Global Positioning System navigational satellites.

HDR (High Dynamic Range) Display—some new displays can display much brighter whites than SDR displays, with some phones and tablets reaching 1600 nits (or cd/m2). These can display an additional 2-4 stops of highlight detail compared to an SDR display, resulting in brighter highlights, deeper shadows, improved tonal separation, and more vivid colors.

HDR merge—a process that combines multiple exposure variations of an image to achieve a dynamic range exceeding that of a single exposure.

HEIC—a file format Apple has chosen for the HEIF (High Efficiency Image Format) standard. It enables smaller files using advanced, modern compression methods while retaining higher image quality than a JPEG alternative.

Highlights—the light tones in the photo.

Histogram—a bar graph showing the relative population of pixels at each level.

Hue—the shade of a color.

JPEG—stands for Joint Photographic Experts Group, is a lossy compression technique for color photos (so photo data is compressed, resulting in smaller files with variable loss of data).

Keepers—photos you decide are worth keeping.

Kelvin Scale—a unit of measure for temperature relating to the color temperature of light sources.

Keystoning—where a building seems to lean backward in a photo.

Lightroom—the cloud-native ecosystem of mobile, desktop and web apps.

Lightroom Classic—the traditional catalog-based version of Lightroom.

LUT (Look Up Tables)—used by profile developers for advanced color adjustments.

Mask—lets you apply an adjustment to one specific area of a photo rather than the entire image.

Members Area—password-protected area on the Lightroom Queen website at https://www.lightroomqueen.com/members

Metadata—data describing the photo, such as how the photo was taken (camera, shutter speed, aperture, lens, etc.), who took the photo (copyright), descriptive data about the content of the photo (keywords, caption), and edits made using Lightroom.

Midtones—range of tones that lie between highlights and shadow.

Moiré—a rainbow-like pattern that is often seen when photographing fabrics.

Noise—common term to describe visual distortion, equivalent of grain in film cameras.

Panorama—wide format (usually a landscape) made by overlapping individual shots and merging them into a long, thin image.

Pixel—a photo is made up of a number of pixels, each of them representing an individual dot of information.

Posterization— A visual defect (also called banding) in an image created by insufficient amounts of data to maintain the appearance of continuous tone.

Preset—a set of edit settings that can be applied to other photos.

Preview—a small copy of the edited photo for display within Lightroom.

Profile—a starting point for editing your raw photo, like choosing a film stock. Also used for special effects.

Raw File—the unprocessed sensor data from the camera.

Rendered File—the processed image data in a standard image file format.

Resample—changing the pixel dimensions of a photo.

Resolution—the number of pixels in an image.

Saturation—the intensity or purity of a color.

SDR (Standard Dynamic Range) Display—the standard that has been used for displays for years, with a typical dynamic range of around 6 stops. These have a brightness range of 100-300 nits (or cd/m2).

Shadows—darker tones in a photo.

Smart Preview—a small copy of the raw data for use within Lightroom.

Specular Highlights—areas of a photo that are meant to be pure white without detail, such as reflections on shiny objects.

Stack—a group of photos that appears as a single photo in the Grid view.

Sync—to synchronize data between the cloud server and other devices.

TAT—stands for Targeted Adjustment Tool. It allows you to drag on a photo to change color or tone curve while visually seeing the results.

TIFF—stands for Tagged Image File Format, a computer file format with lossless compression (so no detail lost).

Tone-mapping—redistributing tonal information to correspond more closely to how our eyes see light.

USM (unsharp mask)—a type of sharpening that creates halos on either side of an edge.

Vignette—a reduction or increase of brightness or saturation in the corners of a photo, which may be a lens defect or added for effect.

White Balance—removing unrealistic color casts so that objects the eye expects to be white appear, for example, a white wedding dress.

White Point—pixels that are pure white.

Workflow—a series of steps undertaken in the same order each time.

THE LIGHTROOM CLOUD PREMIUM MEMBERS AREA

With your book purchase, you also get a year's access* to our **Lightroom Cloud Premium Members Area**.

YOUR LIGHTROOM CLOUD PREMIUM MEMBERS AREA ACCESS INCLUDES:

• **Multiple eBook formats** of this book, regularly updated as Adobe adds new features to the Lightroom Cloud Ecosystem.

• **Email Support** from Victoria and Paul, if you can't find the answer to your Lightroom ecosystem question in the book.

• **Blank Image Analheysis Worksheet** to help you analyze your own photos.

• **Sample Images** so you can follow along with key editing examples.

• Additional **Start-to-Finish editing examples** to continue practicing.

• **Keyboard Shortcut** sheets to speed up your workflow.

• **Discounts** on future purchases on the Lightroom Queen website.

ACCESS TO THE MEMBERS AREA & BONUS DOWNLOADS

If you purchased this book from https://www.lightroomqueen.com, your book is already registered, and you can find the downloads in the Members Area.

If you purchased from a third-party retailer such as Amazon, you'll need to register your book to gain access to the Lightroom Cloud Premium Members Area.

To register your book, we need:

• Proof of Purchase, for example, your confirmation email, shipping confirmation, a scan/photograph of the packing slip, a screenshot of the order confirmation on Amazon's website, etc. We need to be able to read the order number and order/delivery date.

• The book reference code: **CC79202310LS**

Send us the details using either:

• The book registration form: https://www.lightroomqueen.com/register

• Email: registration@lightroomqueen.com

What happens next?

We'll upgrade your Members Area account and confirm by email. This can take up to 48 hours, as it requires a real human to press the buttons.

You can then log into the Members Area at https://www.lightroomqueen.com/members to access the downloads and email support contact form.

** Members Area access is valid for 365 days (from the date of book purchase if new, or from the date of publication if purchased used). You can extend it at a low cost, so you always have the most up-to-date information about the Lightroom cloud-based ecosystem.*

INDEX

Printed in the USA
CPSIA information can be obtained
at www.ICGtesting.com
CBHW042222071123
1750CB00008B/16